More Than You See
A Guide to Art

Frederick A. Horowitz
Washtenaw Community College

HARCOURT BRACE JOVANOVICH, PUBLISHERS

San Diego New York Chicago Atlanta Washington, D.C.

London Sydney Toronto

Cover: Henri Matisse, *Open Window, Collioure,* 1905. Oil on canvas, 21¾″ × 18⅛″. Collection Mrs. John Hay Whitney, New York.

Requests for permission to make copies of any part of the work should be mailed to: Permissions, Harcourt Brace Jovanovich, Publishers, Orlando, Florida 32887.

ISBN: 0-15-564080-1
Library of Congress Catalog Card Number: 84-81489

Printed in the United States of America

Preface

Many people think of art as a painting hanging in a museum that they never visit. Others may enjoy art, but feel they don't know enough about it. All of us have looked at a painting or sculpture and wondered: What does it mean? Why was it made? What can it mean to me? We may have been delighted by what we looked at and wished we knew more about it. Or we may have felt puzzled and unsure of ourselves. Sometimes we may find ourselves wondering: What is art? What makes a work of art good, and how can I tell? We may have looked at buildings downtown or in our neighborhood and wondered: Why do they look like that? We may ask ourselves how seriously to take art, and may even wonder whether we need it at all.

This book is an attempt to link the reader to the world of art—a world that is accessible, enjoyable, and endlessly fascinating.

It is based on the assumptions that there are no wrong responses to art and no bad reasons for liking it.

What kind of art will we discuss? As the title of this book indicates, we will be involved with the visual arts: primarily painting, and, to some extent, sculpture, architecture, crafts, photography, films, and television. We will focus on painting because in Western civilization painting has been the main vehicle of serious artistic production. For the most part we will concentrate on the kind of art we find in museums and galleries, though we will also consider art that is found outside the museum. Throughout the book we will take into account not only the art, but the attitudes and philosophies of the artists themselves.

This book asks the reader many questions. It opens to the reader the many ways that people have responded to art. No one approach is touted as the only approach. Indeed, the thoughtful viewer will be alert to the many meanings that a work of art can hold, and to the many ways that he or she can be drawn to it personally.

These thoughts are developed in chapters 1 and 2, which stress the depth and breadth of art. Chapter 3 introduces the three-dimensional worlds of architecture and sculpture; chapter 4 follows with a consideration of images and the compelling appeal of subject matter; chapter 5 introduces the analysis of form; chapter 6 stresses the cultural aspects of works of art. Together, these early chapters should pro-

vide the reader with an understanding of the many ways that art has been, and may be, experienced.

Chapters 4–6 deal mainly with art that is representational. In chapters 7 and 8, however, we consider the background and aims of abstract and post-modern art. The subjective and often idiosyncratic nature of these more recent developments in art prompts an investigation of the ever-changing relationship between art and society in chapter 9. Chapter 10 invites the reader into the world of the artist through a discussion of artistic creativity.

Chapters 11 and 12 are more philosophical, inquiring into problems of meaning and problems concerning the evaluation of art. Included in these two chapters are thumbnail surveys of Western art history; chapter 11 focusing on the changing content of art and chapter 12 relating the sequence of artistic styles.

Chapter 13 moves in for a closer look at the art, explaining painting techniques and other means that artists use to create illusion. Chapters 14 and 15 conclude the book with practical information and suggestions; chapter 14 helps the reader get more out of a museum visit, and chapter 15 encourages the reader to enjoy what is near at hand.

Teaching in a community college has convinced me that art doesn't pose problems to people, but misconceptions about art do. Our attitudes and expectations—the way we approach works of art—can be the major factor in determining whether or not we get something out of the experience.

This book is a brief preface to the study of art. It provides a map by which the reader might make his or her way through that world and feel at home in it. I hope that you will be encouraged to go on investigating art: reading about it, thinking about it, experiencing it. I hope this book will strengthen confidence in your capacity to make contact with art in a way that is meaningful and pleasurable for you.

I am fortunate to have had the help of a number of people in the development of this book. I would like to thank them here for their contributions and for their encouragement: Martha Agnew; R. Ward Bissell of the Department of Art History, University of Michigan; Robert C. Brumbaugh of the Anthropology Department, University of Michigan; James M. Carpenter of Colby College; Dale Cleaver of the Department of Art, University of Tennessee; Sabra Feldman; my brother David; Meryl Johnson; Diane Kirkpatrick of the Department of Art History, University of Michigan; Bobbie Levine, docent at the University of Michigan Museum of Art; Hattula Moholy-Nagy; John Robinson; Jessica Schwartz of the Department of Physiology, University of Michigan Medical School; Sherri Smith of the School of Art, University of Michigan; Stuart Susnick of the Anthropology Department, Washtenaw Community College; and Dan D. Wood, Southern Illinois University. I also wish to thank Ann Doty Savage, Jacquelyn Torres, Ellen Lee, and Suzanne Gurney for their patience and diligence in the preparation of the manuscript. I would like to express my appreciation to the people at Harcourt Brace Jovanovich whose efforts made this book a reality; to Albert I. Richards for his encouragement and guidance, to Nancy Hornick for her superb editing skills, to Candace Young for managing cheerfully to track down all the right pictures and get them to the right places, and to Cheryl Solheid for her fine work on the design of the book. It has been gratifying to work with them. I also want to express my deep appreciation to my father and mother for their encouragement and support over the years. Finally, a very special thanks to Nancy V.A. Hansen, whose imagination, wisdom, sense of organization, ruthless editing, patience, and impatience provided an invaluable contribution to this book. For that contribution and for her inspiration, this book is dedicated to her.

Frederick A. Horowitz

To the Reader

From time to time we all need to escape the rational and systematic modes of thinking that we use when reading a newspaper, shopping for groceries, or balancing a checkbook. We need to speculate, to daydream, or to reflect over things in a free-form way. All of us require the refreshment and self-renewal provided by the open-ended exercise of our minds.

As children, our lives were enriched by the powers of fantasy and imagination. Through fantasy we made sense out of the world around us. Fantasy gave us pleasure. It transported us to cloud castles in the sky and enabled us to dwell in the pictures of a book. Imagination kept our senses open and connected us to things. We pondered the patterns in a leaf or on a frosty window pane; we were intrigued by a color, enchanted by a glowing light, mystified by a distant sound. Experiences such as these were rich and satisfying because our imagination gave them meaning.

Later we began to see things from other people's points of view and to encompass other people's values. We learned the habit of relating our experiences to larger schemes of things. We learned to categorize experience. Our reactions became more pragmatic and objective. These new ways of thinking enabled us to survive in an adult world. But they also narrowed the range of our responses to that world. And they inhibited the personal growth uniquely provided by the activity of fantasy and imagination.

As adults, we tend to associate imagination with childhood and childish things. But imagination is crucial in adult experience as well. Imagination is a way of thinking. It is creative. It lifts us out of routine and keeps us fresh, open, and flexible. It is the source of invention, insight, humor, and romance.

We carry into adulthood the impulse to explore, to discover, to be touched deeply by what we experience, and to respond. It is here that art can be of use to us, for art, nourishing the imagination, helps us fulfill these needs. Art is not a gloss on life or a diversion from it. Art speaks to our central concerns as human beings. Through our contact with art we can continue to reach beyond ourselves and to develop ourselves throughout our lives.

Art can't be known by how you define it, nor is it a body of knowledge that you learn. How many facts, names, or dates we

know about art is relatively unimportant. What counts is that we open up to art, experience it, and enjoy it. This book is about how that can happen.

Contents

vii

Look at those lines. They are not tricks.

They are real and they work and they make you

think. I am giving you more than you see because

it is always changing. It is alive.

Josef Albers

1 | *Making Connections with Art*

No child ever had to take a course in art appreciation. Children make connections with things they see and touch in a way that is immediate and strong. In adult life, our relation to art may be more tenuous. What fascinated us as children now seems naive and uninteresting. And what we see in museums or in reproductions is often confusing and difficult to understand. The old, happy rapport with pictures may seem a thing of the past.

My purpose in this book is to help you make connections with art. The experiences of our childhood show us that such connections are possible, that art can touch us and nourish us. We can connect with art as adults, too, but in order to do so we shall probably have to relinquish the idea that only art that speaks to us directly and immediately is worth looking at.

Works of art that challenge our understanding may also have something to offer us. The strangeness of their appearance or the unfamiliarity of their content may make it impossible for us to grasp all at once what they are about. Ideas contained within works of art take time to unfold. But if we are patient, open-minded, and willing to reflect on what we've seen, we will establish a relationship with it.

Art can do more than provide a comforting world in which to find refuge. It can broaden our horizons. It can connect us to people in other times and places. It can present us with extraordinary visions, and compel us to explore our own minds and experiences.

I won't argue on these pages for an indiscriminate appreciation of art. Not all art is of equal value. Certainly, not all art that is obscure is good. But a painting or a sculpture that simply states what we already know and like may not provide us with much nourishment. Repeating what is familiar and comfortable can be a trap, stultifying experience rather than enlarging it. The most rewarding experiences in art are, I believe, those that extend vision and awareness.

So let's begin with the assumption

that it's worth the effort to involve ourselves not just with the things that appeal to us directly and immediately, but also with art that we feel uncertain about, and wonder about.

Investigating Art

All of us have had the experience of being unsure of what we think about a work of art, or unsure of how to put what we do think into words. Works of art that look strange, whether abstract or representational, present problems to anyone who confronts them for the first time. Our familiar guidelines may suddenly seem irrelevant. What's going on here, we ask. Can I understand it? Can it mean anything to me?

Some of the discussions you will read later in this book will help guide your investigation of art. They will set out for you some of the possible approaches to art that can help you get the most out of it. But for now I will make a few general suggestions that you may find useful, whatever it is you are looking at.

When you look at a work of art, allow yourself time. Make yourself stay there. Give yourself ten minutes. Get comfortable, and just look at it. Don't look for anything in particular. Don't try to think. It may seem a little crazy, but if you do that, things will start to pop out at you. You will find yourself seeing more and more.

To build further upon the experience, talk about what you see. Toss around your thoughts and ideas with other people. Don't hesitate to ask questions about what you see. What do you notice? Why? What seems unusual?

Talking and also writing about what you see helps you to discover and to refine your thoughts. In discussing a piece, try not to rely on other people's words and phrases. Don't try to sound like an art critic. Speak or write in the language you know. Find the words that have meaning for you—that come out of your life, and out of the experiences that you bring to the piece.

Try to be as accurate as you can by using words that are as precise as you can find. If you take an art course, your instructor, or other students, can help you by insisting on clarity when you are vague. In time, you may come to need terms that art critics use. The terminology of art critics and historians can serve as a useful tool to help you see more precisely and to communicate more accurately. Like any tool, however, it should be used properly.

If you think something you see is good, it's not enough for you to say so and let it go at that. Deciding whether it's good or not could conceivably be an end point in a discussion. More interesting, and certainly of more use to you and the others you are speaking to, is to know *why* you think it's good. Your interest ought to be placed in what's going on in it, in what you've discovered, rather than in whether you label it good or not.

Often the very first word that comes into your mind carries the greatest significance for you. Trust it. Don't worry about what somebody else would say. For no matter how far-fetched it may appear it carries with it the truth of your experience. There's no such thing as a wrong reaction to art.

One word of caution. When you talk or write about a work of art, look at it. Make sure there is a basis for what you are saying in the work itself. Bouncing

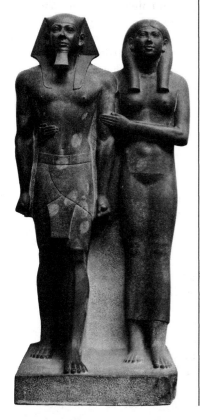

1-1
Pair Statue of Mycerinus and His Queen Kha-Merer-Nebty II, from Giza, Dynasty IV, 2599-2571 B.C. Slate schist, 54″ high. 11.1738, Harvard University and Museum of Fine Arts Expedition. Courtesy, Museum of Fine Arts, Boston.

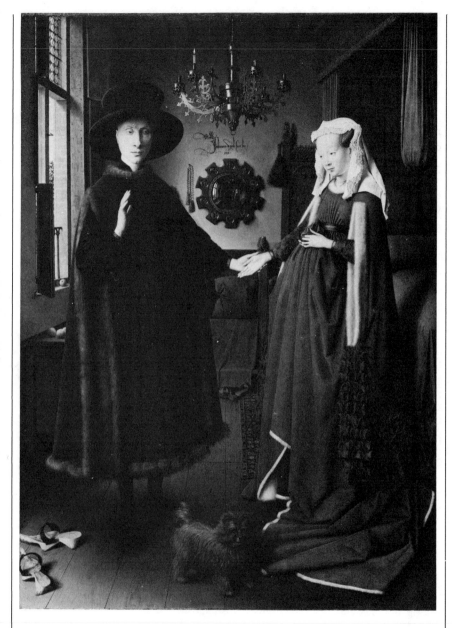

your pet theories off a painting may be fun, but you risk missing out on what the painter is trying to tell you.

Certainly, reading about the piece, its social background, or about the artist, can illuminate it for you and provide a foundation for a better understanding of it. There are times when only a history book or an anthropological study can provide keys to the piece, and no amount of guesswork can disclose its meaning.

But it's impossible for anyone to know *all* there is to know about a work of art. Meanings in art just don't stay put. Over time, old associations may be lost. Perspectives change, new meanings are discovered, theories and opinions are

revised. Meanings, in art at least, are multiple, and always open to discussion.

One can never be perfectly objective about a work of art. For each person, the precise meaning of a work of art shades into something unique, because each viewer brings his or her own point of view to the piece. Even advanced studies of works of art inevitably reflect the personality and interests of the writer.

Your investigation will frequently reveal many aspects of a work of art, and many levels of meaning. The more of these you discover, the stronger your connection to it will be. Like the human personality, a work of art has depth, and can hold many surprises.

The contemplation of art is a way of contemplating life, for all of life finds expression in art. That is why the contemplation of art is limitless—and also, why it is rewarding.

2 | *What Is Art, and Where Does It Fit in?*

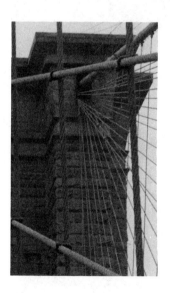

What is art? How can it be identified? What sets it apart from other things? Consider the following:

- If we think of art as an expression of beauty, we shall discover much art that seems indifferent to beauty.
- If we think of art as a means of self-expression, we shall discover art in which self-expression was discouraged.
- If we think of art as existing purely for its own sake, distinct from practical activities, we shall find it in societies where it is so intertwined with the making of things that there is no word for it in the language.
- If we think of art as a form of communication, we shall find art that is purely decorative.

It is this diversity of forms and functions that makes art difficult to see as a whole.

Attempts to define art bring with them an infinite train of questions, and raise lengthy theoretical problems. It's just plain hard to pin art down to certain characteristics and then draw a line around them. I'm not sure I could say with certainty what things are art and what things are not. I know that some things puzzle me, and make me question the assumptions I have made about art. Definitions of art are widening today, partly because we are learning more about the art of other cultures, but mostly, I think, because many contemporary artists are forcing back the boundaries of art in their work. They are breaking old rules and giving us something new and different. Some people, confronting the new, are quick to say that what they see is not art. My own tendency is to say: It's art. I might not like it. I might think it's terrible. But if someone who did it, did it to be art, and calls it art, I'll go along with it. Why not? Maybe one of us will know a little better next time.

A Definition of Art

Any definition of art should be understood to be a concept, rather than a fact. With that, I'll suggest that art can be

- an object,
- a certain quality in things,
- an experience.
- And, whatever its form, it must originate in the mind of man.

Examples of the first category would be Rembrandt's *Night Watch* (Fig. 2-1), an African mask, or the Statue of Liberty. They are *objects* intended to be considered as works of art.

2-1
Rembrandt van Rijn,
The Shooting Company
of Captain Frans
Banning Cocq (Night
Watch), **1642. Oil on**
canvas, approx. 12′8″
× 16′6″. Rijksmuseum,
Amsterdam.

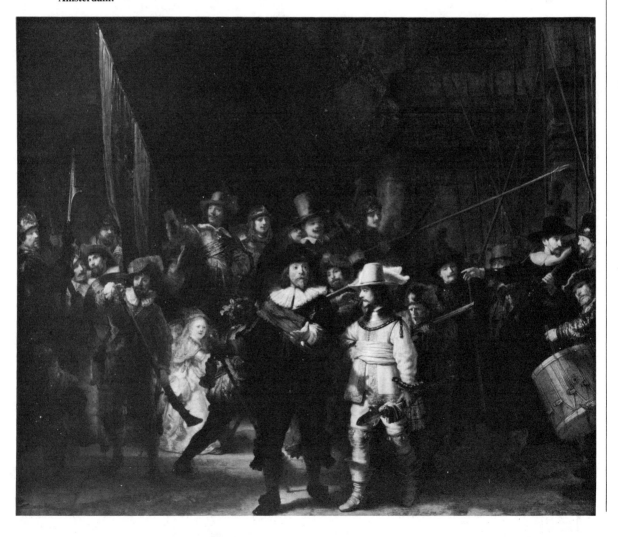

Some things not intended as art objects may be regarded as art because of their aesthetic quality—that is, a quality of attractiveness or beauty—or their high level of creative or technical excellence. It is a *quality in them* that demands that they be considered art. Things in this category are not generally found in museums, though they sometimes wind up there. They are, for the most part, out in the wide world: the Brooklyn Bridge (Fig. 2-2), a space craft, or a Shaker pitchfork, for example, may be seen as works of art.

2-2
The Brooklyn Bridge. Designed by John Roebling. Completed 1883.

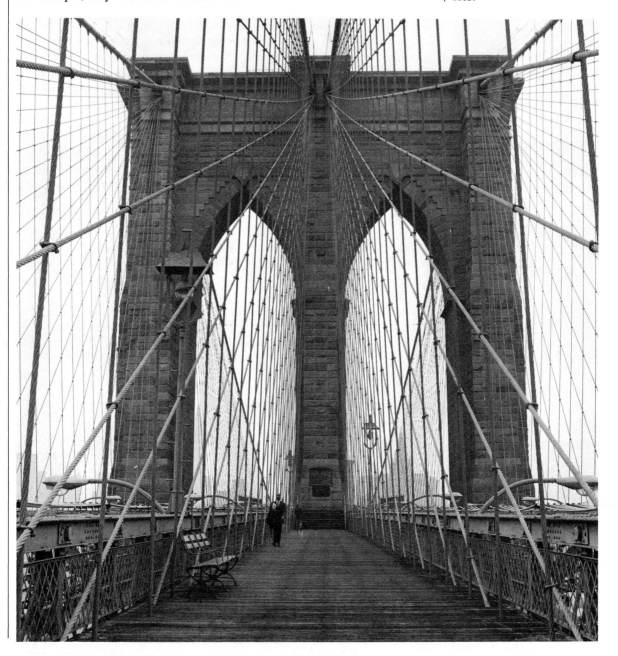

Recent developments in art—which I shall talk about later in detail—have compelled the recognition of art as *experience* rather than object. Some art is less a thing that we can look at or touch than a process, an activity, or an idea. It may have no aesthetic quality at all. For example, Douglas Huebler's *Variable Piece 4/Secrets* (Fig. 2-3) involved an idea, a Xerox machine, and nearly 1,800 individuals and their secrets. Huebler completed the piece later by publishing the secrets, with surnames edited, in a book. Without the participants, this intriguing piece would have had no existence.

Finally, art originates in man. Certainly nature, or machines, or chance, or accident can play their parts. Art need not be entirely man-made. But it must have arisen out of someone's mind, or fancy, or intuition, or imagination, or whatever. Even if it is only a matter of making us think about something in a new way by presenting it in a new way, someone has changed it for us, and thereby converted it to an art object. Originating in human experience, any work of art, whatever its content or its form, refers us back to humanity.

Every work of art is a distillation of ideas. Thus a work of art is, inevitably, expressive; it makes a statement of some kind. Whatever the intentions of the maker, his work will tell us something about himself.[1] It will also reveal something about the society of which he was, or is, a part. Accordingly, we may think of art as a record of human experience.

For the artist, art is a way of seeing, and a way of interpreting and expressing what he sees. But it is not like science, which seeks facts and general principles. Art is intuitive and subjective, and thus the experiences it presents, though they may be shared, are one of a kind.

Art has to do with imagination. It carries us beyond our everyday reach, and puts us in contact with something outside, as well as within, ourselves.

Given this, can any art be remote or irrelevant? If art seems remote, it is perhaps because the context out of which it sprang is as yet unknown to us. Art is diverse, rich, varied, because human experience is diverse, rich, varied. There is much in it to experience: would we wish it otherwise?

The Many Functions of Art

Art has had many different functions in human history. Each society defined its own purposes for art, and produced an art suited to those purposes. For ancient Romans, art served as a vehicle of propaganda: their sculptures proclaimed victories, and their buildings extolled the power of the State. Among Indians of the Northwest coast, totem poles relate histories, and at the same time serve as a means of establishing rank on the social scale. For ancient Egyptians, paintings and sculptures, often sealed in tombs away from human sight, served magical purposes. The elaborate system of symbolism developed in the art of Medieval

[1]For the sake of brevity, I have used the pronouns "he," "him," and "his" when referring to artists in general. The reader is asked to consider these not as restrictive terms, but, where applicable, as including women as well.

2-3
Douglas Huebler,
Variable Piece 4/Secrets,
1973.

VARIABLE PIECE 4
NEW YORK CITY.

Visitors to the SOFTWARE exhibition are invited to participate in the transposition of information from one location to another by following the procedure described below:

1. Write or print on this paper an authentic personal secret that you have never revealed before: of course, do not sign it.

2. Slip the paper into the slot of the box provided at this location. Complete the exchange of your secret for that of another person by requesting a photo-copy of one previously submitted.

(To insure your anonymity incoming secrets will remain within the box for 24 hours before being removed to be photo-copied and joining the "library" of secrets for future exchange.)

May 1969 Douglas Huebler

Forms on which the above directions were printed were made available to all visitors at the exhibition SOFTWARE (Jewish Museum, NYC, September 16-November 8, 1970).

Nearly 1,800 "secrets" were submitted for exchange and have been transcribed exactly as written except that surnames have been edited: all are printed in this book and join with this statement as final form of this piece.

March, 1973 Douglas Huebler

Europe communicated church histories and theological concepts. In modern societies like our own, art serves different and sometimes contradictory purposes. One artist paints in order to communicate a message to his audience, while across the street another paints in order to please himself. A third artist explores shapes and colors; a fourth illustrates books.

A list of the ways that art has functioned would have to include the following. (You may find this list surprisingly long; even so, perhaps you can add some things to it.)

Art functions as:

1. an agent of magic (to ensure a successful hunt, to perpetuate the soul after death, to triumph over an enemy, to cure disease, to protect, etc.)
2. an aid to meditation
3. an agent of ritual
4. a record (of events, objects, situations)
5. a substitute for the real thing; a stand-in, or a symbol
6. a souvenir
7. propaganda (to impress; to persuade; to change thinking or behavior)
8. communication (of stories, ideas, events)
9. an agent of social control
10. entertainment, amusement
11. a means of moral improvement
12. education
13. a means of self-expression
14. self-revelation
15. release of emotions
16. exploration of vision
17. a reflection and interpretation of life
18. an expression of beauty
19. decoration or embellishment
20. monetary investment
21. a status symbol

We can see from this list that the functions of art are wide ranging. But that is not surprising. Art is as broad as human experience. *All* of art comes out of life, and is bound up with life. Art is meaningful, but meaningful in ways that differ from society to society, from time to time, and from person to person.

3 | *Feeling Our Way into Architecture and Sculpture*

On the way to work I drive along a block on the edge of town that has some unusual buildings. Six are in a style reminiscent of American Colonial architecture, with white columns and an occasional cupola; one is a Victorian mansion with a mansard roof and shingle siding; one looks like a saloon from the days of the wild West. Just beyond them in the next block is a building whose stucco walls, tile roof and round arches marked out in bricks give it a Medieval Spanish look. Five of these buildings are restaurants, three are office buildings, and one is a funeral home. Most were built within the last five years. You've probably seen buildings like these where you live. Probably none of them are examples of great architecture, but they do illustrate something that architecture is supposed to do, and that is make us feel good. Why we feel good in being reminded of the past as we eat, drink, work, or go about our other daily activities is a good question. What do you think?

Whatever the reasons, it seems to me that apart from their references to the past, the architecture of these buildings is bland and uninteresting. If you compare these buildings to the originals—to the public and domestic architecture from which they were more or less freely copied—you will likely find that the originals were more handsome, better proportioned, and more ingeniously designed.

The Character of a Building

A building can have an *intrinsic* quality that makes it appealing, whether it refers to other buildings or not. That quality has to do with its overall appearance and presence, which is something we feel, or sense, as well as take in with our eyes. Buildings have personality or character, much as do people. It's easy to sense that character when we look at, say, an old barn, a Gothic cathedral (Fig. 3-1), or the Capitol Building in Washington, D.C. (see Fig. 6-15).

Even the buildings on my way to work have character, though it is, I believe, thin and contrived. Less distinctive buildings are more difficult for us to respond to. We may feel that they lack something. But they may be worth thinking about anyway, particularly because so much of what surrounds us and what we live in seems dull and non-descript. Dull it may be, but just how non-descript it is may depend on how carefully we look at it.

About a thousand years ago Chinese artists were fond of describing mountains as proud, humble, serene, majestic, austere, and so on, and it seems to me that we can think of the character of buildings in similar terms. Buildings are made for people, and they can act like people. A friendly house reaches out to you with a porch or a path. A house with small windows and a heavy door, set back from the sidewalk, remains aloof. A house can seem formal, especially if it's symmetrical, or suggest informality and fun by parts and pieces stuck here and there. Think of the kind of house you would like to live in. Its character will reflect your character.

Buildings inevitably express some idea, or concept. A barn is protective, earthy, mothering. A Gothic cathedral lifts our thoughts. The Capitol Building evokes with dignity the tradition of democracy and its origins in classical antiquity. Consider the public buildings where you live: the libraries, restaurants, houses of worship, schools, museums, stores, and banks. How do they show you what they are used for? What impression do they try to make on you? What associations do you make when you look at them?

3-1 (left)
Robert de Luzarches, Amiens Cathedral, west facade, c. 1220–88.

3-2 (right)
Ictinos and Callicrates, the Parthenon, view from the west, Acropolis, Athens, 448–432 B.C.

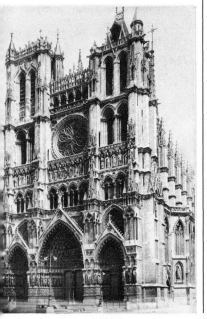

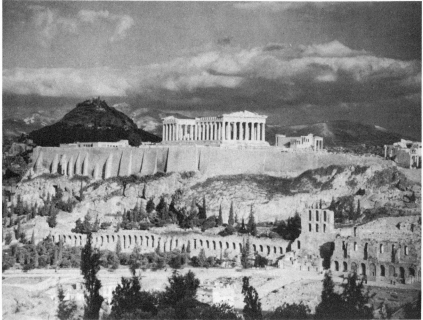

What is the feel of your neighborhood? What does it reflect about the values of the community? What does it reflect about *your* values? Look at the buildings in your neighborhood. Were they constructed one by one? Or were they mass-produced? What effect does that have on the look of the neighborhood? Do you find the consistency or inconsistency attractive? What have people done to change the way things look?

Components of Architecture

Site. Notice the site—where and how a building is placed and what's around it. Does the building blend in with its surroundings or does it want to stand apart? Is the building close to the street or set back? Does it have much space around it? How is it landscaped? Does the building seem to integrate with nature or contrast with it? How important is the site? What does it contribute to your sense of the building?

The Parthenon, dedicated to the goddess Athena, was placed on a site crowning the city named for her (Fig. 3-2). The forms of the building, rigorously geometrical, contrast with the flowing contours of clouds, mountains, and sky, thus providing an image of an entity that is separate, self-contained, and distinct. Yet it is always seen with reference to the natural world that surrounds it, and a kind of balance between the two is reached. The Gothic cathedrals, on the other hand, (for example, Amiens Cathedral, Fig. 3-1), were built among the densely packed houses in the centers of Medieval towns. Immense in size, they dwarfed their surroundings. The Medieval cathedrals were images of the Church itself, which was both authority and protector, a dominating presence in every aspect of social and private life.

Space. A building is fundamentally a space to be in, so it makes sense to be aware of those spaces and how they affect us. Space has a push and pull to it, more felt than seen. A large indoor space can make us feel small at first, but when we adjust it will give a sense of grandeur and importance to us and to what we do in it. Human activity is magnified in the vast spaces created for the pageants of the Church or Court. By contrast, the nooks and crannies of a house can be just the place to withdraw into for a quiet talk or for reflection. In the Cathedral of Notre Dame the space, while unified, is complex and infinitely subdivided (Fig. 3-3). In Brunelleschi's Santo Spirito the space is simpler and more precisely defined, and our orientation to the other parts of the building is more explicit (Fig. 3-4). In Notre Dame, space seems immeasurable and tends to draw us upward, while the space in Santo Spirito seems more finite and contained, and makes us feel part of a clear and orderly world.

Space is defined by wall and ceiling. Walls give us an idea of the massiveness of the building—how thick, solid, and heavy it feels. Is the wall a smooth, closed plane, or is it perforated by windows, arches, or other openings? How much of the wall is open? How much is closed? How does the wall join the ceiling?

Light. Almost inseparable from our experience of space in architecture is our experience of light. In a Gothic cathedral light is diffused, softened and warmed in places by windows of stained glass. Throughout the building and high up,

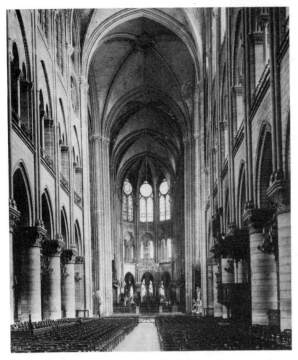

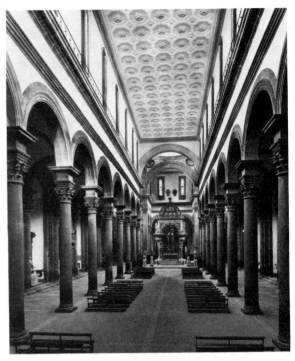

3-3 (left)
Notre Dame Cathedral, east end and part of the nave, Paris, begun c. 1180; modified 1225–50.

3-4 (right)
Filippo Brunelleschi, Santo Spirito, interior, nave, Florence, begun 1436.

under the vaults, the light dims into shadow. Brunelleschi's light is bright, even, and clear throughout the building. What feelings or ideas seem to be expressed by the light in Notre Dame? In Santo Spirito? Think of places you know where the light promotes a certain feeling. Is that light bright? Soft? Warm? Subdued? What effect would candles have had on the perception of interior spaces, or on materials and details, before electric lights?

Decoration. What about the decoration of a building? Is the building ornate? Sparingly decorated? Or is there no ornament at all? Is the decoration integrated into the design of the building or does it seem stuck on? Does it make you more aware of the structure of the building or does it disguise it? Why was that decoration chosen?

I've noticed that in those buildings on the way to work the exterior ornament is important. It gives the buildings identity, as do their signs; and it gives them personality. However, in visual terms the decoration seems contrived and forced. By contrast, in the Parthenon, or on the facade of Amiens Cathedral (Fig. 3-1), the decoration seems inevitable.

Materials. The character of materials—the warmth of wood, the roughness of poured concrete, the elegance of marble, the earthiness of mud or adobe—will also affect our response. A good building puts good materials to work, and lets you feel them and enjoy them. See how glass works on you in the rose window at Notre Dame (Color Plate 1), in the East Wing of the National Gallery (Color Plate 2), and in the underground annex to the law school library at the University of Michigan (see Fig. 10-6). Compare the rich, dense, texture of the stone facade of

Amiens Cathedral with the more simple marble forms of the Parthenon, or with the spare surfaces inside the National Gallery's East Wing.

*Y*ou say to brick, *"What do you want, brick?" Brick says to you, "I like an arch."*

—Louis Kahn, architect, 1973

Color. Have you ever changed the color of a room and noticed how different it felt? Color affects the feel of a place. The interiors of certain mosques, shimmering with the rich and varied colors of tiles, transport the worshipper into another world. By contrast, eighteenth-century Puritan churches in New England were painted gray inside. Rooms painted entirely in pink are used to calm prisoners in police stations. The sculptural decoration of Greek temples of antiquity asserted themselves through bright colors which contrasted with the gleaming, white marble.

Look at the houses in your neighborhood. Are they painted alike? Is color used to differentiate between them? Is color used to make a building stand out or blend in with the surroundings? What accounts for the popularity of certain colors? What messages can colors carry? As an example, why do McDonald's have yellow arches? Why are they called "golden"?

Rhythm. Look down a street in your neighborhood or downtown and see if you can sense a rhythm to the buildings. A rhythm can be created by the repetition of windows, driveways, fences, porches or stoops, street lights, or even garbage cans. Where the rhythms are monotonous—where all the houses look alike—you may find yourself wishing there were some variety. Notice, too, how rhythm is established in a single house or a large building. Generally, the more regular the beat, the more formal the building will appear. As in music, rhythms can be felt as fast or slow, spritely or stately, complex or simple. How does rhythm affect the character of the Parthenon? The Capitol Building? The interior of Santo Spirito? Or the interior of Notre Dame Cathedral?

Distinctive Features. These are some of the usual components of architecture. Along with them, innumerable distinctive and individual details also may contribute to its character. Look around your home, or your room. What do you notice? What combinations of things look appealing? What room seems to be the center of your home? What seems to be at the heart of the room? A fireplace? A chair? A table? A TV set? A window? How does that room, its details and its focal point, reflect your interests and values, or those of your family?

In this detail of the Parthenon showing the columns thrusting against the entablature (Fig. 3-5), you will see forms that are spare, clean-cut, and orderly. The intersection is an image of energy, where opposing forces are engaged and

resolved. A lighter, more sprightly effect is created by the columns and their arches in Santo Spirito (Fig. 3-4), as if surges of energy springing upward triumphed over the force of gravity. When I visited Santo Spirito, I felt that its forms expressed a sense of optimism. (This is not a precise term, but I am talking about my reaction, and not about a measurable architectural element.)

Both the Parthenon and Santo Spirito are based on an aesthetic idea that calls for the clear separation of the parts. Something altogether different occurs in a Gothic cathedral, where part emerges from part organically, in the way that a tree branches, or flowing water divides. The rose window from Notre Dame Cathedral incorporates this aesthetic idea (see Color Plate 1). In the rose window we do not experience opposing forces, but rather we feel a sense of reconciliation, as a myriad of elements are brought into a total scheme. The circle floats on the dark wall, as if unbounded in space or time. Without base or sides or top, it refers inward toward its own center, its circles within circles symbolically moving toward infinity. Its character, like the light it emits, is immaterial and spiritual, in contrast to the more physical forces articulated by the Parthenon and by Santo Spirito.

Buildings act on us for the time we experience them. As we move into and through them, they can change us, change how we feel and how we behave. Of course, we affect architecture as well. Buildings reflect who and what we are. Architecture is probably the only art that is necessary to human survival. It is the place where human dreams and physical realities come to terms.

3-5
Ictinos and Callicrates, the Parthenon, Acropolis, Athens, 448–432 B.C.

The Character of Sculpture

Sculpture, like architecture, takes up space, and therefore exists in a very real way. Like other objects it can be touched, moved, walked around, and dusted off. Its essential character lies in this special presence. A sculpture can depict something such as a figure, but unlike a painting it is not an illusion. If you walk behind a painting the illusion disappears. But unless the sculpture is a relief (flat, or nearly so), it will retain its identity, and remain assertive.

Frontal or Nonfrontal? Sculptors have not always based their work on the idea that a sculpture was something meant to be walked around. Statues in ancient Egypt, in preclassical Greece, in India, and the religious statues of the Middle Ages, were frontal; that is, they all faced forward. You knew that they were solid, of course, and their solidity gave them presence, but if they were to work on you, and impress you, they had to face you, sometimes look at you, and through that direct confrontation assert themselves upon you (see Figs. 6-2 and 7-22).

Michelangelo planned all his figures to be seen from the front (see Fig. 10-2). However, their vigorous, twisting poses invite us to shift our orientation. One of the first to experiment with sculpture in the round was Giovanni da Bologna. Taking Michelangelo's twisting poses one step further, he grouped figures together that would spiral in various directions so that the group could be viewed from all sides (Fig. 3-6). The great sculptor Bernini explored the potential of sculpture to assert itself psychologically. Thus he favored a more frontally oriented sculpture for its dramatic effects. Bernini was able to convey intense and transient emotional states by means of an extraordinary technique that seemed to transform the stone into life (Fig. 3-7). Rodin was less exactingly realistic, but

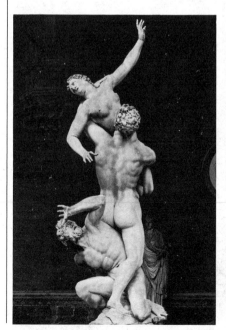
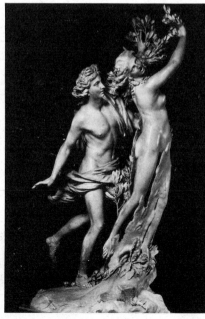

3-6 (left)
Giovanni da Bologna,
Rape of the Sabine Women, **completed 1583. Marble, approx. 13½′ high. Loggia dei Lanzi, Florence.**

3-7 (right)
Gianlorenzo Bernini,
Apollo and Daphne, **1622–25. Marble, approx. 8′ high. Galleria Borghese, Rome.**

more attuned to the movement of masses (Fig. 3-8). He consistently sculptured figures, both in groups and singly, that could be seen from every point of view. Henry Moore likewise encourages the viewer to move around his abstract pieces (Fig. 3-9). It's hard to appreciate the difficulty of getting an object or a grouping to look good from more than one or two points of view. Where it applies, ask yourself how the sculptor took on this challenge. Like the sculptor, you will also begin to see and think in three-dimensional terms.

This is what the sculptor must do. He must strive continually to think of, and use form in its full spatial completeness. He gets the solid shape, as it were, inside his head—he thinks of it, whatever its size, as if he were holding it completely enclosed in the hollow of his hand. He mentally visualizes a complex form "from all round itself": he knows while he looks at one side what the other side is like; he identifies himself with its center of gravity, its mass, its weight; he realizes its volume, as the space that the shape displaces in the air.

—Henry Moore, 1937

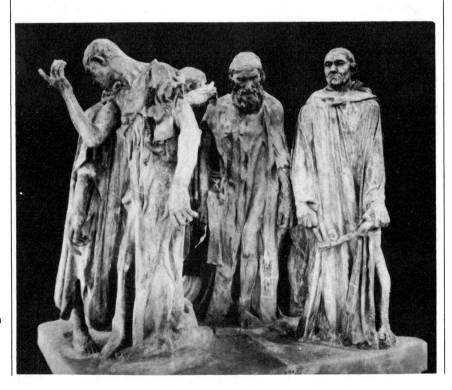

3-8
Auguste Rodin, *The Burghers of Calais*, 1886–87. Bronze, 82″ × 94″ × 75″. Hirshhorn Museum and Sculpture Garden, Smithsonian Institution, Washington, D.C.

Clearly, it's important for our understanding of a sculpture to know whether we are meant to see it from a fixed point of view or to walk around it and see it change. Frontal sculpture has a controlling effect on us; it wants us to stand there opposite it, to tell us something. Sculpture designed to draw us around it is more informal; it invites us to explore it aesthetically, that is, for its beauty.

Mass. Regardless of the angle from which we view a sculpture, we can feel our way best into it when we are aware of its materiality, or substance. Unfortunately, we can't always touch a sculpture to experience this. But we can use our eyes. To begin, we might find it useful to ask ourselves to notice all the things that are there in a sculpture that aren't there in a painting. Mass, or the solidity of the piece, because it is central to our experience of sculpture, provides us with a good point of departure.

Imagine yourself at Chartres Cathedral, looking up at the statues of the Old Testament figures that flank the main entrance (Fig. 3-10). You can readily feel the mass of these statues, because they retain the form of the block of stone as it was quarried. Their mass extends vertically, columnlike, wedding them to the architecture. In Hiram Powers's *Greek Slave* (Fig. 3-11), the mass is more difficult to perceive because the figure is further removed from the original solid block of stone, and perhaps because the realism of the statue catches our eye first. But the mass is there, shaped into gentle contours that flow softly into one another. In the *Greek Slave* flat planes give way to more rounded surfaces, and frontality yields to a quiet turn. The figure is free-standing; we can walk around it, and feel its graceful and tranquil movement in space. Now look at the *Burghers of*

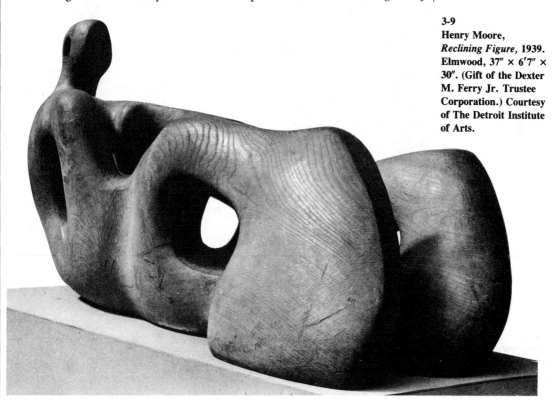

3-9
Henry Moore,
Reclining Figure, **1939.**
Elmwood, 37″ × 6′7″ ×
30″. (Gift of the Dexter
M. Ferry Jr. Trustee
Corporation.) Courtesy
of The Detroit Institute
of Arts.

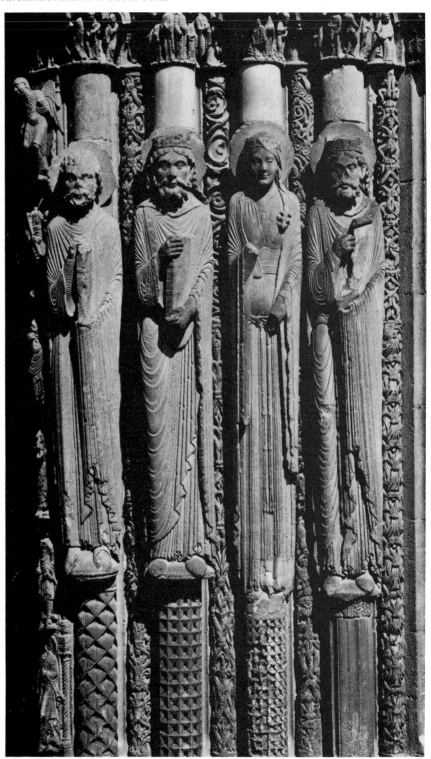

3-10
**Chartres Cathedral,
central portal, detail
of jamb figures,**
c. **1145–70.**

Calais by Rodin (Fig. 3-8). Here we see greater movement and assertiveness where restless forms tilt and strain against each other. Between the figures space opens up, and we see the masses scooping and carving it out, bringing it into the grouping, expanding and compressing it so that it is practically as active as the masses themselves. Henry Moore's *Reclining Figure* (Fig. 3-9) has an organic quality. The mass, penetrated by space, twists upon itself voluptuously. Its transitions from broad to narrow, and from thick to thin, suggest movement despite the restful pose of the figure. In Calder's mobile (Color Plate 2), mass is reduced to thin planes and lines arching into space like a three-dimensional drawing. The delicate tension of weights and balances makes the forms seem alive.

Closed Forms and Open Forms. As you can see, we also experience the hollows and spaces between, within, around, and beyond the solids. At Chartres the sculpture is closed upon itself, blocklike; space is simply what's left over. The *Greek Slave* is more open, and we can sense the soft movement of air around her body. Rodin's grouping, even more open, incorporates space. The space feels energized here, and it changes as you walk around the piece. In Moore's *Figure* the distinction between inside and outside is ambiguous; space flows into solid and solid thins out until you're looking at space again. Space participates in this piece, takes on the movement of the solids, and gives the piece its mystery. The Calder mobile is an entirely open form. The design makes us clearly aware of space as a void through which the sculptured forms move. More than the other sculptures, this piece requires space that extends well beyond itself.

Placement. Because sculptures exist in real space, their location will affect our reaction to them. Do we look up at them? Across at them? Are they part of an architectural structure? Or can we walk around them? The statues at Chartres are a part of the building. With their elongated forms and vertical movements, they echo the overall design and character of the architecture. Looming over us, abstract, remote, they seem beyond reach, as though partially in another world. Our lovely Greek slave girl, about whom you will read more in chapter 11, stands independent, in our world. However, she is also placed on a pedestal, which lifts her above us, and by implication, beyond everyday experience. Rodin wished to avoid the rarified quality induced by the pedestal, and intended, in violation of tradition, that the *Burghers* be placed on the ground where they could mingle naturally with the people of the town. The placement of Moore's *Figure* on a low platform locates it in our world, where its hard, weighty presence contrasts with the more ephemeral human one. In contrast, the mobile floats in airy tranquility, seemingly weightless and free.

Technique. Traditionally in Western art, sculpture was either carved or modeled. The sculpture at Chartres and the *Greek Slave* were carved out of stone. To Michelangelo, carving was the only proper method of making sculpture. He conceived it as releasing the figure from the confines of the stone. In modeling, the sculptor builds up the piece with a soft material such as clay, wax, or plaster, and later has it cast in a harder, more permanent material, typically bronze. The *Burghers of Calais,* for example, was modeled in plaster and cast in bronze.

Like many sculptors today, Calder constructed his pieces (Color Plate 2). For the National Gallery piece, his largest, he called in experts to help him gauge the weight and the tensile strength of the material. Because of its size and weight (it

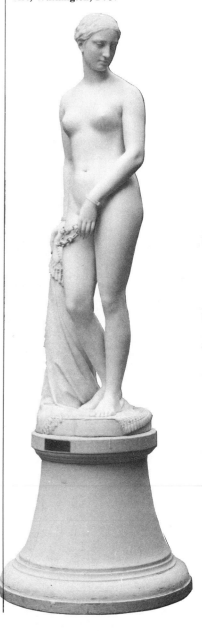

3-11
Hiram Powers, *The Greek Slave*, c. 1846. Marble, life-sized. In the collection of The Corcoran Gallery of Art, Washington, D.C.

extends 70 feet and weighs 900 pounds), it was doubtful for a time that it could be done at all.

A carved sculpture is limited by the shape of the block, and tends to be self-contained; a modeled piece tends to be more expansive, while a piece that is constructed or otherwise fabricated can be even more free. In carved and in modeled sculpture the material yields directly to the will of the artist, and we can see—sometimes literally—his touch in the piece. Constructed pieces, on the other hand, can be made by technicians following the instructions of the artist.

Material. Feeling our way into sculpture also means getting a feel for its material. The material gives character to the piece and the piece can make us aware of the character of the material. How heavy is it? How hard is it? Is its surface rough? Smooth? Sleek? Dull? Grainy? Shiny? How does it reflect light? What is its color? Is the color natural or was it applied? How light or dark is it? The durability and graininess of the stone at Chartres, the soft glow of the marble in the *Greek Slave,* the rippling energy of Rodin's bronze, the organic flow of Moore's elmwood, with its visible grain, and the crispness and springiness of the aluminum and steel in Calder's mobile are a part of what there is to enjoy in the sculpture we have seen.

Sculptural materials are not as yielding as paint, but assert themselves in the piece. When you look at a sculpture, ask yourself: What did the sculptor do to bring out the character of the material? Do you experience that character? Or did the sculptor suppress it in order to make you see something else? What, finally, is the interplay between the material and the image? To help you answer these questions, imagine the sculpture made out of something else. What difference would there be? How would the character of the piece be affected?

We live for the most part in a visual world, but much of what we love comes to us through touch—a cool breeze or mist on your cheek, dewy grass, the warm touch of skin, smooth pebbles in your hand. Sculptors work with a particular material because they love its properties and they love what it can do. They think and feel in terms of the material—its hardness, its resistance, its weight, density, moisture, coolness, and so on. Perhaps sculpture originated when someone noticed that a rock resembled a figure, and worked it a bit just to make it more realistic. But sculpture, like pottery or weaving, would not have become an art unless people loved the feel of materials in their hands, loved their touch and texture, and loved the way they could be shaped to give form to ideas.

4 | *The Power of Images*

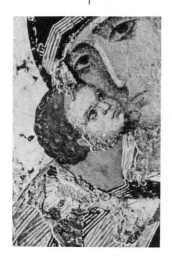

Have you ever watched someone put a lump of clay on a potter's wheel and form a pot out of it? Or seen a glassblower create a vase out of shapeless, molten matter? The transformation of the material into the object is smooth and gradual. It's hard to say just when we stop thinking of the clay or glass as "material" and begin to think of it instead as a pot or a vase. Very likely it is when we first perceive the form of the object that our focus on the material begins to slip away and we cross over from looking at material to looking at a "thing."

If you have ever watched someone painting a picture you will have noticed something similar. At first you will see only colored dabs and marks on the canvas, but at some point these marks are transformed into an image, as if by magic. The marks are no longer marks, at least not unless we think about them. In the hands of the painter they appear to become what they represent.

The transformation of materials in the work of painters is especially uncanny, for it is not objects that they make, but images, images altogether unrelated to the material out of which they are made. The clay of a pot, or the glass of a vase is never very far from our consciousness when we look at these objects. The material of a sculpture generally asserts itself upon us. But in a painting we may gaze contentedly at the trees and never see the paint.

Images can be so compelling that we sometimes react to them as though they were the real thing. Those reactions can be quite automatic. For example, if an artist sketches a portrait, we may say that it looks like him or her; but if we get just a bit carried away, we may exclaim, "It's him!" or "It's her!" almost as if a duplicate of the person had been created while we watched.

Similarly, a child drawing with crayons "makes a man" or "makes a house." When I collect my students' drawings I am likely to say "turn in your flowerpots here," or "put your eggs there." We frequently refer to

LES POIRES,

Vendues pour payer les 6,000 fr. d'amende du journal le *Charivari.*

(CHEZ AUBERT, GALERIE VÉRO-DODAT.)

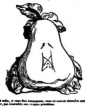

4-1
Charles Philipon, *Les Poires* **("Metamorphosis of the Pear") from** *Le Charivari,* **1834. Revised version of a drawing made by Philipon at his trial.**

Michelangelo's *David* and to Leonardo's *Mona Lisa* as though they were the people themselves, and not images of them. Of course this is just a kind of verbal shorthand, but it does reveal an attitude.

Images are potent things. Because it's so easy to forget that they are illusions, and to confuse them instead with the real thing, they can provoke intense reactions. Children who draw their teacher's face on the blackboard, or embellish political posters with mustaches understand this very well. From the Middle Ages and the Renaissance come accounts of artists who got back at their enemies by exaggerating their features, or by painting their faces on characters in Hell. Caricature was used as an ideological weapon during the Protestant Reformation, when scathing depictions of Catholic clergy were circulated. Thomas Nast's cartoons of the 1870s attacking "Boss" Tweed, a corrupt New York politician, led to Tweed's downfall.

In 1831 in France, Charles Philipon published a drawing representing the French King Louis Phillippe as a pear—in French slang, a "fathead" (Fig. 4-1). Late that year, for "crimes against the person of the king," he was fined and sentenced to six months in prison. In 1832, Honoré Daumier spent five months in prison for his scatological drawing of the King. Both artists' drawings were published in Philipon's weekly, *La Caricature.* The weekly newspaper was seized by the government 27 times during its four years of publication for the political cartoons it carried; later, from 1835 to 1848, political caricature was banned in France.

"Can I help it if His Majesty's face is like a pear?"

—Charles Philipon, at his trial in 1831

Images in the Past

History provides countless examples that point to the uncanny power that images have held, and continue to hold, for all human beings. From antiquity come stories of realistic images with astonishing, even miraculous powers. In the first century A.D. Pliny, a Roman, recounts the story of grapes painted by the Greek artist, Zeuxis, which were so lifelike that sparrows pecked at them, and of a horse painted by Apelles that caused real horses to neigh. Ku K'ai-chih, a fourth century Chinese painter, is reported to have pierced his portrait of a young girl with a thorn, causing her to fall ill. When he removed the thorn, she became well again.

Throughout Medieval Europe many stories circulated that attested to the miraculous powers of images of holy persons. Sudden cures, military victories, or rescues were attributed to them. Some were said to speak. These images were carefully treated and regarded with reverence.

The beautiful mural depicting the Madonna and her heavenly court (Fig. 4-2) was painted on the wall of the council chamber in the city hall of Siena, Italy, by Simone Martini. The Madonna was the patron saint of Siena. The presence of the Queen of Heaven and her retinue in the room where the city fathers deliberated on the course of their republic suggests an invocation to her wisdom and guidance, and demonstrates the belief in the influence of images on human affairs.

Paintings showing famous historical judgements were placed in Flemish law courts in the fifteenth century to remind judges of their responsibilities. Today, paintings of Washington and Lincoln hang in courthouses, and busts of Homer and Shakespeare keep watch in school libraries. The Statue of Liberty in New York harbor and the statue of Lincoln in the Lincoln Memorial are objects of patriotic veneration to many people. Images are still used in public and religious ceremonies and are carried in processions, both secular and religious.

The oldest images we know of were almost certainly believed to have had magical power. Painted on the walls of caves during the Old Stone Age, these images, which depicted the large mammals on which people depended for food, may have been part of a hunting ritual (Fig. 4-3). It is unlikely that they were made simply to be admired objectively for their beauty. Any such detached considerations of beauty—which we call "aesthetic"—would very likely have been subordinated to feelings of awe called up by the mysterious power of the image.

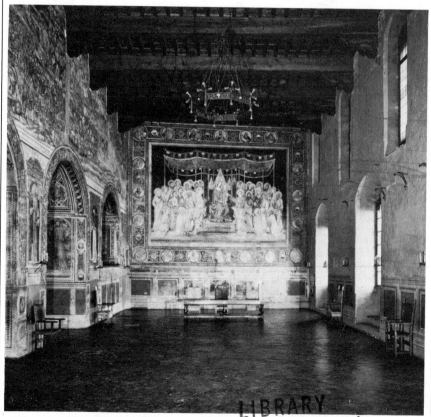

4-2
Simone Martini, *Madonna Enthroned*, 1315. Fresco. Palazzo Publico, Siena.

Ancient civilizations continued to regard art as having magical properties. In Assyria, gods and animals carved on walls protected the king. In Egypt, paintings and sculptures were conceived of as repositories for the souls of departed individuals. The soul was believed to live on in them. Objects painted on the walls of tombs could be utilized in the next world (Fig. 4-4).

Throughout the ancient world statues were worshipped as gods. The ban for Hebrews on graven images in the Ten Commandments, reiterated throughout the Bible, indicates how widespread—and appealing—the practice of image worship must have been. The development of a more life-like art in Greece was accompanied throughout the classical period by a belief in the supernatural properties of images. In late antiquity people believed that spirits could inhabit images. Christians regarded these spirits as malevolent, and feared them. The notion of resident evil spirits clung to three-dimensional sculpture in particular, and may account, in part at least, for the preference of early Christianity for an art of two dimensions.

4-3
Three Cows and One Horse, ceiling of Axial Gallery, Lascaux, *c.* 15,000–13,000 B.C., approx. life-sized. Dordogne, France.

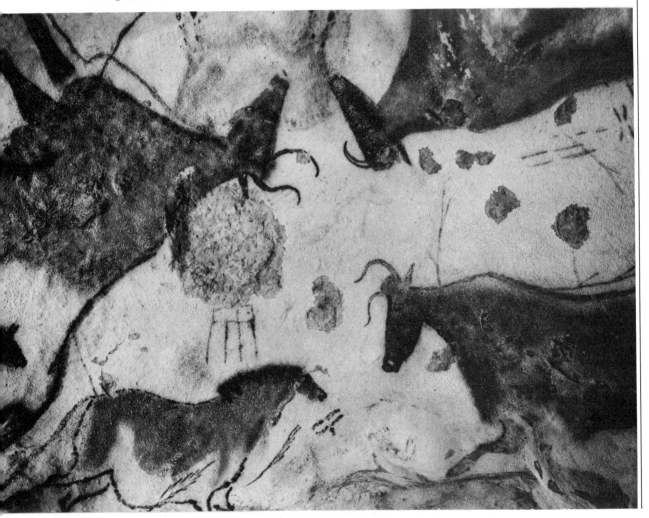

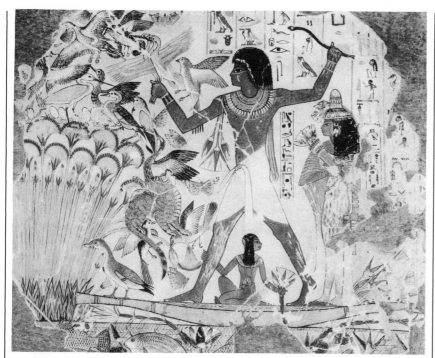

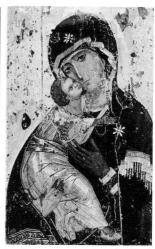

4-4 (left)
Theban Tomb of Neb-
Amun (unlocated),
c. 1450 B.C., British
Museum. Courtesy of
The Oriental Institute,
University of Chicago.

4-5 (right)
The Vladimir Madonna,
twelfth century.
Original dimensions of
panel approx. 21″ × 30″.
State Historical
Museum, Moscow.

Because the art of Greece and Rome was associated with pagan beliefs and demonic magic, the explicit naturalism that characterized it was suspect by Christians. Accordingly, in the Middle Ages, the Church encouraged the development of a less representational, more abstract and symbolic art.

In the early Middle Ages, images of Christ, the Madonna and Christ Child, and saints, mainly in the form of panel paintings, were introduced in the Eastern Roman Empire. These images, called icons, were placed in homes as well as churches. Icons were considered to be holy, and many were believed to have protective powers.

This icon, called the *Vladimir Madonna* (Fig. 4-5), was brought to Russia from Constantinople. In times of crisis it was carried by the faithful in procession; its miraculous powers were believed to have saved Vladimir, Kazan, Moscow, and other Russian cities from invasion.

Because people venerated icons with an intensity verging on idolatry (worship of idols), images—paintings, sculptures, and mosaics—were actually banned in the eighth century throughout the Byzantine (Eastern Roman) Empire. Later on, images were reinstated when the Church was convinced that they would function to direct the consciousness of the worshippers beyond the images to what they represented. Defenders of pictures had to argue that images were semblances, and not the real thing.

The controversy over images stirred the Islamic world as well. In the eighth century an edict banned all representations of human forms. The Moslem antagonism toward figurative representation persisted from time to time and in certain areas, and accounts for the predominance of abstract and nonfigurative forms in Islamic art.

Because images frequently acted as a link with the supernatural, the depiction of such figures as gods, kings, and saints was a very serious matter. Often, exact and highly detailed descriptions governed the appearance of these figures. To deviate from these prescribed formulas would at times have been considered heresy.

In Egypt, where a highly conservative artistic tradition existed for thousands of years, a codified system of proportions determined precisely the appearance of the king and the gods. Such as system is called a "canon." Only by correct execution of the image according to the prescribed rules could effectiveness be ensured. Curiously enough, the canon was relaxed for depictions of lesser personages. Was it because it didn't matter as much if the magic didn't work to preserve them? Or, perhaps because the more dignified, formalized treatment was reserved for those who were special?

Buddhist art in Tibet also has canonical measurements and elaborate directions for picturing the vast number of deities. These directions, set out in the sacred scriptures, prescribe the colors of the gods' bodies and their halos, as well as their clothes, their positions and gestures, and other identifying attributes. The images functioned as aids to meditation, and the artists, who were monks, were obliged to show these characteristics plainly (Color Plate 3). Any deviation was considered a sin. So rigidly controlled was this art that images were often printed from wood or metal blocks, and compositions changed little over centuries.

Christian art was devoted to communicating sacred histories and religious concepts. To this end, an intricate system of iconography (the specific image and its meanings) was developed during the Middle Ages by artists repeating limited subject matter over a long period of time. This iconography amounted to a pictorial language in which the meanings of numerous symbols and the attributes identifying holy figures were precisely fixed and became traditional (for example, see Fig. 5-19). Byzantine artists developed a formula for the depiction of the head of Christ, both to maintain the dignity of the image and to ensure that it would be recognizable wherever it appeared. These rules were intended to preserve the holiness of the image.

The strong feelings that made images the focus of veneration in the Ancient and Medieval worlds made them targets of violence as well. The anxiety over idolatry was so intense that it led to the destruction of Christian, Jewish, and Moslem art during the controversies of the eighth century. Similarly, throughout the Middle Ages, Christians, believing it an act of piety to destroy pagan idols, deprived posterity of Greek and Roman statues. In late Medieval Italy we find painted images of the Devil scratched with knives or stones. These actions were probably motivated by intense religious feelings, and were not likely thought of as desecrations.

The onslaught against images extended to modern times. Protestant reformers of the sixteenth century, equating statues and images in churches with idolatry, encouraged their destruction. Violent attacks on images broke out in Germany, Switzerland, France, the Netherlands, Scotland, and England. English Puritans in the sixteenth and seventeenth centuries whitewashed over murals, hauled what art they could out of churches, and managed to destroy a great deal of the Medieval art of England and Ireland. During the French Revolution, zealous anti-

Royalist crowds attacked statues of Old Testament kings that had lined the portals of St. Denis, Notre Dame, and Strasbourg Cathedral since the twelfth and thirteenth centuries. Some of the statues were completely destroyed, while others were, like their human counterparts, merely beheaded.

All of this suggests a special attitude toward images, quite a bit removed from the more objective, aesthetic attitude typically taken toward works of art today. Those readers who regard art as something to be enjoyed will have to imagine the depth of feeling that images have inspired. Other readers may themselves have experienced the wondrous power of images to evoke a sense of awe in the minds and hearts of the faithful.

Images Today

What is the power of images today? We must look for the answer to images that are in use in society. Most people today respond to the power of some kind of image. Consider, for instance, how you treat a photograph of someone you know, such as a boyfriend or a girlfriend. Because you care about that person, chances are you treat his or her photograph with respect. You provide it with an attractive frame and put it in a good spot. You may even find yourself smiling at it.

But if your boyfriend or girlfriend breaks up with you, you may want to take that miserable photograph and tear it to pieces, just as though the photograph were actually the person. In twentieth-century Sicily, the statue of a local saint was pitched over a cliff when the saint was thought to have answered prayers for an end to a drought with a devastating rainstorm. Coaches of opposing teams are burned in effigy at pep rallies on college campuses, and political leaders are similarly disposed of by impassioned adversaries. The overthrow of a dictator will be accompanied by the toppling of his statue in a public square by an emotional crowd (Fig. 4-6).

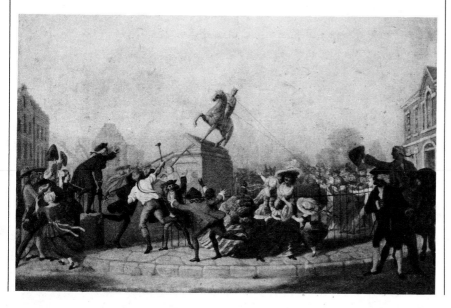

4-6
William Walcutt,
Demolishing the Statue of George III, 1864.
Oil on canvas, 25½" × 38". Private collection.

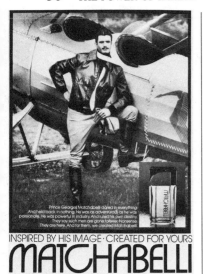

INSPIRED BY HIS IMAGE · CREATED FOR YOURS
MATCHABELLI
A DISTINCTIVE MAN'S COLOGNE

4-7
Courtesy of Prince Matchabelli.

Cinematic statements of human experience are exceptionally believable and persuasive. Anyone who goes to the movies is aware of the capability of this art to arouse a whole range of feelings, as well as to communicate powerfully ideas about matters that affect us. Movies and television are experienced as a reality to which we belong for a while.

The lifelike character of the cinematic image tends to obliterate the distinction between actor and role. Ancient Greek myths tell of people who fell in love with statues; today, people fall in love with screen idols. Actors who play the part of doctors on television receive letters from people asking them for medical advice and even get invitations to speak at medical school commencements. For example, actor Robert Young, who played Dr. Marcus Welby on television, was the principal speaker at the 1973 commencement of the University of Michigan Medical School.

Images on television and in still photography influence our purchases and our votes. Photographic images create an aura of desirability around an object by associating it with fun, friendship, romance, sophistication, or good looks. "Image makers" are hired to sell cars and candidates. The size of the advertising business today testifies to the extraordinary power of images to affect our thinking and our behavior (see Fig. 4-7).

How do you respond to a work of art? For many people the first and most lasting response may be to its subject matter. What else accounts for the popularity of reproductions of sporting events, kittens and puppies, celebrities, or scenes of natural beauty? More than just *reminders* of the real thing, they function as stand-ins. A poster of W.C. Fields brings his presence into your room and cheers you up. A photograph of the Rocky Mountains, taped to the wall of an office, allows us to escape the tedium for a moment or two. A painting of a clipper ship at sea, of the festive mood of a holiday with the family, or of an appealing face reaches out to us and draws us into its charmed embrace.

But this is not all there is to it. Enjoying the subject matter does not necessarily mean appreciating the art. In order to get the most out of a work of art, we would have to look at it in a different way. And that is what we shall take up next.

5 | *Reading Paintings*

It's just about impossible *not* to react to the content of a painting or sculpture. But if you react only to the *images* that you see, your enjoyment of art is likely to be less than it could be. If all you consider is the subject matter—the skaters on the ice, the ruined castle, the cornfields in the sunlight—you will miss out on something even more basic and essential to the piece; an intrinsic quality that makes it worth looking at. In addition you may be restricting yourself unnecessarily. You may be preventing yourself from enjoying works of art simply because the subject matter doesn't strike your fancy. Subject matter is only one aspect of what makes a painting or a sculpture appealing: Why let it have all your attention when there's so much more to enjoy?

If you want to get more out of a representational painting or sculpture, start with this simple observation: the image you see is not the same as reality, or even a reproduction of reality, but an *interpretation* of reality. Once you accept that, your understanding of paintings and sculptures will deepen. When your relationship to the piece becomes more detached and objective—ironically—you will actually begin to become involved with what you see in a stronger way. Only then can you begin to look *beyond* the image and see the piece as a work of art.

Getting past the image isn't easy, but it can be done. To begin, let's reach back to the last chapter and pick out the most lifelike image: the motion picture image.

It is easy to think of movies as a window through which we look at reality. Most filmmakers do everything they can to make us forget we're watching a movie. They want us to be so involved that it feels real to us. As a consequence we are not likely to notice the way it has been put together. Usually it takes a second viewing of a film to pick up on the various techniques that were used to get us so involved. On second viewing we begin to recognize the significance of the opening shot, or the effect of closeups, camera

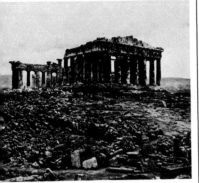

5-1
The Parthenon, **source photo. New York State Office of Parks, Recreation and Historic Preservation, Bureau of Historic Sites, Olana State Historic Site, Taconic Region.**

angles, or lighting, to notice the telescoping of time in the telling of the story, or the effect of the music on our perception of the story and the characters. Seeing a movie over again makes us aware that its elements were consciously selected and composed.

Moreover, if we test a movie's characters and story against our own experiences we may well conclude that movies are *not* like life. I suspect that if movies simply imitated life, most of us would find them unbearably dull. Does this surprise you? Think about having to sit through two hours of somebody's unedited home movies.

Like films, realistic paintings have always been enjoyed for their lifelike quality. But our receptiveness to illusion tends to blind us. As we saw in the last chapter we are very apt to forget the paint when we look at the trees. We don't see that every painting, like every movie, is a fabrication. Consequently we may not recognize what the artist himself put into it. Painters, like filmmakers, are apt to convince us that they duplicate life in their art. We assume that the artist simply records on canvas what he sees before him. This is the fundamental misunderstanding that undermines the appreciation of paintings.

Decisions

A little reflection will show that a painter can't just indiscriminately put down what is in front of him. After he chooses what he wants to paint, he must decide what view to take, how much of it to include, and what to leave out. Will the subject be close or far away? In the center or to the side? How does the artist treat

5-2
Ben Shahn, *Handball,* **1939. Tempera on paper over composition board, 22 ¾″ × 31¼″. Collection, The Museum of Modern Art, New York. (Abby Aldrich Rockefeller Fund.)**

the objects he is painting? Does he paint every leaf in the tree? A few? Or does he suggest its general shape? What degree of clarity will the artist choose? Will all of the painting be sharp and clear or will the artist choose to bring one part into focus? How visible will the brushstrokes be? How large or small will the painting be?

You can't assume that what you see in a painting just happened to be there looking like that when the painter came along. A painter may spend a lot of time arranging his subject matter. Preparatory drawings for figure compositions reveal that artists often arrange and rearrange figures many times before they are satisfied. It takes imagination to give a scene unity and still have it look natural. Still-lifes, which typically look casual, require that the artist combine objects in an interesting way. When painting a landscape the artist can choose the time of day, the weather, and the season of the year. If he includes people, he must decide who they will be, what they will do, and where they will be placed. If the people were not in the original scene, or if the artist rearranges the rocks and trees, or makes the mountains loftier, who would know? Even a painter working from a photograph, as many have done in the last hundred years, is likewise free to deviate from his model. (For examples, see Fig. 5-1 and Color Plate 4 and Figs. 5-2 and 5-3.)

Those are some of the *conscious* decisions that a painter makes when working with the subject before him. Artists make *unconscious* decisions as well. An anecdote quoted by the art historian Heinrich Wolfflin in *Principles of Art History* speaks to this point.[1] It tells of four young painters who agreed to paint the same landscape as exactly as possible, and then to compare their paintings. When they looked at the results they were astonished to see how different each painting was from the other, "as different as the personalities of the four painters."

5-3
Ben Shahn, *New York City, c.* **1932. Silver print, approx. 7″ × 10½″. Courtesy of the Fogg Art Museum, Harvard University. (Gift of Mrs. Bernarda B. Shahn.)**

In everyday life our personality emerges and makes itself known through each decision that we make. The car we choose, our clothes, the way we wear our hair, the way we speak and the very words we use are expressions of who we are. Listen to a few people describe an event, or a movie they have seen, and you will likely hear very different accounts—as different as are their personalities.

Inevitably, paintings—at least, those produced since the late Middle Ages— reveal the personality of the artist as much as they reveal the subject. Therefore it's more accurate to regard them as personal statements than as reproductions. We should understand the subject to be a point of departure for the painting. Every representational painter must, of necessity, decide what to select from the infinite possibilities presented by the subject. The form the painting takes is determined by the selections that are made, and thus must be seen as an expression of the artist's personality. His interests, feelings, and attitudes—conscious and unconscious—will determine the appearance of the painting at least as much as the subject itself.

Simply thinking of a painting as a mechanical reproduction, imagining that the artist is merely a good eye and an expert hand, is needlessly limiting. In order to appreciate a painting you need to ask certain questions about it, questions that can reveal to you how *unlike* its probable model or subject it is. These questions can direct you to the choices the artist made when he put the painting together, and can help you to see why those choices were made.

The Elements of Form

Color. Look at the elements of form: color, light, texture, volume, shape, line, composition. Isolate each one in turn. With color, for example, ask yourself: Are the colors light or dark? Bright and intense or dull and grayed? Bluish or orangey? Are they pastel? Do they contrast highly with each other or are they closely related? Do they have sharp, clear edges? Rough edges? Soft edges? Do they merge into each other? Do they overlap one another or do they blend? Are the colors opaque or transparent? Are they glossy or matte? How are they distributed? Which colors are grouped together? Which colors draw attention to themselves? Which colors seem to move toward you? Which colors seem to recede?

The distinctive use of color is easy to recognize in Frederic Church's *Parthenon* (Color Plate 4) and Vincent van Gogh's *Starry Night* (Color Plate 5). How realistic is the color in *Starry Night?* In the *Parthenon?* What effect do these colors have on your perception of the subject?

We tend to think of color in terms of hue, such as red, green, or blue. But color is more than that. Painters rarely use colors as they come out of the tube, preferring instead to mix them to create distinctive colors and to adjust them carefully to each other. In a good painting colors are orchestrated so that the effect of all the colors together will be more striking than individual colors here and there.

Light. Color affects the character of the light in a painting. Because light is impalpable, as well as inevitable, it is often overlooked. Yet its role, however subtle, is likely to be an important one. Ask yourself: Is the light bright or dim? Is it even or contrasting? Is it direct or reflected, or a combination of these? Does the

light sparkle, shine, or glow? Can you tell its color? How is it used? Does it direct your attention to something? Does it suppress something?

How would you describe the light in El Greco's *View of Toledo* (Color Plate 6)? Now compare it with Church's use of light in the *Parthenon*. What effect does the light have on your perception of the subject?

Texture. The texture of a painting is determined primarily by the kind of paint used and how it is applied. Does the paint look thick or thin? Is it rough or smooth? Dense or watery? Now look at the brushstrokes. Did the painter use long, wavy strokes, or short, choppy ones? Can you see the strokes at all? Or do they blend into each other and become invisible? Does the paint create blobs? Ridges? Flat patches? Stains?

What kind of paint was used? Oil, acrylic, tempera, watercolor, or something else? What particular effects are achieved by the kind of paint used? How was the paint applied? By brush? By palette knife? By airbrush? Was it poured on? Sponged on? Rolled on?

Texture is also affected by the surface on which the artist paints. Since the Renaissance, most artists have used canvas. For special effects, some artists use a rough textured surface such as burlap or handmade paper, or a smooth surface such as masonite, plastic, or glass.

What texture do you find in this detail of Van Gogh's *Starry Night* (Color Plate 7)? How would you describe the brushstrokes? How are they arranged? What feeling do they bring to the painting?

Volume. Painters create the illusion of solid forms, or volumes, in their paintings. Although volumes in the real world are typically self-contained and measurable, they may take on remarkably different aspects in a painting. Ask yourself: Are the volumes hard, clear, and distinct? Or soft, vague, and ephemeral? Are they thick and bulky, or thin and attenuated? Are they rounded or angular? How are the volumes created? By light and shadow? By color changes? By the use of lines on the surface? Are the volumes fully rounded? In low relief? Or do the figures and objects seem flat?

Raphael's *Madonna della Sedia* (Color Plate 8) and Max Beckmann's *Begin the Beguine* (Color Plate 9) contain strongly contrasting volumes. How solid do these volumes seem to be? What techniques were used to create these volumes? How do the volumes affect the sense of reality in each painting?

Shape. We can interpret the figures and objects we see in a painting as volumes. We can also see them as shapes. Shapes are flat, self-contained areas, made up of objects or clusters of objects. The areas around or between the objects may also be identified as shapes. These so-called "negative shapes" can be just as important to the composition of the painting as the objects themselves.

Look at the shapes. Are they curved or straight edged? Geometric or free form? Simple or fussy? Are they especially graceful? Do they feel choppy? Are they regular in size and similar in shape, or are they varied? Are they few or many? Are their edges hard or soft? Are they easy to identify and define, or do you have difficulty seeing them?

In Raphael's *Madonna della Sedia* and Max Beckmann's *Begin the Beguine* there is a strong interest in shape. Can you identify some of the shapes in each? What words would you choose to describe them?

5-4
Leonardo da Vinci, *The Last Supper,* **c. 1495–98. Fresco, 15¼′ × 29¼′. Santa Maria delle Grazie, Milan.**

Line. The edges of shapes can be seen as lines. Ask yourself: are they straight or curved? Long or short? Are they choppy? Smooth? Wobbly? Thick or fine? If straight, do they make sharp angles? If curved, are the curves busy or simple? Do the lines bring movement into the painting? Are the lines clear and well-defined or soft and blurry? Are there lines at all?

Look again at the paintings by Raphael and Beckmann. Are the lines actually painted in, or are they implied? What is the character of the lines in each? What movement do they bring?

Compositional Lines. Paintings are often organized within units—shapes, or clusters of shapes—separated by lines, actual or implied. These lines, which we may call compositional lines, give the painting order, structure, and coherence. At the same time, they guide the eye through the painting.

Compositional lines are the skeletal elements of a painting. Sometimes these lines are called ''axes.'' If the composition is balanced on either side of the compositional line, the line is regarded as an ''axis.''

Look for the major compositional line along which the picture seems to be arranged. It is likely to be the first you notice. What drew your attention to it? Is it horizontal? Vertical? Diagonal? Curved? How does it function? Does it separate something? Does it draw your attention to something? Does it have a dual function? Does the painting contain two or more of these lines? What is their relationship?

If the major compositional line is horizontal, it will tend to give a calm quality to the painting. Vertical lines are assertive, dignified, and uplifting. Curves give movement to a painting; diagonals inject excitement. These reactions are probably rooted in human psychology.

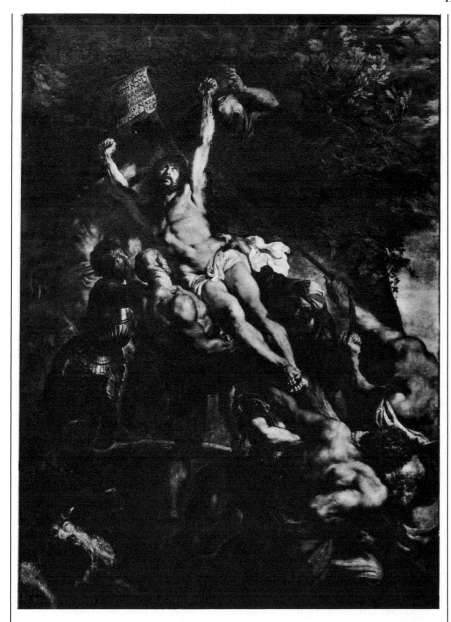

5-5
Peter Paul Rubens, *The Elevation of the Cross,* c. 1610–11. Oil on panel, 15′2″ × 11′2″. Antwerp Cathedral.

The major compositional line in Leonardo da Vinci's *Last Supper* (Fig. 5-4) and in Peter Paul Rubens's *Elevation of the Cross* (Fig. 5-5) is not hard to find. How appropriate is each to the subject? Is it echoed by others in the composition? For vertical compositional lines, see Jan van Eyck's *Giovanni Arnolfini and His Bride* (Color Plate 28).

Combinations of compositional lines may structure a painting along an ''X'' form or a spiral; they may build along diagonals or curves, or create more stable shapes: rectangular, square, or pyramidal. Identifying these shapes will help you to see the composition of the painting.

5-6 (left)
Raphael Sanzio, *Madonna and Child and St. John the Baptist*, 1507. Oil on panel, 48" × 31½". Louvre, Paris.

5-7 (right)
Thomas Eakins, *The Biglin Brothers Turning the Stake*, 1873. Oil on canvas, approx. 40¼" × 60¼" The Cleveland Museum of Art. (Hinman B. Hurlbut Collection.)

In *Madonna and Child and St. John the Baptist* (Fig. 5-6) Raphael combines figures and clothes to create a shape approximating a pyramid. This shape: geometrical, symmetrical, and stable, helps to create the feeling that the painter has caught and preserved random movements in a moment of perfection.

Can you pick out the major compositional lines in Thomas Eakins's painting *The Biglin Brothers Turning the Stake* (Fig. 5-7)? Which seem to be the most important? What relationship do they have to one another? How did Eakins use them to compose the painting? Where do they direct you to look? What shapes are created by combinations of these lines? What feelings do these shapes bring to this sporting scene?

Composition. Composition refers to how a work of art is put together, or organized. Shapes and compositional lines are important elements of composition. Even color and light may be used as compositional devices. Since representational paintings often look so natural, our tendency is to overlook composition and to take for granted the placement of the various elements in the painting. By studying the roles played in a good painting by color, light, shapes, and compositional lines, you can see that they act to draw your eye through the painting in an orderly way: emphasizing that which is important and subordinating that which is less important. Ultimately, the purpose of composition is to give form to the idea as clearly and as forcefully as possible.

Notice where your eye comes to rest in the painting. This is called the focal point. Typically this will be the most important part of the painting, the key area that is the heart of the painting. Ask yourself why your eye rests at that place. What path or paths directed your eye to it? What keeps your eye there?

A painting may have more than one focal point, or none at all. Does more than one place hold your eye? Does that add to the effect of the painting, or does it detract from it?

Where is the focal point in Giotto's *Lamentation* (Fig. 5-8)? In Jacques Louis David's *Oath of the Horatii* (Fig. 5-9)? How are line, color, and light used to bring your eye to the focal point? What else is used to focus our attention?

Composition has to do with the selection and arrangement of elements. What the painter selects to paint is important, but where he places it in the picture can be just as important. For example, a figure shown close up will be imposing; a figure painted in the distance will be less so. A figure placed at the edge of the picture will have a different feeling from a figure located right in the center.

Do you look up, down, or across at the figure in a portrait? Are the still life objects placed below you on a table, or elevated to eye level? Is the horizon of the landscape high, or is it low? Do you get a bird's eye view? Are you near or far? Do you seem to be standing at the center of things, or off to one side? Your distance from the subject, and the point of view that you are given, establishes a particular psychological relationship with what is in the painting.

What is the relationship of the main figures to the background? How important is the setting? How much of the background do you see? How much detail is given around the figure?

Consider now Hyacinthe Rigaud's portrait of *Louis XIV* (Fig. 5-10), Walt Kuhn's *Clown with Folded Arms* (Fig. 5-11), and John Sloan's *Wake of the Ferry* (Fig. 5-12). Where is each figure placed? How close are we to each? How impor-

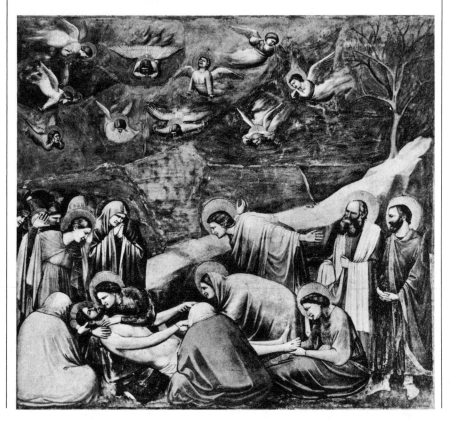

5-8
Giotto, *The Lamentation*, c. 1305. Fresco. Arena Chapel, Padua.

5-9
Jacques Louis David,
The Oath of the Horatii,
1784. Oil on canvas,
approx. 10′ × 14′.
Louvre, Paris.

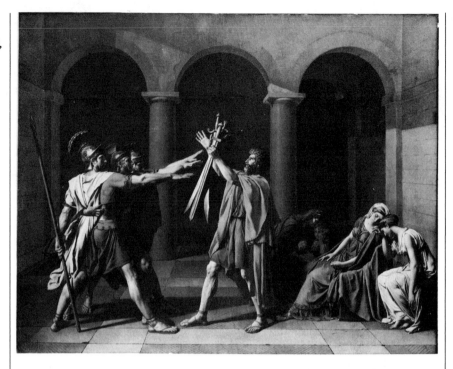

tant is the background? As a consequence of these choices, what relationship is established between us and the person in the painting?

Surface Pattern. Figures and objects are arranged beside each other on the flat surface of any painting. Figures and objects may also appear to be located in receding space. It is useful to keep these two situations distinct when you investigate composition. The pattern of a painting—its arrangement of shapes and lines on the surface—is one thing; depth is another.

Paintings are structured in various ways with regard to surface and space, and these structures affect the character of the painting to a considerable degree. Let's start with the surface pattern. Look at the way the left and the right sides of a painting relate to each other. Is the painting symmetrical—evenly balanced? Is it assymmetrical—that is, do its shapes and colors act as weights and balances, forces and counterforces, that you can identify? Does the painting seem to build up gradually as your eye moves into it from the side? Are the figures and objects crowded? Comfortable? Spread out? Isolated?

Study the arrangement of figures and setting in Duccio's *Nativity* (Fig. 5-13), in Fra Angelico's *Annuciation* (Fig. 5-14), and in Pieter de Hooch's *Dutch Courtyard* (Fig. 5-15). How carefully are the figures placed? What is their relationship to the setting? How does the composition convey the story to you?

The surface pattern of a painting may suggest a rhythm to you. You may also discover rhythms within distinct areas of the painting. Rhythm is created by the repetition of similar shapes, lines, or colors, just as the repetition of a beat creates rhythm in music. Rhythms knit together the various parts. Though they may be

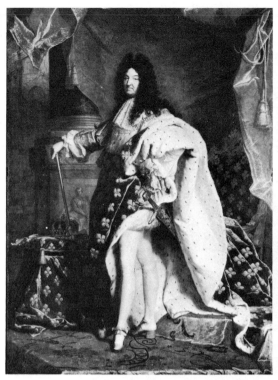

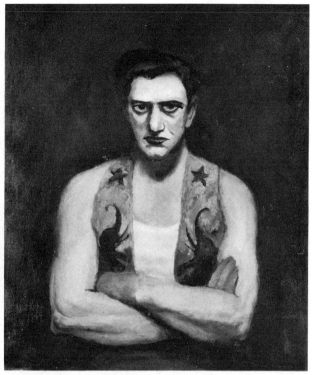

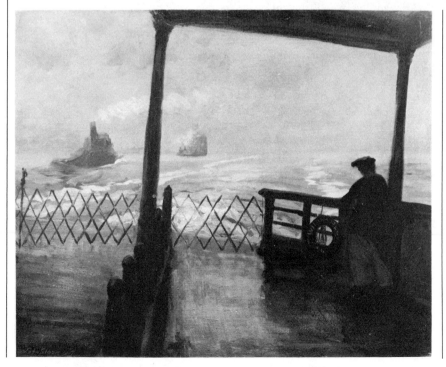

**5-10 (upper left)
Hyacinthe Rigaud,
Louis XIV, 1701.
Oil on canvas, approx.
9′2″ × 5′11″. Louvre,
Paris.**

**5-11 (upper right)
Walt Kuhn, *Clown with
Folded Arms*, 1944. Oil
on canvas, 30″ × 25¼″.
Temple Fund Purchase
1945.8. Courtesy of the
Pennsylvania Academy
of the Fine Arts,
Philadelphia.**

**5-12 (left)
John Sloan, *The Wake
of the Ferry II*, 1907.
Oil on canvas, 26″ ×
32″. The Phillips
Collection,
Washington, D.C.**

5-13
Duccio di Buoninsegna,
Nativity, c. **1308–1311.
Central panel: 17¼″ ×
17½″. National Gallery
of Art, Washington.
(Andrew W. Mellon
Collection.)**

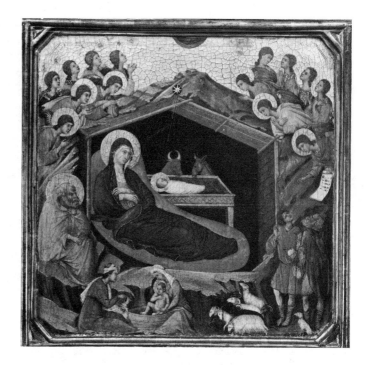

more difficult to identify than in music, visual rhythms may be an important structural element in a painting.

Compare the overall rhythm of the mosaic representing *Justinian and Attendants* (Fig. 5-16) with that of Pieter Brueghel's *Wedding Dance* (Fig. 5-17). What elements of form are used to create those rhythms? Look again at Duccio's *Nativity* and Fra Angelico's *Annunciation*. What lines are repeated? What shapes are repeated? How do the rhythms they establish affect each painting?

Space. Now we'll consider the space. How is your eye carried back into the picture? Gradually? Predictably? Or are you snapped back suddenly into the distance? Is the space orderly? Measurable? Ambiguous? Clear? Is it deep or is it shallow? Is it flat?

How does the artist achieve the illusion of depth in the picture? By means of overlapping planes? Decreasing the size? By contrasts of dark and light? Going from high contrast colors in the foreground to low contrast colors in the distance? Using bright colors in the foreground and pale colors in the distance (atmospheric perspective)? Does the artist construct a mathematically based perspective system (linear perspective)? Does the artist provide paths to lead your eye back into space? Conversely, does the artist do things to flatten space and bring the background closer?

These four paintings—Domenico Veneziano's *Madonna and Child with Saints* (Fig. 5-18), El Greco's *Agony in the Garden* (Fig. 5-19), Nicolas Poussin's *Landscape with Burial of Phocion* (Fig. 5-20), and Fairfield Porter's *Flowers by the Sea* (Color Plate 10)—reveal contrasting approaches to space. Where is the space clear, calm, and orderly? Where is it ambiguous? Where does it seem mysterious? Which paintings have the deepest space? The shallowest? How did

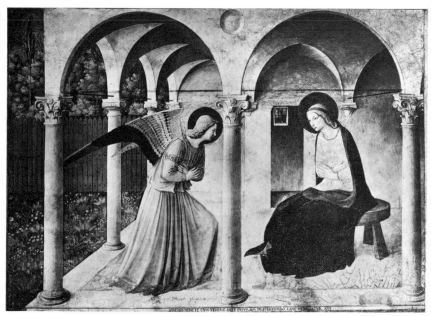

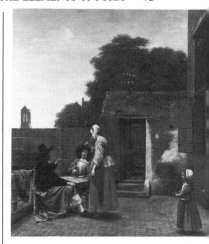

5-14 (left)
Fra Angelico, *The Annunciation*, c. 1440 –45. Fresco. San Marco, Florence.

5-15 (right)
Pieter de Hooch, *A Dutch Courtyard*, c. 1656. Oil on canvas. 26¾″ × 23″ National Gallery of Art, Washington, D.C. (Andrew W. Mellon Collection.)

the artist create a sense of space in each? What feeling or mood does the space carry?

We have asked many questions, not all of which can be answered in every case. Some of these questions just won't apply to the image you might be looking at or thinking about. But others will, and you can think up more, depending on what you are analyzing. Because every painting you look at presents you with a unique situation, it's up to you to see what you can find in it. What do you notice first? Why? Which elements seem to dominate? Which are of less importance? What do they contribute? What multiple functions might they have? What effect do they have on the painting? Always keep in mind that a serious painter will try to consider every aspect of his painting and leave nothing to chance.

To assess the impact of a particular element, try to imagine what the painting would look like if that element were altered or replaced with something different. Without touching the painting, block out an area with your hand to help yourself visualize the change. What would the landscape be like if a certain tree were removed from the foreground, or if it bent a different way? What would the portrait be like if you weren't looking *up* at the king? What would happen if the background to a figure were more detailed? Less detailed? If the sky were bluer, or grayer? If the water were rougher, or smoother? If the paint were thicker, or thinner? If the colors contrasted more, or contrasted less?

It is not enough merely to isolate everything that you see in a painting and let it go at that. What matters is to recognize the roles that these formal elements play; how they function in the painting. Ultimately, you will want to see how they affect the painting and your experience of it.

The roles played by color, light, texture, volumes, shapes, lines, pattern, and space can be described best by words drawn from analogous nonvisual experiences. Colors are aptly described as ''warm'' and ''cool''. Color can also be

5-16
Justinian and Attendants, c. A.D. **547.** apse mosaic from San Vitale, Ravenna.

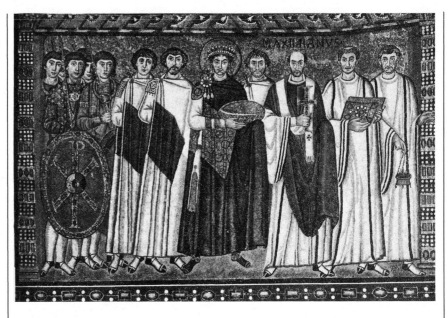

sweet, sour, luscious, luminous, velvety, austere, harsh, or gentle. Color can scream, and it can whisper. Light can be warm or cool, hot or cold; it can be harsh, gentle, cheerful, or eerie. Texture can be rough or polished, heavy or light, turbulent or serene. Brushstrokes can be deft, dashing, turbulent, coarse, or refined. Volumes can be robust or delicate, heavy or light, aggressive or tranquil. Shapes can be gentle, graceful, robust, eccentric, or harsh. Lines can be graceful, nervous, gentle, violent, soft, strong, elegant, or crude. The surface arrangement can be balanced, stately, harmonious, simple, complex, or chaotic. Rhythms can be quick, graceful, regular, off-beat, solemn, or monotonous. Space can be tense, serene, constricting, ample, logical, or dreamlike.

Think of every painting as having a personality. Can you see it as happy, gentle, vigorous, ferocious, pompous, honest, polished, coarse, loud, quiet, elegant, sensuous, austere? Or can you think of it as having a certain taste or flavor, or a fragrance?

These ways of describing paintings and what is in them are not, of course, precise. But they may be the best way of showing how formal elements function in a painting and determine its character.

A Formal Analysis:
Rubens's *Crowning of St. Catherine*

The illustrations in this chapter were chosen because they show with exceptional clarity how the various formal elements appear and function. To see how these elements are combined in one painting, we will study Peter Paul Rubens's *Crowning of St. Catherine* (Color Plate 11). This painting was commissioned in 1633 as an altarpiece for a church in Malines, Belgium. It depicts the vision, or dream, of an early Christian martyr, St. Catherine of Alexandria, in which she

sees herself crowned by the infant Jesus. With her in the painting are two other martyred saints, Apollonia of Alexandria on the left, and Margaret of Antioch on the right. The pincers held by Apollonia and the dragon held by Margaret are attributes—symbols—of their martyrdom.

Working on a grand scale (104 ⅝″ × 84 ⅜″), Rubens gives this visionary event a great physical energy and presence. He almost persuades us that movement is occuring as we watch. The movement, however, is not random, and the painting is not chaotic, for wherever we look our eyes inevitably come to rest in the serene center, where the primary event—the crowning of the saint—is taking place. It is this event that Rubens wants us to witness and remember, and it is here that our eyes linger.

Rubens constructs this painting very deliberately. He emphasizes the importance of Mary, Jesus, and the head of St. Catherine by placing them in the center of the painting. Lines drawn diagonally from corner to corner would intersect at the hand of Jesus that holds the crown. Rubens restates these directions in the strong diagonals that rise from the lower corners of the painting, one along the edge of Apollonia's gown and the other along the back of St. Catherine. These lines bring us to the central area. The figure of Mary is at the apex of a triangle that stabilizes the motion-filled composition. Mary's gaze, together with the oval silhouette of her shoulder and arms, carries our eyes gently downward to the area of the crown and the head of St. Catherine. There is a rough correspondence in size between figures on the left and figures on the right. This symmetry emphasizes the center, and at the same time gives a sense of solemnity to the event.

Much of the action in the painting is aligned along its central vertical axis, which runs through the entire canvas from top to bottom. We can follow its

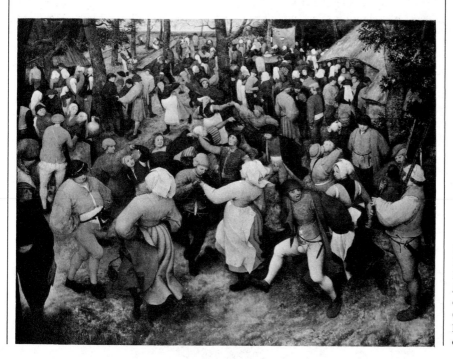

5-17
Pieter Brueghel the Elder, *The Wedding Dance,* **1566. Oil on canvas, 47″ × 62″. Courtesy of the Detroit Institute of Arts, City of Detroit purchase.**

**5-18 (left)
Domenico Veneziano,
*Madonna and Child
with Saints* (St. Lucy
Altarpiece), c. 1445.
Tempera on wood
panel, approx. 6′7½″
× 7′. Galleria degli
Uffizi, Florence.**

**5-19 (right)
El Greco, *The Agony in
the Garden*, c. 1590. Oil
on canvas, 40¼″ ×
44¾″. The Toledo
Museum of Art. (Gift
of Edward Drummond
Libbey.)**

descent from the vertical arm of the trellis through the heads of Mary and Jesus to Jesus' hand holding the crown, then through the head of St. Catherine downward along the palm branch to the bottom of the painting. The axis is repeated by the sides of the trellis. These sides form strong verticals that extend downward along the edge of the purple gown of St. Apollonia on one side and along the edge of the white gown of the kneeling St. Catherine on the other, and give stability to the composition. Besides restating the central axis, the sides of the trellis frame, and thereby emphasize, the central figures.

The arch of the trellis completes the frame. St. Catherine's left arm echoes in reverse the curve of the arch, and pushes our eyes in a clockwise direction that rises along the figure of Apollonia to the cherub above her, and descends along the cherubs and the figure of Margaret on the right to complete the effect of an oval shape surrounding the central figures. The radial elements of the trellis point to Mary. Below the arch of the trellis, repeated curves—the palm branch held by the cherub, the arcs of the trellis, and the cherub's wing—bring us down to Mary's inclined head, and again to the head of Jesus. By both framing and echoing their heads, these curves serve to integrate the background with them.

Rubens paints these figures larger than life size, and draws us into the action by omitting a foreground that would otherwise have separated us from them. Rubens nearly eliminates the background as well, and in this way focuses our attention on the action. We look up at the cherubs and down at St. Catherine as if we are there at the scene. All of the figures and the action are brought close to us,

5-20
Nicolas Poussin,
*Landscape with Burial
of Phocion,* 1648.
Oil on canvas, 47″
× 70½″. Louvre, Paris.

so that everything we see contributes to the immediacy of the event. That sense of immediacy and robust energy also emanates from the loose and vigorous brush-strokes (you will see them better in Color Plate 30). Long, zig-zagging strokes, like currents of water, animate larger areas such as the gowns, while shorter, more blended brushstrokes quiet the action in the faces of the figures.

An amazingly bright light seems to radiate out of this painting. Although the scene takes place out of doors, the light does not cast harsh shadows, but is soft, rich, and warm. The entire scene has a kind of shimmering haze, giving it an appropriately dreamlike quality. This soft shimmer is achieved by gentle blending of color into color, by layering of transparent colors, and by softening the edges of all shapes.

Light is also used to impress the story upon us. By highlighting faces and gestures, Rubens makes sure we feel the absorption of the figures in the mystical event; through our empathy with them, we ourselves become absorbed. The many reds, pinks, oranges, and purples warm the scene. The colors are sweet, rich, and sensuous, reflecting off surfaces even in the shadows.

Rubens also uses color to organize the painting. He reserves his strongest and purest colors for the central area—the large area of Mary's red tunic and, secondly, the contrasting blue of her robe. These colors attract our attention and hold it there. Rubens surrounds the bright colors with contrasting darks to make the center even stronger. Outside the center, spots of red and pink catch our eye and give movement. At the same time, the balance of purples to the left and right stabilize the composition.

Rubens's brush technique makes us aware of surfaces. Rich fabrics, glowing skin, and soft hair invite us to touch them, at least in our imagination. The sense of materiality here—of substance—is matched by few painters.

The volumes are voluptuous and rounded; the shapes are bounded by energetically flowing lines. The curves echo and re-echo one another, like harmony in music. We have already observed how repetitions of the arch of the trellis bring

our eyes to Mary and then to the head of Christ. See also the way the folds of Mary's blue robe correspond to the line dividing the purple and yellow areas in the gown of the figure on the left; and the way those folds are taken into the curve of the palm branch held by St. Catherine. The curve continues along Mary's knee, and is repeated in her left shoulder. See too how the gesture of St. Catherine's left arm is restated by the arm of the cherub in the upper right, and in reverse by the arm of the cherub in the upper left. These and many other subtle correspondences give the painting a harmony and unity that would be impossible to attain in reality, and in that way elevate the painting above the level of natural events to a more sublime realm.

Yet rather than a human event rendered in otherworldly terms, we see a spiritual event rendered in human terms. The figures, weighty and solid, belong to the natural world. Rubens dresses them in contemporary costume, gives them personality, and suffuses the painting with human grace and charm. Rubens thus celebrates the spiritual in palpable, earthly terms. But we can go further in understanding this painting by turning that idea around again: we can see in the painting a statement of faith in the possibility of life to be exalted—a faith that people can be good, wise, and beautiful in both image and spirit.

Rubens shows us a dream wrapped in a legend. Perhaps that mysterious blending of illusion and reality which is the nature of dreams inspired the painter, who experienced much the same process in the creation of his art.

Formal Analysis and Interpretation

By going beyond merely *describing* the subject matter to looking at *how* the subject matter is presented, you will come to a deeper understanding of the painting. Your investigation of formal elements will help you see the painting through the eyes of the painter. By becoming aware of the formal relationships that are subtly embedded in a painting, you will discover what was done to give it character and interest. Your questions will also reveal the attitudes and feelings of the artist toward his subject matter. Isolating and examining the formal elements will help you learn in the clearest possible way what the painting is meant to say, and enables you to establish what is possibly the most intimate and pleasurable relationship to the painting.

It may take a while to get accustomed to looking at paintings in this way. In art appreciation and art history classes time is usually devoted to formal analysis. Often slides of two works of art are projected side by side so that a comparison can be made. Comparisons reveal differences in the handling of form, especially when the subject matter is similar. If you are in a museum you can do the same thing. Choose two paintings with similar subject matter and see how the artists presented each in a different way. With a little effort, more and more about the paintings—and the artists—will come to light.

Formal analysis is a point of departure in the investigation of art. It is a way of looking that can take you from sight to insight. Formal analysis opens the doors to appreciation by helping you to see that a representational painting does not just mirror reality, but makes a statement about it. And it helps you to read and to interpret that statement as thoroughly and as lucidly as possible.

6 | *Studying Art and Its History*

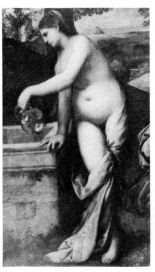

The kind of looking we do in a formal analysis helps us to recognize the decisions that an artist makes. These decisions, determined by his attitudes and feelings, translate those attitudes and feelings into tangible forms. Because of this it makes sense to see a painting, or any work of art, as an expression of the personality of its creator.

But there is more to it than that. Let's consider again Rubens's painting, the *Crowning of St. Catherine* (Color Plate 11). The subject of the painting and the characters in it were almost certainly decided by the Augustinian fathers who ordered it. The size of the painting was most likely determined by the space behind the altar where it was to be placed. The attributes of the saints, the color of Mary's clothes, and the presence of cherubs were all in accordance with traditional iconography. The subject matter and the form—an altarpiece depicting a scene from a saint's life—were common in Western art from the Middle Ages on, though the type was restricted to Catholic countries after the Reformation. Finally, although the style of the painting is highly individual, it shares many characteristics with the work of Rubens's contemporaries.

Clearly, a work of art is more than the product of an individual artist. It is also a product of its place and time. The role art plays in the society, the political, economic, and social situation, the religious or philosophical outlook, and the availability of materials, will all have an impact on the art.

While the actual weight of each of these factors is always open to speculation, no one will question their influence. Who uses the art? Who pays for it? These factors will determine the subject matter and will affect the way that subject matter is presented.

Think of the art produced by any society. What materials are used? Is the art mainly two-dimensional or three-dimensional? Is the art meant to be seen at rest or in motion? Is it meant to be touched or not? Is the art a source of reverence, information, or enjoyment? Is originality encouraged or not?

Is the artist a magic worker, a gentleman, an artisan, a monk, a businessman, or a nonconformist? Is the artist a man or a woman? A professional or an amateur? Does the artist show us the inside of a thing, the outside of a thing, the essence of a thing, an idealized version (like the Rubens painting) or does he weave the subject into an abstract design? All of these are culturally determined.

Conventions in Art

The study of art and its history makes us aware of the extent to which a work of art is subject to traditional forms, procedures, and modes of presentation. Consider, for example, in painting or sculpture:

- the size of a figure
- how time is presented
- the subject matter

How these things are determined is not altogether in the hands of the artist—at least, not so much as we might think. In considerable measure they are a matter of convention, that is, a way of seeing and doing things established by tradition.

Incorporated in the art of any time or place is an accumulation of conventions. Within each culture its own conventions seem perfectly natural. Consequently, they are invisible to an extent—invisible, that is, until comparisons with works from other cultures and other periods bring them to light.

Let us examine these three examples—size, time, and subject matter—to see how they are treated in various cultures. We shall also try to find out *why* they appear that way.

Presentation of Size

What determines the size of a figure in a painting? Is it simply up to the artist? Perhaps you will think that the size of a figure is determined by its location in space, the largest figure being closest (Fig. 6-1). This accords with the rules of linear perspective, the mathematically-based system devised in the Renaissance. Because that system corresponds to the way we see things, it seems to make sense to us. (Of course, the way we see the world is itself conditioned by the traditions of Western art—the art that evolved in Europe and later spread to the Western Hemisphere.)

Before the Renaissance, other considerations determined the size of a figure, and these also made sense. Size had symbolic meaning. In Christian art of the Middle Ages representations of God, Christ, Mary, and of saints were shown larger than ordinary mortals to convey the idea of divinity. See, for example, Duccio's painting of the *Nativity* (Fig. 5-13). Important people were also made larger so that they could be easily identified in the scene. Similarly, in Buddhist art, narrative scenes usually depict Buddha as larger than everyone else. In Egyp-

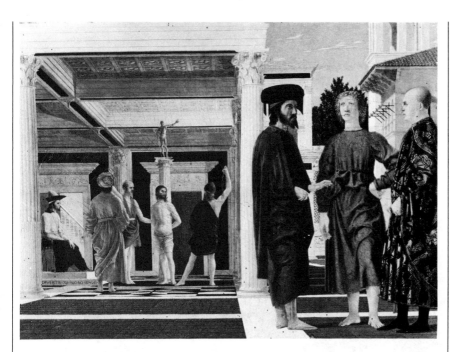

tian art the size of figures was determined by social rank, and the king, who was believed to be partly divine, was the largest of all (see Fig. 4-4). To an Egyptian, a Buddhist, or to someone living in Medieval Europe, *our* system, in which figures diminish in size as they recede in space, would seem to violate the natural order of things.

In some Chinese or Japanese art, where figures placed farther back in a room are sometimes no smaller than those placed in the front, we have yet another way of seeing. The Asian artist might insist that his vision is more truthful than ours: after all, do people really shrink when they walk away from you?

Asian art points up the difficulties inherent in the Western perspective system. Western artists find it a problem to show figures combined with large-scale architecture, or to show crowds in which the more distant figures remain clear. In these situations, figures can become tiny, indistinct, or irrelevant. In Eastern traditions (in Turkey, Persia, and India, as well as China and Japan) artists solve these problems by flattening out the space in order to bring distant figures forward, where they can be clearly seen (Color Plate 12). Figures meant to be in the background are shown higher up in the picture . The architecture, also unconstrained by the rules of linear perspective, is treated so as not to overwhelm the composition and dwarf the figures. Unconfined by the Renaissance perspective system, but working within their own conventions, Eastern artists invented rich arrangements of line and pattern.

The size of a figure in a painting thus depends in part on the particular convention in which the artist happens to be working. The Renaissance perspective system is but one of a number of conventions—traditional, or customary practices—for the depiction of space, any and all of which may lay claim to a basis in truth.

Presentation of Time

Next we'll consider how time is presented in a work of art. Based on the art most familiar to us, we might think it only natural that a work of art show us a single moment in time. Think of Rembrandt's *Night Watch* (see Fig. 2-1), or of Impressionist painting (Color Plate 26) or of photographs. All of these capture a single moment in time. But not every artistic tradition aims at this as a matter of course.

The art of ancient Egypt and Assyria presented figures and events existing *beyond* the reach of time. The solid, blocklike forms in sculpture (Fig. 6-2) and the crisp, factual delineations in painting (see Fig. 4-4) were meant to guarantee immunity from change and decay. Whether as propaganda or as magic, the art had no interest in time-bound phenomena, but rather in the eternal order of things.

In Medieval art a painting or carving may show more than one episode of a story, thus depicting *various* moments of time in a single frame. Consequently, the same figure may appear in more than one place. In this mosaic of the nativity (Fig. 6-3) you can see the infant Christ held by Mary, and again, in the lower right, being washed by the two midwives. The Magi appear on the left, riding toward the star over the manger, and on the right, presenting their gifts. Of course, no one would have construed that these people were in two places at the same time, any more than you or I would be confused by the conventional layout of a comic strip. The Medieval mode of pictorial presentation makes sense, in its way, for it is able to present an entire story efficiently in a limited space.

The idea that a scene should highlight a precise moment in time had occurred in some Greek and Roman art, but was of little concern in the Middle Ages. It reappears on the eve of the Renaissance, in Italy, in the work of a few artists of the early fourteenth century (see Figs. 5-8 and 7-1). Their art expresses the intuition of a more rational world than that conceived of in pre-Classical antiquity or in the Middle Ages. In Renaissance art, linear perspective, with its ordered space, was joined with the complementary notion of the depiction of a precise moment in time (Fig. 6-4). Thus fixed in space and time, human events could be given an immediacy beyond the scope of the more abstract art of Egypt, Assyria, or

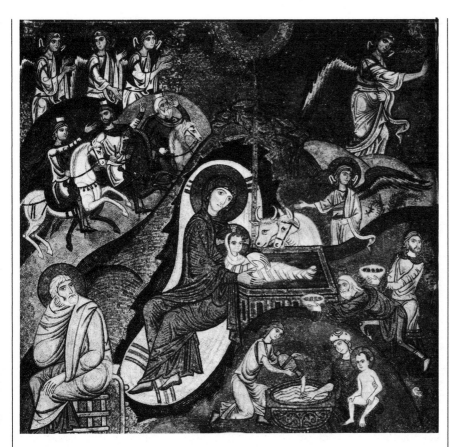

6-3
The Nativity, 12th
century. Mosaic.
Palatine Chapel,
Palermo.

Medieval Europe (Fig. 6-5), with their meditations on timeless events and eternal truths.

Scenes presenting a single moment in time involve us with the drama of specific individuals who have character and feeling. Just as we are drawn up close in time and space, we are also drawn up close psychologically. By replacing the old convention with a new way of seeing (which itself eventually became a convention) artists of the Renaissance presented a new reality.

Subject Matter

So far our discussion has demonstrated that *how* a painting or sculpture looks depends not just on the artist but on the culture that produces it. We can go even further and say that *what is depicted* in a painting also depends on the culture.

Landscape art provides a striking example of this. Nearly everyone enjoys looking at views of landscapes today. We find them in calendars, Christmas cards, cigarette advertisements, and films. Northern European painters of the fifteenth and sixteenth centuries like Bosch (see Fig. 11-16), Patinir, Altdorfer, and Brueghel (see Fig. 5-17) created imaginative landscape settings. But these were exceptions. The regular use of the landscape as an independent subject

6-4
Masaccio, *Expulsion
from the Garden, c.*
1425. Fresco. Brancacci
Chapel, Santa Maria
del Carmine, Florence.

appeared in European painting only as late as the seventeenth century, primarily in Holland. Of the landscapes that were produced before this, most were intended as settings for human dramas; even the Dutch were reluctant to omit the human presence in their landscapes. Despite the beauty of these paintings, many art critics outside of Holland in the seventeenth and eighteenth centuries ridiculed the Dutch landscape painters and thought of their paintings as meaningless. It was not until the nineteenth century that landscape painting came to be widely accepted as legitimate.

Landscapes of course appeared in the backgrounds of portraits and figure paintings beginning in the late Middle Ages. Many of them are quite detailed. Sometimes actual locations were introduced and can be identified, but evidence that an artist painted his painting on the spot is extremely rare (with the exception of an occasional ink wash or watercolor study). All landscapes were painted in the studio right up until the nineteenth century, when at last a few artists, anxious to capture more precisely the light and atmosphere of a particular site, dared to paint out of doors.

While landscape painting was a relatively late development in the West, another culture had long focused on it with great intensity: the Chinese. For over one thousand years landscape was for Chinese artists the highest expression of their art (Fig. 6-6).

What accounts for this disparity? The answer lies within the cultures themselves. The contrasting attitudes toward landscape as subject matter reflect contrasting philosophical attitudes toward the natural world. During the Middle Ages, Christians were bidden to look away from this world to the next. The natural world was of little concern. In the Renaissance, the natural world was conceived as a stage for human actions. The Chinese tradition, on the other hand, held that man was small within the natural order. For the Chinese, nature was pervaded by a living, cosmic spirit. Chinese tradition therefore encouraged people to contemplate nature, either directly or through paintings, as a means of attaining harmony with that spirit.

Clearly, for Western culture at least, nature as subject matter just wasn't as natural as we might think. Not everyone found it as interesting as we do today, or thought of it as beautiful or precious. The status of landscape as subject matter has always been determined by cultural predispositions, not individual tastes. Even the way a landscape is painted is not just based on the whim of the painter, as we shall see next.

Western painting from the fifteenth century onward is characterized by the use of oil paint, in which an infinite range of color and blended strokes lend themselves to illusionistic depictions of the subject. Chinese landscapes are painted in ink and are made up of distinct brush strokes and washes (Fig. 6-7). These marks retain their identities; they do not transform themselves into realistic images by Western standards. However, they *evoke* natural forms, and because of their innate expressiveness, they manage to convey the essence or the character of whatever they depict. Thus where Western art aims at an optically correct representation of the outward appearance of a mountain or tree. (See, for example, Poussin's *Landscape with Burial of Phocion,* Figure 5-20). Chinese art aims to transmit the inner nature, the ''spirit resonance'' of the mountain or tree.[1]

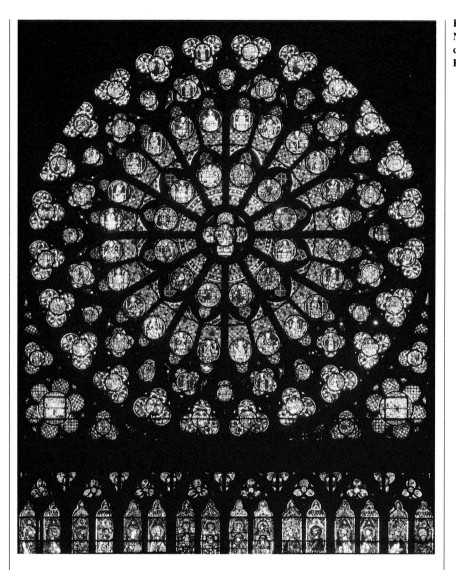

Plate 1
North rose window,
c. 1250, Notre Dame,
Paris.

Plate 2
I. M. Pei, East Wing of the National Gallery of Art, Washington, D.C., 1978. Mobile by Alexander Calder.

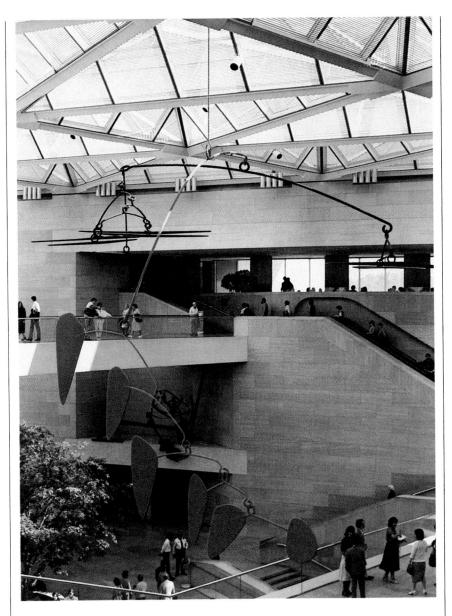

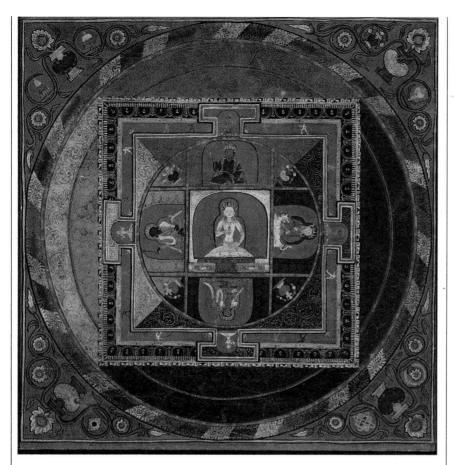

Plate 3
Mandala of Vajrasattva,
Tibet, 14th century.
Opaque watercolor on
cotton, 15½″ × 15½″.
The Brooklyn Museum.
(E. C. Woodward and
various funds.)

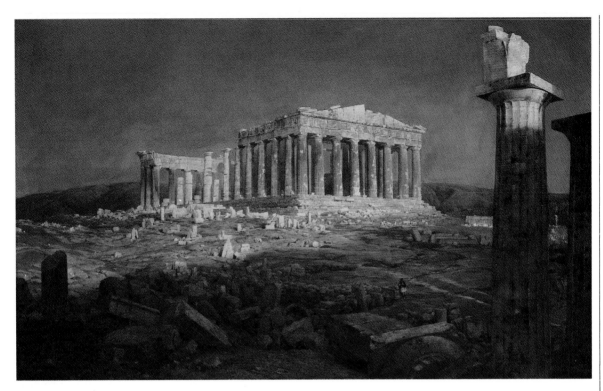

Plate 4
Frederic Church,
The Parthenon, **1871. Oil**
on canvas, 44³/₁₆″ × 72⅛″.
The Metropolitan
Museum of Art, New York.
(Bequest of Maria De
Witt Jesup, 1915.)

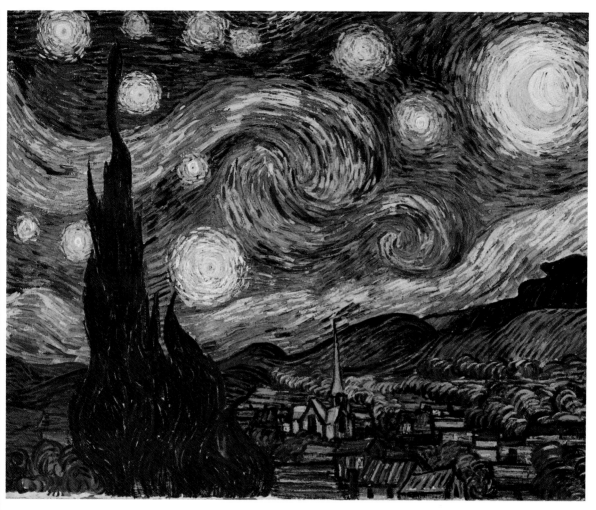

Plate 5
Vincent van Gogh,
Starry Night, 1889. Oil
on canvas, 29″ × 36¼″.
Collection, The Museum
of Modern Art, New
York. (Acquired through
the Lillie P. Bliss Bequest.)

Plate 6
El Greco, *View of Toledo*, c. 1597. Oil on canvas, 47¾″ × 42¾″. The Metropolitan Museum of Art, New York. (Bequest of Mrs. H. O. Havemeyer, 1929. The H. O. Havemeyer Collection.)

Plate 7
**Vincent van Gogh,
detail of *Starry Night*,
1889. Collection, The
Museum of Modern
Art, New York.**

Plate 8
Raphael Sanzio,
Madonna della Sedia,
1514. Oil on board,
diameter 28⅖″. Galleria
Palatina, Palazzo Pitti,
Florence.

What is the relation of the figure to the landscape? The figure in a Western painting will often seem to stand apart from and to dominate its world (Fig. 6-8). The figure in a Chinese landscape will be small. It will appear to be enveloped by the world around it, and we thus see it as integrated into that world (Fig. 6-7). The decision as to where the figure is placed in relation to the landscape reflects a cultural attitude regarding the relationship between man and nature.

The kind of perspective used is also determined by tradition. Typically in Western painting the point of view is low, as though the viewer were standing on the ground on the edge of the landscape, looking across at it. As the landscape recedes into the distance, objects regularly diminish in size, as they appear to do in the natural world. In Chinese landscapes the viewer is given an aerial view. Objects do not diminish in a regular way. You may find yourself looking down and up and even around the side of a mountain or rock. In this way you are drawn *into* the space of the scene and invited to walk around in it. Western paintings, based on linear perspective, suggest a rational, logical order, whatever their subject matter. By contrast, the more intuitive perspective of Chinese paintings inevitably lends them an imagined quality.

6-5
The Story of Adam and Eve **from the Carrow Psalter, c. 1250. The Walters Art Gallery, Baltimore.**

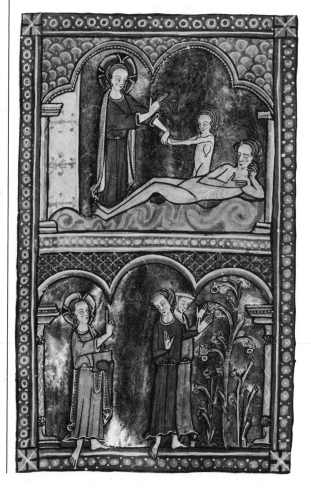
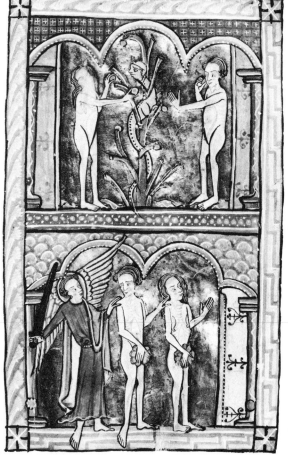

6-6 (left)
Wen Cheng-Ming,
Landscape, **c. 1517.**
Ink on paper, 36¾″ ×
8³⁄₁₆″. The University
of Michigan Museum
of Art.

6-7 (right)
Wen Cheng-Ming,
Landscape, **detail.**

As we can see, very different roles for landscape appear in the two cultures. In the West, landscape was for centuries of little or no interest. In the East it was of consummate importance. When landscape appears in Western art, its character contrasts strongly with that of Chinese landscape. Even the relationship between the viewer and the subject matter is different: Western landscapes we observe from the outside; Chinese landscapes we contemplate from within.

Conventions and Style

Artistic conventions represent a particular way of seeing and doing prescribed by the culture. Every society thinks of its own traditions—if it considers them at all—as sensible and self-evident. But as we have seen, what is obvious or natural in one place may not be so obvious or natural in another.

Artistic conventions that are unfamiliar to us may look strange. We are tempted to think that there was something wrong with the way the artist saw his subject. It may be that the artist was clumsy. It is also possible that he was

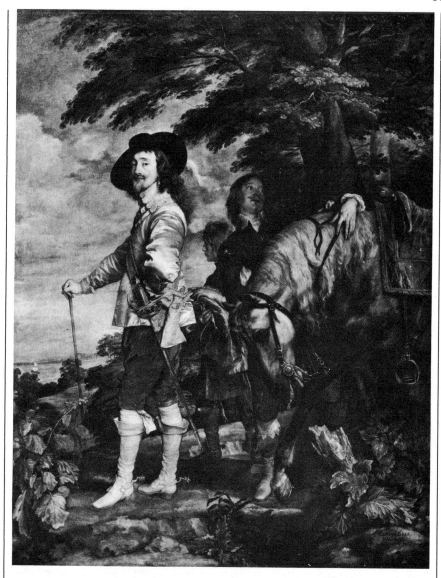

6-8
Anthony van Dyck,
Charles I at the Hunt,
1635. Oil on canvas,
approx. 9′ × 7′.
Louvre, Paris.

working successfully within a framework of conventions different from ones to which we are accustomed. Conventions different from our own are not mistakes, or wrong ways of looking at things, but *different* ways of looking at things.

The art produced in any culture reveals the preoccupations of the society. We can discover those preoccupations by asking: What is included? What is omitted? How is it shown? The art of every culture articulates, in concrete terms, the assumptions the society has made about the nature of life and experience. Who are we? What is our place? How does the universe work? What counts? The study of art history contributes to our understanding of the answers that various peoples have given to these crucial questions. And it reminds us that these questions have been answered in strikingly different ways.

It is not that works of art necessarily address themselves consciously to these questions. Some do, of course. But all works of art, *in their very appearance,* tell us these things. The forms themselves speak to us both of the artist and of the culture of which he was a part. The visual statements that works of art make about their society can reveal as much as written statements, and even more.

In order to interpret these statements art historians frequently compare various representations of specific subject matter, as we have done here with landscape. How has the nude been represented in various cultures? How have images of women differed in art from ancient times to the present? Compare, for example, the depiction of the nude by the Medieval artist (Fig. 6-5) with that of Masaccio in the Renaissance (Fig. 6-4), or the (literally) elevated image of the *Greek Slave* (see Fig. 3-11) with Picasso's *Les Desmoiselles d'Avignon* (see Fig. 7-9). Art historians observe differences such as these and attempt to evaluate them.

As a part of that effort, art historians focus on style. When we look at the art of any one period we find a consistency of appearance. That consistency of appearance—the ways things look—is called a style. A style is formed by the whole range of conventions that are in use at a particular time. It also reflects the creative achievements of individual personalities. For these reasons, style is central to the study of art and its history. If the study of art and art history is in part the comparison of changing styles, it is because these styles speak for the times in which they were produced. The replacement of one style by another suggests a new way of looking at things. What is dropped? What is retained? And why? Art history raises these questions, and tries to provide answers to them.

Going Beyond Face Value

The study of art and its history sharpens our eyes and trains us to read works of art for the statements they contain. We now know that there are a number of ways we can read a painting (or any work of art). We'll consider some of them now.

One way is, of course, just to look at what is being presented. Paintings show us what things mattered to the society. They can show us the jewels and the fine clothes, the globes and the telescopes, the ships and the cannon, castles and villages, violence and beauty, piety, and pomp. What is omitted is important too.

Paintings have long been enjoyed simply as illustrations of stories, so it is also important to be acquainted with the theme of the painting. What is the story? Who are the players? Is the subject historical? Allegorical—that is, do the characters represent specific ideas? Is the subject a combination of the two? What changes, if any, has the painter made in telling the tale?

This surface reading of paintings must sometimes be supplemented by another approach: the recognition and interpretation of symbols. A symbol is a pictorial element that stands for something else. For example, a dollar sign, a halo, and Elsie the Borden cow are all familiar symbols. Like all symbols, they function because their meanings are acknowledged by all members of the society. Ignorance of symbols and their meanings can leave us open to misinterpretations of what we see in a painting or sculpture. Did the early Christians wear plates on their heads? Do we worship cows? In societies having minimal literacy, or no

written language at all, the meanings of symbols are quite specific. In literate societies symbols are more challenging to recognize. They have not been codified, and their meanings are looser, more open to interpretation. For example a landscape, however realistic and natural it may appear, may contain symbolic meaning, as when it represents a storm, a rainbow, or a sunset. Symbolic meaning might be imparted by details such as a tree broken at the trunk, or a ruined building. What do you think of when you see a shadow on the wall? A skull? A dog sleeping by the hearth?

Some of the symbols I have mentioned can be seen in Jacob van Ruisdael's painting of the *Jewish Cemetery* (Fig. 6-9). The cemetery is a real place, but the ruined building is an invention of the painter. What other symbols can you find in the painting?

Of course, we can enjoy the images we see purely as naturalistic representations. But to close our eyes to the secondary meanings they evoke, or once evoked to their audiences, would be to miss out on a complete understanding of them.

6-9
Jacob van Ruisdael,
The Jewish Cemetery,
c. 1655. Oil on canvas,
56″ × 74½″. Courtesy
of The Detroit Institute
of Arts. (Gift of Julius
H. Haass in memory of
his brother Dr. E. W.
Haass.)

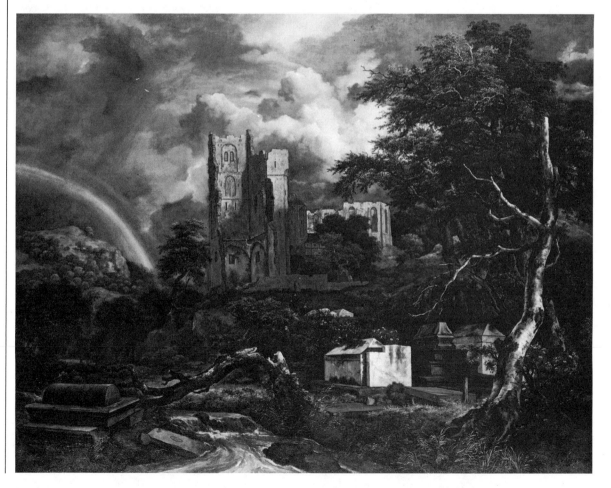

People often use gestures to communicate without words. Gestures frequently appear in paintings, where they may also have specific meanings. In Persian art, a finger placed before the mouth indicates surprise. In early Christian art, hands open and raised to the level of the shoulders represents an attitude of prayer. The English art historian Michael Baxendall, who investigated the sign language developed in the Middle Ages by Benedictine monks, suggests that the gestures of Adam and Eve in Masaccio's *Expulsion from the Garden* (Fig. 6-4) have precise meanings: Adam displays shame, while Eve displays grief.[2]

Colors frequently carry symbolic meanings. In some cultures, colors are prescribed for certain figures or objects. The ancient Egyptians used red to represent evil. In China red traditionally symbolizes happiness. In paintings of the Renaissance, the color of Mary's robe was always blue. In the Hindu art of India, blue is the color of Krishna. Persian miniatures used black to represent India. Since these colors were used in part for indentification, any arbitrariness in their use was out of the question.

There are, of course, a number of possible reasons why a color is selected. The color of a tree, for example, may be chosen because it was matched with nature, insofar as the artist was able to do this. It may be a matter of convention, such as the gravy-colored trees that flourished in paintings between the sixteenth and the eighteenth centuries. Or the color may come out of the artist's imagination. Clearly then, it is important for our understanding of a painting to distinguish the mode in which color is used.

Certainly, if we want to be open to *all* the meanings that are contained in a painting, we can't restrict our attention to subject matter alone. Some meanings lie beneath the surface of the subject matter, and we need to know about them to make sense of what we see.

Finally, meaning is communicated through *form*. As I pointed out in the last chapter, looking carefully at the form of a painting, that is, the way the subject matter is presented, strengthens our understanding of its content. We achieve insight into a painting, or for that matter any work of art, when our analysis leads us to consider *why* the form was handled in a particular way. Our analysis becomes a kind of "psyching out" of the piece we are looking at, or a reading between the lines in order to discover its implicit meanings.

Our comparison of Eastern and Western landscapes was an example of this kind of inquiry. Essentially, we are asking ourselves what values, ideas, and attitudes are embodied in the painting. These may have been so much a part of their time and place that the artist, taking them for granted, may have been only marginally aware of them, if at all. But time and change can make them clear to us. So much so, in fact, that sometimes the first reaction we have to a painting or to a sculpture—or for that matter, to an advertisement—is a response to just these meanings. For example, look at Figures 6-10 and 6-11. How is each woman dressed? How is she posed? Where is she placed? What is she doing? Where is she looking? What else is included in the scene? What do these images tell you about changing social attitudes toward women?

These, then, are some of the ways that we may study works of art for the meanings they contain. The trick is: never take what you see at face value. Keep in mind that any work of art is a highly selective, highly refined, and inevitably, highly fictive version of reality. Its appearance will be determined not simply by

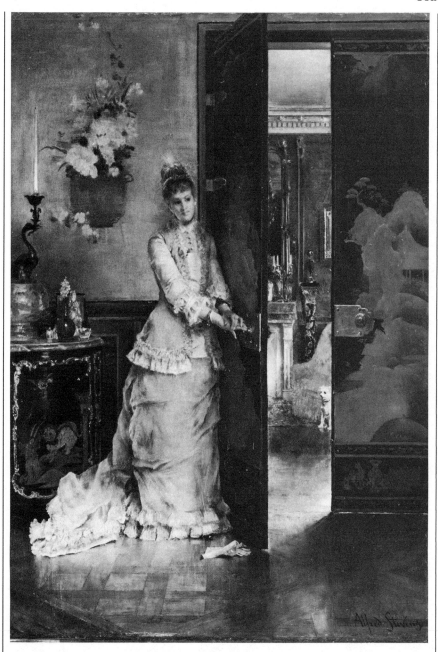

**6-10 (left)
Alfred Stevens, *Hide
and Seek (Cache-
Cache)*, c. 1876–80.
Oil on panel, 29¼″ ×
20⅜″. University of
Michigan Museum of
Art. (Bequest of
Margaret Watson
Parker, acc. no.
1955/1.85.)**

**6-11 (right)
Courtesy of The
Archives: The
Coca-Cola Company.**

the subject and not simply by the personality of the artist, but also by the styles
and conventions of his time.

We can think of culture as a lens through which we view reality. However
clear-eyed, however rational we may think it is, culture colors whatever we look
at, and modifies it in some way. Thus culture determines to a great extent what
we see in a work of art, what ideas will find expression, and what the artist's
attitudes will be.

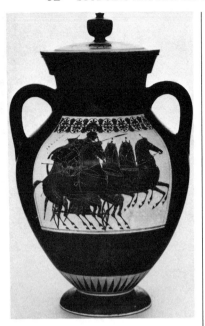

**6-12
Exekias, Group E,
*Quadriga Wheeling
Right* amphora and lid,
Attic Greek, c. 550–530
B.C. Wheel-thrown,
slip-decorated earthen-
ware, approx. 18″ high.
The Toledo Museum of
Art. (Gift of Edward
Drummond Libbey.)**

**6-13
Giorgione, *The Pastoral
Concert*, c. 1508. Oil on
canvas, approx. 43″ ×
54″. Louvre, Paris.**

We can learn from all works of art—even the ones we don't particularly enjoy. By learning to read them for the statements they make, we can form an idea about the attitudes, values, and beliefs of people and cultures unlike our own. There is a history to art because there is a history to human experience. The advancement of our understanding of that experience is one of the goals of art historians.

Western Traditions

Now let's turn our attention to the art of Western civilization. Western art is only one of a number of artistic traditions, but it is the one that has been given to us. Any discussion of Western art and civilization must take into account the major changes in outlook that occurred at various times—changes that made themselves felt in the art. In chapter 11, we will consider some of the particular ideas and interests that Western art has incorporated over the years. In chapter 12, we will survey the artistic styles that characterize the major art historical periods. If, however, we were to look at Western art in the most general terms, emphasizing the constants rather than the variables, what would we find? In the remainder of this chapter, we shall look at the art from the High Renaissance to the beginning of the modern period—from about A.D. 1500 to 1900. This art provides the background to our own epoch; it has shaped our environment, and constitutes most of what we see in museums today. What is its character? What preoccupations do we find?

To begin with, the art focused on human activities. We find this at the roots of

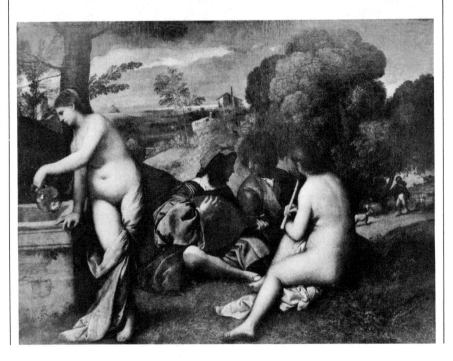

Western art, in Greece, where freestanding statues of handsome youths were dedicated to the gods and where crisp, lively images of men and women decorated the pottery (Fig. 6-12). Unlike the art of other cultures, where figures were meditative or distant, Greek painting showed people engaged in activities—running, sailing, fighting, conversing, and so on—and gave them the vigor, self-awareness, and individuality that remains a part of Western art to this day.

Furthermore, Western art is, strikingly, an art of realism; it is an art that corresponds as far as possible to visual perception. Artists working in this tradition have asked not only "What is it?" and "What do I see?" but "How does it look?" and "How can I make a convincing illusion of what I see?" We find the beginnings of this interest in Greece and Rome. Following the Middle Ages, with its other-worldly focus, Renaissance art revived the idea of art as imitation.

We must keep in mind, however, that while art since the Renaissance has presented convincing depictions of the external world it rarely aimed to show life just as it is. Much more often than not it sought to *idealize* life: the most perfect examples from nature would be chosen as models and then presented in even more beautiful form. The teachings of the Greek philosopher Plato (c. 427–347 B.C.), rediscovered during the Renaissance, were the basis for the belief that such "improvements"—essentially, images of perfection—would furnish a better idea of truth or reality than the depiction of things as they are.

*A*lways take from nature that which you wish to paint, and always choose the most beautiful.

—Leon Battista Alberti (from *On Painting*, 1435)

In addition to the idealized forms, the *themes* that were selected frequently conveyed a picture of life on a loftier plane. Illustrations of Biblical stories and of Greek and Roman history and mythology were especially popular, appearing again and again. Imaginative and philosophical images such as Giorgione's *Pastoral Concert* (Fig. 6-13) were also admired because of their refined evocation of a supposed Golden Age of antiquity. Only subjects such as these seemed sufficiently worthy for art.

At times the idealizing was linked to an educational or moralizing end. The function of art to instruct and to improve, as well as to delight the senses, was continually asserted from the Renaissance on. That this principle had been articulated in ancient Rome only gave it greater authority. In 1649, the Spanish painter and theoretician, Francisco Pacheco, wrote that religious paintings "perfect our understanding, move our will, refresh our memory of divine things. They heighten our spirits . . . and show to our eyes and hearts the heroic and magnanimous acts of patience, of justice, chastity, meekness, charity and contempt for worldly things in such a way that they instantly cause us to seek virtue, and to

shun vice and thus put us on the roads that lead to blessedness.''[3] On October 16, 1780, Sir Joshua Reynolds, in a lecture to students at the Royal Academy in Somerset, England, asserted that the artist's task is ''to raise the thoughts, and extend the views of the spectator'' to the ultimate purpose of leading people to virtue. The Official Catalogue of the Salon exhibition of 1793 in Paris declared in its introduction: ''The arts should never limit themselves to the single aim of pleasing by faithful imitation. The artist must remember that the goal which he has set before him is, like that of all work of genius, to instruct men, inspire in them the love of goodness and to encourage them to honorable living.''[4] And in 1869 William Cullen Bryant concluded his argument for the establishment of a public art museum in New York (later to become the Metropolitan Museum of Art) by pointing out that by providing ''attractive entertainments of an innocent and improving character'', the museum would combat the temptations of vice bred by a large and overpopulated city.

In accordance with this attitude much of the art, whether religious or secular, aimed to inspire people by providing them with images of piety, nobility, dignity, grandeur, and courage. Not all art responded to the call for moral uplift, however. A great deal of Western art remained happily and resolutely decorative. People looked to art simply for enjoyment much as we do today. Artists such as Titian, Rubens, and Velázquez, who painted intensely moving religious and historical dramas, also gave us paintings for pleasure and sensual delight. Much of the Rococo art of the eighteenth century shunned all that was serious. (See, for example, Fragonard's *Blind Man's Buff,* Fig. 9-3.) The landscapes of Claude Lorrain in the seventeenth century and the cityscapes of Canaletto and Guardi in the eighteenth were more picturesque than profound. Yet each of these artists, in his own way, elevated whatever he painted to a higher, more poetic, more imaginative plane.

In sum, the art focused primarily on human activity, which was depicted in lucid but imaginative statements. Aspiring to truth through images of a perfected world, and providing inspiration through depictions of exemplary action, art often served high-minded moral and instructional purposes. At the same time, the capacity of art to give pleasure remained a constant.

Unhappily, the idealization of life occurred on a somewhat less exalted level. Paintings tended to flatter their subjects. (Even Joshua Reynolds, who was quite successful as a portrait painter, flattered his sitters; this may be the reason why he had so many commissions.) It's easy to recognize this kind of flattery in the idealized but, to our eyes, pretentious way that the subjects in a portrait were presented (Fig. 6-14. See also Fig. 9-1, a self-portrait.)

Even more important to our understanding of Western art is that we recognize the accommodation that art made to the version of reality that these patrons wished to project. Painting, sculpture, and architecture put into tangible forms the outlook of a particular class. They would not necessarily have spoken for the whole of society, especially when the disparity between classes within the society was wider than it is today. Scenes depicting idyllic life in the country, or poor-but-happy beggar children in the city were part of the fantasy life of the rich. Only rarely did a work of art record the grimmer reality experienced by the poor, or give expression to their hopes and dreams.

6-14
**Drawing by Donald
Reilly; © 1966 The
New Yorker Magazine,
Inc.**

"Give me more angels and make them gladder to see me."

Thus Western art tended to prefer the wings of fantasy to the mirror of reality. Most often these wings carried it directly to antiquity; to the persons and events of the Bible, of Greece, and of Rome. This orientation to ancient history, noticeable in any trip to a museum, and evident even in the illustrations of this book, puzzles many people today. What magic did the ancient past possess that charmed successive generations?

The answer lies in an idealistic attitude toward antiquity which has only recently, in our own century, come to be questioned. As far back as late Roman antiquity the belief prevailed that the greatest wisdom resided in the past. Since that time, people in Western countries have looked upon two ancient civilizations as exemplars for mankind for all time: one, the civilization of Greece and Rome,

and the other, the Hebrew civilization of the Near East. This reverence for the past was to condition Western thinking, and its art, virtually to the present.

During the Middle Ages, classical learning was preserved by the Church along with the teachings of the early Church fathers. The writings of certain classical philosophers continued to be considered authoritative. In the Renaissance, people believed that the study of classical antiquity would bring about a renewal of Western civilization. That renewal would produce the kind of person who, at that time, was associated with classical civilization: proud, capable, virtuous, and free.

While Renaissance humanists were absorbed in classical antiquity, the Protestant Reformation of the sixteenth century brought into focus the Bible and early Christianity. Protestant theorists, like the classicists, looked for a regeneration of society based on events and teachings of the ancient past. Thus Renaissance and Reformation alike were haunted by the assumption that civilization had declined since that more perfect time.

Modern culture reverses that sequence. With faith in the inevitability of progress, it has tended to trust in the eventual perfection of society through social and technological advances. It is therefore not easy for us to appreciate the degree to which people gave authority to the teachings of antiquity. As late as the sev-

6-15
The Capitol Building, Washington, D.C. Designed by William Thornton, 1792; later additions by Benjamin Latrobe, Charles Bulfinch, and Thomas Ustick Walter.

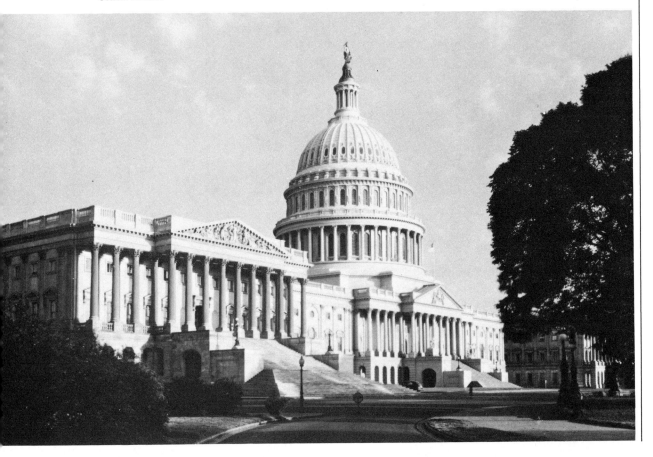

enteenth century, and to an extent even beyond that time, the Bible, as the word of God, and the teachings of certain Greco-Roman scholars, such as Aristotle, Hippocrates, and Galen, were thought to be the final word on the physical nature of the universe, on man, and on man's place in the universe. The evidence of scientific investigation, such as it was, carried less weight. The dispassionate scientific outlook with which we are familiar today was unknown until the seventeenth century: before then, people sought and found in the world around them proofs for what had already been revealed in ancient texts. (Except for Leonardo da Vinci, who wrote in his notebook: ''To me it seems that those sciences are vain and full of error which are not born of experience, mother of all certainty, first-hand experience which in its origins, or means, or end has passed through one of the five senses.'')

While the idea of material progress eventually took hold, Western civilization never resolved its doubts as to whether society had improved in a moral sense, or in terms of its ideals. Hence the demand for an art which would inspire, by helping to recover the image and the spirit of antiquity.

Beginning with the Renaissance, and continuing virtually to our own time, classical art became a foundation for painters, sculptors, and architects. Because ancient statues were thought to provide examples of form brought to perfection, they were used as models by painters and sculptors. Roman buildings provided a basis for architecture. Architects journeyed to Rome so they could observe the remaining monuments firsthand. Their studies included measurements of proportions as well as sketches of architectural details. These found their way into their buildings. The ''grandeur that was Rome'' was to live on in courthouses, banks, and public buildings thoughout Europe and the United States (Fig. 6-15).

In the nineteenth century the longing look backward fell on the Middle Ages. Romanticism, with its sense of the questing soul, and its celebration of intense states of emotion and exaltation, found its Golden Age in the Medieval period, glorified as a time of faith, passion, and spirituality. Because Gothic architecture in particular seemed the perfect expression of its age, it was revived in countless examples in Europe and the United States.

But for the most part in Western art we find a tendency to ''classicize''; to adjust the forms and themes of the painting or sculpture to agree with the forms and the principles of Greco-Roman art. The aim was for an art that would not only be beautiful, but that would edify and inspire as well. Art and architecture based on Greco-Roman forms seemed expressive of lofty ideals, and allowed both artist and patron to feel themselves a part of the classical tradition.

When we look at Western art from the Renaissance to the modern period this, then, is generally what we find:

- an interest in human activity
- realism
- idealism, including a fascination with antiquity

As a caution, keep in mind that not all the art shared these characteristics. For some artists, imitation was not an aim. Much of the art spurned idealism, and aimed instead at realism, information, or amusement. Not all artists have been

fascinated by antiquity. But even if these characteristics were not prominent, they were there in the background, providing something to react against.

In our own time, much of what was traditional in art has been overthrown, just as we have experienced upheavals and revolutions in the areas of science, technology, society, religion, and politics. If we look carefully, however, we will be able to see a certain continuity of the tradition. To this day, Western art, whether abstract or representational, remains an art of strongly individualized statements of human experience. In popular culture, movies and television programs satisfy the desire for true-to-life images of human activity. At the same time, idealized versions of reality are presented in glossy TV productions, situation comedies, sugar-coated romances, TV advertisements, and typical Hollywood endings; occasionally, films are condemned because they refuse to gloss over harsh and unpleasant aspects of life. Our culture is still suffused with survivals and reminders of antiquity. Modern architecture reacted against classical decorative forms, but many contemporary architects and designers no longer feel compelled to define what is modern in terms of that reaction (see, for example, Color Plate 22). For that matter, we may sense in the pure, precise form of a modern skyscraper a spirit akin to that of Greece and Rome.

Conclusion

Works of art provide remarkable statements of human experience. Whatever the specific intention of the artist, and however original his thought, the art produced by him inevitably expresses something of the outlook of the time and place of which he was a part. It may be expressed consciously, and be clearly stated in the title and in the subject matter; but also—and often more revealing—it is expressed unconsciously and automatically through form.

Art history makes us aware that cultures develop styles and pictorial conventions to frame reality. Familiarity with these styles and conventions helps us to distinguish between what tradition and what the artist have contributed. The distinction between these two is crucial to the understanding of any work of art.

The careful investigation of a work of art carries us beyond its face value and brings to light the meanings that it once carried to its audience. Understanding those meanings can bring those works of art to life in a stronger way for us, too.

By providing information about the past, the study of art history helps us to see ourselves in relation to those who came before us. Ultimately, it can provide illumination for our own lives. Art history raises questions such as: How were those people different from us? How were they like us? What values have changed? What things persist? Are our lives any better than theirs were? Are we any wiser? And what makes us unique?

7 | *Abstract Art*

U p to now we have been talking mostly about representational art, whose meanings are imparted through images closely tied to the real world. Representational works of art instruct us in knowing, seeing, and feeling about the subject. But what about abstract art? What's left to a painting or a sculpture when you take away recognizable subject matter? Will it still have something to say to us? Why would an artist want to distort an object in a painting? How are we expected to understand that painting? Are we all expected to understand it in the same way?

Abstract art raises some serious questions. It presents its audience with certain challenges that just aren't there in representational painting. One of the early abstract artists, Wassily Kandinsky, said that abstract art ''speaks of mystery in terms of mystery.'' While it may be that mystery is at the heart of abstract art (perhaps some mystery is at the heart of every work of art), I think that it's possible to clear away some of the confusion surrounding it. To that

end this chapter will trace the development and discuss, in general terms, the nature of abstract art. By the end of this chapter, we will have some answers to these questions.

Form as a Visual Language

To begin, let me ask you to set aside for now the obvious differences between abstract and representational art. I'd like to suggest that there really is no fundamental division between abstract and representational art. In a sense, *all* art is abstract. Every painting, however realistic it may appear, departs in some ways from the subject. The artist extracts from the subject what he feels to be significant, and presents it in forms that express his ideas most effectively.

Thus *all* artists have an interest in form. Form is the language through which meaning is communicated. Artists use elements of form, such as color, light, shapes, and lines, as writ-

ers use words, or as composers use sound. Artists who learn to use this language skillfully are able to express themselves clearly and powerfully.

To theoreticians of the past, form sometimes seemed less important than the subject matter of a work of art. Until this century, paintings were frequently ranked according to their subject matter or theme. People felt that paintings should show noble things. Accordingly, paintings showing historical events were considered superior to landscapes and still lifes. Paintings that affirmed human dignity took precedence over those that depicted what was merely anecdotal or amusing. This emphasis on content was based on the realization that art exerts an influence on human life. Nevertheless most critics today consider this kind of evaluation to be naive and restrictive.

Artists of the past were perfectly aware that a painting's worth depends on more than its subject matter. As we saw in chapter 5, *Reading Paintings,* representational painters were highly attuned to the effects of form—as attuned as are contemporary artists whose work has no recognizable images.

Consider, for example, Giotto's *Meeting of Joachim and Anna at the Golden Gate* (Fig. 7-1). In depicting Joachim and Anna's joyful reunion, Giotto merges their bodies into a single arched shape. We can feel the appropriateness of that shape to the theme of reunion. Above them, the arch connecting the twin towers

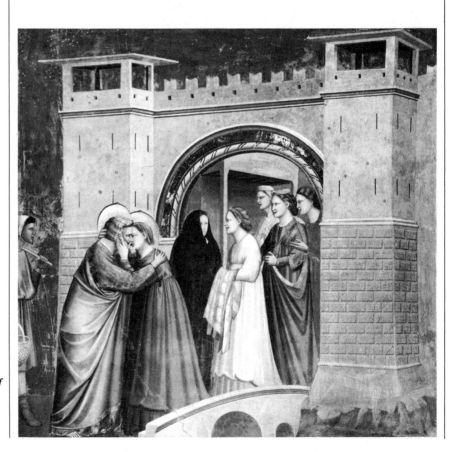

7-1
Giotto, *The Meeting of Joachim and Anna at the Golden Gate,* c. 1305. Fresco. Arena Chapel, Padua.

echoes the curve they make. Similar curves appear in the bridge and in its arches. In this way Giotto causes the central action to reverberate throughout the picture. The repetition of curves restates the central theme, while it both unifies and enriches the image.

The *Death of Marat* (Fig. 7-2) provides another example of the ingenious use of form. In this painting, David creates a heroic image out of a sordid subject—a man assassinated in his bathtub. How was David able to accomplish this? He selected a low point of view, which gives stature to Marat. By eliminating background details, he ensures that our eyes stay fixed on the figure. Verticals and

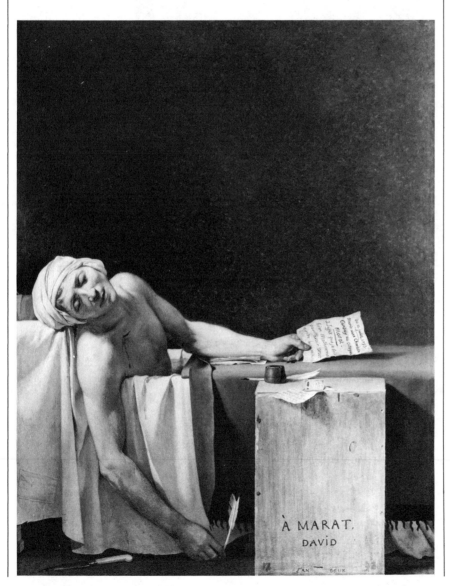

7-2
Jacques Louis David,
The Death of Marat,
1793. Oil on canvas,
approx. 63″ × 49″.
Musees Royaux des
Beaux-Arts, Brussels.

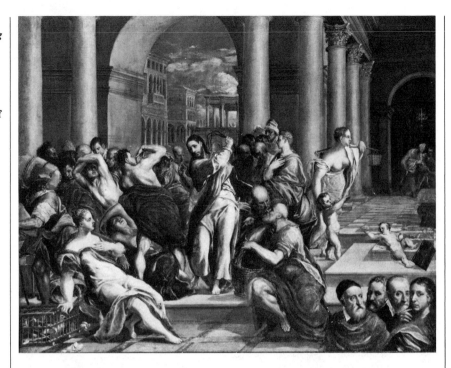

horizontals predominate, and produce a feeling of monumental calm. But more than anything, it is that vast, empty space above the figure that makes this painting distinctive. By covering it with a piece of paper you will see how much it contributes to the painting.

Representational artists of course had to subordinate their interest in form to the demands of realism. To put colors wherever they pleased, or to disrupt the logical flow of space was likely to encourage criticism. But at the same time, all artists tried to present their subject matter as memorably as possible. They realized that the imaginative handling of form would achieve this aim.

Representational painters often explored form as keenly and as persistently as abstract artists today. The handling of color, light, space, and composition, as well as the development of painting techniques, were seen as providing worthy challenges. At times subject matter may have been no more than a pretext for the artist's investigation of form.

Comparing the early and the late work of an artist can be revealing. As an artist matures, his work may move beyond the conventional imagery of his time to reveal something much more his own. Superfluous details drop away, and the compositions become more unified. The brushstrokes loosen up and become more expressive. Some artists developed a more personal use of color, or created light effects seldom if ever seen in nature. Some even distorted faces, figures, and space to intensify the emotional effect, to emphasize a point, or simply to make the painting more exciting (Figs. 7-3 and 7-4). Strong, mature personalities in the history of art felt the constraints of literal representation—and left it behind.

Merely to copy what you saw seemed unworthy. It was a fundamental prin-

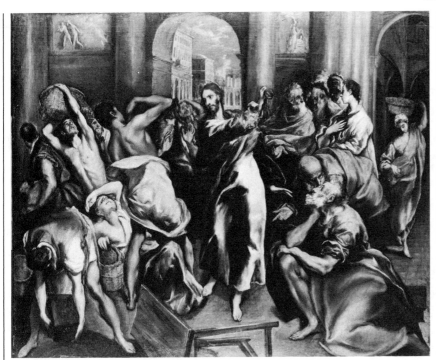

ciple of Renaissance art that paintings should aim not to copy, but to surpass nature. Everyone assumed that paintings would present a greater beauty and harmony than that ordinarily found in nature and man. As we saw in the last chapter, artists aimed to portray an imaginary ideal. Today this principle survives largely in popular art: television programs, advertisements, greeting cards, and calendars present wish-fulfilling images of life.

A careful reading of representational paintings reveals not only that painters couldn't duplicate reality (as we saw in chapter 5), but that they didn't especially want to. Inventiveness and imagination—in composition, gesture and expression, or the ability to conceive of a memorable scene—were regarded as no less essential to a great painting than the accuracy of the drawing. Through the imaginative manipulation of form, painters strove to develop a language of their own.

Nevertheless, most painters were satisfied to explore formal relationships within the limitations of convincing images of reality. Those artists who intentionally distorted natural forms generally did so in ways that still preserved obvious ties to visual reality. Natural forms could be altered, but they were still respected.

Beyond Representation

Not until the latter decades of the nineteenth century did some artists push form until it truly broke free of limitations imposed by representationalism. At that

time most artists, as well as the public, found acceptable only those paintings that presented subject matter with a high degree of realism and detail. They admired the kind of polished brush techniques that could accomplish this. But avant-garde artists rejected technical skill as a goal for art. They questioned the idea that detailed representation is of primary importance. They felt that the art of precise representational images was confining.

Like other people at that time, artists were attracted to what was thought of as exotic or primitive. A number of artists were excited by their discovery of Japanese prints—prints that arrived in Europe wrapped around imported china. The bright flat colors, strong patterns, radical perspectives, and daring asymmetrical compositions opened the eyes of artists like Whistler, Van Gogh, Degas, and Toulouse-Lautrec, who at times incorporated these new visual ideas into their work (Figs. 7-5 and 7-6). Most important, the prints inspired them to reach for greater freedom in their interpretation of the subject.

By the end of the century, many artists were thinking of the subject as a point of departure. Artists like Van Gogh, Gauguin (Fig. 7-7), and Munch (see Fig. 9-5) had moved away from exact representation by altering aspects of the subject they painted. Colors became independent, stronger. Space was bent or flattened. Shapes, lines, and even brushstrokes began to assert themselves. By handling form in this less restricted way, artists discovered that they were able to present images that were fresh, exciting, intense. At the same time, they were making their art more expressive of their feelings and ideas.

7-5
Utagawa Hiroshige,
Fireworks at Ryogoku
Bridge in the Cool of
the Evening, c. **1853.**
Color woodcut, approx.
8¾″ × 13¾″. The
University of Michigan
Museum of Art.
(Margaret Watson
Parker Bequest, acc. no.
1948/1.143.)

7-6
James McNeill
Whistler, *Old Battersea
Bridge, c.* 1878.
Etching, Kennedy 177
iv/v, approx. 8″ ×
11½″. The University of
Michigan Museum of
Art. (Margaret Watson
Parker Bequest, acc.
no. 1954/1.371.)

*S*ome advice: do not paint too much after nature. Art is an
abstraction; derive this abstraction from nature while dreaming before
it, and think more of the creation which will result than of nature.
Creating like our Divine Master is the only way of rising toward God.

—Paul Gauguin, 1888

In addition, these artists sensed that a more abstract handling of form would
disclose the true nature of the subject—something that a more photographic
representation could not show. By depicting people, objects, landscapes, as they
had never been seen before, artists felt that they were revealing things that no one
realized were there. They regarded their paintings not as *re*presentations but as
interpretations of what they saw (see Color Plate 5).

Experimentation with abstraction brought about an increasing discrepancy
between the appearance of objects and how they were represented. Cézanne (Fig.
7-8) discovered that by making minute adjustments of lines and planes, which
distorted natural appearances, he could create energies more intense than a pho-
tograph or a correct representational image could achieve, and, at the same time,
disclose relationships that would otherwise remain unseen. He worked with both
landscape and commonplace objects—apples, bottles, pottery—stretching and
compressing both objects and the space, thus giving to the subject an unusual
gravity and intensity. Basing their work on Cézanne's investigations, Picasso and
others fragmented and disguised objects almost beyond recognition (Figs. 7-9

7-7 (left)
Paul Gauguin, *The White Horse*, 1898. Oil on canvas, 55½″ × 35″. Galerie du Jeu de Paume, Paris.

7-8 (right)
Paul Cezanne, *Still Life with Basket of Apples*, 1895. Oil on canvas, 24¾″ × 32″. Courtesy of The Art Institute of Chicago. (Helen Birch Bartlett Memorial Collection.)

and 7-10). Form and space crumpled and became ambiguous; solid planes became transparent. At the same time, painters like Matisse and Vlaminck (Color Plate 13) continued Gauguin's investigation of the painting as a patterned surface of rich colors.

In the early 1900s, the wooden figures and masks created by artists of the Ivory Coast of Africa were discovered by European artists. As a result, Picasso, Modigliani, Matisse, Brancusi (Fig. 7-26), Lipchitz (Fig. 7-12), Moore (see Fig. 3-9), and many other painters and sculptors experienced a breakthrough in the conceptualizing of the human figure, and in their understanding of form in general. Distortions and unexpected relationships of form gave to African carvings a striking, evocative character (Fig. 7-11). They seemed to reach beyond outward appearances and put the viewer in touch with another, more elemental reality. Inspired by this art, European artists explored the idea that form could have an independent reality, or in Picasso's words, could ''live its own life.''

Picasso and Braque were absorbed with the life of forms when, between 1910 and 1912, they developed Cubism and invented collage (Fig. 7-10 and Color Plate 19). In recreating the object, as well as the space in which it exists, they presented a new reality—one that exists only in the painting. To heighten the play between ''real'' reality and the painted reality, they occasionally incorporated words that were copied from the typeface of newspapers and magazines into their paintings. Picasso and Braque also glued, or ''collaged'', actual objects—pieces of newspaper, corrugated cardboard, sheet music, and so on—into many of their paintings.

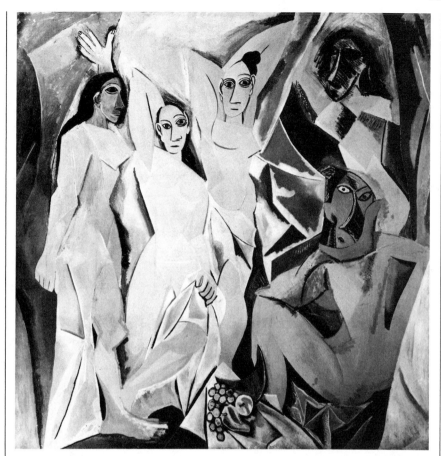

*M any think that Cubism is an art of transition, an experiment
which is to bring ulterior results. Those who think that way have not
understood it. Cubism is not either a seed or fetus, but an art dealing
primarily with forms, and when a form is realized it is there to live its
own life.*

—**Pablo Picasso (from Albert H. Barr, Jr.,**
Picasso: Fifty Years of his Art)

Abstract paintings implicitly raised questions about the nature of perception,
already a matter of keen interest in the latter half of the nineteenth century. What
can we know for certain? How do we assimilate what we see? What sort of reality
is contained in a painting? They raised questions about the nature of art and the

role of the artist. Should paintings merely do what photographs could do better? Is the artist no more than a showman, presenting familiar objects arranged in attractive ways for our amusement? What can a painting show us that nothing else can? How can it accomplish this?

The distortion of objects and space that we experience in abstract paintings is intended to catch us by surprise, push us off balance. We are forced to resolve a dilemma; to put together in our minds a whole, complete, and consistent world where there is none before us. In these paintings the artist asserts the power of his imagination to reorder experience, and invites the viewer to engage in that reordering with him. Mystery, ambiguity, irony, fantasy, and humor, as well as the creative and imaginative presence of the artist, become a part of what modern art is about (see Fig. 7-13 and Color Plates 14 and 15).

I always seek very consciously to construct a world where a tree can be quite different, where I myself may well discover suddenly that my right hand has seven fingers whereas my left hand has only five. I mean a world where everything and anything is possible and where there is no longer any reason to be at all surprised, or rather not *to be surprised by all that one discovers there.*

—Marc Chagall (from Edouard Roditi, *Dialogues on Art*, 1960)

It was becoming increasingly clear in the early part of the century that pure form—colors, shapes, lines, volumes, and their arrangement—was not only beautiful, but was capable of producing considerable psychological impact on the viewer. The exploration of form led a number of painters and sculptors—Kandinsky, Mondrian, and others—to purge their work of recognizable subject matter altogether. They felt that so-called nonobjective form—form that does not represent something else—could provide sufficient content for a painting or sculpture.

They came to regard the representation of objects not merely as unncessary but also as an impediment to the strongest experiences that art is capable of producing. The representation of objects seemed too tied to the specific, the particular, the familiar. They believed that through the contemplation of pure form and the logic of formal relationships, the viewer would be led beyond the world of appearances to another, more profound reality.

In nonobjective paintings and sculptures (paintings and sculptures having no recognizable subject matter) the subject matter of the piece is not something *outside* of the piece. Instead, the colors, shapes, textures, masses, and spaces, and their weights, balances, and movements become the subject matter. The

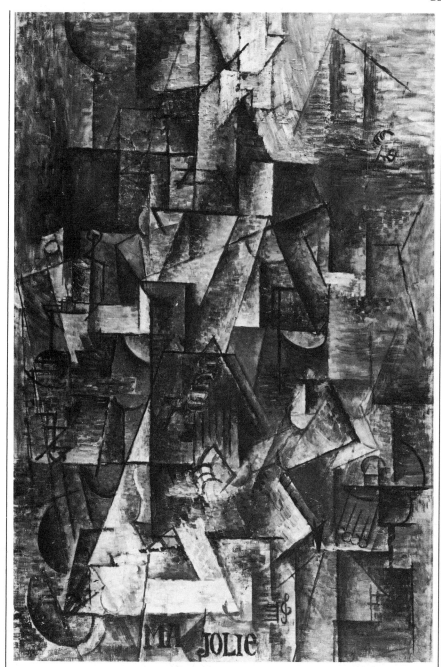

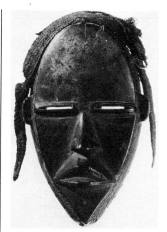

**7-10 (left)
Pablo Picasso,** *Ma Jolie,*
**winter, 1911–12. Oil
on canvas, 39⅜″ ×
25¾″. Collection, The
Museum of Modern
Art, New York.
(Acquired through the
Lillie P. Bliss Bequest.)**

**7-11 (right)
Dan people, Poro Society
mask, Gold Coast, Africa,
19th–20th century.
Wood, 9″ × 5¾″ ×
2⅝″. Courtesy of The
Detroit Institute of
Arts. (Bequest of
Robert H. Tannahill.)**

ideas that these never-before-seen worlds call up to us provide the central meaning of these pieces (Color Plate 16).

The development of abstract art was an intensely serious business, and not, as has often been thought, a matter of whimsy, or of indifference to content or meaning. Many of the artists who developed abstract art regarded it in spiritual terms. They saw their art as evoking something universal, fundamental, and

7-12
Jacques Lipchitz, *Sailor with Guitar,* 1914. Bronze, 31″ high. The Philadelphia Museum of Art. (Given by Mrs. Morris Wenger in memory of her husband.)

profound. Some of the later abstract artists saw their art in these terms also, while others would regard their work as a reflection of their own minds or state of being. Still others would claim that there is no reference in the content of their work to anything outside the work itself. These points of view are all based on the idea that a work of art is an independent entity whose intrinsic forms are capable of providing meaning.

It is not my task to reproduce appearances. A photographic plate can do that. I want to penetrate within. I want to reach the heart.

—Paul Klee

The beauty of pure form was not the discovery of abstract artists. Neither was the awareness of the emotional power of form, or the desire to evoke the inner essence of things. Nor was the notion that subject matter exists to fire the imagination of the artist rather than to be copied. All of these ideas, as we have seen, were shared with traditional artists. What was new was their willingness to carry their work further from objective reality than traditional artists. For many artists abstraction seemed the only possible way to bring their ideas to realization.

The breakthroughs that created abstract art were brought about by painters educated in the representational tradition. These painters frequented museums and collected reproductions of the works of representational painters they admired. Paul Cézanne (1839-1906) referred to the Louvre museum as "the book in which we learn to read." Paul Gauguin (1848-1903) brought with him to Tahiti photographic reproductions of the work of Raphael, Michelangelo, and Rembrandt. Piet Mondrian (1872-1944), one of the first nonobjective painters, earned money in his early twenties by copying pictures in a museum. Henri Matisse (1869-1954), widely known for his abstractions of the human body, insisted that his students draw and sculpt from the model in the traditional way. Georges Braque (1882-1963) had a reproduction of Corot's *Portrait of Christine Nilsson* (1874) pinned to the wall of his studio for many years, and Arshile Gorky, a pioneer of American Abstract Expressionism in the 1940s, tacked a print of Uccello's *Battle of San Romano* (1454-1457) to his studio wall. During his long career, Picasso reinvestigated through his own paintings, at various times, the art of ancient Greece, and of Rembrandt, Poussin, Velázquez,

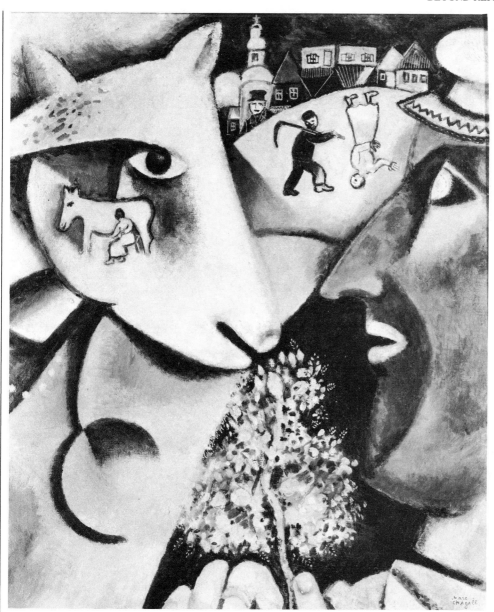

Goya, Ingres, Delacroix, Manet, and Cézanne.

Clearly there was respect for painters of the past, particularly those whose formal interests coincided with their own. But the modern painters were rebels for whom realism itself held no particular value. They had shaken off the constraints that realism imposed on those earlier artists. Now they could explore and develop in a more thorough way the ideas and formal concerns that they found in earlier paintings. In a sense, they could carry those ideas to their logical conclusions (Figs. 7-14 and 7-15).

7-13
Marc Chagall, *I and my Village,* **1911. Oil on canvas, 21¾″ × 18¼″. The Philadelphia Museum of Art. (Gift of Mr. and Mrs. Rodolphe M. de Schauensee.)**

7-14
Pieter J. Saenredam,
*Interior of the Church
of St. Odulphus in
Assendelft,* 1649. Oil
on panel, 19¾″ ×
30″. Rijksmuseum,
Amsterdam.

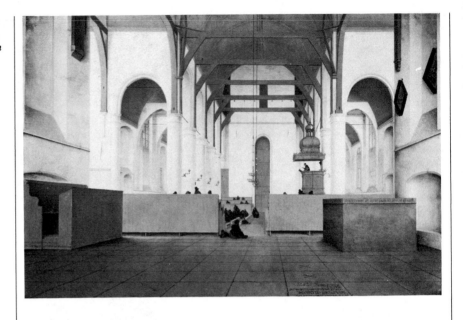

I wish to approach truth as closely as possible, and therefore I abstract everything until I arrive at the fundamental quality . . .

—Piet Mondrian, 1914

Background of Abstract Art

All artists build on what they have received, of course, and often base their investigations on the work of an artist whom they admire. Unlike earlier artists, however, abstract artists made revolutionary changes, probably among the most revolutionary and sudden changes in the history of art. Why did these changes occur at this time? Why were the changes so swift? Probably no one can answer these questions fully. However, there were events in the art world itself that foreshadowed abstract art.

In the nineteenth century, a number of artists became interested in exploring form and subordinating subject matter. In part, they were reacting against the official art schools, which were emphasizing subject matter and technique, and discouraging formal experimentation. At the same time, they were asserting their individuality, an idea encouraged by Romantic artists, poets, musicians, and writers earlier in the century. Manet had been exploring unusual compositions in the 1860s, 1870s, and 1880s. The Impressionists introduced bright colors and thick, juicy paint, and made the viewer keenly aware of the surface of the painting. The use of the camera, with its automatic fidelity to life, suggested that

abstraction was a more viable direction for a painter. At the same time, snapshots presented casually composed images that could be used in painting. Japanese and, in the twentieth century, African art also pointed to new ways of handling form. European academic art continued to hold sway in the art schools and with the public; but its meticulous realism and glorified subject matter seemed phoney and devoid of spirit to many young artists.

Radical experimentation with form was also stimulated by events beyond the world of art; it coincided with stunning revelations about the nature of man and the universe. The discovery of X-rays, radio waves, and radioactivity, and the development of electrical technology, brought to everyone the realization that invisible forces shape and govern the natural world. Advances in psychology revealed the existence of an invisible, inner realm—the unconscious—that shapes and governs the human personality. All of these developments suggested a discrepency between appearance and reality—a theme taken up in modern literature and theatre as well as painting.

The old notion of the universe as a vast, but logical machine was called into question. Einstein's discoveries altered our understanding of time and space; the automobile and airplane altered our experience of them. Microscopes, high pow-

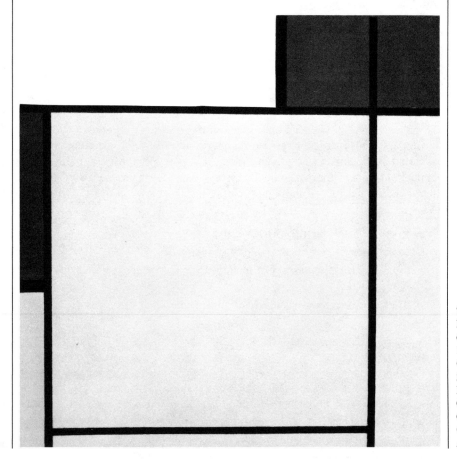

7-15
Piet Mondrian,
Composition with Red,
Yellow, and Blue, **1927.**
Oil on canvas, 20⅛″ ×
20⅛″. The Cleveland
Museum of Art,
Contemporary
Collection of the
Cleveland Museum of
Art.

er telescopes, and experimental photography presented new images of the world. The telephone, the electric light, radio, and the automobile drastically transformed patterns of life. Hope and apprehension mingled at what was felt to be the threshold of a new age, as social, economic, and political turmoil culminated in the cataclysm of World War I. Clearly the old art, with its acceptance of surface appearances, its orderliness, its technical refinement, and its affection for the past was no longer adequate. Only an art that was abstract seemed in keeping with modern times.

The Nature of Abstract Art

Abstract art isn't just another way to say the same thing. Its very nature implies something different. In "going further," abstract art conveys the idea that reality lies *beyond* what we see through our eyes. Reality is not equivalent to the world we take in through our senses, and it can't be conveyed or understood by depictions of what we see around us. Representational painting, whatever its particular style, expresses a fundamentally rational, common sense outlook. Its space is orderly, even measurable. The objects depicted are solid, touchable things whose surfaces may be so meticulously painted that we are tempted to think of them as real.

Abstract art abandons the depiction of tangible objects in a measurable space, as though it were no longer valid to make objective and confident statements about reality. Hints, nuances, fleeting glimpses, ambiguity, or empty spaces replace the solid, the tangible, the recognizable, the understandable. Abstract art suggests that unseen forces affect all things. One cannot speak with confidence of the objective world: One can only speak of one's own perceptions.

Certainly, abstract paintings and sculptures are, like representational pieces, as varied as the artists who produce them. It is possible, however, to discern a number of distinct aims that compelled artists to involve themselves with abstraction. I mentioned four of these aims earlier in this chapter:

- to reorder and intensify what we see
- to heighten the expressive quality of the piece
- to emphasize some aspect or quality that would otherwise go unrecognized
- to create something beautiful and profound out of pure form

To these we may add:

- to create ambiguity or mystery
- to reveal what is felt but not seen
- to create something absolutely unique
- to explore form out of curiosity
- to reveal the private visions of the artist

These aims are not necessarily at variance with the aims of representational art. But abstract artists would assert that abstraction provides a stronger means of achieving them.

In the course of time it will be proved clearly and infallibly that abstract art, far from being divorced from nature, is rather more closely and intimately linked with it than art ever was in the past.

—Wassily Kandinsky, 1931

How Does Abstract Art Work?

Despite the more tenuous relationship of abstraction to the world of objects, abstract artists can't proceed haphazardly or arbitrarily any more than can representational artists. Since formal elements are the only real subject matter, the artist must handle them with exceptional consideration. There are no illusions of reality to tempt our attention away from what he does. All there is to look at in the painting are the colors, shapes, lines, and textures that make up the picture. In a sculpture, all we have are solids and voids, material, and color. Each calculation is crucial, and any lapse of judgment can mean the failure of the piece as a whole. Tossing together a few shapes at random, making a texture, or just squeezing pretty colors out of the tube can't make art.

The illustrations I have selected for this chapter are, of course, exceptionally strong examples of abstract art. What you or I see when we visit a gallery may be dull and boring. Remember that abstract art is all fairly recent, and the process of time that distinguishes quality has scarcely begun to occur. Certainly representational art has its share of mediocre work too. No style of art is automatically better than any other, and no style can ensure success.

Abstract art is successful when its forms become visually exciting; when they begin to add up, to make sense together, to "work." Furthermore, a good abstract painting or sculpture, like a good representational painting or sculpture, will have a strong conception behind it. It will have something to say. No art simply goes through the motions—certainly, no art of quality. Abstract art can make you more aware, more conscious, just as a representational painting can. This is because form itself is expressive, and has the potential to communicate ideas (Fig. 7-16).

It is the expressiveness of form that makes possible the parallels we sometimes find between representational and abstract images. Look at the sensuous line that flows along the contour of Giorgione's *Sleeping Venus* (Fig. 7-17). You also see it in Modigliani's *Reclining Nude* (Fig. 7-18), and again in Henry Moore's sculpture, *Reclining Figure* (see Fig. 3-9). The angularity of the contour in Grunewald's drawing *Christ on the Cross* (Fig. 7-19) conveys anguish and pain. Max

**7-16
Saul Steinberg,
Speeches. © 1954 by
Saul Steinberg.
Reprinted with
permission by the
Julian Bach Agency,
Inc. First published in
The Labyrinth by
Harper and Row.**

Beckmann uses angularity to create a similar effect in his print, *Descent from the Cross* (Fig. 7-20). Both Vermeer and Vuillard create a serene orderliness by resolving the disparate elements of their interiors into simple shapes bathed in a soft light (Color Plates 17 and 18).

In representational painting, artists developed a language of gesture and expression to communicate emotional states (see, for example, Jacques-Louis David's *Death of Socrates* (Fig. 12-12). In abstract art, where form is not restricted, form itself can carry an emotional thrust. In Picasso's *Weeping Woman* (Fig. 7-21), everything—the knife-edged shapes, the crazed lines, the sour colors, the coarse brush strokes, the violence done to the face—expresses the anguish of the woman. The whole of the painting speaks of her pain.

Artists working in non-Western traditions were highly conscious of the expressive power of abstract form. Consider the ferocity of the figure of *Vajrabhairava,* the Lamaist (Buddhist) deity (Fig. 7-22), whose multiple arms and legs are not only symbols of power, but make us feel that power in drumlike rhythms. Like much of non-Western art, the sculpture combines both abstract and naturalistic forms, each intensifying the other. The great Japanese artist Hokusai also worked in an abstract tradition. His extraordinary image of the *Great Wave* (Fig. 7-23) impresses upon us the awesome power and beauty of the wave.

If we compare abstract images to snapshots, or for that matter, to our recollections of the real thing, we are again reminded of the capacity of abstract form to convey meaning. The expressive spaces of Giorgio de Chirico's *Mystery and Melancholy of a Street* (Fig. 7-24), and Ben Shahn's *Miners' Wives* (Fig. 7-25)

7-17
Giorgione, *Sleeping Venus, c.* 1505. Oil on canvas, 42½″ × 69″. Staatliche Kunstsammlungen Dresden, Gemaldegalerie Alte Meister.

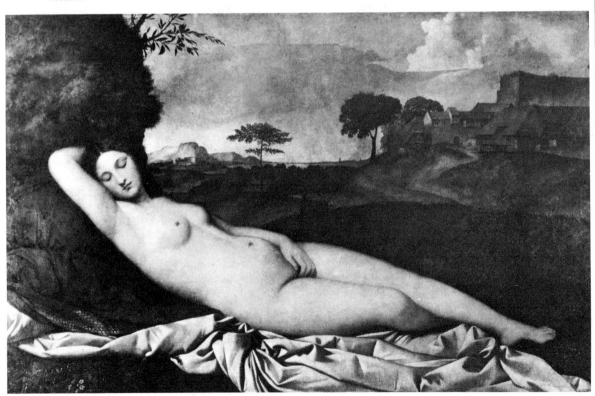

would not likely be realized in a photograph of the subject. We are affected by the serene, gracefulness of Brancusi's *Fish* (Fig. 7-26), the brooding mystery of Georgia O'Keeffe's *Black Cross, New Mexico* (Fig. 7-27), and Hokusai's *Great Wave* because they reach beyond natural appearances to reveal what is profoundly essential to the subject.

Twentieth-century photographers have shared the interest in abstract form. A number of photographers have used the camera to reveal a world of abstract forms—forms that are all the more striking because they actually exist in the real world (Fig. 7-28).

Picasso's *Sheet of Music and Guitar*

Now I think it might be useful to consider some of the things a person can think about when looking at a particular abstract image. Look at Picasso's *Sheet of Music and Guitar* (Color Plate 19), a collage of pasted paper and pastel that was done in the winter of 1912–1913. It measures 16 ½″ × 18½″. What are some of the ways we can respond to it?

1. To begin with we can see it as an interplay of abstract forms, and involve ourselves with its shapes and their relationships.

 We might ask: How varied are the shapes? What shapes seem related to

7-18
Amedeo Modigliani,
Reclining Nude, c.
1919. Oil on canvas,
28½″ × 45⅞″.
Collection, The
Museum of Modern
Art, New York. (Mrs.
Simon Guggenheim
Fund.)

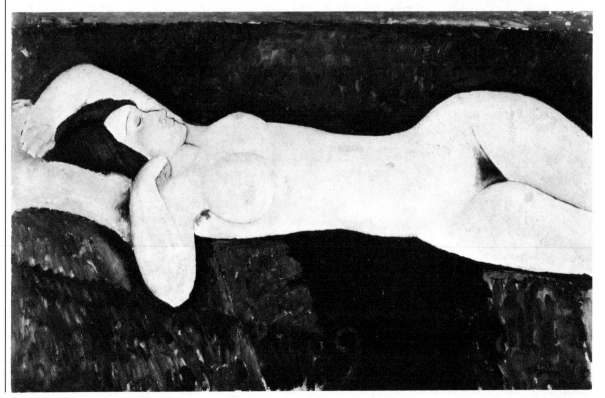

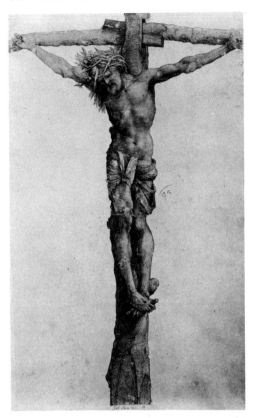

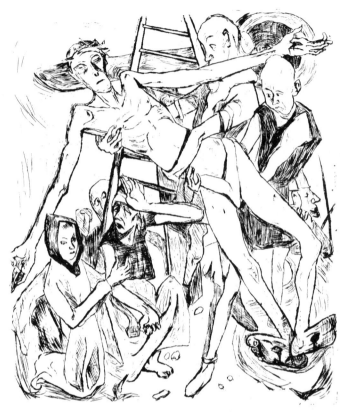

7-19 (left)
Matthias Grunewald,
Christ on the Cross.
Drawing, finely brushed
chalk. Early 16th
century Staatliche
Kunsthalle, Karlsruhe,
Germany.

7-20 (right)
Max Beckmann, *The*
Descent from the Cross,
1918. Drypoint, 12¹/₁₆″
× 10³/₁₆″. Collection,
The Museum of
Modern Art, New
York. (Gift of Bertha M.
Slattery.)

each other? Why? What shapes seem to be in front, and which are farther back? Does this ever reverse? What kind of lines are used? Which lines seem related? What rhythms can you feel? Why are so few colors used? Why did Picasso use these particular colors? What kind of space has Picasso created? Is it flat? Is there depth?

We might also ask: What makes a shape interesting? Are certain shapes inherently more interesting than others? More pleasing? Are abstract forms more interesting than those that resemble recognizable objects, or the other way around? Is a shape or a color lovely in itself, or does it become lovely in the context in which it is placed?

2. We can think about what difference it makes that the piece is made of glued paper. How many different textures do we see? Would it be more or less interesting to us if it were all in paint, rather than paper and pastel? How is paper being used in a new way, and why?

Another line of thought: How does collage affect our sense of the "realness" of the piece? Does the use of the actual sheet music make the picture seem more "real" despite the obvious abstraction of the guitar? Or does it suggest something fanciful and capricious on the part of the artist? Does collage make the space seem more real, because of the overlapping of papers, or does it force its flatness to our attention?

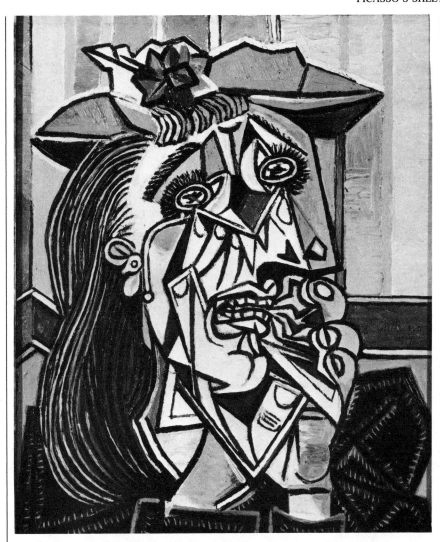

7-21
Pablo Picasso, *Weeping Woman*, 1937. Oil on canvas, approx. 21″ × 17½″. Private collection, London.

3. Why did Picasso put a guitar in the piece? Why the actual sheet music? Is it only coincidental that music is a theme in this abstract picture? Is Picasso using the theme of music to tell us something about abstract art? Does this image in some ways resemble music? What associations might a guitar have had for Picasso?

4. Is the collage orderly, or casual? Clear, or ambiguous? Is there humor in it? A sense of play?

5. What does the collage tell us about music? About art? About Picasso? About life and experience in the early twentieth century? About ourselves?

6. We can look upon the collage as a historic milestone. We can see it as an important breakthrough in the history of art: an artist having made an image, not out of paint or precious materials, but by cutting out pieces of ordinary paper and arranging them. Why did this happen at that particular

time in art history? In the wider context of social history? To what extent was what Picasso did in consonance with his time? What influence did it have on later art?

7. We can think of the picture as a milestone in the career of the artist. We might investigate what was going on in the other work of Picasso at that time or even what events were taking place in his life.

These are my musings—very likely, you've thought of some things yourself. Clearly, every picture we look at can open up many lines of thinking.

Meaning in Abstract Forms

There was a time in the United States when abstract artists were thought of as demented, antisocial, and unpatriotic. Today most people accept and enjoy at

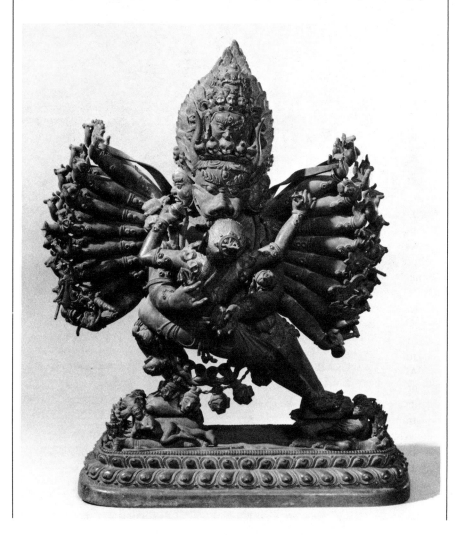

7-22
Vajrabhairava and His Śakti, 16th–17th century, Tibetan. Gilt copper, approx. 15″ × 27″. Courtesy of the Museum of Fine Arts, Boston. (Bigelow Collection.)

7-23
Katsushika Hokusai,
The Great Wave, **from**
Thirty-Six Views of Mt.
Fuji, **c. 1822. Wood-**
block print, 10″ ×
14¾″, 21.6765,
Spaulding Collection.
Courtesy of the
Museum of Fine Arts,
Boston.

least some art in which familiar things appear exaggerated or distorted. Consider the popularity of Van Gogh, or the cartoons of Walt Disney. Nonobjective paintings and sculptures are placed in banks, hotels, and public squares, and abstract shapes and patterns find their way into popular art. Linoleum designs, formica table tops, wall decoration, package designs, fabrics, popular illustration, movies, and television advertisements have all been affected by abstract art. Nevertheless abstract art still presents us with special problems. Paintings and sculptures that present nothing but their own forms may seem to have nothing to say, and thus create confusion for the viewer accustomed to recognizable images. Distortions of objects may seem to rob a picture of its beauty and meaning.

Abstract art thus raises the question of meaning in a work of art. How specific or literal in meaning must a work of art be? Based on paintings of the past, in which specific meanings were imparted through precise images, we may come to abstract art expecting the same access to meaning. This approach causes us trouble. Abstract art tends to be evocative, or suggestive, rather than literal or descriptive. To a degree not found in traditional art it is open-ended, and dependent on the willing imagination of the viewer to complete its meaning.

Since the late nineteenth century a number of artists have encouraged a nondirected contemplation of their work by avoiding titles that give specific information about the subject. Whistler suggested an analogy with music by calling his

7-24 (left)
Giorgio de Chirico, *Mystery and Melancholy of a Street,* 1914. Oil on canvas, 34¼″ × 28⅛″. Private collection.

7-25 (right)
Ben Shahn, *Miners' Wives,* 1948. Egg tempera on board, 48″ × 36″. Philadelphia Museum of Art. (Given by Wright S. Ludington.)

paintings ''serenades'' and ''nocturnes.'' Later, Kandinsky, Mondrian, and other nonobjective painters used the words ''improvisation'' and ''composition'' as titles for their paintings. Sometimes an artist chooses a title that simply identifies the predominating forms within the painting. Other titles may refer to the person who inspired them, to the place where they were painted, or to the order of a piece in a sequence of works.

While the lack of specificity in abstract art may seem perplexing, it presents no problem in other areas. Music, for example, doesn't transmit distinct bits of information. (Can you describe the message of a Beethoven symphony, or a jazz piece?) Nor does it, typically, reproduce sounds of the real world or tell stories. It has no words. Yet we sense that music contains ideas. It directs our thoughts, creates moods and affects our feelings. We react to it and we enjoy it. Its rhythms, sounds, and melodies are beautiful in themselves.

Dance and architecture are generally indifferent to the communication of literal messages. Nevertheless, they too create moods and influence the way we think and feel. Through the expressiveness of their forms alone, they direct our thoughts to some aspect of experience and engage us in it.

It might be useful to borrow a leaf from our experience with music, architecture, and dance, when we contemplate abstract art. We may discover that precise, prefabricated messages are not required for our enjoyment of it. The absence of literal meaning can be a liberating experience. Because it is not tied to the familiar and the literal, abstract art can give you experiences that representational

painting can't. You can see things that you won't see anywhere else. You can muse over them in a way you can't do with art whose meaning is spelled out for you by its title and limited by its subject matter.

When you look at abstract art, don't try to puzzle out a message or read it like a script: try to experience it. Keep your mind and senses open. Try not to impose your own preconceptions on what you see. Let it lead you where it wants to go. If the painting or sculpture works for you, it can open your eyes and reveal something new, fresh, or unforeseen.

Perhaps we have to set aside the idea, central to Western thought since the Greeks, that knowing must be based on logic and reason to have validity. Orderly systems of knowledge have brought about a magnificent science and technology in the West. But art experiences are of a different kind. What we apprehend is taken in, not through logic and rational thinking, but "through the skin," so to speak. Art experiences bypass the logical, systematic modes of thinking that we use in order to understand, say, how a car works, or to learn why water freezes. Art experiences may have more to do with our subconscious than our conscious minds, which may be why art of all kinds—theater, music, poetry, and films, for example—can affect us so strongly.

From time to time each of us experiences what we call "intuition," "gut

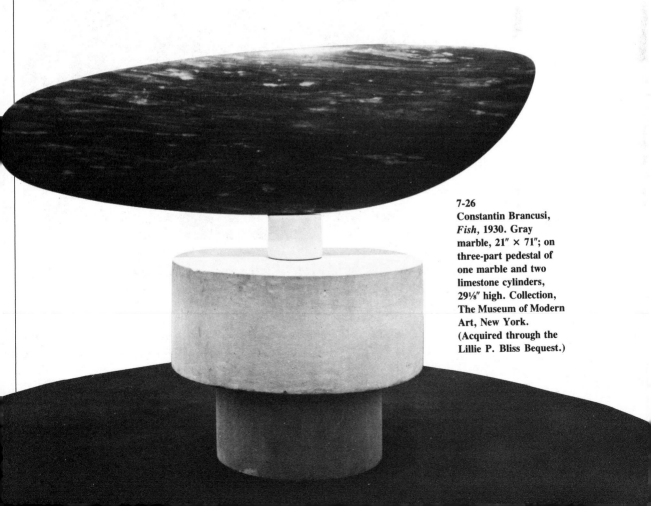

7-26
Constantin Brancusi, *Fish*, 1930. Gray marble, 21″ × 71″; on three-part pedestal of one marble and two limestone cylinders, 29⅛″ high. Collection, The Museum of Modern Art, New York. (Acquired through the Lillie P. Bliss Bequest.)

7-27
Georgia O'Keeffe,
*Black Cross, New
Mexico*, 1929. Oil on
canvas, 36″ × 30″. The
Art Institute of Chicago
Special Picture Fund.
© Georgia O'Keeffe.

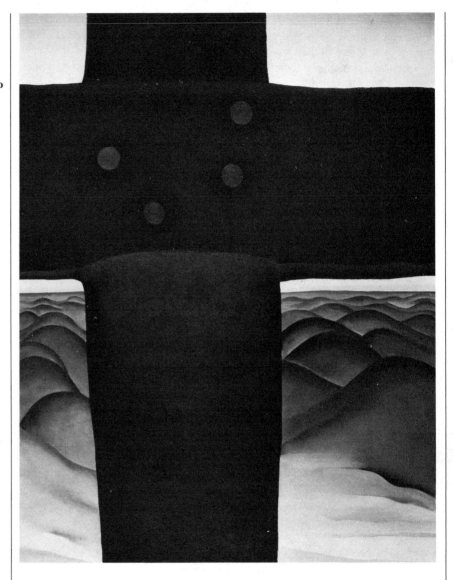

feelings,'' or ''sixth sense.'' Perhaps you have experienced spiritual feelings, exaltation, empathy, or love. You may have felt a sense of awe in the presence of mountains, the ocean, or stars on a clear night. You may have experienced a state of total awareness or involvement through meditation, or through participation in a religious ritual. All of these are ways of knowing—nonrational ways of knowing—but no less real. It is this kind of knowing that art, and abstract art particularly, calls upon.

Responses to art of any kind are often difficult to pin down. They are subjective. They vary in intensity. One person will feel an affinity for a work of art that leaves another cold. One person can find humor in a piece while another finds it serious. One can find passion while another finds order. Perhaps all of them are

right. Often you don't really feel the piece, or grasp its meaning, until much later.

What you actually experience when you experience art may be very hard to say, and harder yet to explain. But that does not mean that the experiences are not genuine. It's best to look—and look long enough—at what is there. Just as you would with representational art, see what the artist is doing with form. In abstract art the elements of form, unconstrained by the limitations imposed by representation, can be handled as the artist feels they are needed. Color, light, space, lines, patterns, and textures can all speak to us. The task of the artist is to make these eloquent.

You can get an idea of the way this happens through some remarks made by the artist Josef Albers in an interview he gave in 1970.[1] As he showed the interviewer around his studio, he pointed out the many tubes of paint he was using:

> On this shelf alone I have eighty different kinds of yellow and forty greys. I have them sent from all over the place . . . to put two colors side by side really excites me. They *breathe* together. It's like a pulse beat. And there is one color that dominates, just as a child takes over one parent. Greens are very jealous of each other, for instance. I like to take a very weak color and make it rich and beautiful by working on its neighbors. What's gloomier than raw sienna? Now look at what I've done to it there: It's gold. It's shining and alive, like an actor on the stage. Turning sand into gold, that's my work and aim.

7-28
Margaret Bourke-White, *Contour Plowing—Colorado,* **1954.** © LIFE *Magazine,* Time Inc., New York.

Albers was fascinated by the interaction of colors. He saw them as actors on a stage, having roles to play, and who could influence one another just as people do. He makes us aware that the identity of a color is influenced by what surrounds it. Raw sienna in the tube is a tan color, but when placed beside certain colors it can shine like gold. It is as if Albers could make two colors out of one.

What might the color have been that turned sand into gold? Raw sienna looks muddy (artists call it an "earth color") but next to a darker color it would appear lighter. Next to a bluer or a more purple color, or even a muddier one, the yellow in it would assert itself. In small amounts it would shine more.

In any painting, a sensitive handling of elements—whatever they happen to be—awakens and transforms those elements into something more than they are by themselves. Interacting with each other, they combine to make a whole that is greater than the sum of its parts.

Albers's own paintings provide an example (Color Plate 20). Using a simple format of nested squares, carefully selecting the colors and the amounts, applying the colors pure and unmixed, he releases the energies that are inherent in those colors. Albers shows us the amazing ways colors behave—how they advance and recede in space, how they give off light, how they lose and recapture their identities.

Every painting or sculpture—whether abstract or representational—is a context in which formal elements play off of each other. Through this interaction a presence is created that transcends those individual elements. The painting becomes more than dabs of color on canvas; the sculpture more than masses and

spaces. A personality emerges, and the piece takes on a life of its own. Of this, Albers had written:

> *The aim of life*
> *is living creatures*
> *The aim of art*
> *is living creations*
>
> —*Poems and Drawings*

Conclusion

Modern history has seen cataclysmic changes in age old patterns of life. Since the early part of the nineteenth century, urban population increases, industrialization, political and ideological totalitarianisms, the assimilation of diverse communities into a mass culture, and the effects of technology have resulted in the increasing regimentation and isolation of the individual. During this time we have seen the emergence of an art that clings stubbornly to the belief that people must be free to explore on their own terms who they are and what they experience. It has not been an art of glory, of certainties, of formality, or of sentimentality. It has not often been refined, well-mannered, gentle, or sweet. It has not often looked backwards to the past. It has been honest, intensely personal, and direct. It has sought to penetrate to the heart of things.

Abstract art conveys the idea that another reality lies beyond the world of appearances. Through images of a world experienced, rather than a world observed, it points to the discrepancy between reality and appearance—a discrepancy also perceived by the natural sciences and in psychology. The abstract arts of other cultures were similarly based on the presumed existence of another reality, that of the spiritual world, and were intended to transport the mind of the viewer to that world through the power of abstract forms. The meanings, of course, were precise. In modern abstract art, however, we are free to discover and carry away our own meanings.

In contrast with the art of the past, which supplied us with visions confirming our certainties, abstract art supplies us with visions through which we may address mystery. It corresponds in spirit with Albert Einstein's statement that "the most beautiful thing we can experience is the mysterious." If the worlds within worlds of abstract art indeed penetrate to the heart of things, it is because, like all art, they distill within themselves some aspect of experience, some fragment of truth as it is given us at any time to know.

8 | Post-Modern Art

Subjective Vision

Now as never before, artists have the opportunity to explore individual interests. In the past, art articulated the beliefs and values of society (or, more specifically, of the patrons of art) through traditional subjects and themes. These of course were subject to interpretation by the artists. But by present day standards artists were held on a short tether in terms of how far they could depart from either customary subject matter or the way in which subject matter could be depicted. Within these restrictions, some of them managed to be extraordinarily creative. But originality was never as highly regarded as it is today, and those who ventured too far from tradition into private visions were usually dismissed as eccentrics.

The current value placed on originality reflects the tendency to affirm that subjective experience—yours and mine—takes precedence over tradition as a means of knowing the world and our place in it. This attitude is charac-teristic of our time and has itself become a convention of modernism. This attitude is not characteristic of the past; it may not be true in the future. Its spirit is democratic, liberal, romantic. It is a response to a time characterized by rapid change; by the falling away of old certainties, institutionalized truths, and a common core of social, political, and religious beliefs and practices. Authoritarianism of any kind is sus-pect. We tend to accept nothing with-out the test of our own experience, and believe that we must find things out for ourselves.

This way of thinking is reflected in an art that has more than ever before taken on the aspect of continuous experimentation. Art appears to us today as a continuing search for the new. Most artists working today place a great value on originality. They are attracted by the unknown. Many see their art primarily as a vehicle of explo-ration into their own personal world. In this chapter we shall investigate some of the recent work that exemplifies this movement toward subjective vision.

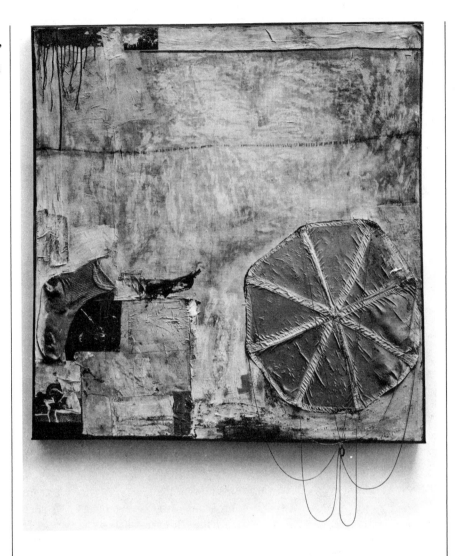

Since the 1960s, it has become apparent that a number of artists have been moving in directions that are distinct from abstract art, yet they are not involved with representational imagery either. Because of the variety of directions they have taken, and the absence of any uniform program, they have been called, simply and tentatively, post-modern artists, based on the idea that they are exploring beyond the frontiers of modern art. (It is possible, of course, that in time this art will be considered simply another manifestation of modern art.)

What they share is an eagerness to push out the boundaries of art; to remove what they see as arbitrary, conventional limitations to what art is, what it looks like, and what an artist does. They have opened up a number of issues about art that had heretofore been considered settled: What constitutes a work of art? Is it always and only a product? Can it be an event, a place, or a person? Where is its proper place—always in the gallery? Can it be located outside? What materials

can be used in a work of art? Must it remain the same over time, or look the same each time it is presented? Must art have substance at all? Can it have motion? Can chance or accident play a part in it? How long must it last?

In the background was a situation in the art world in which painting had suddenly become "safe." By the mid sixties, abstract art was being collected avidly, and Pop Art, with its recognizable images based on commercial art and mass-produced objects, had attained respectability. Art had become an investment, a status symbol, an all too predictable aesthetic experience. To a number of young artists it seemed time for something new. They felt a need to break away from the heady concerns of Abstract Expressionist painting, which celebrated the life of forms and the passionate involvement of the artist in their creation. They wanted to go beyond the aesthetic limits of Pop Art as well. Their aim was to draw art closer to life, and to a broader range of experience.

Any incentive to paint is as good as any other. There is no poor subject. Painting is always strongest when in spite of composition, color, etc., it appears as a fact, or an inevitability, as opposed to a souvenir or arrangement.

Painting relates to both art and life. Neither can be made. (I try to act in that gap between the two.)

A pair of socks is no less suitable to make a painting with than wood, nails, turpentine, oil and fabric.

A canvas is never empty.

—**Robert Rauschenberg, 1959**

Blurring the Line Between Art and Life

Already in the 1950s Robert Rauschenberg and Jasper Johns had begun extending the boundaries of art by incorporating into their work ordinary manufactured objects from the real world, or replicas of them (Figs. 8-1 and 8-2). Their work awakens us to the idea that anything becomes art if the artist places it in an art context.

In the early 1960s, "Assemblages", "Environments", and "Happenings" pushed the boundaries of art further by taking it out of the gallery or museum and into the world of immediate, tangible experience. Assemblages consisted of everyday objects removed from their usual context and stacked, heaped, or otherwise combined so as to be looked at apart from their function. Environments were essentially Assemblages that you could walk around in (Fig. 8-3). People

8-2
Jasper Johns, *Painted Bronze*, 1964. Painted bronze, approx. 5½" × 8" × 4¾". Kunstmuseum Basel, Ludwig Collection.

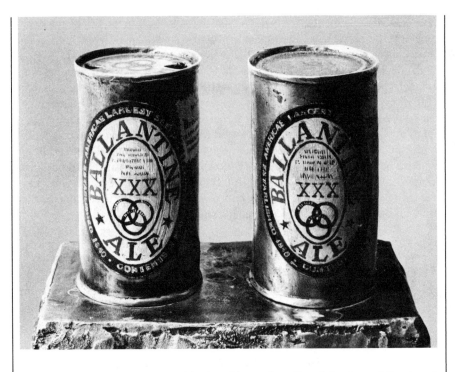

8-3
Allan Kaprow, *Yard*, 1961.

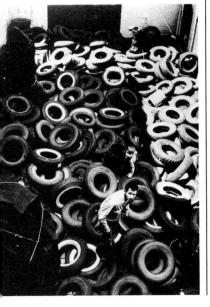

were encouraged to interact with the objects they found in Assemblages and Environments. From that interaction evolved the idea of a participatory event, or a "Happening" (Fig. 8-4).

Assemblages, Environments, and Happenings broke down the old distinctions between art and non-art, between art and "reality," and between artist and spectator. They demonstrated that aesthetic purity and refinement is not necessary to art, and pointed instead to the central importance of idea and attitude. Art was no longer something "special." Post-modern artists in the 1970s and 1980s would explore the implications of these ideas by further blurring the line between art and life, but in ways that were highly personal and idiosyncratic.

The common function of these alternatives is to release an artist from conventional notions of a detached, closed arrangement of time-space. A picture, a piece of music, a poem, a drama, each confined within its respective frame, fixed number of measures, stanzas, and stages, however great they may be in their own right, simply will not allow for breaking the barrier between art and life. And this is what the objective is.

—Allan Kaprow (from *Assemblages, Environments, and Happenings*, 1966)

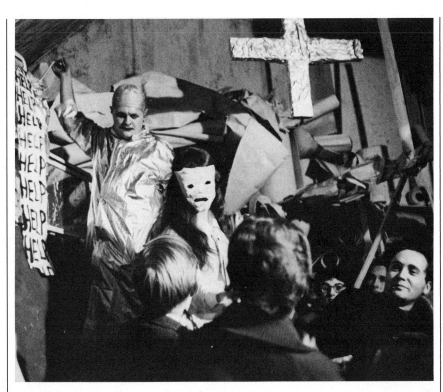

Unique Pieces

Post-modern art is not a style, but a collection of individuals doing different things. Some artists present us with objects, constructions, and environments that exist somewhere between painting, sculpture, and architecture. These pieces are unique—not abstractions of other objects. Because of this detachment from conventional points of reference, they can take on those forms that will most nearly reflect the imaginative world of their creator. For example, the pieces of Eva Hesse (Fig. 8-5), at once delicate and mysterious, may strike us as imaginative rather than beautiful—but many people find them so powerful an experience that beauty seems irrelevant, or, rather, it emerges in a different guise.

Frequently we are expected to interact with post-modern pieces. We may touch them, move them, walk on or through them, be inside them, read them, or listen to their sounds. As in Douglas Huebler's *Variable Piece 4/Secrets* (see Fig. 2-3), they may require the participation of the spectator to bring them into being or to complete them. They show us that the hushed, reverential, nontouching atmosphere of the museum, is not the only way to experience art. These pieces are meant to give us experiences that are more intense and accessible because of our physical involvement with them. To experience Lucas Samaras's *Mirrored Room* (Fig. 8-6), for example, you must go inside, where you feel as though you are floating in an infinite, sparkling space.

Art as performance has its roots in the wild, sometimes impromptu events staged in auditoriums, cabarets, and streets by Futurist groups in Italy and Russia

before World War I. As Happenings again merged art with theater in the 1960s, they revived the idea of the artist as performer, and artists created an art around themselves. One example is Pat Oleszko, a performance artist. Her imaginative costumes and lively personality have charmed audiences since the 1960s (Fig. 8-7). Her costumes are more like wearable sculpture: she has been at various times a taxi cab, the Statue of Liberty, a saw, and Picasso's *Three Musicians* (see the original in Color Plate 15). Oleszko's costumes, her skits, song and dance routines, films, group projects, and impromptu appearances provide fun, entertainment, and social satire.

Natural environments altered in some way that is neither conventionally aesthetic nor practical can provoke reactions different from our reactions to parks, gardens, or paintings of landscapes. These "site pieces" encourage us to ponder the nature of our relationship to the earth. They remind us of traces left by civilizations whose attitudes toward the earth were less utilitarian than ours. Site pieces carry us away from points of reference to society or to culture. Robert Smithson's *Spiral Jetty*, for instance, brings us into a world where we experience ourselves in relation to vast reaches of space and time (Fig. 8-8).

Sometimes we are presented with a thought, a proposition, information, the demonstration of a concept, or simply a word. The artist encourages us to explore what these mean to us in terms of our own experiences. These presentations—examples of Conceptual Art—suggest that an idea implanted in our minds can

8-5
Eva Hesse, *Untitled*, 1970. Fiberglass over polyethylene over aluminum wire. 7 units, each 7'2"–7'3" × 10"–16". Private collection.

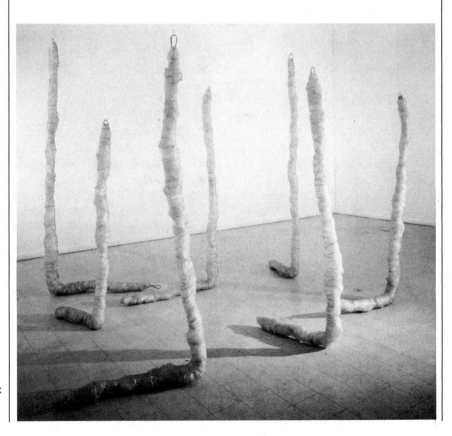

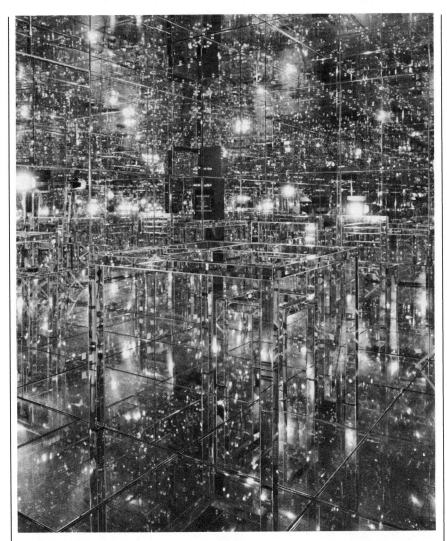

8-6
Lucas Samaras,
Mirrored Room, 1966.
Mirrors, 8′ × 8′ × 10′.
Albright-Knox Art
Gallery, Buffalo, New
York. (Gift of Seymour
H. Knox, 1966.)

exist as a work of art. They imply that the essence of a work of art is not its form or appearance but the idea or ideas that it elicits. Douglas Huebler's *Variable Piece 4/Secrets* (Fig. 2-3) is a witty example.

Sol LeWitt is a Conceptual artist. His wall drawing, *Location of a Rectangle* (Fig. 8-9), provides an example of this direction. Its appeal lies in the playful elegance of its conception, rather than in the visual result.

The words "system," "establishment," and "power structure" came into colloquial use in the 1960s to denote complex sociopolitical institutions and their reciprocal interactions. In the 1970s computer systems, electronic circuitry, and an awareness of ecological systems also affected the public consciousness.

Process, systems, and structures—as well as chance and randomness—have turned up in various ways in the work of a number of artists in recent years. Hans Haacke has explored physical, political, economic, and social systems through photographs, documents, maps, and even self-contained environments demon-

8-7
Pat Oleszko, *The Padettes of Potown, the Primary Colored Group.*

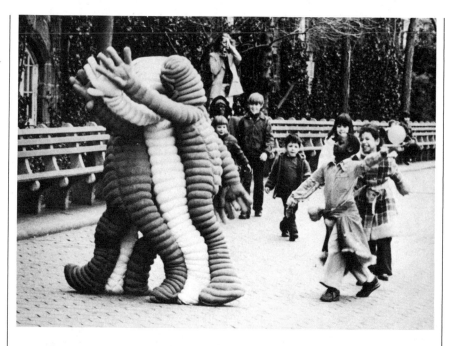

strating natural phenomena. He has been particularly interested in the social and political processes that operate in the art world within contemporary Western society, and in the ways that these processes, and the systems they form, affect the public's understanding of art. Haacke's *News* (Fig. 8-10) was an installation of working ticker-tape machines that brought the news of five news services into the museum. At the end of each day, the news was collected and stored in cannisters. For Haacke, the museum context was essential to the piece, for only there would it jar the observer into a consideration of the elitism and the unreality that Haacke regards as a part of the art world today.

Haacke packaged a process we don't usually pay attention to—news gathering. In contrast to other works of art usually found in museums, his piece was clearly linked to everyday life. It was informative, up to date, and available to all free of charge. What parallels with art might be found in the process of news gathering? How important are these parallels to our understanding of and reliance on news?

*T*he artist's business requires his involvement in practically everything....An artist is not an isolated system. In order to survive, he has to continuously interact with the world around him. Theoretically, there are no limits to his involvement.

—**Hans Haacke, 1968**

Like other post-modern artists, many painters and sculptors have sought to mesh the creator with the work. This has brought a shift away from the aesthetics and overt formal concerns associated with abstract art to an emphasis on the expressive, psychological, or narrative content. Representational imagery appears frequently, but even at its most realistic, tends to retain the idiosyncratic vision of the artist.

The technique and the materials are often left undisguised. This enables the viewer to become involved with the process of creation; to re-experience with the artist the transformation of material into idea.

Since the 1960s, Nancy Graves has made highly individual paintings, drawings, films, assemblages, and sculptures, typically based on scientific data. Graves uses the word "whimsical" to describe her work. Recently she has been exploring bronze casting techniques that permit her to transform leaves, seed pods, corn husks, palm fronds, and other natural forms into imaginative, brightly painted sculptures (Fig. 8-11).

Contemporary science fiction films provide an arena for post-modernist ideas and interests. Here the imagination is exercised in the context of the real, tangible

8-8
Robert Smithson, *Spiral Jetty*, 1969–70. Black rock, salt crystal, and earth, 160′ diameter. Rozel Point, Utah.

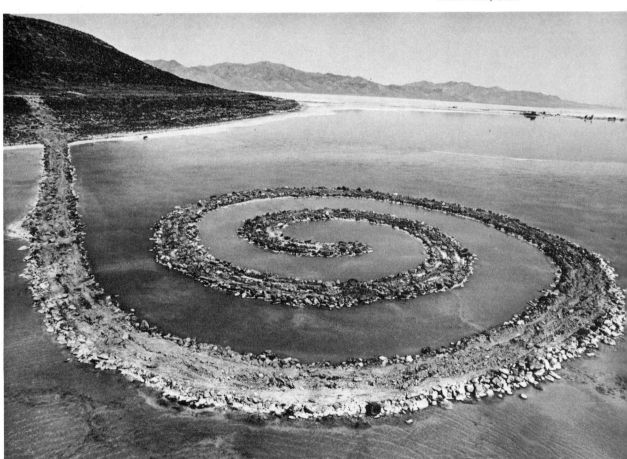

world. The fantastic special effects and sets of such films as *Star Wars* (1977), *Star Trek II: The Wrath of Khan* (1982), *Blade Runner* (1982), and *Tron* (1982), fulfill the yearnings of artists for situations that integrate art with life (Fig. 8-12). They are total environments, obliterating the lines drawn between technology and art, between sculpture and architecture, and between clothing and costume. The films themselves are magnificent examples of the integration of art and technology, a technology that allows filmmakers the free play of space, gravity, substance, and motion, and that makes it possible to create visual effects impossible to achieve in the real world.

In short, post-modern art shuns the familiar—or makes us see it in new ways—in order to induce one of a kind experiences. These experiences may be interpreted by each individual as he or she pleases.

In pushing art to its limits, post-modern artists create situations that carry our imagination to its limits. Unlike abstract art, the aesthetics of the piece—how

The Location of a Rectangle

8-9
Sol LeWitt, *Location of a Rectangle***, 1975. Wall-drawing, 11″ × 15½″, with artist's instructions. Wadsworth Atheneum, Hartford, The Ella Gallup Sumner and Mary Catlin Sumner Collection.**

Instructions from the artist: A rectangle whose left and right sides are two thirds as long as its top and bottom sides and whose left side is located where a line drawn from a point halfway between the midpoint of the top side of the square and the upper left corner to a point halfway between a point halfway between the center of the square and the lower left corner and the midpoint of the bottom side is crossed by two lines, the first of which is drawn from a point halfway between the midpoint of the left side and the upper left corner to a point halfway between the point halfway between the center of the square and the upper right corner and the midpoint of the right side, the second line from a point halfway between the point where the first line ends and a point halfway between the midpoint of the bottom side and the lower right corner to a point halfway between a point halfway between the center of the square and the lower left corner and the midpoint of the left side.

8-10
Hans Haacke, *News*,
1969–70. Five teletype
machines printing out
wire service news.
Installation in the
Software Show at the
Jewish Museum,
New York.

lovely, pure, or polished it looks—is not necessarily a concern. The artists may use form or material only to generate an idea.

In common with much of abstract art, and modern art in general, post-modern art tries to lift our minds out of their usual channels, forces shifts in our thinking, and takes us from certainty to uncertainty—at least for a while. It may be later, on reflection, that the significance of the experience becomes clear, and we return once more to certainty. If so, we return not as we left, but enlightened, perhaps changed, in some way.

Christo's *Running Fence*

The above discussion will provide you with some ideas about recent developments in the art world. In each case I suggested a few general ideas about the works of art. Now let's spend some time with one work.

Christo's *Running Fence* (Color Plate 21) is an extraordinarily imaginative piece, rich in meanings. The project took four years, during which time Christo was involved with property owners, lawyers, engineers, surveyors, environmentalists, politicians, boards, courts, and commisioners. There were meetings with the 59 ranchers and landowners on whose property the fence was to be located, eighteen public hearings, a 450-page Environmental Impact Report, and sessions in the Superior Courts of California before contracts were signed and permission was finally granted. To understand *Running Fence*, we must realize that for

Christo, all this preparation was not preliminary, but as much a part of the art as the structure itself.

More than 300 workers helped to construct the fence. Made of white nylon, 18 feet high and 24½ miles long, it was constructed in California where it was on display, as planned, for two weeks in September, 1976. After that it was removed. The project—which cost about $3 million—was funded by the prior sale of drawings and collages that Christo made in connection with *Running Fence*. With that as introduction, let's consider what lines of thinking it can generate.

1. Works of art as we usually think of them are made to last. The transience of *Running Fence*, like other projects of Christo, moves it toward real-life experiences. Can we see it as a poignant commentary on life? On history? On personal experience? Is it a message of faith? Or simply a message about our throwaway culture?

2. Most art today is done by one individual in private. Because Christo's pieces are group efforts, and quite public, they recall traditional projects such as the building of churches and cathedrals in the Middle Ages, old-time barn raisings, and the decoration of Christmas trees. Can you think of any other group projects in art?

 Christo's project involved democratic governmental and judicial processes, and it tested the exercise of private property rights. What sociopolitical meanings might Christo's four year struggle contain? Consider the statement of Christo's wife, Jeanne-Claude, that "the real dimensions of *Running Fence* are political, social, and economical."[1]

 The participation of many individuals in the project is central to Christo's ideas. Christo believes that the experiences and interpretations of people involved in his pieces enrich the work. Do you agree that these interpretations can also be considered contributions? If so, would you consider all those drawn into the work as creators too?

3. Consider the physical aspect of *Running Fence* aesthetically. Its photographs show a graceful, sensuous form whose colors changed with the light. At night it glowed under the full moon. People who saw it said its movement made it seem alive. The *Fence* was not straight, but wound over the hills like a river. Occasionally, part of it would dip out of view. It grew out of the ocean; we view it against the sky and against the earth. Do you enjoy its contrast with the landscape? Its harmony with the landscape? Both? Does it intrude, or does it compliment the landscape?

 Why would Christo want to move out of the gallery, and out of the city, to create this shape on the landscape?

 Its scale is awesome. Or, if we like, it may be no more than a fine, curving line. How important is its scale? Can we isolate it from its surroundings?

 What could you have experienced up close? Far away? Walking along it? What might you have discovered along the way?

4. *Running Fence* is also a screen that hides things. Hiding something can make us more aware of it. We look at packages and wonder what's inside,

or look at curtains and wonder what is behind them. Out on the landscape, *Running Fence* acts as a baffle but also as a frame; it obscures and reveals at the same time.

We wonder: What might hiding, screening, obscuring mean to Christo, who has used this theme repeatedly in his work? What might it mean to us? What might it mean in sexual or psychological terms? In social or philosophical terms?

Running Fence is also, of course, a fence. It marks a place and it makes a boundary of some kind. Yet it opened at places to allow for passage of automobiles, cattle, and wildlife. What might a boundary or a border suggest to you? Can we see this aspect of *Running Fence* as a political statement?

5. Most of the viewers of *Running Fence* will know it secondhand, through photographs, films, and books. Thus the project raises the questions: How necessary is it to have experienced this—or, any work of art—firsthand? What advantages might there be to viewing a work in reproduction? Which experience tends to encourage exploration of the ideas contained in the piece? Which yields more information? Which would be more exciting? More memorable? More aesthetic? To what extent is the real existence of any work of art in the mind?

 Most art is known to its audience today through photographic reproductions, films, and television. How does this affect our understanding of works of art? How might it affect the future history of art? How is our understanding of news events shaped by our watching them on television?

 Photographs of site pieces by Christo, Smithson, and others are remarkably beautiful, and films such as the Maysles brothers's *Christo's Valley Curtain* (1972) and *Running Fence* (1972–76), and Robert Smithson's *Spiral Jetty* (1970) are also fascinating and informative. Photographs and films do much more than provide a record: they shape our experience of the pieces as well. Thus we might ask: To what extent might the photographs and the films be considered the end products? To what extent might they be considered as art, rather than as the report of the art? Consider that the Maysles brothers made their films with the cooperation and patronage of Christo, while the *Spiral Jetty* film is Smithson's own work, and that these films, photographs, and books are a source of revenue.

6. What works of art might be considered predecessors of the physical aspect of *Running Fence?* Might Christo have been influenced by the Great Wall of China or Hadrian's wall in England? The Iron Curtain? Picasso's collages? Dada pieces (see Fig. 11-6)? Old movies about buccaneers and sailing ships?

The answers to some of these questions may be found in Christo's own background. At a meeting of the College Art Association in New York in 1982, Christo suggested that an experience in Bulgaria, where he was born, might explain his fascination with concealment. Bulgaria lies behind the Iron Curtain, and Christo pointed out that when he was growing up the only thing that entered Bulgaria from the West was the railroad train known as the Orient Express, which ran between London and Istanbul. While in art school he and his fellow students were required by the government to tidy up the countryside where the train passed through to present a pleasing picture of Communist Bulgaria to the West. Even the haystacks were to be formed in a certain way. These weekend activities made him aware of the interplay of appearance and concealment as a theme in art.

At the same time, the experience of altering a site could have provided a basis for thinking about the landscape as material (not just subject) for art. We too might want to consider whether the reshaping of a site constitutes an art form. We recognize parks and landscape architecture as forms of art. But what about a field of neatly packed haystacks? Furrows ploughed up in rows? Quarries? Excavation sites? A final thought: Was the Bulgarian government an unwitting patron of avant garde art?

Christo also spoke of his immigration to the West from behind the Iron Curtain. His fascination with the Iron Curtain, both as image and idea, is more than implicit in his work. In 1962 in Paris, Christo piled oil drums on one another to create a wall that blocked off a narrow street. He called this piece *Iron Curtain*. In time, the oil drums were removed; the *Iron Curtain* dissolved easily, leaving its audience to ponder walls, what they are and why they are.

Christo would like to wrap the German Reichstag (Parliament) in Berlin entirely in cloth—but in order to do this he must get the consent of the United States, Great Britain, France, and the Soviet Union. If he accomplishes this, the project would serve as a rare example of international unanimity.

Individualism and Conservatism

All artists look into their own thoughts, feelings, and imagination and find direction there. What the public sees as individualistic is often the cutting edge of new artistic ideas, attitudes, proposals, forms, projects, and images that will eventually pass into the public domain. By the time the art appears in college art history courses, it comes to be seen in terms that are broader, more universal. It is seen as embodying certain cultural values in its forms, as carrying symbolic meanings,

political meanings, sociological meanings, or as an example of the prevailing style. Those are, of course, valid ways to look at it. Nevertheless, a work of art remains in essence a personal statement, the expression of one individual, irreducibly subjective.

The study of art in Western civilization reveals a tendency toward artistic freedom. It asserted itself in the Renaissance, received impetus during the Romantic period, and attained full consciousness with modern art. During those years the boundaries of art, its imagery and its content, were in a state of expansion. It would be well to remember that even before modern times an artist such as Bosch, El Greco, or Rembrandt might, by virtue of his originality, puzzle his audience to the point of despair.

But there were conservative tendencies as well. A fundamental commonality of form and intention maintained itself among Western artists, even including the independent geniuses. Even Rembrandt (see Figs. 2-1, 10-3, and 11-3), whom we think of as a great individualist, is known to have possessed statues from Roman antiquity, as well as paintings by and reproductions of the work of Raphael, Leonardo, Durer, and other artists of the Renaissance. Occasionally Rembrandt even borrowed the poses of figures for his own compositions from Raphael and from engravings of ancient statuary, and his subject matter—landscapes, portraits, and illustrations of Bible stories—was typical of his time.

However diverse the styles and attitudes of Western artists have been since the Renaissance, there was a general agreement that art—at least serious works of art—should be beautiful, meaningful in some religious or humanistic way, and lasting. Late nineteenth-century artists such as Monet, Van Gogh, Renoir, and Cézanne still adhered to these principles, and they are implicit in the art and in the writings of the pioneers of abstract art. It was the Dada group, formed during World War I, that first held them up for question. Post-modern artists regard them as untenable for the most part, because it is just these values that keep art pure, precious, and apart from life.

Art and Non-Art

If recent art has attempted to shun associations with the forms and ideas of the art of the past—with what we know as "fine arts"—it has, with the same motion, moved into closer proximity with all that is extraneous to it: to the prosaic and unexceptional aspects of everyday experience, to materials that are drab and commercial, to investigations that traditionally fall within the domains of natural and social sciences, mathematics, and philosophy, to what is subject to chance, accident, or natural processes. In using new subject matter, it also may speak in the language of that subject matter. At times the methods and the procedures of those "non-art" activities are of greater use and interest to the artist than methods and procedures traditionally associated with art.

Artists in the past revealed the beauty of things, but always tried to persuade their audiences that their art was more beautiful than what it depicted. People who view post-modern art may be disturbed because they can't see the art in it. Of course, it's really not the art that has been relinquished, but the aesthetic aspects.

The beauty, the idealism, the sentiment—those things we typically associate with art—are absent. But if art as we have come to know it is not there, then, according to Allan Kaprow, "the rest of the world has become endlessly available."[2] Kaprow developed this idea further in an essay published in *ArtNews* magazine in 1971. There he contended that "non-art" objects were more exciting than objects intended as art. He asserted that the Lunar Module mooncraft was superior to contemporary sculptural efforts, that the broadcast exchanges between the Apollo II astronauts and the Manned Spacecraft Center in Houston were better than poetry. He praised bright, plastic and stainless steel gasoline stations, mechanical clothes conveyors used in dry cleaners' shops, and vapor trails in the sky. Kaprow suggested that the impact these have on us derives from their being unintended as art.

Roots of Post-Modernism

If Kaprow, Rauschenberg, Johns, and post-modern artists in general have a spiritual father in art, that figure is Marcel Duchamp. In 1914, Duchamp began to exhibit what he called his "ready-mades": commercial objects that he bought in the store and presented, unchanged but for his signature, in an art gallery (Fig. 8-13). Later, in 1917, Duchamp attempted to exhibit a urinal, which he entitled *Fountain* and signed with the name of the manufacturer, Mr. R. Mutt. The work was rejected on the grounds that it was obscene, and unoriginal as well. In defense of the latter charge, Duchamp replied: "Whether Mr. Mutt with his own hands made the fountain or not has no importance. He CHOSE it. He took an ordinary article of life, placed it so that its useful significance disappeared under the new title and point of view—created a new thought for that object." To the charge of obscenity he replied that similar objects are commonly found displayed in plumbers' shops, and added his opinion that "the only works of art America has given [produced] are her plumbing and her bridges."

Ready-mades blurred the line between art and the real world. More important than the particular objects themselves, however, was Duchamp's intention. In effect, he thumbed his nose at the idea that art was something precious and apart from everyday realities (see, for example, Fig. 8-14). Duchamp's humble objects were chosen precisely for their lack of character.

Duchamp was associated with the Dada movement. The name "Dada"—a nonsense word—was picked by the artists and writers who formed the group. Created out of the disillusionment of World War I, the Dadaists scorned what they considered to be the hypocritical self-satisfaction of contemporary Western civilization. They rejected the art that accommodated its complacent middle classes—an art they perceived as primarily concerned with aesthetics. They felt that aesthetic concerns had deadened art. Hence they purged their work—whether art, music, dance, theater, or poetry—of both aesthetic considerations and rational coherence. Through creative activity that was utterly nonaesthetic, and even antiaesthetic, they hoped to force people to reinspect old assumptions. What is art? What is reality? What might be the relation between the two? Their use of

everyday objects broke the tyranny of beauty, and suggested that life was as interesting as art.

Duchamp and the Dadaists insisted that art must challenge the mind. What was beautiful, historic, or permanent held no interest. They rejected art that was out of touch with present realities—social, political, or cultural. Their hard-headed manifestos and public events, some of which ended in riots, conveyed a belief in the possibility of an art that, although overtly nihilistic, would be genuinely redemptive to society.

Dada is a state of mind . . .
Like everything in life, Dada is useless.
Dada is without pretension, as life should be.
Perhaps you will understand me better when I tell you that Dada is
a virgin microbe that penetrates with the insistence of air into all the
spaces that reason has not been able to fill with words or conventions.

—**Tristan Tzara, poet and founder of Dada, 1924**

The Dada movement as such was short-lived. By the 1920s its members were directing their energies elsewhere. But its influence on later artists was profound. Dada's interest in everyday, ostensibly non-art objects was revived in the fifties and sixties, and post-modern artists have continued to work, as Rauschenberg indicated, in the gap between art and life. Perhaps above all, Duchamp revealed to artists the freedom that was open to them.

Another root of post-modern art can be found in the Bauhaus, an art school founded in Germany in 1919. Unlike the Dadaists, for whom aesthetics was a nasty idea, Bauhaus artists were intensely involved with formal concerns—but their interests extended beyond the fine arts. From the beginning, the Bauhaus took a matter-of-fact attitude toward the fine arts, integrating painting and sculpture with architecture, industrial design, and crafts, on the basis of a common search for principles of basic design. Classes at the Bauhaus were called ''workshops,'' and the same preliminary courses were required of all students, regardless of their intended area of concentration.

Those Preliminary or Foundation Courses were taught by Josef Albers and Laszlo Moholy-Nagy, who used them to initiate and to develop ideas that were to have considerable impact in later years. Albers and Moholy eventually brought their ideas to the United States. Albers, after teaching at the experimental Black Mountain College in North Carolina, became the chairman of the Department of Art at Yale. Moholy became the director of The New Bauhaus in Chicago, and eventually established the School of Design, later to be called the Institute of Design, in that city.

At these schools, art was regarded as a way of seeing, of operating. Experimentation and investigation were encouraged. Attitude seemed to be as important

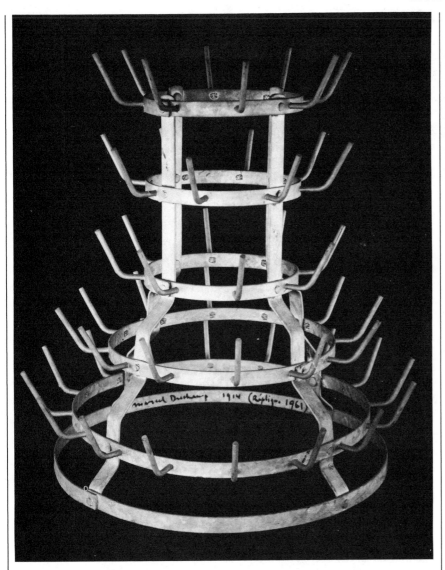

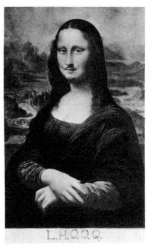

8-13 (left)
Marcel Duchamp,
Bottle Rack, **1914,**
Ready-made; replica
1961. Metal. Mrs.
Marcel Duchamp.

8-14 (right)
Marcel Duchamp,
L.H.O.O.Q., **1919.**
Rectified ready-made:
pencil on a
reproduction, 7¾″ ×
4⅞″. Private collection.

as talent. While at the Bauhaus, Moholy wrote a statement that became widely known (and disparaged by artistic conservatives): "Everyone is talented."

Albers and Moholy taught with an enthusiasm that stemmed from the belief that art itself is a form of learning—a means of furthering insight and awareness. Their focus in teaching was less on the product than on the process by which it is realized. Albers repeatedly told his students, "I'm not training you to be professionals, I'm training you to ask questions."

Albers taught no style; in fact he often expressed satisfaction that his students' work was so different from his own, as well as from each other's. In a 1958 interview in the *Yale Literary Magazine* he advised his students to "keep off the band wagon," and reminded them that "true individuality—personality—is not a result of forced individualness or stylization, but of truthfulness to one's self—

of honesty and modesty." He would often tell his students at Yale: "In all of your other classes, you must come up with one answer. Here you can come up with many answers—all of them right."

Robert Rauschenberg (Fig. 8-1) studied with Albers at Black Mountain. While Albers was seeking general principles of color and design, Rauschenberg was interested in breaking the rules. Nevertheless, years later he described Albers as "a beautiful teacher," and added: "He didn't teach you how to 'do art.' The focus was always on your personal sense of looking . . . I consider Albers the most important teacher I've ever had."[3]

Moholy's artistic life can be seen as a precursor to attitudes prevailing in art today. During his career, Moholy painted on canvas, aluminum, and plexiglas; he developed a kind of three-dimensional painting which he called a "Space Modulator;" he designed merchandise exhibitions and the interiors of stores; he produced innovative layouts for books and posters; he developed typefaces; he constructed sculptures, both stable and kinetic, using new materials including various kinds of plastics, glass, nickel, and chrome (his sculptures using transparent materials were also called Space Modulators); he developed photography and "photograms" (Moholy's term) as art forms; he created sets and special effects for the theater and made documentary films; he designed sets and special effects for the 1936 science fiction film *The Shape of Things to Come* (most were not used, perhaps because they were too rich); from 1922 to 1930 he designed a machine in chrome and glass that would throw moving patterns of light and shadow on the walls and ceiling of a room (Fig. 8-15), and he made a film of the light effects; he designed the interior of a vista dome passenger car for the Baltimore and Ohio Railroad (never realized), pens and inkstands for the Parker Pen Company, and a six-in-one hand tool for a mail-order catalogue. His book, *The New Vision,* had photographs showing the electric transformers of a railway system, street traffic at night, a gyroscope spinning, a lighted merry-go-round revolving, umbrellas crowded together, drops of petroleum on water, and the skeleton of a dirigible under construction.

Moholy's art encompassed whatever he seized on. The possibilities seemed endless to him, for he thought of art as a way of addressing life rather than as a precious gem to be sequestered. Through his life and his work, Moholy demonstrated that the world is indeed "endlessly available." The following is an account by his wife from his biography:[4]

One night we stood on the top platform of the Berlin Radio tower. Below was an intricate pattern of light and darkness, the flashing bands of trains and automobile headlights; above were the airfield beacons in the sky. Moholy must have seen it a hundred times. He lived only a few blocks away, and he had done some fine photographs from the platform on which we stood. But his enthusiasm was that of a surprised child.

"This is it—almost—this is almost painting with light."

The engine of a train puffed thick, white clouds into the night; the billowy denseness was rifted by streaks of glowing sparks.

"I've always wanted to do just this—to project light and color on clouds or on curtains of falling water. People would respond to it with a new excitement which is not aroused by two-dimensional paintings. Color would be plastic—."

The Artist as Amateur

Many people still think of art as a painting hanging in a museum they never visit. Along with this go ideas about beauty and aesthetics that fall short of including much of what we see and experience in our daily lives. Recent art has suggested that light coming through fiberglass can affect us as much as Titian's red; that there is an aesthetic character to scientific data; that photographs taken at random can intrigue us; and that demonstrations of Euclid's theorems will reveal the serene beauty and symmetry of geometry. To the mind that is open and aware, the possibilities for excitement and discovery have no limit.

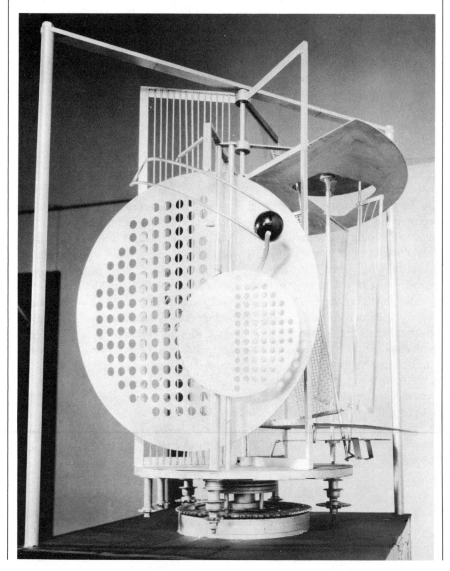

8-15
Laszlo Moholy-Nagy, *Light Display Machine*, 1922–30. Kinetic sculpture of steel, plastic, wood, and other materials with electric motor, approx. 60″ high. Courtesy of the Busch-Reisinger Museum, Harvard University. (Gift, Sibyl Moholy-Nagy.)

If art today has to some extent lost the "master" as the prototype of the artist, it has gained the "amateur," in the sense of a person who is involved with an activity for the interest and the pleasure of the involvement itself. The artist as master who dazzles with his technical performance has given way in this art to the artist as amateur who, more quietly, invites you to share his enthusiasms, interests, investigations, ideas, hunches, musings, and curiosity. This is not, of course, to say that these artists are without skill, but rather that skill is not flaunted as an end in itself.

Perhaps every artist is at heart an amateur ("lover" in French), and every amateur, an artist; for the amateur contemplates his subject aesthetically. He does not use it; he relishes it. He brings to it something of himself. Ideas, information, data, and solid forms are, in everyday experience, the domain of scientists, mathematicians, statisticians, logicians, semanticists, geographers, ecologists, sociologists, broadcasters, architects, engineers, industrial designers, salesmen, politicians, farmers, bricklayers, carpenters, mechanics, electricians, and so on. Their work interests us only insofar as it is useful to us. Were they to step out of their roles and show us the beauty and the logic, the system and symmetry of their material; were they to share their insights and say, "Look at this. This excites me. What do you think?" Were they to do this they would be, at least for the moment, artists. Perhaps someday this will happen—everyone has talent.

Art as a Catalyst

In the past, no matter how unusual a painting or sculpture might be, it could be resolved into a relatively simple bit of meaning by its subject matter or its title. A great deal might have remained beyond the awareness of the viewer, but this simplistic reading of paintings and sculpture accounted for much of the enjoyment they provided. Their meanings were precise and clearly stated.

This is of course not true of the art we have been looking at. Much of the art of the twentieth century has been intentionally unconventional, ambiguous, speculative, and open ended. It has probed rather than proclaimed; it has questioned everything including itself. The communication of some particular message or objective truth—a prerequisite in traditional art—appears to be of less consequence than its function as a catalyst for the uncovering of experience.

Post-modern art suggests that experience counts more than art itself—or invites us to extend our ideas about what art looks like to incorporate a wider range of possibilities. In a world of uncertainty post-modern art expresses trust in subjective experience. It affirms that experience—yours and mine—is valid, however personal, conditional, chancy, or open to change. It suggests further that experience may be valid precisely because of these conditions.

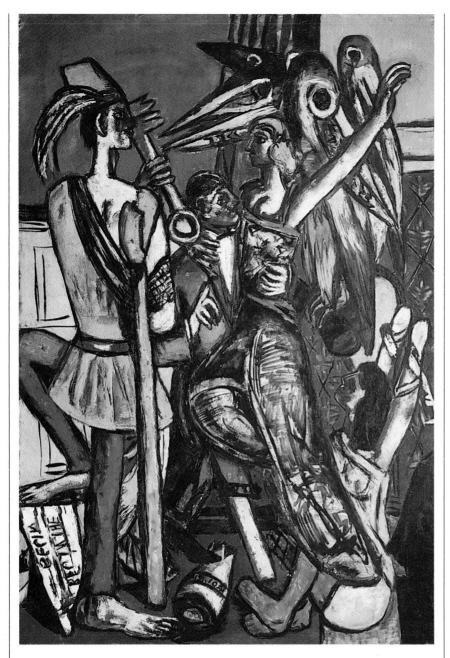

Plate 9
Max Beckmann, *Begin the Beguine*, 1946. Oil on canvas, 69⅝″ × 47⅜″. The University of Michigan Museum of Art.

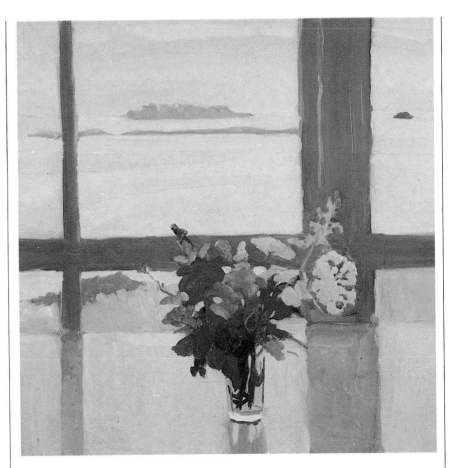

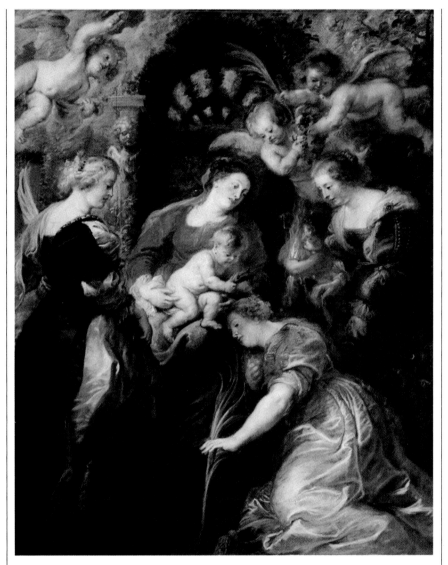

Plate 11
Peter Paul Rubens,
The Crowning of
St. Catherine, **1633. Oil**
on canvas, approx.
8½′ × 7′. The Toledo
Museum of Art. (Gift of
Edward Drummond
Libbey.)

Plate 13
Maurice de Vlaminck,
Under the Bridge at
Chatou, **1906. Oil on**
canvas, 21½″ × 27⅝″,
signed lower left:
Vlaminck. (The Evelyn
Sharp Collection.)

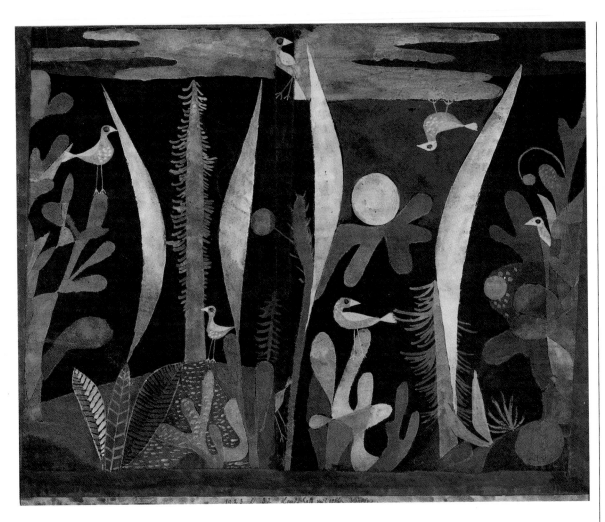

Plate 14
Paul Klee, *Landscape
with Yellow Birds,* 1923.
Watercolor, 14″ × 43¼″.
Private collection,
Basel.

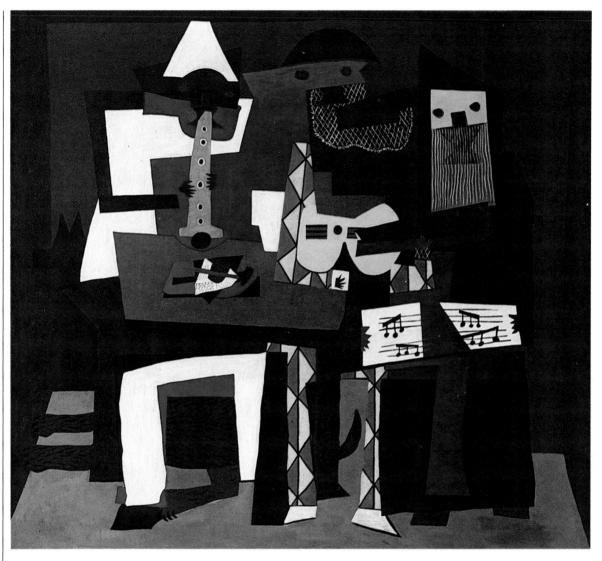

Plate 15
Pablo Picasso, *The*
Three Musicians, **1921.**
Oil on canvas,
6′7″ × 7′3¾″.
Collection, The
Museum of Modern
Art, New York. (Mrs.
Simon Guggenheim
Fund.)

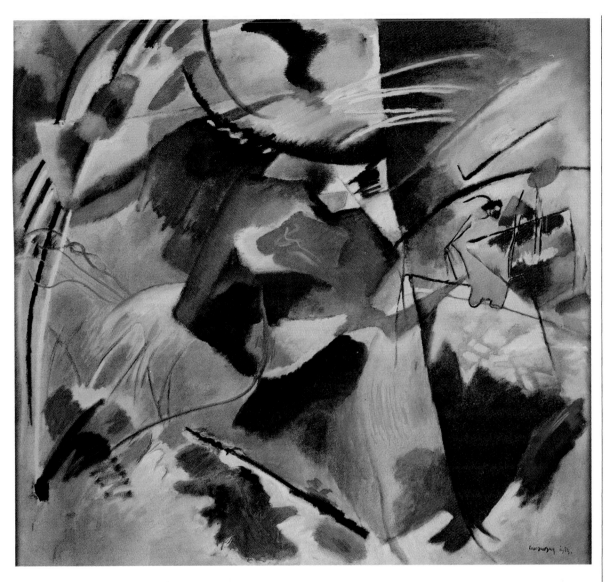

Plate 16
Wassily Kandinsky,
Improvisation with Green
Center, **c. 1913. Oil on**
canvas, 43¼″ × 47½″.
Courtesy of the Art
Institute of Chicago.
(Arthur Jerome Eddy
Memorial Collection.)

9 | Art and the Real World

Some societies have no word for art. It is not that they have no art but that they make no distinction between art and doings things well. Art is too integrated with life to be recognized as an independent entity. It is part of the real world: a net that catches fish better because it is well made, or a mask that has more power because it is well conceived and executed.

In medieval Europe art was integrated into every sphere of life. The roles of artists were clearly defined. Artists were considered on the same level as bakers, shoemakers, weavers, or dyers, and like these and other tradesmen and artisans, artists joined guilds when they were founded in the later Middle Ages. Artists were engaged to create and to decorate both ritual and utilitarian objects. No distinction was made between art and crafts. The word ''art'' evolved out of the Latin term ''ars,'' denoting skill or practical knowledge, and it retained that meaning as it passed into English.

At the center of medieval society was the Church, which exercised power that was political, social, and economic, as well as spiritual. Art made tangible both the presence of the Church and its teachings.

The Gothic cathedrals of northern Europe (see Fig. 3-1) were the supreme artistic achievements of the later Middle Ages. They drew upon the imagination and skill of architects, stone cutters, stone masons, stone carvers, carpenters, wood carvers, glassworkers, painters, and gilders. In addition, many unskilled people volunteered their labor as an act of faith. Immense, complex, gloriously endowed with art, the cathedrals conveyed the authority and splendor of the Church. They were also a source of local pride, for although specialists were imported to work on them, much of the labor and the cost was assumed by the citizens of the town. However, people were shrewd enough to realize that the cathedral would attract pilgrims, whose presence would benefit the economy of the town for years to come.

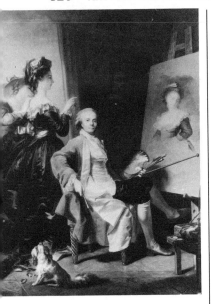

9-1
Jean-Laurent Mosnier,
Portrait of the Artist in
His Studio, **1786,**
approx. 90″ × 68″.
Hermitage, Leningrad.

What is the role of art today? What place does it have in our culture? How does it relate to our daily lives? To answer these questions we need to agree on the art we are going to talk about. As we have seen, there are many different purposes for art in our society. Many different kinds of art answer to those purposes. Some art is well integrated with everyday life. The advertisements we read in magazines or watch on television, the movies and television shows we see, our cars, clothes, and furniture are all forms of art. What do they reflect about us, our attitudes and values? What messages do they communicate to us? How do films and advertisements shape the way we think? What is the impact of those messages? Each of us would answer these questions in our own way. But each of those responses would help us to understand the role of art and its relation to our daily lives.

For now, however, let's set aside art that is commercial or utilitarian—made to serve practical ends—and consider art that is created more or less for its own sake, or for the interest and pleasure it brings to the artist and his audience. This art is certainly far less integrated into everyday life than commercial art. Many people find it of questionable value. It seems remote and self-involved. People today find themselves asking: Is it enough for art to pursue its own interests? Should artists work to please themselves and a select few, or should they aim to reach wider audiences? Is aesthetic contemplation a sufficient goal for art? Are pleasure and enjoyment worthy goals for art? What, if any, are the social responsibilities of an artist?

In the past, the roles of art were more specifically defined. Today, with the roles less clear, these issues are debated. Many artists are involved with purely artistic concerns. Their audience may be irrelevant to them. They work to please themselves, and believe in the sufficiency of art for art's sake. Others are concerned about the detachment of art and artists from the real world, and have used their work to bring the two together.

Why is there a gap between art and the real world? What efforts have been made to bridge it? How successful have they been?

Art and Society in the Past

To begin at the beginning we must start with ancient Greece. The Greeks developed an art that was representational. Yet they didn't depict things as they happened to be, with all the flaws and imperfections that nature and chance impose. Such depictions would have seemed frivolous and inconsequential. Instead they created images that attempted to present things in their essence, in their most perfect and beautiful form. Their art served as a reference and a conduit to what was permanent, beautiful, and ideal. These principles, as well as the forms in which they found expression, greatly affected the character of Western art up to the present.

Written records from ancient Greece and Rome show that despite the high quality of their work, and the legendary feats of certain individuals, artists as a class were low on the social scale. Indeed, throughout classical antiquity and the Middle Ages artists, since they worked with their hands, were thought of as little different from laborers. With the renewed interest in works of art as aesthetic objects in the Renaissance, the status of artists rose. Artists now took pains to

disassociate themselves from the working class. They emphasized that imagination, inspiration, and learning were as necessary to the creation of art as was technical knowledge. Thus art, once so well integrated into life, gradually came to be regarded as something separate. Art was something to be collected. Not everyone could make art, and, indeed, not everyone could appreciate it fully. Painting and sculpture eventually were included in the liberal arts—pursuits that were, strictly speaking, open only to gentlemen.

Art inevitably reflects the aims and interests of its patrons. In the Middle Ages and the Renaissance, the Church was the primary patron of artists. Paintings and sculptures of the time glorified the Church and imparted its teachings. Later, artists were called upon to embellish the courts of kings and nobility. In the seventeenth century artists associated with royal courts were granted titles. By the end of the eighteenth century painting and sculpture were called ''fine arts,'' and generally reflected the tastes and outlook of the upper classes. The classification of the fine arts was based on the idea that art was created primarily to please the eye and elevate the spirit, rather than serve a merely utilitarian purpose. Art was thought to be for ladies and gentlemen, who alone could appreciate it. (Artists considered themselves to be gentlemen as well, and did what they could to keep women out of the profession.) Thus art became a means of effecting and of demonstrating the lines that were drawn between levels of society (Fig. 9-1).

Most of the successful artists painted an idealized world, conforming to the tastes and outlook of their wealthy patrons. But over the years a determined minority, including Caravaggio, Rembrandt, Vermeer, the Le Nain brothers, Chardin, and Hogarth, committed themselves to painting the world as they saw it. Compare the realism of Louis Le Nain's peasants in *The Cart* (Fig. 9-2) with

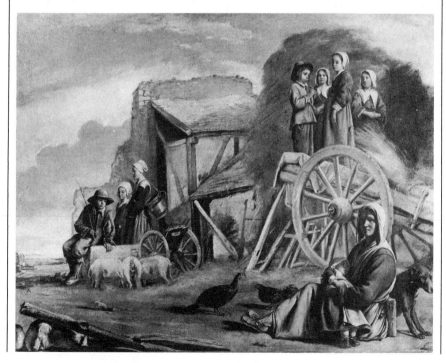

9-2
Louis Le Nain, *The Cart*,
1641. Oil on canvas.
22″ × 28¼″. Louvre,
Paris.

9-3
Jean-Honoré
Fragonard, *Blind*
Man's Buff, **c. 1750-52.**
Oil on canvas, 46″ ×
36″. The Toledo
Museum of Art (Gift of
Edward Drummond
Libbey).

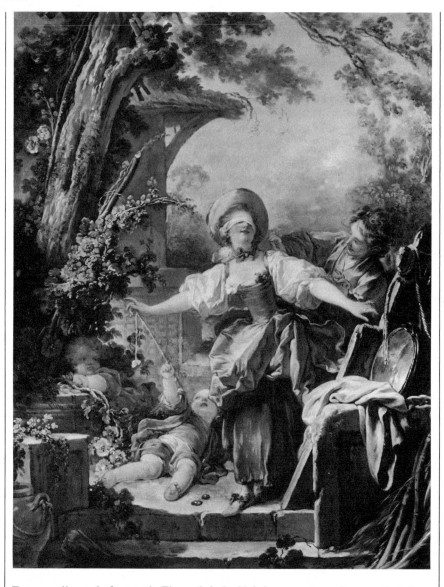

Fragonard's rustic fantasy in Figure 9-3. Le Nain's peasants are in ragged clothes; Fragonard's might well be aristocrats playing at the country life. Is it any wonder that Fragonard was popular with the French aristocracy, while Le Nain was neglected?

Mainstream art, as we saw in chapter 6, was based on the belief that truth could best be grasped in visions of reality that transcended life. Paintings that depicted ordinary people, or everyday situations, were considered to be of little value, or in poor taste. Even Fragonard's charming scenes were disparaged by high-minded critics for their trivial content.

A change in attitude began to occur in the mid-nineteenth century, when paintings of ordinary people and scenes of everyday life were first shown in the

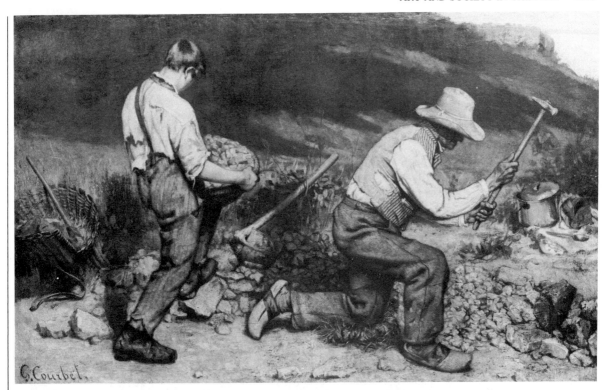

Gustave Courbet, *The Stone Breakers,* **1849. Oil on canvas, approx. 65″ × 54″. Lost during World War II.**

official exhibitions. Though these subjects were typically sweetened and sentimentalized, they reflected an interest in the common man. More revolutionary were the paintings of the Realists, so called because of their refusal to idealize or sentimentalize their subject matter. Their objective portrayal of working class people underscored their objection to what they saw as the escapist nature of the painting of their time (Fig. 9-4).

To be in a position to translate the customs, the ideas, the appearance of my epoch, according to my own estimation; to be not only a painter but a man as well; in short, to create a living art—this is my goal.

—Gustave Courbet, 1855

The Realists enraged the art establishment, but inspired later artists to dedicate themselves to the truthful depiction of experience. As a result, a more subjective art appeared. But this art was, in general, little concerned with social issues. The consciousness of art as an expression of the feelings and insights of the artist was

to carry art away from social commentary toward the more introspective world of abstraction as it evolved in the twentieth century (Fig. 9-5).

Still, a number of efforts have been made in this century to bridge the gap between art and life. The Bauhaus in Germany aimed to connect art with the technology that was seen to be shaping the character of modern life. Walter Gropius, who organized the Bauhaus in 1919, declared that the notion of ''art for art's sake'' was outmoded and anachronistic. Believing that artists had become an elitist and useless class, he asserted that artists should be a part of the world of work, technology, and commercial enterprise. To this end, Bauhaus students were given practical training in trades and technology, as well as in fundamental principles of design, and were expected to work in factories in order to gain firsthand information about production techniques.

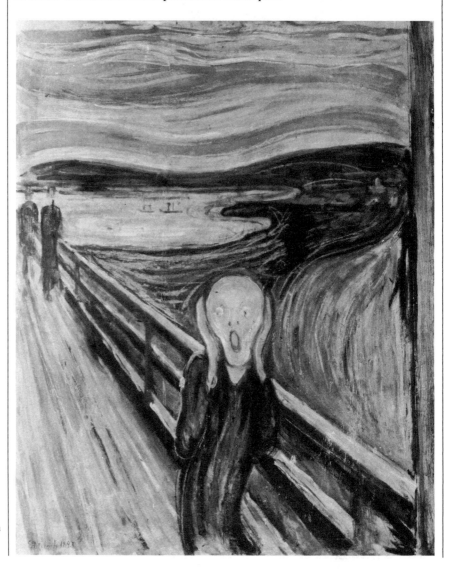

9-5
Edvard Munch, *The Shriek,* 1895. Tempera on board, 36″ × 29″. Munch-museet, Oslo.

These were, of course, revolutionary ideas for an art school. It seemed strange for artists to be seriously involved with the designing of office furniture, electric light fixtures, and kitchen cabinets (Fig. 9-6). But this idea was not really new. Gropius was inspired by the tradition of the medieval guilds, in which tradesmen and anonymous master craftsmen passed on their knowledge to apprentices in workshop situations. By imparting principles of good design, a sense of practicality, and technical know-how, these craftsmen produced individuals who were both skilled and useful. The workshops of the Bauhaus and their close contacts with manufacturing concerns provided a similar foundation for Bauhaus students, called "apprentices," who would likewise make their contributions to society.

Some of the designs produced by Bauhaus faculty and students were massproduced by German companies (for example, see Fig. 10-7). Tending toward the spare and the economical, they demonstrated that well-designed mass-produced articles could satisfy aesthetic needs as well as the demand for efficiency and practicality. Although it was closed under Nazi pressure in 1933, the Bauhaus to this day remains the most influential art school of the twentieth century.

In the United States a very different movement, Regionalism, aimed to bridge the gap between art and life in the 1920s and 1930s. Partly a reaction against European "modernism," it proclaimed that American art should reflect and celebrate American life (Fig. 9-7). Art critics and the public encouraged the depiction of so-called American virtues—honesty, piety, simplicity, and robustness— in scenes mainly of rural or small town life. During the Great Depression, many artists spoke of hardship and poverty through their paintings and prints (Fig. 9-8). They felt that artists should leave their ivory towers and make a contribution to

9-6
Walter Gropius,
Student lounge and bar,
Exposition de la societé
des artistes decorateurs,
1930, Paris.

9-7
Thomas Hart Benton,
Boom Town, **1928. Oil**
on canvas, 45″ × 54″.
Memorial Art Gallery
of the University of
Rochester. (Marion
Stratton Gould Fund,
51.1.)

9-8
William Gropper,
Sweatshop, **1935,**
Lithograph, 9⅝″ × 12⅛″.
The University of
Michigan Museum
of Art.

social welfare through their art. The style of a painting or print was seen as less important than its subject and what the artist was trying to say about it. The movement itself came to be known as Social Realism.

In the early 1930s, unemployed artists were commissioned by the federal government to paint murals in public buildings. For the first time in American history, large scale art was produced that was not sequestered in museums, private homes, or institutions. Post office, courthouse, school, and library walls around the country, covered with scenes of local history and allegorical subjects, gave art a public presence and a relevance that was unprecedented (Fig. 9-9).

Social Realism faded after World War II when abstract art commanded the interest of artists and, increasingly, the public. But concern with social responsibility was to be taken up again in the 1970s, partly in reaction to the perceived self-absorption of abstract art.

Art and Society Today

As we saw in chapter 8, artists in the 1950s like Robert Rauschenberg (Fig. 8-1) and Jasper Johns (Fig. 8-2) began to use common, everyday objects in their work. Later, new art forms—Assemblages, Environments (see Fig. 8-3), and Happenings (see Fig. 8-4) took art off the walls and out of the confines of the galleries. These developments, inspired by the Dada movement of forty years earlier, renewed Dada's interest in the real world—as well as its purposive zaniness. Deploring the stuffiness that still clung to art and the art world, artists again aimed to dissolve the barriers between artist and audience, and between art and life.

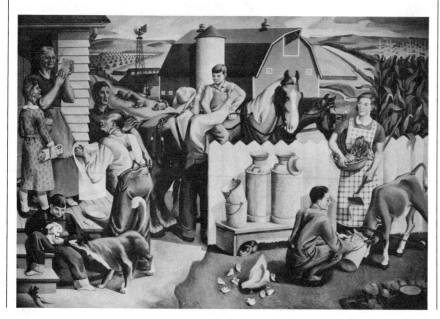

9-9
Richard Haines, *Iowa Farming*, **1937, 7′6″ × 5′. Mural. Post Office, Cresco, Iowa.**

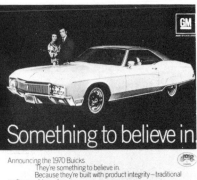

Something to believe in.

Announcing the 1970 Buicks.
 They're something to believe in.
 Because they're built with product integrity—traditional
craftsmanship and care.
 The 1970 Riviera has variable ratio power steering and power
brakes as standard equipment. Plus a cooling system that should
never overheat. And a new carburetor time modulated choke control
(a Buick exclusive) for fast starts in any weather.
 We build our cars with product integrity because we want
them to be something to believe in.
 They always have been.
 They always will be.

Now, wouldn't you really rather have a

1970 Buick.

9-10 (left)
Courtesy of Buick
Motor Division.

9-11 (right)
Tom Wesselmann, *Still*
Life No. 17, **1962.**
Mixed media and
collage on board, 48″ ×
36″. Private collection,
Chicago.

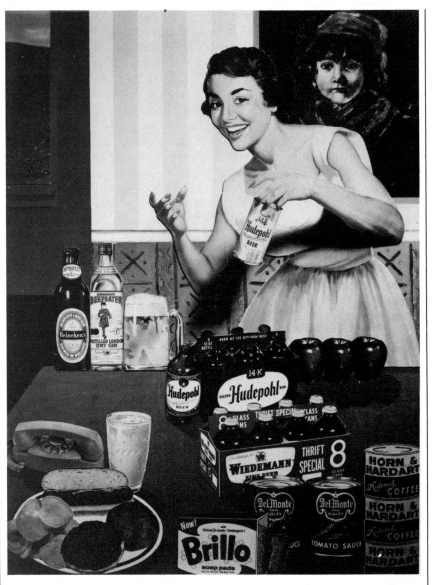

A striking manifestation of this interest occurred in the early 1960s with the sudden appearance of Pop Art. Pop transformed the vocal, antisocial attitudes of Dada into a more easy-going social commentary that was at times humorous, and even affectionate. Pop addressed the issue of how to survive in a society inundated by mass-produced commodities, a society in which shopping and consuming have become the great national pastimes. Attuned to society's worship of these things and the status they confer, Pop emphasized the glamour that consumer products attain in the media and in advertising, and helped us to see the role they had come to play in our lives (see Figs. 9-10 and 9-11).

Pop Art's unblinking reflection of contemporary life and lifestyles at first made people uneasy. Compared to abstract art, with its high seriousness, its

9-12
Ali, *I Love Zoo York,*
**Photo by Henry
Chalfant, 1980..**

passion, its subjectivity, and its aesthetic concerns, Pop Art seemed like a put on. But very quickly Pop began to take hold, and a new Pop sensibility made its way into American society. It brought with it a new vocabulary, popularizing words like "camp" and "funk," which reflected an attitude that found humor and ironic appeal in ordinary objects and situations. The word "Happening" came into general use and appeared in contexts other than artistic. Political events, social gatherings, and even store openings were called Happenings.

In 1968, Abbie Hoffman and the Yippies dropped dollar bills off the balcony of the New York Stock Exchange and watched the stockbrokers scramble for them. On the streets the massive and sometimes violent political demonstrations of the late 1960s were seen as living theater. Always there was the consciousness of a vast audience on the other side of the television news cameras. Political activists had learned that theater can have more impact than politics—or, perhaps, that the two were in fact the same.

It appeared for a time that there was no longer a boundary to art. Art was not just inside frames, or limited to galleries. It didn't even have to be made by artists. Everybody was an artist. Art was wherever and whatever you wanted it to be.

The heightened consciousness of life as art could be seen in the clothes worn by young people at that time. There was both parody and homage, which were central to Pop. There was a fascination with the bizarre and the unusual. Clothing became costume. Old-fashioned clothes and discarded military uniforms were popular attire.

Painting literally appeared in the streets when vans and secondhand school buses were painted with colorful and imaginative designs. In New York City anonymous persons embellished subway cars with spray paints and magic markers (Fig. 9-12). By the mid-1980s some of these "graffiti artists" were exhibiting their work in New York art galleries.

The informality that characterized Pop, and its celebration of commonplace, "artless" things turned up in architecture in the 1970s. For the first time in 40 years, architects started to reassess the pure, austere forms of modern architecture. They felt that this kind of architecture was too cold and impersonal, and its formal idealism had grown out of touch with human needs. They found vitality and richness in architecture that had previously been disparaged: the architecture of a typical American Main Street, of motels and roadside restaurants, of Las Vegas, and the domestic architecture of the past such as one sees reconstructed at Disneyland—in short, architecture that accommodated itself to the lives and tastes of ordinary people. The structures these architects designed are witty and full of the unexpected. They combine the formal interests of modern architecture

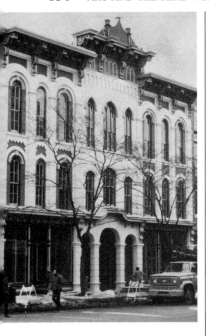

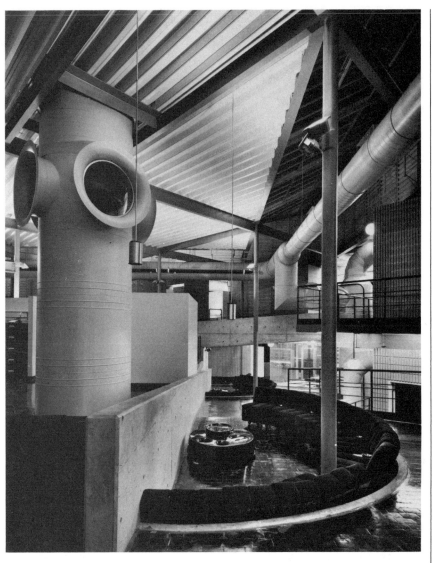

**9-13 (left)
Restoration of the
Goodyears Department
Store building, 1984.
Main Street, Ann
Arbor, Michigan.
Preservation/Urban
Design/ Incorporated,
David S. Evans,
A.I.A., Richard C.
Frank, F.A.I.A.,
Eugene C. Hopkins,
A.I.A..**

**9-14 (right)
Hardy, Holzman,
Pfeiffer Associates,
Occupational Health
Center, Columbus,
Indiana, 1973.**

and even sculpture with the fanciful use of traditional architectural elements for delight, surprise, and welcome associations with the past (see Color Plate 22).

Gradually an awareness of the beauty and value of traditional, local architecture spread. Many old buildings were narrowly saved from demolition. Efforts aimed at preservation began, as individuals recognized in older structures a special character that could never be replaced. Many actually embody the history of a place; all provide links with the past. Well-constructed and frequently one of a kind, their aesthetic quality reaches out to us and provides a unique bridge between art and the real world.

The restoration of the Goodyears Department Store building in Ann Arbor, Michigan (Fig. 9-13) was based on old photographs. The store originally con-

sisted of three buildings dating from 1867 and one from 1871. Over the years, decorative details had been removed or covered over in attempts at modernization; by the 1950s the four buildings were combined into one behind a single, commonplace facade. The architects removed that facade, used what remained of the original buildings, and reconstructed the rest to resemble those buildings as nearly as possible.

In the late 1970s, High Tech was born. Basically a decorative style, it valued the crisp, technological look of hardware, industrial artifacts, and electrical and plumbing fixtures of the kind usually found only in commercial settings or in factories (Fig. 9-14). Frequently bright colors were used to draw attention to the artifact. Attuned to their aesthetic possibilities, High Tech turns them into art.

Pop's probing of assumptions about how art should look opened up other possibilities to artists. As we saw in the last chapter, some artists have involved themselves in projects intended primarily to convey ideas or information to the audience. Their art has integrated with other areas—sociological, scientific, political, and philosophical.

Social movements emerging in the 1960s and 1970s stimulated the desire for an art that would address itself to immediate, real-life concerns. Many women and blacks, committed to their respective causes, saw art as an educational tool. They were painfully aware that their particular experiences were invisible in the mainstream of contemporary art. They were distressed that art—and in particular, abstract art—seemed to be concerned only with its own ends. Rejecting the idea of art for art's sake as elitist, even decadent, they advocated an art committed to raising social consciousness. For example, Judy Chicago's *Dinner Party* (Fig. 9-15), presents a history of the place of women in society through symbols included in the place settings for 39 great women, and the names of hundreds of others on the tiled floor.

The capacity of representational and symbolic images to inform and instruct attracted many of these artists. As with Social Realist art in the 1930s, the ideological thrust is more important than the aesthetics. Their work has renewed attention to the potential of art to communicate specific ideas and influence thinking.

Street art, in the form of outdoor murals on the walls of buildings, emerged in the 1960s and the 1970s. Originating in black urban ghettoes and Latino neighborhoods, it sprang out of the desire to communicate with people otherwise untouched by the establishment art of museums and galleries. It was a genuinely public art, on display in the very environment that nurtured it. It was not to be bought, owned, or hidden away. Many of these murals have a deliberately unsophisticated look that permits them to slip around the barrier that official-looking art might present. This underlies the artists' insistence that their work communicate directly with its intended audience.

The *Wall of Respect* (Fig. 9-16), a lively amalgam of paintings, photographs, and poems, was an early and influential example of street art. Located in the heart of a black neighborhood in Chicago, it evolved over a period of months, drawing on the contributions of 21 black artists, and generating considerable interest within the community.

9-15
Judy Chicago, *Dinner Party*, 1973-79. © Judy Chicago, 1979.

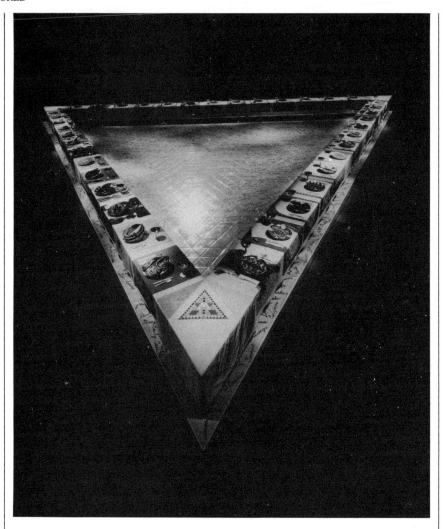

Films and TV, recent arrivals in the world of art, are very much a part of everyday experience. Like other art forms, they reflect, comment on, and shape our understanding of the real world. Over the years films or television shows have occassionally attempted to heighten our consciousness of timely, critical issues. Some have made us aware of social problems. *The Best Years of Our Lives* (1946) deals with problems of returning veterans. *Lost Weekend* (1945) deals with alcoholism, and *The Man with the Golden Arm* (1955) deals with drug problems. Some films have attacked social institutions. *I Am a Fugitive from a Chain Gang* (1932) exposed the injustice and brutality of the chain gang system and led to its reform. *All Quiet on the Western Front* (1930) is a powerful indictment of the institution of war. *Paths of Glory* (1958) and *Dr. Strangelove* (1964) are attacks on the military mentality. In November 1983, nearly 70 percent of the television-viewing audience watched *The Day After,* which depicted the horror of nuclear war.

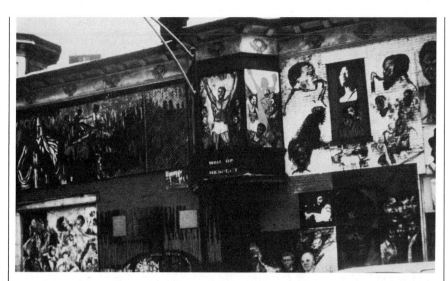

9-16
Twenty-one black
artists, initiated by
O.B.A.C. and William
Walker, *Wall of Respect*,
1967, destroyed
1971. Originally at
43rd and Langley,
Chicago.

*N*o one asked for the Wall of Respect. It just had to be painted. It
made a direct statement to the Black community and the statement
came directly out of the community through its artists.

—Harold Haydon, Chicago artist, 1970

Conclusion

In Western society, from the Renaissance to the twentieth century, art was less an
integral part of everyday life than a pleasurable adjunct to the good life led by the
middle and upper classes. Among the democratizing upheavals of the twentieth
century appeared revolutionary new roles for art, and it was thrust into a fresh and
intense relationship with society.

Artists committed themselves to following their own insights. Many turned to
abstraction as a means of conveying truth and reality as they perceived it. Others
worked to effect social change through explicit subject matter.

The dreams behind twentieth-century art activity were ambitious. But the
goals of these artists remained largely unfulfilled. The Bauhaus attempted to
counter elitism in art by merging art with machine technology. Today the Bau-
haus's goal seems utopian, and Bauhaus design may be seen as just another
modern style. Some Bauhaus painters, such as Kandinsky (Color Plate 16), Klee
(Color Plate 14), and Albers (Color Plate 20), saw no need to connect their
paintings to immediate social concerns. They continued to believe in art for the
sake of the spirit. Other artists aimed to bridge the gap between art and the real
world through the power of ideas that were socially relevant, stressing the social

responsibility of the artist. Yet Social Realism, black art, and feminist art—despite their real-life concerns—have probably not affected many people, perhaps just because of their narrow focus. Pop artists used the visual vocabulary of advertising and the popular arts to create works that communicated to a public long intimidated by "high" art. But despite or because of its references to the everyday world, Pop art remained enigmatic to large segments of the public; indeed, Pop seemed even to scandalize people who resented its trivial subject matter and its implied denigration of art. Films and television shows have brought social concerns to the attention of the public—but they have been relatively few. Does the "Hollywood ending" reflect life in the real world? Entertainment may enlighten us, but its primary function is to divert us, for a time, from real-life concerns.

The detachment of art from the real world still exists today. An acquaintance with art is still often considered a badge of membership in the elite. Fine art frequently is incorporated into magazine ads for snob appeal. At the same time, public school administrators who think of the arts as an indulgence or a diversion from serious concerns drop them from the curriculum when the budget tightens, and parents frequently deprive children of the rewards of art activities by telling them to do something "useful."

Certainly there is ample evidence of a gap between art and life. However, art is still available to anyone who wants to get in touch with it. Many people enjoy the sculpture in the square, or the fountain in the park, or notice the decorative details of a favorite building. Many people watch programs about art on television, hang art on their walls, buy books about art, or read the reviews of art in national news magazines. Many people visit museums and galleries. Although the visits may be occasional, most people probably experience them as pleasant events. Perhaps they are special just *because* they are occasional.

It is precisely that special quality that I think we seek in art. It may seem removed from everyday concerns. At times it may be difficult to understand; but I suspect that there are a good number of us who are delighted that art is there to encounter. We value it just *because* it is different, because it challenges us, and because it allows us to enter into the realm of the creative imagination.

Since the Middle Ages, art has evolved into an increasingly autonomous activity. Independent, self-directed, art today is synonymous with freedom: There are no limits placed on what an artist can do. He can work without restraints and to the limits of his imagination. Perhaps because of that freedom, artists, poets, and writers have a way of generating ideas long before anyone else. Eventually their intuitions make their way into the popular culture, influencing the way we see and how we think.

10 | *Creativity*

Artists throughout history have been hailed as geniuses, angels, and madmen. In the West, the romanticizing of the artist began in the Renaissance, when the wondrous nature of art was transferred to the artists themselves. In his book, *On Painting* (1435), the Renaissance architect and theoretician Alberti referred to painters, sculptors, and architects as "very noble and amazing intellects," and declared that "the master painter who sees his work adored will feel himself considered another god." To an age that admired human courage, power, and will, creativity indeed began to appear as a divine gift. The sixteenth-century biographer Vasari explained the talent of Giotto (c. 1267–1337) as "God's gift in him"; of Leonardo da Vinci, Vasari wrote, "his genius is a gift of God and not an acquirement of human art," and called him "marvelous and divine." Vasari saved his most lavish praise for Michelangelo, whom he also called "divine," and a "genius" sent to earth by God who "endowed him with true moral philosophy and a sweet poetic spirit, so that the world should marvel at the singular eminence of his life and works and all his actions, seeming rather divine than earthly."

Creativity remains impressive, as well as mystifying and intriguing. What makes the artist different? Is talent inborn, or is it developed? What generates creativity? The answers to these questions are at best partial. In this chapter you will see some of the ways that artistic creativity has made itself known. We shall talk about specific examples of artistic creativity rather than psychological theory. We shall also look at the methods and processes by which highly original work has been produced.

Culture and Creativity

While any understanding of creativity must focus on the individual, the influence of the culture on creativity is worth considering. It is the culture,

after all, that places a value on particular activities: the decoration of pottery, the carving of a mask, or the creation of a painting. And while a culture cannot, of itself, create a superior individual, it can encourage individuals to create superior things.

Many cultures have developed artistic traditions of remarkable quality even while the individuals who contributed to it worked within a narrowly restricted format. We have seen examples in the work of ancient Egyptian painters and sculptors (see Figs. 4-4 and 6-2), in Tibetan art (see Color Plate 3 and Fig. 7-22), and in African carving (see Fig. 7-11). High standards are frequently found in the art of ancient civilizations, in tribal arts, folk art, and crafts, that are, in general, the products of individuals of varying skills and creative abilities following formulae passed along by the local tradition.

What accounts for the quality and richness of that art? First, we may be sure that the culture encouraged that development. The art produced in Egypt, in Tibet, and in tribal Africa was deeply integrated into the culture and was, therefore, highly valued. In these and other cultures, much of the art was not only ceremonial, but also utilitarian. In tribal arts, folk art, and crafts, both personal pride and the keen eye of the community kept standards high.

Furthermore, an artistic tradition is a great teacher. It channels and directs the latent creative energies of individuals. A tradition sustains a way of seeing and doing over a long period of time. It acts to develop the vision and to refine the technical skill of the practitioners. Local or national cultural traditions, such as carving a design on a spear, decorating a fishing boat, or festooning a Christmas tree, make it natural for individuals of varying degrees of creative ability to express themselves effectively in visual terms.

Art as an expression of individuality is a relatively recent idea. Throughout history, highly structured artistic traditions have predominated. They survive today in diminishing pockets of tribal art and folk art scattered throughout the world. An inherited tradition is a natural vehicle for expression, much like a language. With its structure and its rules, a language perpetuates certain forms of expression; it also, however, allows for individual style, and through the impress of effective individual contributions will change over time. Similarly, artistic traditions can change over time as individual variations play on inherited themes, motifs, and patterns. Where sanctified by the state or the religion (sometimes there was no distinction between the two), the tradition may be more rigidly fixed in its forms and less prone to change. But while the culture may be conservative with regard to the content of the art, it may nevertheless encourage technical experimentation.

Peruvian Weaving

The impressive variety of weaving techniques in pre-Columbian Peru suggests a major cultural investment in inventing new textile structures and in discovering what designs and patterns these new techniques made possible (Fig. 10-1). Experimentation in weaving was encouraged as generations of individuals built upon what they inherited.

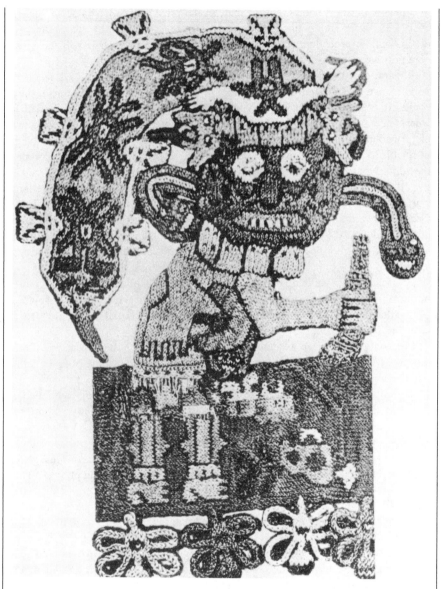

10-1
**The Paracas Textile, detail,
Paracas Necropolis,
Cabeza Larga, Peru, late
1st century B.C. to early
1st century A.D. Cotton
with wool decoration,
65″ × 20″. The
Brooklyn Museum.
(John T. Underwood
Memorial Fund.)**

Techniques in weaving developed over a long period of time in many different places in the world. Weaving is based on the idea of crossing and intersecting yarns at right angles in a regular way. Weaving itself must have developed out of simpler techniques, such as knotting and looping (which we can see today in basketball nets, fishing nets, and string shopping bags). Perhaps the first fiber technology was tying knots to hold things together to make more complex objects that would prove useful as containers, as clothes, or as shelter.

The Peruvian Indians used simple looms that made it possible for parallel rows of yarns stretched between two bars (the warp) to be intersected by perpendicular yarns that were introduced one row at a time (the weft). Weft yarns were attached

to a needle or short stick (shuttle) that, in the most basic weave, passes under every other warp yarn in one direction and over it on the way back. The repetition of this simple procedure produces the "plain weave," which is still the most common weave in use today.

Illustrations painted on Peruvian pottery show that weavers (always women) would place a model before them to look at while they worked. Of course, they could either copy it exactly or devise a variant of their own. That variant, if it were a new pattern or design, might have necessitated some change in technique or procedure. By exploring variations in the weaving procedure, the weavers were able to produce designs in endless varieties and combinations. For example, they could double or triple the weft yarns, or pass the weft yarns over and under two, three, or more warp yarns at a time. They could use a thicker yarn for either warp or weft, or weave weft yarns only part of the way across the warp. They discovered various ways to leave open spaces in the fabric that became part of the design, developed "double weaving," so that objects of double thickness, such as ribbons or straps, could be woven in one piece, and they explored tapestry techniques.

Peruvian Indian weaving demonstrates the evolution of a basic idea into more intricate forms. All of the techniques that were developed—techniques so sophisticated that they have not been improved on since—came out of the simple matrix provided by the loom.

Creativity in Peruvian weaving can be seen as accepting the limitations of the process, while exploring every capacity of the weave. The method of that exploration was to question each thread and to try out everything.

The colors and the specific images—typically of humans, animals, and plants, and also their combinations—were limited in number and strictly organized according to the principle of variety within a restricted format. Variety was achieved by both simple and mirror-image repetitions of an image, and by placing the colors differently within each image in the sequence. The images were abstracted in a somewhat geometric manner natural to the weaving process. The arrangement of the figures was so exacting that the space between—called the "ground"—at times becomes as active as the image of the figure itself. In short, every aspect was consciously considered, and nothing is extraneous to the design (Color Plate 23).

When we look at Peruvian and many other figurative weavings we should keep in mind that the patterns or images are not applied to the fabric as we might daub paint on a picture, but are integrated with the structure of the fabric. A key feature of weaving is this intimate relationship of design and technique, where the subtlest modification of the technique produces changes in the image. The Peruvian Indians produced images that were unique within the limitations inherent in the technique.

A close view of this and other artistic traditions in premodern cultures reveals that such traditions acted not to repress creativity, but to encourage it. Today we may regard any limited range of possibilities as stultifying, but, in fact, it is the limitation placed on the artist that encourages creativity and ingenuity. Robert Brumbaugh, the anthropologist who observed the Telefomin people of Papua New Guinea (see page 183), suggests that because of the narrow restrictions on their art, inventiveness and ingenuity are perhaps more prized than in our more

open, but still conformist, society. By selecting out from the infinite range of possibilities, traditional cultures are able to direct the attentions of many minds to single ideas, and in this way are able to develop and perpetuate an art of exceptional quality.

The conditions that produced this kind of art have altered, and consequently the great tribal arts and folk arts are disappearing. New concepts of time, new materials and techniques, new economies with new production demands, and newly learned tastes have meant the eradication of age-old artistic traditions. Today, both the fishermen in Greece and the farmers in Ireland prefer factory-made acrylic sweaters to those knit in traditional patterns at home from hand-spun wool. Throughout the world, "tourist art" represents the pathetic finale of once vigorous native traditions.

Creativity in Western Culture

In Western culture, artistic creativity has been shaped by very different circumstances. Artists, particularly since the Renaissance, have been far less subject to limitations imposed by tradition than artists in premodern or tribal cultures. The separation of fine art from utilitarian objects emphasized the aesthetic value of a work of art and promoted the individuality of the artist. Works of art came to be seen as demonstrations of skill and imagination. In this context a more free-wheeling, independent kind of creativity evolved.

In the years between the Renaissance and the nineteenth century, artists and public concurred in the belief that a work of art should be beautiful, appropriate, and skillfully made. Within this context—somewhat more narrow than today's standards—individuality was recognized and generally admired. Creativity was identified with the solution of immediate technical problems, but also—and at least as important—with the demonstration of superior imaginative faculties.

In modern times, the declining power of tradition placed even greater value on originality. Individuality and experimentation were encouraged by the more rapid rate of social change, as well as the increasingly democratic outlook of the West.

As early as the first part of the nineteenth century, observers noted a growing interest in personal exploration and experimentation. In his review of the Paris Salon exhibition of 1827, the French artist and writer Étienne Delécluze made the following statement:

> This exposition is odd because of the diversity of the works admitted to it. Never has the diffusion of the tastes under which the artists have worked been so great as it is at present. There is not one painting whose composition, draftsmanship and coloring is not attached to a system peculiar to each originator.[1]

Four years later the Paris Salon was reviewed by the German poet Heinrich Heine. His commentary has a surprisingly modern sound:

> Every painter now works according to his own taste and on his own account Every artist strives to paint as differently as possible from all others, or, as the current phrase has it, to develop his own individuality.[2]

To account for this, we ought to look once again at the social context. By the end of the eighteenth century, political, economic, and social factors had brought about the decline of the centuries-old system of patronage by royalty, by the aristocracy, and by the Church. With the passing of these traditional patrons, artists lost the security that they provided—but at the same time, they were released from the restrictions that these conservative institutions imposed. Artists were now on their own, competing for a market made up of the burgeoning middle class, and a gradually widening range of individual tastes.

The loss of religious and royal patronage meant the end of the formal integration of art with society. The intimate relationship with the institutions of Church and Crown being gone, artists had to ask themselves a new set of questions: What role did they now play in society? Whose needs would their art serve? What subjects would they be interested in? What style would be appropriate? Of one thing they could be sure: they were now more free to follow their own interests; in fact, they could work to please themselves alone if they chose.

Nineteenth-century Romanticism encouraged individualism in the arts; in the twentieth century, freedom of expression was regarded as a right. Unfettered creativity is highly regarded today because individualism makes sense to us. We connect it with cherished concepts of human freedom and dignity that have evolved, however haltingly, in Western civilization.

For painters, sculptors, and craftsmen today, artistic freedom presents a great challenge. The dos and don'ts once imposed by tradition channeled the artist's energies and directed his work, or for innovative artists, provided points of departure. Artists today must not only seek solutions to problems but, to a greater degree than ever, must invent the problems themselves.

Artists of the past would be stupefied at the freedom accorded to present day artists, and would perhaps be envious of the high premium placed on creativity. As we have seen, from the classical period to the Renaissance, artists were considered to be skilled laborers (except for the rare and celebrated ones). Individuality was so unimportant that not until the Renaissance did it become common for artists even to sign their work. Artists were paid for their murals by the square foot or per figure. As late as the sixteenth century, in Florence, painters belonged to the guild of physicians and apothecaries, possibly because, like apothecaries, their work consisted of obtaining and applying pulverized materials. Finally, it might be well to note here that Michelangelo's father attempted to discourage his son from becoming an artist out of the belief that manual labor was beneath the dignity of the family.

With this as a background we shall now inspect some outstanding individual artists and how they approached their work.

Giotto

As far back as the early fourteenth century the Florentine painter Giotto amazed viewers of his frescoes with his ability to depict solid figures in a three-dimensional space and to give those figures a warm, human quality (see Figs. 5-8 and 7-1). Although his figures may look naive and doll-like to our eyes, they were

much more realistic than any painted by his predecessors, and evidently made a deep impression on those who viewed them. In the same century Boccaccio, writing about Giotto's achievement, stated that "there was nothing . . . that he could not recreate with pencil, pen or brush so faithfully, that it hardly seemed a copy, but rather the thing itself. Indeed, mortal sight was often puzzled, face to face with his creations, and took the painted thing for the actual object."

Giotto gave his figures a solid appearance by subordinating their details in order to emphasize their bulk. He also painted them in light and shadow. Certainly he was not the first person to observe that light and shadow reveal the solidity of objects. Other painters he knew—Cimabue and Duccio—had tentatively explored the use of light to model form. But Giotto's volumes convince us, because he handled light in a way that is consistent and unified, and not arbitrary. While this effect may seem obvious to us, we should note that no painter in Italy had done it before Giotto. We might also note that Giotto neglected to paint the shadows that his figures cast on the ground. Could this have been an oversight? Or did he consider the shadows irrelevant?

Giotto inherited a tradition of painting, with its particular forms and conventions. But instead of working within the framework of the convention, he questioned the convention itself. Why must the figures in a religious painting look flat, stiff, other-worldly? Wouldn't it be more effective, more moving, if the viewers could identify with their humanity? Essentially, he found new ideas to investigate, which led him to break new ground.

Giotto's creative genius set a course for Western painting, as artists attempted to emulate his triumphs. But it took over a century before artists fully understood and absorbed the lessons he taught.

Artistic Problems

Throughout the fourteenth, fifteenth, and early sixteenth centuries, artists applied themselves to the problems of creating accurate images of the natural world. Not until the fifteenth century did artists formulate rules of linear perspective. Their increasing understanding of human anatomy was demonstrated throughout the century in painting and sculpture. An array of artistic problems such as the representation of volume in the round and deep space, foreshortening, the pleasing arrangement of figures in groups, the depiction of ideal beauty, and the use of gesture and facial expression to convey feeling and states of mind called upon the imagination of painters and sculptors alike.

By the end of the Renaissance, all the basic problems of representation had been solved. Later, in a development that can be traced through art history to the present, artists took it on themselves to seek out more subtle visual problems and to provide solutions to them. Michelangelo, Tintoretto and Caravaggio invented new and dramatic poses (see Figs. 10-2, 12-8, and Color Plate 24). Caravaggio developed spotlighting as a means of composing a painting, intensifying the drama, and directing the attention of the viewer (see Color Plate 24 and Fig. 13-9). He discovered a spiritual feeling in the light. Rembrandt converted that light to a more personal mode (see Figs. 10-3 and 11-3). Vermeer and Chardin reduced the number of objects in their paintings and explored the relationships

between them (see Color Plate 17 and Fig. 13-10). David placed walls parallel to the picture plane to remove distractions and to intensify the focus on the main characters (see Figs. 5-9, 7-2, and 12-12). Edward Manet investigated the distinction between idealism and realism (compare Fig. 11-5 and Fig. 6-13). The Impressionists, attempting to recreate the sparkle of outdoor light, gave the brushstroke an identity beyond the objects they described (see Color Plates 26 and 29). Rodin insisted on direct observation of the model instead of preconceived ideas about poses and proportions (see Fig. 3-8). Mondrian explored compositions in which the center was empty and interest was distributed equally throughout the picture (see Fig. 7-15). Frank Stella studied the idea of unifying the image with the edge of the canvas (see Fig. 11-10). Eva Hesse found an eloquence in casual arrangements of homely materials (see Figs. 8-5 and 10-10).

These are, of course, only a sample of the range of visual possibilities that artists have investigated in their work. Now let's take a closer look at two of these artists—Michelangelo and Rembrandt—and see how they isolated specific visual problems and worked toward their solution. We shall begin with the work of Michelangelo.

10-2
Michelangelo, *Day*, from the tomb of Giuliano de' Medici, 1520–34. Marble, over life-sized. New Sacristy, San Lorenzo, Florence.

Michelangelo: *Day*

Sculpture has a factual aspect to it: it not only has a presence, it *is* a presence. Since ancient times sculptors have exploited the potential of hard material to assert itself upon the viewer when transformed into a recognizable figure. Renaissance sculptors were concerned with making their sculptures lifelike; Michelangelo's idea of sculpture was quite different. He conceived of sculpture primarily in its material aspect, as mass, rather than as merely an imitation of the subject. Thus he was able to bring an awesome presence to the piece. Michelangelo had the capacity to visualize the sculpture in the block of stone, but also to retain the feeling of the block of stone in the sculpture.

Like other artists of the Renaissance, Michelangelo took as his ideal the antique statues that remained in his native Italy, including some that were being unearthed during his lifetime. But he brought to his figures a sense of inner life, of an intense psychic or emotional energy that went beyond anything that he could have known from classical antiquity or, for that matter, from the Renaissance. Michelangelo achieved this by

conceiving original poses for the figure, and by exaggerating parts of the anatomy. He discovered that a twisting pose *(contrapposto)* could give a figure a sense of movement arising from within. Combined with exceptionally powerful musculature, a figure would seem to be exerting an outward thrust emanating from a life force centered inside the stone.

The magnificent allegorical figure of *Day* (Fig. 10-2) in the Medici Chapel peers out at us uneasily, weighed down by some exterior force seemingly both physical and psychological. His muscles are extraordinarily powerful and taut, as if he were trying to pull free, and yet he seems strangely frozen, as if powerless to move. His left hand and right foot are still not free of the stone, and his pose on the curved base is unstable, as if he were being pulled downward by the counterforce of gravity. The torso is conceived in terms of simple masses twisting against one another in conflicting directions; the right arm swings one way, and the left leg crosses over in opposition. These tensions draw you back to the statue again and again as they beg for resolution; you're waiting to see which way he's going to go. Michelangelo may be telling us that life resolves itself only in God's time, not in ours. The face gives us no answers: roughed out, unfinished, it is a man in the process of emerging from the stone. The shadow cast over his deep set eyes leaves room for our own interpretation of his expression.

Michelangelo's ability to fuse the life of the figure with the life of the stone was a superior creative achievement. His revelation of the expressive capacity of the body opened up new possibilities for the human figure and the role it could play in art. Michelangelo's particular vision of the human body influenced his contemporaries, while his idea of sculpture as mass, and his ability to touch the material and bring it to life was to influence Rodin, Henry Moore, and other sculptors of the twentieth century.

Rembrandt: *St. Jerome Reading in an Italian Landscape*

Now let's look at Rembrandt's etching of *St. Jerome Reading in an Italian Landscape* (Fig. 10-3). According to legend, St. Jerome removed a thorn from the paw of a lion, for which he earned himself a furry friend for life. In this work, Rembrandt appropriately includes the lion, but breaks with convention in showing the saint out of doors; traditionally Jerome is shown in his study where he translates the Bible into Latin.

Like the setting, the composition is also unconventional. Surprisingly, Rembrandt gives the buildings in the background the greatest detail, while the figure of St. Jerome—the principal subject of the etching—is scarcely touched in. Rembrandt not only experiments with the overall composition, but with the treatment of areas within it. The figure of St. Jerome, although loosely treated, is convincingly solid. In contrast, the hindquarters of the nearby lion are flattened with parallel lines while its head receives more detail and seems fully rounded. As we look throughout the etching we find that the line handling in each section differs so that we get a surprise wherever we look. Yet the picture holds together, in part because it resolves into a few areas of dark and light.

By substituting suggestions for more finished details, and by incorporating the white of the page into the solid figure, Rembrandt anticipated the drawings and paintings of modern artists, whose experiments with composition and solid forms were more explicit. The interplay of lights and darks, the push of flat against solid areas, the variation in line and tone, and the unexpected compositional decisions test out and even reverse conventional procedures and make this print an unusually rich visual experience.

With all this, the picture is more than an impersonal formal exercise. Let's imagine ourselves there. What would catch our eye? Very likely we would notice the lion before we saw an old man peacefully reading. As we focused our gaze on it, other things would fade, or just go unnoticed. We might also enjoy looking at the cluster of picturesque buildings in the distance, which would throw the man

and the lion out of focus. A tree overhead would scarcely be glimpsed out of the corner of our eye. Rembrandt's treatment of the scene, besides being visually inventive, is true to the way we might see it if we were on the spot. His treatment of details is not arbitrary, but corresponds with our natural perception.

At the same time, the composition makes a particular statement about the subject matter. The light pouring over St. Jerome makes him special, even though the lion is at the center. Yet, by presenting his subject in so quiet and undramatic a fashion, Rembrandt makes it feel natural and true to life. The lion turns away from us; the saint is almost lost to sight in the sunshine. The wondrously understated, casual depiction of St. Jerome makes him more personal, more like someone you can relate to in an everyday kind of way. He even seems nearsighted, judging from the way he holds his book close to his eyes. It is altogether a fantastic, dreamlike world here, where a lion contemplates a beautiful landscape and an old man, half-seen, peacefully reads in the sunlight nearby; but Rembrandt seems to be telling us, simply, quietly, this is the way things might be.

The Creative Process

Works of art, however original, do not spring full-blown from the imagination, but are better understood as the result of a process. Before working on a canvas, painters typically developed their ideas through sketches and drawings, and before approaching the marble, sculptors made drawings and models. Some painters are known to have made small wax figures that they grouped together as a basis for the painting, sometimes setting them into a small shadowbox with a candle as a light source. Compare the study by Guercino in Figure 10-4 with the final version in Color Plate 25. What changes did Guercino make? What ideas developed as the work progressed?

When I came back from Paris, I painted those rowing pictures. I made a little boat out of a cigar box and rag figures, with red and white shirts, blue ribbons around the head, and I put them out in to the sunlight on the roof and tried to get the true tones.

—Thomas Eakins (see Fig. 5-7)

Michelangelo made meticulous drawings of the figure in preparation for both sculptures and paintings. He also made careful models out of clay and wax in preparation for his marble figures. He kept the models around and used some of them for more than one painting or sculpture.

Rodin made innumerable models in clay and wax before working on his larger pieces. His *Burghers of Calais* (see Fig. 3-8) was developed over a period of

10-4
Guercino (Giovanni Francesco Barbieri), *Study for Esther Before Ahasuerus.* **c. 1639. Pen and brown ink and wash, laid down, 8½″ × 10¼″. The University of Michigan Museum of Art.**

about five years, during which time he worked out ideas for poses and composition. Each figure was modeled in the nude as an aid to understanding the pose. During his long life Rodin made more than seven thousand figure drawings for his own information, and frequently reworked drawings made years earlier. He often drew the same pose again and again, and at times even traced over it in order to try a different handling or to refine its fluid movement.

Many artists painted the same subject repeatedly. This narrowing of concentration permitted an intensive exploration of the particular problems and opportunities presented by that subject—a procedure reminiscent of that of the Peruvian weavers. Cézanne was fascinated by a mountain—St. Victoire—and worked out his ideas by painting it again and again. Raphael repeatedly drew and painted two, three, and four-figure compositions, inventing and reinventing complex interweavings of gaze and gesture. His *Madonna and Child and St. John the Baptist* (Fig. 5-6) is a particularly beautiful resolution of this grouping. Hokusai's

print showing the *Great Wave* (Fig. 7-23) is taken from a series of *Thirty-Six Views of Mt. Fuji.*

Time and reflection . . . modify little by little our vision, and at last comprehension comes to us.

—**Paul Cézanne, about 1905**

Compositional drawings commonly show *pentimenti*—places where the artist changed his mind and drew over the first marks. In the drawings of Raphael we frequently see a change in the gesture of an arm or the tilt of a head, as though in a double-exposure. The early and late states of some of Rembrandt's etchings show striking changes in composition. Rodin occasionally composed by cutting out drawings of his nudes and collaging them together. Hokusai would paste cutout drawings of figures into his settings in preparation for his prints. Today artists work out compositions using the instant camera, the slide projector, the duplicating machine, the light table, and tracing paper.

Artists learn from each other, relying on techniques, poses, and compositional formats of other artists as starting points. Borrowing ideas is considered normal. The landscape and buildings in the background of *St. Jerome Reading in an Italian Landscape* are based on a sixteenth-century Italian drawing that was in Rembrandt's possession. Michelangelo's well-known Adam in the Sistine Chapel is derived from a sculptured relief by Jacopo della Quercia dating from the 1420s or 1430s. Van Dyck's *Charles I at the Hunt* (see Fig. 6-8) was so admired in France that Rigaud used the pose for his portrait of Louis XIV (see Fig. 5-10). For the *Stone Breakers* (see Fig. 9-4), Courbet borrowed poses from Poussin's *Et in Arcadia Ego* (see Fig. 12-10). Manet's *Luncheon on the Grass* (Fig. 11-5) is a restatement of Giorgione's *Pastoral Concert* (Fig. 6-13). The poses of the three foreground figures in Manet's painting are derived from figures in a Renaissance engraving based on a composition by Raphael depicting the *Judgment of Paris,* which is itself based on a group of figures carved on a Roman sarcophagus. Of course, the artists typically rework the earlier ideas to suit their own purposes.

Models, drawings, tracings, repetitions of a theme, and borrowings were not impediments to the creativity of these artists. On the contrary, persistent investigation and reworking of an idea, with each study the basis for the next, was a means of moving from what was known to what was yet to be discovered.

These practices reveal the conscious, rational aspect of creativity. In place of the burst of inspiration, we find—more realistically—an exhaustive and disciplined investigation of a problem or situation until alternative solutions or directions have been examined and tested. It is clear that without thoughtful decisions, commitment, courage, and hard work, nothing of value can be achieved. Thomas

Edison's statement, ''Genius is one percent inspiration and 99 percent perspiration'' could apply as well to the arts as to the sciences.

Every artist works within limitations; sometimes, as we have just seen, these limitations are self-imposed in order to give method and direction to the investigation. Inevitably, limitations are imposed from the outside as well. The size of the studio, the drying time of paint, the surface of the paper and the density of ink affect the work. Creative artists (like the Peruvian weavers) take advantage of the situation to convert a limitation into a possibility.

Architects and builders find themselves grappling with limitations imposed by the climate and weather, the site, available technology and materials, the purpose of the building, and its cost limitations. Throughout history, architecture has been shaped in response to these conditions. Steeply pitched roofs in northern Europe, flat roofs in the Mediterranean region, and domed roofs in the Middle East accomodated to weather and climate; light conditions affected the development of shimmering stained glass windows in northern Gothic cathedrals and thick walls perforated by small windows in the churches of the Mediterranean countries. Human ingenuity has given us collapsible architecture for nomads, vaults and domes to span large crowds of people in permanent structures, balconies to extend the private domain outside, and glass windows to bring the outside in. The extraordinary range of architectural phenomena testifies to the capacity of the creative mind to make delight of necessity (Fig. 10-5).

Architecture has developed through an uncountable number of small, even unconscious, contributions of anonymous individuals modifying traditional ways of making and shaping spaces. But certain outstanding buildings are the result of

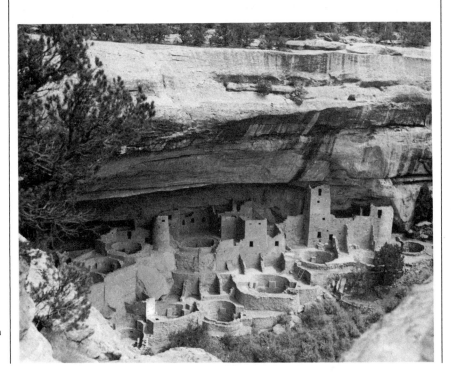

10-5
Cliff Palace, Mesa Verde, Colorado. c. A.D. 1100.

an imaginative concept on the part of the architect. These buildings are admired for more than their technical achievements.

Gunnar Birkerts: The Underground Library

In Ann Arbor, Michigan the architect Gunnar Birkerts was presented with the challenge of designing an addition to the Law School Library at the University of Michigan. Because it was felt that the addition should not obscure the older building—a twentieth-century Gothic revival structure designed by James Gamble Rogers—Birkerts had to locate his addition entirely underground. The result is far from claustrophobic, and does not suffer from glaring artificial light. Instead, it is amazingly spacious and luminous (Fig. 10-6). Birkert's solution was

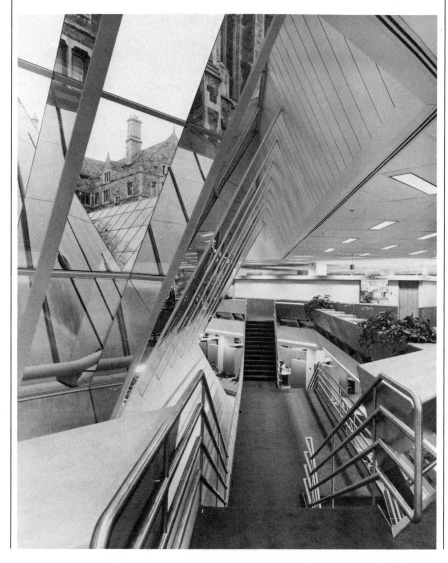

10-6
Gunnar Birkerts, Underground Law Library, 1981. University of Michigan, Ann Arbor, Michigan.

to build a gigantic V-shaped trench that descends past all three levels of the library, admitting natural light, providing a sense of spaciousness, and offering picture window views of the fanciful older building towering above it. A smaller, triangle-shaped skylight located above a cozy lounge admits soft, natural light at the rear of the building. Hanging plants and green carpeting throughout also bring the outside in. The underground library is so popular that librarians report having to prevent undergraduates from taking study space away from the law students.

When considering creativity, we should be aware that total control of the means or the material exists only in fantasy worlds. In reality, all of us are limited by context and circumstances; it is how we exert ourselves on these various givens, and use them to our advantage, that tests our creative powers.

Caravaggio: *The Conversion of St. Paul*

Caravaggio's painting, the *Conversion of St. Paul,* (Color Plate 24) provides a classic example of making a virtue of necessity. Designed as a side panel in a small chapel, it was to be approached from its right side; in fact, because of the narrowness of the room and the location of the altar and its platform in front of the painting, the anticipated view was oblique. Caravaggio's unusual placement of the fallen St. Paul may be understood as an ingenius solution to the problem posed by the site. By looking at the reproduction from just beyond its right edge, you will discover that the foreshortening of the figure (that is, the way it comes out at you) and its placement are not arbitrary. Instead, the figure draws you into the picture, just as it does when you enter the chapel where it still hangs.

The Mind in Motion

An idea may be spontaneous—out of the blue—but it is likely to have been generated only after a period of thought, involvement, and work. Caravaggio had already been involved with foreshortening (see Fig. 13-9), as well as with dramatic light effects. Good ideas—ideas that make sense—occur to minds that are prepared for them. Consider the following examples from the twentieth century.

In 1925, a young furniture designer on the Bauhaus faculty named Marcel Breuer bought a bicycle and rode it to pass the time until classes began. Noticing the handlebars and the light strong frame of tubular steel, he conceived the idea of using that material for furniture. With the aid of a local plumber he created the first tubular steel chair that very year (Fig. 10-7). Later he refined the design, and by 1926 his chairs were being manufactured and sold.

Up to the time of Breuer's discovery, furniture in the Bauhaus, as elsewhere, was constructed of wood. Breuer recognized that tubular steel, with its light, efficient, machinelike appearance was more compatible with streamlined, modern architecture than wood. Breuer made his breakthrough by questioning the premise that wood alone was appropriate material for furniture. While the idea apparently occurred to him in a flash, it was made possible because he had been

Plate 17
Jan Vermeer, *A Painter in His Studio*, c. 1666. Oil on canvas, 51¼″ × 43¼″. Kunsthistorisches Museum, Vienna.

Plate 18
Edouard Vuillard,
L'Aiguillée, **1893.**
Oil on canvas,
15⅞″ × 12¼″.
Yale University
Art Gallery. (Gift of
Mr. and Mrs. Paul
Mellon, B.A. 1929.)

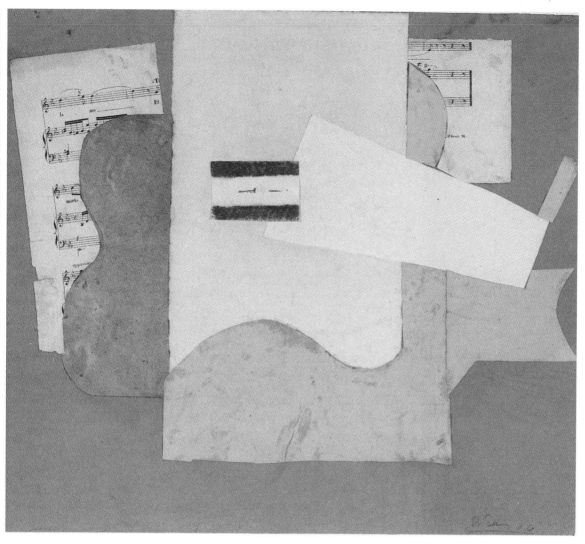

Plate 19
Pablo Picasso, *Sheet of
Music and Guitar*,
1912-13. Collage,
16½″ × 18½″. Musée
National d'Art Moderne,
Paris.

Plate 20
Josef Albers, *Homage*
to the Square—
Floating, **1957. Oil**
on masonite panel,
23¹³⁄₁₆″ × 23¹³⁄₁₆″. Yale
University Art Gallery.
(Gift of Anni Albers
and the Josef Albers
Foundation, Inc.)

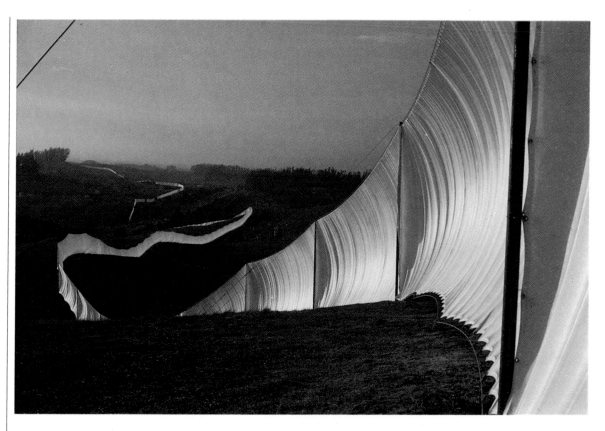

Plate 21
Christo, *Running Fence*, 1972-76. Steel posts and nylon sheeting, 18′ high, 24 miles long, Sonoma and Marin Counties, California. Photo courtesy of Jeanne-Claude, © Christo 1976.

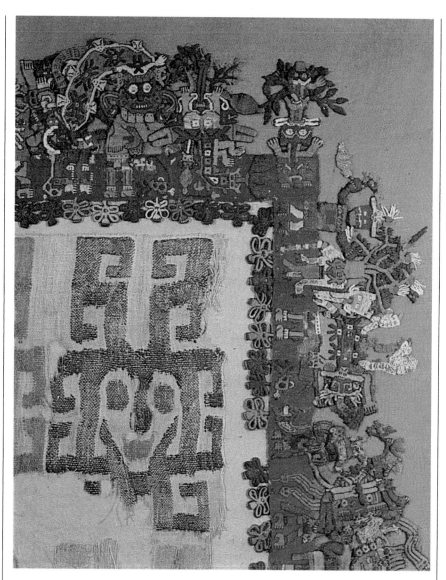

Plate 23
Detail of the Paracas Textile, Paracas Necropolis, Cabeza Larga, Peru, late 1st century B.C. to early 1st century A.D. The Brooklyn Museum. (John T. Underwood Memorial Fund.)

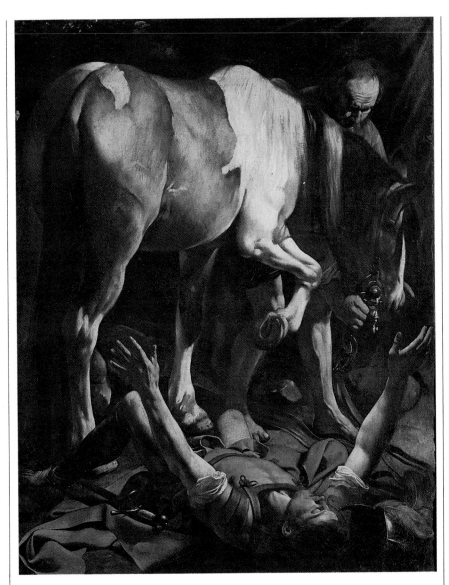

10-7
Marcel Breuer,
Armchair, 1925. Chrome-
plated steel tube,
canvas, 28" high.
Manufacturer: Gebrüder
Thonet A.G., Germany.
Collection, the Museum of
Modern Art, New
York. (Gift of Herbert
Bayer.)

working with furniture, and thus he was likely to relate what he experienced to furniture.

Charlie Chaplin's films contain unforgettable moments of inspired visual thinking. The paraphernalia of modern, urban life—escalators, revolving doors, assembly lines, roller skates—became springboards for Chaplin's imagination as he explored their potential for unanticipated uses. In *The Gold Rush* (1925), for example, he manages to convince his starving companion, as well as the audience, that a boot can provide a sumptuous dinner (Fig. 10-8). In another scene he plunges two forks into dinner rolls and transforms forks and rolls into dancing feet.

In another example of visual wit, Picasso joined the handlebars of a bicycle to the seat to make the head of a bull (Fig. 10-9). Much later Picasso was heard to say that he'd like to toss the *Bull's Head* on the ground and watch someone discover it, pick it up, dismantle it, and fit the pieces back into a bicycle.

These three examples appear to show capricious and spontaneous thinking. Breuer looked at a bicycle and saw furniture; Picasso looked at a bicycle and saw a bull; Chaplin looked at shoelaces and saw spaghetti. We ought not to forget, however, that they were already geared into thinking along certain lines. Breuer had furniture on his mind. Picasso enjoyed bullfights, and frequently incorporated the bull into his art. Both Picasso and Chaplin were devoted to taking objects

10-8
Charles Chaplin in *The Gold Rush*, **1925.**

out of context and turning them into something else. Their individual mental sets enabled all three to wrest particular ideas from the situation before them. What seems capricious and spontaneous would perhaps be better understood as the product of a mind both focused and in motion.

Again we are reminded of the Peruvian weavers whose culture focused their thinking in a certain direction. All of them asked: What is unique about this situation? How does it limit me? What possibilities might it provide me? But the twentieth-century artists were able to go farther in their answers than the tradition-bound Peruvians. They could go where their personalities and imaginations took them and come up with something more radically novel, surprising, and individual. It is this that separates their kind of creativity from the more restrictive creativity of the Peruvian culture. We think of the Peruvian weavings as inventive and ingenious, but the work of Birkerts, Breuer, Chaplin, Picasso, and Caravaggio, seems first and above all to be imaginative.

It is this very element—imagination—that appeared to distinguish art from crafts in the Renaissance and to substantiate the superiority of artist over craftsman at that time. Artists like Michelangelo made it clear that a work of art was more than simply a contribution to a tradition: it was a singular creation conceived in one man's imagination, divinely inspired, and fired by great feeling. Art became a way of seeing deeply into things, and a means of discovering truths. The examples set by Giotto, Michelangelo, Rembrandt, and other dedicated individuals showed creativity to be an activity of the highest spiritual order.

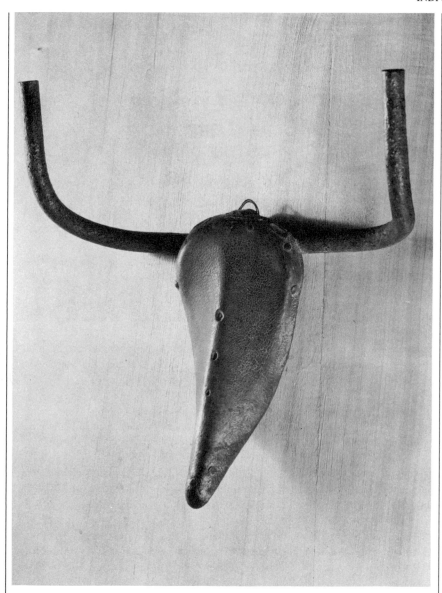

10-9
Pablo Picasso, *Head of Bull*, 1943. Handlebars and seat of a bicycle, 16⅛″ high. Musée Picasso, Paris.

Individualism: Eva Hesse

Contemporary artists look inward for the direction once supplied by tradition. Theoretically, at least, anything is possible. But the openness of the situation today multiplies the opportunities for disaster. Creativity is not the same as doing whatever you want.

It takes a special kind of courage to be oneself in art; to trust what's inside you and believe that your work will make sense some day. For serious artists a life in art represents a struggle toward self-realization. In our time, that struggle has been romanticized, while the reality—the risk, and the fears—generally remains hidden.

10-10
Eva Hesse, *Repetition 19, III*, 1968. Nineteen tubular fiberglass units, 19″ to 20¼″ high, 11″ to 12¾″ diameter. Collection, The Museum of Modern Art, New York. (Gift of Charles and Anita Blatt.)

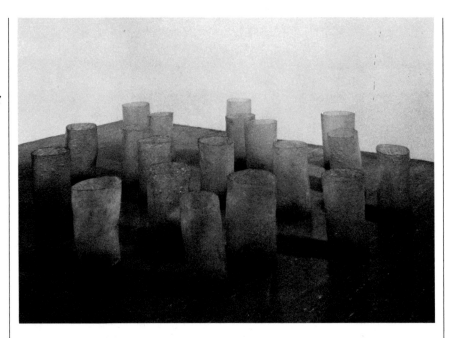

Eva Hesse (see Figs. 10-10 and 8-5) was an immensely creative artist, in part because she was able to take risks in her art. In 1964, when she was 28, she entered into her diary:

> Making art. "painting a painting." The Art, the history, the tradition, is too much there. I want to be surprised, to find something new. I don't want to know the answer before but want an answer that can surprise.[3]

Some months afterward she wrote: "Without trying I'll never know." Five years later she had become well-known in the art world. Interviewed in 1970, she reiterated the theme of risk and exploration:

> That's why I think I might be so good. I have no fear. I could take risks . . . I'm willing really to walk on the edge, and if I haven't achieved it, that's where I want to go.[4]

Hesse developed an unconventional and highly individual art, neither painting nor sculpture as we traditionally know them. She was careful that her pieces not have obvious resemblances to other things; the associations should be subtle, private. She also managed to stay away from the looks and styles that were currently popular in the New York art world. Hesse was convinced that if the work reflected herself, it would take on individuality and strength:

> I don't know if I am completely out of the tradition. I know art history and I know what I believe in. I know where I come from and who I am related to or the work that I have looked at and that I am really personally moved by and feel close to or am connected or attached to. But I feel so strongly that the only art is the art of the artist

personally and found out as much as possible for himself and by himself. So I am aware of connectiveness—it is impossible to be isolated completely—but my interest is in solely finding my own way.[5]

Her pieces were not polished or graceful, and they avoided effects that were pretty. They just seem to *be* there, hanging, lying, or leaning in positions natural to them, as though they had taken on some strange, awkward kind of life. That loose, chancey way with materials, and the evocative personal imagery opened new directions for artists in the late sixties and seventies. With its uncompromising reflection of a self, her work demonstrated how far art could go to embody the personal world of the artist. In this respect her example remains important and instructive to this day. Hesse thought of her art in personal terms:

First when I work it's only the abstract qualities that I'm really working with, which is to say the material, the form it's going to take, the size, the scale, the positioning or where it comes from in my room—if it hangs from the ceiling or lies on the floor. However, I don't value the totality of the image on these abstract or aesthetic points. For me it's a total image that has to do with me and life. It can't be divorced as an idea or composition or form. I don't believe art can be based on that. This is where art and life come together.[6]

Eva Hesse's mature work was produced in a span of less than five years. She died of a brain tumor in 1970, at age 34.

These eloquent statements from Hesse's interviews and writings convey some sense of that hidden experience—the perilous ''walk on the edge''—that constitutes, for contemporary artists, a life in art.

I have learned anything is possible. I know that. That vision or concept will come through total risk, freedom, discipline. I will do it.

—Eva Hesse, 1969

Conclusion

In this chapter I have emphasized the problem-solving nature of creative thinking. Although clear enough to artists, this aspect is often overlooked by their audience. Artists set goals for themselves in the form of problems to be solved, and their work may be understood as a search for solutions.

Knowing what problem to address is as important as the answer given. It is possible that Michelangelo left much of his sculpture unfinished because he felt that his solutions were insufficient. His reach may have extended beyond his grasp—but that reach carried him beyond conventional solutions to the intensely personal and visionary work that he finally achieved.

All artists work within a specific and restrictive context. Caravaggio in the seventeenth century and Birkerts in the twentieth succeeded in converting severe limitations into opportunities. For these artists, the limitations were starting points, providing challenges that forced them to contemplate and ultimately to realize unusually creative solutions.

Creative solutions, particularly when they are of a high order, can strike us as having been obvious. Such may be the case with Giotto's conception of perspective. But we should keep in mind how long it took artists to understand and repeat his performance; even today perspective must be learned. It is useful to remember that the wheel, the zero, and the paper bag once existed only in someone's imagination.

All artists need a starting point. No one can just plunge in and start creating; there has to be a narrowing of focus. Generally, it was provided by tradition. In art schools today there is a wide range of starting points, reflecting the current diversity of interests in the art world and in the culture as a whole. Art teachers select particular problems for their students because they believe that those problems provide challenge and growth. A good teacher will encourage students to seek their own solutions to those problems, and eventually to establish problems of their own.

Art can't be nourished in a vacuum. For art to happen, it has to make sense in the life of a community, whether that community is a tribe, a city, a nation, or a family. Creativity is a natural impulse, but it can be encouraged or stifled.

For most artists, being creative is hard work, requiring diligence and self discipline. Many surrender some of the usual satisfactions of life to devote themselves to it. But being on the edge of an idea, and discovering something new is incomparably exciting. As my artist friend Nancy Hansen put it, it is "being so involved you don't even know you're happy."

The capacity to be creative distinguishes what is most human in us. In every area of human endeavor creative individuals enrich our lives by changing the way we see and experience things. By aspiring to understanding, and by their devotion to that goal, they offer illumination and growth to us all.

11 | *Meaning and Meanings*

All of us, I'm sure, have stood in a museum or looked at a reproduction and wondered: What does this mean? How can I judge the quality of what I see? How can I be certain that my interpretation or my judgments are right? In this chapter and the next we shall investigate some of the ways in which art has been interpreted and evaluated. We shall also discuss some of the factors affecting our understanding of works of art. We owe it to ourselves, as well as to the artists, to consider our responses to art so as to approach it in a thoughtful way; that is, in a way that keeps us open to the quality that is there before us. Much of what you or I might admire was disparaged in the past out of prejudice or simple ignorance. For this reason, it is critically important that we inspect the ideas that we bring to the art we experience. And that is what we shall do now.

Traditionally in Western culture, painting and sculpture illustrated a story. Not surprisingly, interpretations of art tended to identify the significance of a painting or sculpture with its subject matter; at times, in fact, it seems like the art and the subject matter were thought of as the same thing. A painting or a sculpture was good if its subject matter was thought to be ennobling or appealing, and bad if the viewer disparaged its subject matter.

Paintings and sculptures were particularly acclaimed when they combined fastidious realism with elevated themes. David's *Oath of the Horatii* (Fig. 5-9) was an immensely popular painting. Its success derived as much from the ideas and associations generated by its subject as from its aesthetic qualities. Viewers of the painting thought of it as providing an example for human action. The story of the three Roman brothers who pledged to fight to the death for their country conveyed a social and political message cast in terms of high moral purpose. That message—patriotism, courage, heroism, and duty—carried special weight for Frenchmen in those years just before the Revolution. The paint-

ing attracted crowds of people wherever it was exhibited, and flowers were placed in tribute before it.

The great success of Hiram Powers's *Greek Slave* (see Fig. 3-11) was attributable to the viewers's sympathetic identification with the subject, a Christian victim of tyranny sold into slavery (and thus charmingly naked through no fault of her own.) Her nudity—always a subject of anxiety in Western art and culture—was defended by a minister who wrote, "Brocade, cloth of gold, could not be a more complete protection than the vesture of holiness in which she stands."[1] A contemporary account in a magazine reported the effect that the virtuous statue had on viewers:

> They look at the beauteous figure and the whole manner undergoes a change. Men take off their hats; ladies seat themselves silently, and almost unconsciously; and usually it is minutes before a word is uttered. All conversation is in a hushed tone, and everybody looks serious on departing.[2]

Powers himself had encouraged this kind of response. In a statement accompanying the statue's tour of the United States in 1847, Powers referred to the statue as though it were an actual person:

> The Slave has been taken from one of the Greek Islands by the Turks, in the time of the Greek Revolution, the history of which is familiar to all. Her father and mother, and perhaps all her kindred, have been destroyed by her foes, and she alone preserved as a treasure too valuable to be thrown away. She is now among barbarian strangers, under the pressure of a full recollection of the calamitous events which have brought her to her present state; and she stands exposed to the people she abhors, and waits her fate with intense anxiety, tempered indeed by the support of her reliance upon the goodness of God. Gather all the afflictions together and add to them the fortitude and resignation of a Christian, and no room will be left for shame. Such are the circumstances under which the "Greek Slave" is supposed to stand.[3]

When Frederic Church exhibited his huge ($3\frac{1}{2}' \times 7\frac{1}{2}'$) painting *Niagara* (Fig. 11-1) in 1857, people were invited to bring opera glasses and scan it as though it were the real thing. An early viewer said, "It was there before me, the eighth wonder of the world." Another was "fascinated as before the reality itself." In an age when God's presence was associated with glorious works of nature, this painting was experienced in almost religious terms. While the painting has intrinsic artistic merit, it is undoubtedly the falls themselves, and what *they* represented, that accounted for the painting's extraordinary popularity.

Today we are better able to perceive the distinction between a work of art and its subject matter. We are attuned to looking for meanings in the work other than those conveyed directly by the theme or story. It is understood that a work of art has multiple meanings. It can mean one thing to the artist and another thing to his audience. It may also mean something different to each person. We no longer think of there being a "right way" to look at it. Every person brings his or her own thoughts to a work of art, and draws out of it something unique. The possibility that different people will draw different meanings from a single work of art does not suggest the weakness of the piece but its richness and strength.

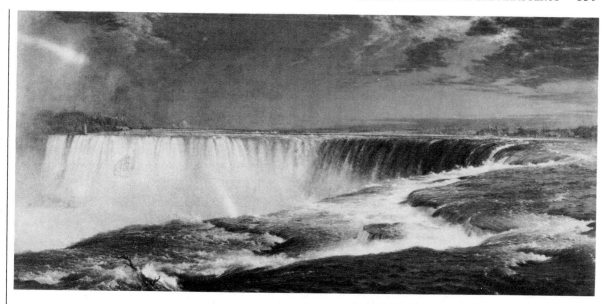

11-1
Frederic Edwin
Church, *Niagara*, 1857.
Oil on canvas, 42″ ×
90″. In the collection of
The Corcoran Gallery
of Art, Washington,
D.C. Museum Purchase.

Guercino: *Esther Before Ahasuerus*

The various meanings that a work of art may contain could be demonstrated by any painting or sculpture. We have already discussed some of the many ideas raised by Picasso's *Sheet of Music and Guitar* (Color Plate 19) and Christo's *Running Fence* (Color Plate 21). Now let's consider an older, more traditional work of art, Guercino's *Esther Before Ahasuerus* (Color Plate 25), which is located in my home town. This painting illustrates the Bible story of the Jewish queen who entered the pagan king's chamber unannounced, and hence at risk to her life, to plead for her people's safety. In holding out the scepter Ahasuerus indicates his sympathy for her, and suggests to the viewer the ultimate success of her mission. What significance might this painting hold for people? What special meanings might it contain?

- We can admire Guercino's remarkable powers of representation. The excellent drawing, the solid, convincing volumes, and the brush technique that suggests the textures of cloth, fur, skin, jewels, and pearls create the illusion of an event taking place before our eyes.
- We might react to the beauty of the painting, and consider such formal aspects as Guercino's arrangement of the figures and their poses, the lush color, or the soft light.
- Guercino's preparatory drawings (of which one is illustrated in Figure 10-4) reveal his preoccupation with the composition. His adjustments and rearrangements of the figures show his concern with telling the story in the most effective way. By limiting the figures to four, and bringing the viewer close to them, Guercino gives the scene an intimate,

personal quality. Thus he encourages us to react to the human drama in the painting, enjoy the expressiveness of faces and gestures, and speculate on the feelings of the characters.

- We can focus on the theme, and see the painting as exhorting the viewer to accept challenging situations such as speaking out for what you believe in. Or we might see in it the theme of faith in human love, or as a religious tale with a moral.

- An observer today might find in the painting the lesson that women have had to play games to get what they want from men. Another might find in the painting the statement that men dominate and women faint.

- The cardinal who commissioned the painting would have seen it as a part of the contemporary program of the Catholic Church, which favored a religious art in which people could identify with the characters. He would certainly have interpreted it as a Christian allegory: an Old Testament queen finds herself singularly able to act as intercessor, or spokeswoman, to save lives, just as the Virgin Mary intercedes in Heaven for those who pray to her for help.

- A Marxist critic might see the painting as a celebration of kingship, with its throne, scepter, and luxurious garments. Or he might see it as a celebration of the power of the ruling class, which identified itself with the gracious and benevolent king. Or he might see it as a depiction of class conflict.

- A psychologist might react to the dynamics of the relationships between the people, or study the painting for what it reveals about the painter, his personality, and his state of mind.

- An art historian might see the painting as an example of a popular Baroque theme, and note the attention to drama, character, and allegory that characterized that period. He might be interested in it as a point in Guercino's stylistic development or as exemplifying the Baroque style. He might find in it influences of other artists or discover in it signs of Guercino's individuality. His interest might center on Guercino's concern with psychological states. Or he might see it as a response by Guercino to the prevailing taste for noble subject matter.

Guercino's *Esther* soon passed into the collection of Pope Urban VIII (1568–1644). It would not likely have occurred to the audience of that time to consider the painting from all the points of view you have just read. Contemporaries would surely have noted:

1. the beauty of the painting
2. the exactness of the imitation
3. the appropriateness of the depiction
4. the religious or allegorical meanings
5. the style and technique of the artist

and they would have regarded the painting as satisfactorily exemplifying the Church's program of Counter-Reformation. Any other meanings the painting might have held for its viewers is a matter of speculation.

While art critics since the Renaissance insisted on convincing representation, they also looked carefully at the distinctive personal styles and techniques of the artist. They expressed admiration for draughtsmanship, brushwork, and handling of color, as well as for imagination and inventiveness. But this was not to overlook the content (any more than we do today, when we go to a museum or look at a movie). Any art worth talking about was made to convey some content, and that content never ceased to occupy the interests of artists and critics alike.

The Changing Content of Art

The content of works of art—the ideas and meanings it contains—varies from place to place, and changes over time as well. In the West there has been a gradual expansion of what art speaks to, as artists, reacting to new situations and searching to express themselves in new ways, infused new meanings into their work. The following will give you an idea of this process.

The Egyptians conceived of figures that were idealized, abstract, and otherwordly; the Greeks developed an art of idealized images of human beings capable of action in this world; the Romans saw value in an art that could communicate specific ideas in literal terms. Early Christian artists infused symbolic meanings into the art and converted the worldly scenes of Rome into images of the spiritual world of Christianity.

In the Middle Ages art was closely integrated with patterns of life. It was regarded as primarily functional: secular art consisted of the creation and embellishment of useful objects, while religious art served the Church. Although a sense of the supernatural clung to images, writings from the later Middle Ages attest to changing attitudes toward the art, out of which evolved more objective, aesthetic responses.

During the Renaissance the idea of art as something separate and apart from life emerged. The artist was no longer a mere craftsman, but an intellectual. The surge of interest in classical antiquity manifested itself in the art. Human figures, outwardly beautiful and powerful looking, implicitly blended pagan antiquity and Christian themes to create the optimistic scenarios of Renaissance art. At the same time, perhaps also inspired by classical sources, artists adapted a more objective—in a loose sense, scientific—attitude toward the natural world, and attempted to present ever more accurate and convincing images of it.

These two aims for art—the realization of ideal beauty and of truth to appearances—were united in the work of artists working in the High Renaissance, that is, in the years roughly between 1500 and 1520. Artists like Leonardo, Raphael, and Giorgione (see Figs. 5-6, 6-13, 7-17, 12-7, and Color Plate 8) selected the most beautiful examples in nature as their models and then proceeded to improve upon them (Fig. 11-2). They established an ideal for art: the beautiful and imaginative handling of natural forms, faithfully represented while also expressive of an ideal state of being.

In the sixteenth century artists and their audiences praised individuality in works of art. Baroque artists of the seventeenth century expanded the range of

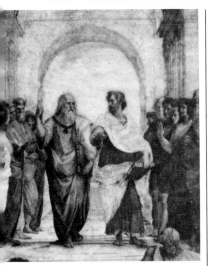

11-2 (left)
Raphael Sanzio, *The*
School of Athens, **1509-**
11, detail. Stanza della
Segnatura, Vatican,
Rome.

11-3 (right)
Rembrandt van Rijn,
Hendrickje Bathing in a
Stream, **1654. Oil, 24⅜″**
× 18½″. Reproduced
by courtesy of the
Trustees, The National
Gallery, London.

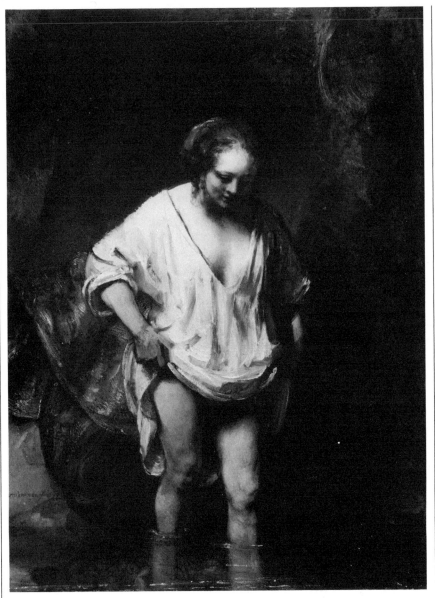

subject matter beyond the noble and idealized to include landscape, still life, and prosaic subjects. The depiction of psychological states was of particular interest (Fig. 11-3). It was in the late Baroque period that the word ''pleasure'' was first used as a critical term for art. In 1719 the French critic Jean Baptiste Dubos wrote that ''the first aim of painting is to move us,'' and in 1760, a prize was established in the French Academy for the depiction of ''expression''—that is, expression of emotions.

Eighteenth-century critics insisted that noble subject matter and elevated feelings alone provided art with its proper content, but in the nineteenth century,

Romantic artists and critics exalted *all* human feelings, not just the noble or heroic ones, and broadened the range of subject matter to include what was exotic, mysterious, morbid, and frightening (Fig. 11-4). Romantic painters found new meaning in nature. Romantic landscapes were given a character that carried them beyond the merely picturesque; at times, as in the work of Caspar David Friedrich (Fig. 11-14) and Frederic Church (Fig. 11-1), landscapes were experienced as expressions of the glory and grandeur of God.

*F*ine works of art would never become dated if they contained nothing but genuine feeling. The language of the emotions and the impulses of the human heart never change.

—**Eugene Delacroix, 1854**

The idea that art was first and foremost a vehicle for the self-expression of artist, musician, author, or poet, occurred to people during the Romantic period. Around 1830, Friedrich wrote, ''A painter should not merely paint what he sees in front of him, he ought to paint what he sees within himself.'' The public began to look for individuality, daring, and passion in works of art. By mid-century, the more temperate qualities of ''sentiment'' and ''feeling'' would also be admired.

At mid-century, Realist painting spurned the exotica of Romanticism and connected art with truth, which it promoted as the core content and sole interest of art. Realist artists such as Courbet and Millet expanded the content of art by focusing on the working class and on peasants. In painting these subjects without idealization, without ingratiating them to the viewer, these artists brought politics into the content of art. Art had always borne a message, but not until the Realist movement was shock value a part of the content of painting. Manet's paintings *Luncheon on the Grass* (Fig. 11-5) and *Olympia* presented nudes that looked like contemporary people without their clothes, scandalizing a public unaccustomed to the indelicateness of truth.

Manet went on to paint pictures in which the narrative, or story, was of so little importance that people thought he had emptied his paintings of content. But he had found new meaning in experiments with form. His flattened volumes, seemingly casual compositions, and loose brush technique seemed fresh, immediate, and modern. They inspired the Impressionist painters who followed him. To the public, Impressionist paintings looked incomplete. Their surfaces appeared like a jumble of paint, and they didn't seem to have any message. But before long people learned to look at those paintings in a new way. They discovered a world of light and color and atmosphere that no painting had ever previously achieved. People realized that dramatic subject matter was not essential to a painting, and

11-4
Eugène Delacroix,
Massacre at Chios,
1822-24. Oil on canvas,
13½′ × 11¾′. Louvre,
Paris.

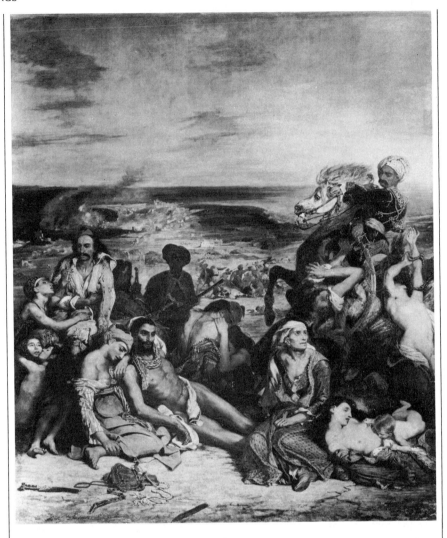

11-4
Eugène Delacroix, *Massacre at Chios*, 1822-24. Oil on canvas, 13½′ × 11¾′. Louvre, Paris.

they discovered that the action of the paint itself could be beautiful and uniquely expressive (Color Plate 26).

In the late nineteenth century, artists found that meaning could be communicated by abstracting natural forms. This idea was investigated by artists of the twentieth century. Abstract art initiated its audience into the life of form; to the inherent expressiveness of paint, shape, line, color, and material. As painters explored paint, sculptors likewise explored material and space, and architects became interested in exploring pure architectural form, rather than in reviving older styles. Twentieth-century art has uniquely taken its own forms as content. Like abstract art, Dada and Surrealism were involved with the idea of mystery and ambiguity. Dada opposed aesthetics and made absurdity a subject (Fig. 11-6). Later, Surrealism brought dreams and the unconscious into the content of art (Fig. 11-7).

Abstract Expressionist painting was the first American style to exert influence abroad. Developed in New York City in the 1940s and 1950s, Abstract Expressionism involves us with the creation of the painting—an intuitive, open-ended activity that is finished only when the painting locks together through a logic of its own. That give and take between painter and painting, as old as art itself, is powerfully expressed in the canvases of Arshile Gorky and Jackson Pollock (Fig. 11-8). There, accident and spontaneity play key roles. Pollock spread large, bare canvases on the ground. Then he worked around them like a dancer, pouring paint directly onto the surface or trailing ribbons of paint across the composition from the ends of paint-dipped sticks and worn brushes. Perhaps no other painter had ever been so closely involved with his canvas—Pollock referred to himself as being "in" the canvas when he painted. Nor had painting ever presented as content the process of its own creation.

Abstract Expressionist painters such as Franz Kline and Willem de Kooning (Fig. 11-9) continued to work with the idea of paint as a vehicle of content. Their

11-5
Edouard Manet, *Le Déjeuner sur l'herbe (Luncheon on the Grass)*, **1863. Oil on canvas, approx. 7′ × 8′10″. Louvre, Paris.**

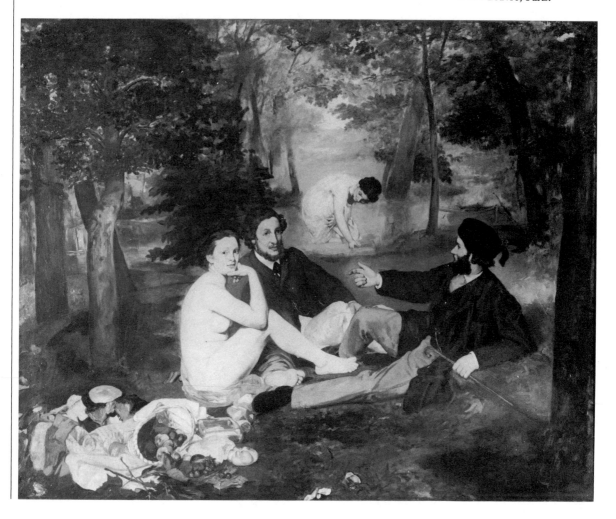

rapid-fire, slashing brushstrokes and sudden shifts of direction brought a sense of gut level instinct and raw energy to their art.

Later abstract painting, such as that of Minimalist painters in the 1960s and 1970s, took overt emotion and its vehicle, the spontaneous gesture, out of painting, and thus seemed to empty painting of the presence of the artist. Even content, ever open to question in abstract art, seemed dismissed, as artists insisted on the absence of allusions to either subject matter or values outside of the painting itself. However, by this rejection of ulterior meanings, these artists believed that they were better able to focus in on the idea of the painting as its own content (Fig. 11-10).

Concurrent with Minimalism in the 1960s, Pop Art broke onto the scene. Like Dada before it, Pop Art found content in everyday objects of the real world. Like Minimalist art, Pop explored the idea of removing traces of the painter, his moods and feelings, from the work of art. This idea had already surfaced in the inscrutible objects of Dadaists like Marcel Duchamp (see Fig. 8-13), Man Ray (Fig. 11-6), and Meret Oppenheim, and was to be taken even further in post-modern art.

Pop Art parodied life, and even parodied art itself with its images based on advertising art, billboards, comics, and even fine art. Like the Dadaists, Pop artists such as Tom Wesselman, Andy Warhol (Fig. 11-11), and Claes Oldenburg (Fig. 11-12), brought a new kind of wit and humor to art: not by depicting wit and humor, but by making witty and humorous objects. Oldenburg's giant sculptures—some of them realized as public monuments—celebrate the droll objects that mark the days of our lives: lipstick, Good Humor ice cream bars, electric light plugs, ice bags. His sculptures function as visual puns; in his public appear-

11-6
Man Ray, *Enigma of Isadore Ducasse,* **1920. Construction of sewing machine wrapped in cloth tied with cord. No longer extant.**

ances Oldenburg delights in his audience's contributing their ideas as to what his sculptures mean to them.

Although the public could easily perceive the humor in Pop Art, there was a dark, satirical side as well. Perhaps it was this combination of humor and irony that gave Pop its power.

The legitimacy of personal and private interpretations of art is fundamental to post-modern art. At the same time, some post-modern artists have seen their work primarily in terms of the imparting of specific, ''nonartistic'' information. The content of art is as important as it always has been, but it now falls to each artist to decide for himself what his art will say and how precisely delineated his statement will be. Ideas about what art can mean, and how it can communicate meaning, are among the issues engaging artists today.

Over the years, ideas about what art can encompass have changed considerably, just as ideas about what is meaningful or significant have changed in the culture as a whole. The exchange is reciprocal: art reflects, but also influences these changes. While changes in the content of art are inevitable, it is well to remember that they are made by individuals, each of whom struggled to extract meaning from experience and incorporate it into tangible form.

Blind Spots

We have all heard people say things like, ''Art is a matter of taste,'' and ''I know what I like.'' Beneath these statements is the simple truth that people tend to enjoy what is familiar to them, and to shun what is unfamiliar. Those who say, ''I don't like that,'' may very likely be saying, ''I don't understand that.''

11-7
Salvador Dali, *The Phantom Cart*, 1933. Oil on wood, 6¼″ × 8″. Yale University Art Gallery, New Haven. (Gift of Thomas F. Howard.)

11-8
Jackson Pollock,
Number 1, 1948, **1948.**
Oil on canvas, 5′8″
× 8′8″. Collection, The
Museum of Modern Art,
New York. Purchase.

How far can we go to untie ourselves from what we know about and are sure of? Art history is filled with examples of the rejection of artists, of styles, and of the treasures of entire cultures, either through misunderstanding of their aims and standards or because they conflicted with prevailing taste. As you read these examples, ask yourself: what were the blind spots that prevented understanding?

■ The Aztec and Inca empires produced spectacular objects in gold and silver. Looted by the Spanish in the sixteenth century, these objects were valued not for the art, but for their metal. Consequently, practically all of them were melted down for bullion. It is reported that in 1533 Pizarro's soldiers melted down eleven tons of Inca gold objects. Those few objects spared and sent to Spain were reduced to bullion in the Royal Mint by order of the king.

■ Michelangelo is reported to have said in conversation that Flemish painting "will appeal to women, especially to the very old and the very young, and also to monks and nuns and to certain noblemen who have no sense of true harmony," and added that it was "without substance or vigor."

- In 1566 El Greco offered to cover Michelangelo's *Last Judgement* with a mural of his own that he claimed would be more modest and just as well painted.

- In 1644 John Evelyn, an educated Englishman on tour in Europe, described Gothic architecture (see Figs. 3-1 and 3-3) as "congestions of heavy, dark, melancholy, and monkish Piles, without any just proportion, Use or Beauty."

- In 1724 the Spanish painter Antonio Palomino called El Greco's late work "contemptible and ridiculous" (see, for example, Fig. 7-4).

- Early in the seventeenth century, Caravaggio (see Color Plate 24 and Fig. 13-9) was said by the Italian art critic Giovanni Battista Agucchi to have "deserted Beauty."

- Later in that century, Francesco Albani, an Italian painter, said of Caravaggio's followers (see, for example, Fig. 11-13) that their manner "is the precipice and total ruin of the most noble and accomplished art of painting." He blamed them for an art "now totally depraved, for these fellows illustrate no thoughts, nor do they even introduce any thoughts in what they represent."

- In 1809 the German art theoretician and critic, F.W.B. von Ramdohr wrote that he saw in Caspar David Friedrich's altar painting, *Crucifixion in the Mountains* (Fig. 11-14), a tendency "dangerous to good taste . . . and the dreadful omen of a rapidly onrushing barbarism."

- In 1877 the noted art critic John Ruskin wrote the following in reference to a painting by James McNeill Whistler (Color Plate 27):

 "For Mr. Whistler's own sake, no less than for the protection of the purchaser, Sir Coutts Lindsay ought not to have admitted works into the gallery in which the ill-educated conceit of the artist so nearly approached the aspect of wilful imposture. I have seen, and heard, much of cockney impudence before now; but never expected to hear a coxcomb ask two hundred guineas for flinging a pot of paint in the public's face."[4]

- Vincent van Gogh (see Color Plate 5 and Fig. 15-4), who is among the most popular artists in the world today, sold only one painting in his entire life. After his death in 1890 his brother Theo was unable to arrange for an exhibition of his paintings.

- In 1913 Theodore Roosevelt visited the "Armory Show," which introduced European modern art to the United States. Afterwards he wrote:

 "Probably we err in treating most of these pictures seriously. It is likely that many of them represent in the painters the astute appreciation of the power to make folly lucrative which the late P.T. Barnum showed with his faked mermaid. There are thousands of people who will pay small sums to look at a faked mermaid; and now and then one of this kind with enough money will buy a Cubist picture, or a picture of a misshapen nude woman, repellent from every standpoint."[5]

11-9
Willem de Kooning,
Woman I, 1950-52. Oil
on canvas, approx. 6′4″
× 5′. Collection, The
Museum of Modern
Art, New York.
Purchase.

In addition to limited understanding, religious and political zealousness have
played a major role in the condemnation and destruction of art. In chapter 4, I
mentioned the pillaging of art by reformers of various persuasions anxious to
purify a religion or a society. But the ideological hatred of the art of a particular
country or culture is not a thing of the distant past. In the twentieth century,
modern art has been regarded as subversive in the United States, suppressed in
the Soviet Union and in China, and destroyed in Nazi Germany. United in
their condemnation of modern art, Nazis, Communists, and certain
conservative Americans created a curious situation: the Nazis condemned it as
"degenerate," "Bolshevik," and "Jewish," the Communists labelled it

11-10
Frank Stella, *Die Fahne Hoch,* 1959. Black enamel on canvas, approx. 10′ × 6′. Collection of the Whitney Museum of American Art. (Gift of Mr. and Mrs. Eugene Schwartz and purchased through the generosity of Peter M. Brandt, The Lauder Foundation, The Sydney and Frances Lewis Foundation, Philip Morris Incorporated, Mr. and Mrs. Albrecht Saalfield, Mrs. Percy Uris, and the National Endowment for the Arts, Acq. #75.22.)

''decadent'' and ''bourgeois'' (that is, Western), and the Americans saw it as ''communistic.''

All of these examples should prompt us to ask what blind spots we might have as a society. What might we—all of us—be neglecting, dismissing, condemning, or destroying because we are unprepared to find meaning in it?

Awareness

We like to think of ourselves today as a bit more broadminded, and perhaps we are. It would not have occurred to earlier generations to ask themselves what their blind spots might be. Today art's public—and here I refer to people who involve themselves in an ongoing way with art and the ideas it raises—tends to be tolerant. It hasn't always been that way, of course. Compared to ours, most societies have been more restrictive and conservative. What makes us different?

To begin with we live in a shrinking world characterized by the commingling of cultures. Exposure to other cultures has made us more aware of the wide range of art; what was strange and exotic no longer seems alien.

Furthermore, we have a century of modern art behind us—an art forged by strong-willed individualists. We are aware of the bitter struggles of avant-garde artists against a smug and self-righteous art establishment. With their example in mind we are less likely to condemn individual work that we don't understand; we are, perhaps, more patient and willing to learn.

Abstract art has contributed immensely to the education of our vision. It has led us to a renewed appreciation of art and artists whose formal language was highly developed, such as early Greek sculpture, Russian icons (see Fig. 4-5), folk art, and the art of non-Western cultures. Fifteenth-century painters such as Fra Angelico (see Fig. 5-14), and Piero della Francesca (see Fig. 6-1), once termed ''Italian Primitives,'' are now recognized and admired for the beauty and expressiveness of their compositions. Tintoretto (Fig. 12-8), and El Greco, whose expressionistic distortions of figure and space (see Figs. 5-19 and 7-4) caused their reputations to be severely disparaged, are now admired for these qualities. The twentieth century has elevated the reputations of the seventeenth-century painters Georges de la Tour (Fig. 11-15) and Vermeer (Color Plate 17) and the eighteenth-century painter Chardin (see Fig. 13-10), all of whom endured a long period of obscurity.

In the mid-nineteenth century, Realist painting encouraged the reappraisal of the Le Nain brothers (see Fig. 9-2), whose objective paintings of peasant life had condemned them to oblivion. Renewed interest in Hieronymous Bosch (c. 1450-1516) occurred in the late-nineteenth century, when individuality and imagination in art were highly valued (Fig. 11-16). The Surrealist movement of the 1930s, fascinated with dreams, fantasy, and the unconscious, drew attention to the work of this long neglected painter.

Individual artists have helped us to look at unfamiliar art with new eyes. Inspired by the art of Japan and Africa, Whistler, Toulouse-Lautrec, Picasso and others made it possible for the public to appreciate that art (see Figs. 7-5 and 7-6). Mondrian helped the public to penetrate beneath the picturesqueness and the

symbolism of seventeenth-century Dutch church interiors (see Figs. 7-14 and 7-15).

The recent interest of a number of painters and photographers in the narrative aspect of art, and the strong current of representational painting in the 1970s and 1980s, has led to a revival of interest in Academic painting of the nineteenth century. Long condemned to the lower depths of art museums, paintings by old "war-horses" such as Landseer, Gérôme, Cabanel, and Bouguereau (Fig. 11-17)

11-11
Andy Warhol, *100 Cans*, 1962. Oil on canvas, 72″ × 52″. Albright-Knox Art Gallery, Buffalo, New York. (Gift of Seymour H. Knox, 1963.)

11-12
Claes Oldenburg, *Giant Three-Way Plug,* **1970. Cor-Ten steel and polished bronze, 60⅞″ × 120⅝″ × 78″. Allen Memorial Art Museum, Oberlin College. (Gift of artist and Fund for Contemporary Art, 70.38.)**

have been dusted off and proudly displayed to a public ready to admire their pictorial imagination and fastidious brush techniques. In 1981, Landseer was given a retrospective at the Philadelphia Museum of Art; in 1984 and 1985, Bouguereau was given a major show in Paris, Montreal, and Hartford, Connecticut.

The art of the past is constantly reappraised in light of what contemporary artists teach the public to see. Once having slipped into the past, however, a work of art can never be the same. We can't possibly experience the bulls of Lascaux (see Fig. 4-3), the statue of Mycerinus (see Fig. 6-2), or the legs, garters, and pink-ribboned shoes of Louis XIV (see Fig. 5-10) as they were experienced by their intended audiences. We wonder: What might be missing? What meanings might have gotten lost? Can the original meanings be retrieved?

Art Historical Research

Art historians attempt to provide answers to these questions. They uncover and interpret information that yields greater understanding of what we see. A good

11-13
Bartolomeo Manfredi, *Fortune Teller*, c. 1610-15. Oil on canvas, 47⅝″ × 60″. Courtesy of the Detroit Institute of Arts. (Founders Society Purchase, Acquisitions Fund.)

example is Erwin Panofsky's investigation of Jan van Eyck's unusual double portrait of the Arnolfini couple (Color Plate 28).[6] This painting, discovered in Brussels in 1815 by an English officer, was believed to be one described in earlier accounts, in which the couple was identified as Giovanni Arnolfini and Jeanne de Cename—but those early descriptions did not match the present painting. Was it the same painting? And if not, who is the couple? Panofsky's detective work reveals that the earlier descriptions were written by individuals who had not actually seen the painting, but who were simply repeating what they had read about it. Panofsky traces these accounts to an original unknown source who did see the painting. He conjectures that the confusion occurred when a Latin legal term used by that source to describe the couple joined ''by faith'' in marriage was misunderstood to indicate the presence of a third figure—Faith—who conducted the ceremony.

Why might that term, ''by faith,'' have been used in the original description? Panofsky points out that the Catholic Church at that time recognized the legitimacy of a marriage of ''mutual consent expressed by words and actions.'' The marriage was formalized by (1) the pronouncement of a formula by the bride and repeated by the groom and which the groom confirmed by raising his arm; (2) by a pledge generally represented by a ring; and (3) by the joining of hands. As you can see, all of these are depicted in the painting.

Above the mirror on the back wall we find the curious inscription, in Latin, ''Johannes de Eyck fuit hic (Jan van Eyck has been here) 1434.'' The meaning of the inscription—and the painting—now becomes clear. Van Eyck not only signs the painting as the artist, but identifies himself as a legal witness to the ceremony.

The painting is to be understood, in Panofsky's words, as a "pictorial marriage certificate."

Panofsky suggests that this "certificate" further confirms the identity of the figures. Since neither of them had relatives in Bruges, where they lived, the usefulness of a portrait that is also a document is understandable.

Panofsky then inquires about the remarkable realism of the painting; its meticulous revelation of an interior, the objects within it, and the minute descriptions in paint of a variety of materials and their precise textures. Do these objects just happen to have been there, as Van Eyck seems to be saying? Is the realism, then, an example of a modern attitude, where a painting is made for the pleasure it gives us? Or may we find here the medieval interest in allegorical or symbolic meaning in objects we see? How would the scene have been understood in its time?

Panofsky reminds us that the scene takes place in a bedroom and not in a living room, and thus relates to the sacrament of marriage. Symbols are indeed abundant. The single candle burning in the chandelier, having no practical usefulness as daylight fills the room, represents both the wisdom of God and, more specifically, the marriage ceremony. On the back of the armchair is a carving of St. Margaret, patron saint of childbirth. The couple has removed their shoes, an

11-14
Caspar David Friedrich, *The Crucifixion in the Mountains,* **1808. Oil on canvas, 46″ × 44″. Staatliche Kunstsammlungen, Dresden.**

11-15
Georges de la Tour,
Joseph the Carpenter, c.
1645. Oil on canvas,
39″ × 26″. Louvre,
Paris.

allusion to the biblical verse in which God admonishes Moses to remove his shoes, ''for the place whereon thou standest is holy.'' The dog, like the candle, is a symbol of faith.

But these objects and their meanings are not thrust upon us in a way that would make them obvious or intrusive. Rather, there is a *disguised* symbolism here. Everything seems natural, seems to belong. Still, it is not a casual event we observe. Van Eyck's symmetrical composition gives a sense of solemnity and suggests that deeper meanings reside in the scene.

The fitting together of the symbolic and the realistic gives the painting its special charm. In Panofsky's words, ''medieval symbolism and modern realism are so perfectly reconciled that the former has become inherent in the latter.''

11-16
Hieronymus Bosch,
Hell, right panel, from
*The Garden of Earthly
Delights*, c. 1500.
Detail. Oil on panel,
approx. 7'2" × 3'.
Prado, Madrid.

This brief account of Panofsky's investigation shows how art historical research can illuminate a work of art. Panofsky takes a lovely but puzzling painting and gives it a context and a history, tells us who is in it, explains why it was painted, how symbols were incorporated, and their meaning, analyzes the effect of the composition, and reveals a number of the aims of the painter. This information helps us to see beyond the surface of the painting and to appreciate all that we are seeing.

How Other Fields Contribute

Art historical research is aided by information derived from other fields. Let's take a look at some of these areas now, and see what they have contributed to our understanding of works of art.

Psychology has trained us to look for unintended meanings in works of art. Studies in the psychology of perception have helped broaden our understanding of art and the development of artistic styles. Perceptual psychologists have attempted to explain how and why we react as we do to lines, shapes, patterns of composition, and colors. Psychological studies have attempted to answer questions such as: What are the limits of artistic freedom? How does art communicate feeling? What psychological factors affect our response to a work of art?

The psychological approach has not only brought insight into the art, but it has also encouraged the study of the history of aesthetics, of taste, and of criticism. Psychoanalysis has also made contributions to our understanding of art. A number of psychoanalytical studies of artists have been made based on their work, including a famous study of Leonardo da Vinci by Sigmund Freud. The psychoanalytic approach stresses the individuality of the artist.

Other approaches emphasize the cultural and social context of the art. Anthropology has yielded understanding and appreciation of cultures previously regarded as bizarre. Anthropologists have been able to show the connections between the culture and its art, thereby providing some of the keys to understanding the art. We now know more about such things as the role of the artist in a society, the status of the artist, the degree of artistic freedom and the restrictions, methods of artistic production, the meaning of the traditional designs and motifs, and the role and function of the art within its own culture.

Special studies have enabled us to see some of the ways that religion, philosophy, politics, and economics have shaped the art. Most scholars try, in a dispassionate way, to supply missing pieces. Among them, theorists suggest ways of looking at art history. In particular, Marxist art critics affirm that politics and economics determine the form and purposes of works of art.

Historical scholarship and documentation have contributed to our understanding of the contexts in which art occurs. Translations and publications of documentary material—books, articles, speeches, letters, diaries, even contracts between artist and patron—have proliferated in recent years. The interpretation of historical data by art historians is gradually revealing more and more about art and artists of the past. Consider the following example:

In the early 1980s, the Australian architect and art historian John James pinpointed on a map over one thousand Gothic churches built between 1140 and

1240 in the Paris Basin, an area containing many towns and cities, including Paris. James's map revealed something curious. He discovered an unsuspected density of building in the region of Soissons, northeast of Paris—a density exceeding that of Paris and its region. What could account for all that building in Soissons? After examining a number of possible explanations, James investigated the economy of Soissons in the twelfth and thirteenth centuries. He found that,

11-17
William Bouguereau,
Nymphs and Satyr,
1873. Oil on canvas,
102⅜″ × 70⅞″. Sterling
and Francine Clark Art
Institute, Williams-
town, Massachusetts.

unlike today, Soissons contained many vineyards, and that these vineyards were great commercial enterprises. Further research revealed that the summers between c.1200 and 1250 were extremely hot and dry—excellent weather for grapes! Records testified to enormous wine production in Soissons between 1180 and 1250, and James realized that this thriving economic base, and the cash surpluses it generated, had contributed to the boom in building.

Science and technology have also helped broaden our understanding of art and its meanings. Planes, trains, and cars get us to places our grandparents could only have read about, and allow us to experience the art and architecture in its proper setting. Photographic reproductions have made available to us virtually the entirety of the world's existing artistic output, and even some art that no longer exists. Can you imagine an art appreciation or an art history course without slides? Or an art book without pictures?

Restoration of paintings has revealed colors darkened over time. Recent cleanings have shown that many painters believed to have used a narrow range of dark colors in fact used a broad range of bright colors. A recent cleaning of Rembrandt's painting popularly called, the *Night Watch* (see Fig. 2-1), revealed that this painting in fact depicts a daytime scene.

Microscopes, X-rays, and infrared light are tools essential to the restoration of art. Knowledge of chemistry has helped not only to restore pieces that are damaged, darkened, or decayed, but to ensure their preservation. Along with the preservation of art, science and technology have contributed information about the art itself. When conservators remove damaged frescoes from the wall on which they were painted and transfer them onto a stiff backing, they may discover the artist's underdrawing. Comparing that drawing to the final painting can sometimes reveal surprising changes made by the artist as the painting took shape.

Chemical analyses of paint and canvas help us to know precisely what materials were used. This helps to determine who did the painting, where it was painted, and when. We can even learn *how* it was painted, as X-rays and infrared light reveal where the artist changed his mind along the way and added or subtracted something. One X-ray revealed the whereabouts of a missing Picasso by showing that Picasso had painted over it. An infrared photograph of Van Eyck's *Portrait of Giovanni Arnolfini and His Bride* (Color Plate 28) revealed in the underdrawing a slightly less elegant positioning of Arnolfini's raised hand.

Autoradiography—exposing a painting to atomic radiation so that it becomes slightly radioactive—can identify pigments. It can also show what X-rays miss, and likewise reveal the stages of a painting's development. Recently a self-portrait of Anthony van Dyck (1599-1641) was discovered beneath his painting of *St. Rosalie Interceding for the Plague-Stricken of Palermo* at the Metropolitan Museum of Art in New York. The self-portrait revealed that Van Dyck's eyes were blue.

Studies using radioactive isotopes are used to obtain information about pigments and to identify the metal used in sculpture. They can indicate when later applications of paint were made to a canvas and, in the case of antique sculptures, they can tell what part of the world the metal came from.

Not only have these investigations given us a stronger grasp of art, they have acted to strip away the naive prejudices and misunderstandings that inhibited that

grasp in the past. Enlightened societies in the twentieth century are replacing the old snobbish attitudes toward foreign cultures with an attitude recognizing that each culture in its own way makes sense. By overcoming prejudice we can feel our way toward others perceived to be unlike ourselves, and appreciate, enjoy, and learn from their art.

Conclusion

Art critics and historians have moved away from a worshipful attitude toward works of art and what they mean because it is now clear that they can mean many things. We can acquire a sounder and more genuine appreciation of works of art by realizing that they can hold any number of possible meanings for ourselves, as well as for others.

The meaning of a work of art is always open to interpretation. There is no key to the absolute meaning because, to the best of our understanding, there can be no absolute meaning. But there are a number of things you can do to help yourself to understand the multiple meanings that a work of art can hold. One of them is to be willing to reflect upon the piece afterwards. By turning it around in your mind, by letting it work on your imagination you give it a chance to take hold. For art of the past, an awareness of the historical context and the social background can help unlock meanings. You can learn what the artist meant the piece to be, and that can help you understand why it looks the way it does. You can also find out what the work meant to its original audience.

Don't overlook the value of reading about art, even the art of our own time. In a culture as diverse as ours, books help make connections we can't possibly make on our own. We should neither expect nor want books to "explain the meaning" of works of art, but they can provide background information and point to some of the possible meanings that may be discovered in them.

Our grasp of a work of art seems to strengthen as the object begins to recede in time. The distance and objectivity gained help to discern the framework of ideas in which the art is located. Perhaps society, too, needs to turn it around in its mind. For contemporary art the going is a little rougher. Here we must rely somewhat more on speculation and intuition, and perhaps we must be somewhat more self-aware. What makes contempory art worth knowing about is that it is the expression of our time—the artists are alive and working, and living in our world. More than any other art we see, their art talks about us, and we can interpret it in terms of our own experiences.

A work of art that is too easily understood may hold little for us. Many admirable works of art challenge us. We may not understand them at first and we may never understand them completely. But with study and reflection, we may find ourselves moving toward insight and comprehension.

It may be that every work of art contains at its core a mystery that defies explanation. If so, it is well to remember that however private or obscure, every work of art has in it something universal, and, in some way, touches upon us all.

12 | *Evaluating Art*

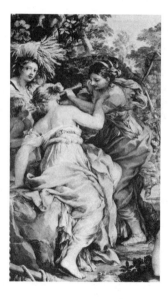

Telefomin tribe, Papua New Guinea: About once in a generation the doorboard that marks the entrance to a house needs to be replaced. The Telefomin have only two basic designs, and only one of these is appropriate for the decoration of a doorboard (Fig. 12-1). The owner of the house will carve and paint the design. His problem is to rearrange the traditional design so that his own doorboard will be distinct. There are rules as to what symbolic elements must be included. Working out a unique and attractive design within these restrictions isn't easy, but getting a good result is a matter of pride and self respect. It may take him weeks of planning and consideration. If he gets stuck he will wait for a dream to show him the way.

Mykonos, Greece: Every spring the fishermen of Mykonos freshen up the designs on their boats, which have lain idle on the beach all winter. Tassos, a fisherman, spent the month of March discussing his plans for the colors that would go on his boat. He asked the advice of anyone—Greek or foreign—who would sit down with him for a drink. From the table at his favorite cafe the boat could be scrutinized. After many suggestions and many toasts to life, to the sun, and to the boat, he bought the cans of paint and went to work. There was yellow paint, orange paint, red, and blue. Then the revisions: wouldn't it be better if the *yellow* were the stripe and the *blue* were the background? More advice. Changes were made. At last he was satisfied and the fishing could begin.

All artists have some idea of what to aim for in a work of art—but what about the audience? What do you look for in a work of art? How do you evaluate what you see? When you are at a museum, are you tempted to read the title before you say anything about the painting? Do you wait until the tour guide says something about it? Do you always agree with what you hear?

All of us wonder about the judgements we make. We're not always sure we've got it right—or sure that the other person has it right either. What

**12-1
Doorboard on house,
Telefomin, Papua New
Guinea. 1978.**

determines whether the work is good? Is it only a matter of taste? Is it a matter of tradition? Or can artistic value be judged objectively? And if so, what criteria can guide us in making those judgements?

Many people believe that artistic judgements are wholly subjective—a matter of personal preference. We tend to allow our own taste to serve as the final arbiter of what is good in art. After all, what more needs to be said for a painting than that you like it? That it means something to *you*? What could be more compelling, more solid, than that? Surely no appeal to objective standards carries the same weight as our own gut feelings.

Of course nearly everybody thinks he or she has good taste. But if subjective judgements are challenged, they fail to provide convincing arguments for quality. What would you say to someone who is crazy about a painting that you think is just about the worst thing you've seen? How can you convince someone to like what you like? Whose standards are better or higher, and how would you determine this? Whose taste would you trust? Do you trust your own taste? How would you defend it?

Objective Standards

Sooner or later, any reasonable discussion of artistic quality will have to appeal to objective standards. Personal preference by itself does not provide a basis by which to judge art. Simply to say that you like something doesn't mean that it is necessarily good, nor does it explain *why* it is good.

The argument for objective standards is a compelling one. It makes sense that a work of art is good because of some quality it has—and not because you like it. And, in addition, that quality is there forever. After all, can a work of art be good today and bad tomorrow?

Universal standards would provide a solid foundation for evaluating artistic quality. The most common criteria—beauty, effectiveness of representation, the significance of the idea or message contained in the piece, originality, and skill of execution—seem good guides to the discernment of artistic merit. They do have their problems, however. But for now, let's see what they provide.

1. Beauty is most commonly thought of as a measure for art. When we speak about beauty another person will usually know just what we mean and will, at least to an extent, concur in our response. Most people will agree that a sunset is lovely and not ugly, that the prince is handsomer than the toad, and that the Parthenon is more beautiful than a newspaper stand. So we find it sensible to conclude that beauty is self-evident, and exists beyond the caprice of individual preference, of fad, or of local tradition.

2. The capacity of art to recreate reality is universally recognized. Vivid, lifelike images inevitably command attention and admiration. Anybody can make simple designs or sketches, but it is not easy to represent solid figures in deep, believable space, or to compel a figure with thoughts and feelings to emerge from stone or clay. So both the self-evident power of

the illusion and our awareness of how difficult it is to achieve, argue for imitation as a criterion of art.

3. Works of art have frequently been evaluated in accordance with their messages. Does the piece communicate an idea or a principle that you cherish? Does it point a moral? Is it educational? If so, the piece is valued highly.

4. Another criterion for art is originality. Anybody can copy someone else's ideas. Indeed, most artists conform to popular or current styles or formats. Those few artists who broke through conventions, who developed new insights—and whose work you see here and in books on art history—are relatively few. So it seems appropriate to place originality on our list of criteria for art.

5. The most widespread criterion for artistic merit may be skill. In traditional cultures, where the art is rigidly restricted, the well-executed piece stands out and is acclaimed. The ancient Greeks admired technical skill; in the Middle Ages people praised it, and the academies of Europe enshrined it; today it is still drummed into the heads of art students. It is hard to imagine art of quality that is carelessly done.

But a closer look reveals that beauty, imitation, enlightenment, originality, and skill are undependable measures of artistic merit. Let's examine them again, one by one.

1. *Beauty*. The central problem with beauty is that no one can agree on what it is. The study of art history—or just a visit to a museum—makes us aware of considerable differences in conceptions of beauty. None of these conceptions has ever been indispensable. None has ever been applied universally. The existence of various and conflicting ideas of beauty suggests that beauty is not as self-evident as we might have supposed, and casts doubt on the reliability of any of the criteria by which it may be determined. Which idea of beauty is the truest? Whose criterion is the right one?

2. *Imitation*. As we saw in chapter 5, *Reading Paintings, no* painting simply imitates its subject. Illusions of reality are created by various means, and widely disparate versions of the same subject may *all* strike us as being "truthful" or "realistic."

 In chapter 7, *Abstract Art,* we saw that artists have never been content with imitation alone, but sought to inject something of the imagination into whatever they depicted. At times—as in the Middle Ages, in the work of abstract artists, non-Western artists, and individualists such as El Greco—imitation was regarded as an impediment to the effective expression of ideas.

3. *A precise message*. Modern art, and modern aesthetic sensibility, have called into question this venerable criterion. Modern artists have struggled to release their art from the idea that a painting is a visual adaptation of a literal statement. Visual ideas—artistic ideas—though they may be described, may not contain conventional "messages."

*B*eauty is something that one adds to buildings for ornament and richness, as occurs in gilded roofs, in precious marble incrustations, in colored paintings.

> —Isidorus of Seville (c. A.D. 570–636)

[Beauty is] a certain regular harmony of all the parts of a thing of such a kind that nothing could be added or taken away or altered without making it less pleasing.

> —Leon Battista Alberti (from *De Re Aedificatoria* [On Architecture], 1550)

*T*here is no Excellent Beauty, that hath not some strangeness in the proportion.

> —Francis Bacon (from *Of Beauty*, 1612)

*I*t is solely the power of **character** *that makes for beauty in art.*

> —Auguste Rodin, 1911

4. *Originality.* Works of art are almost never created in isolation, but are to some extent the result of influences exerted upon the creator by other artists. Works of art may be seen as the result of the mingling of ideas, and even of groups of artists working toward an idea. Impressionism was produced by a group of artists in close contact with each other. Braque and Picasso together produced Cubism. The Dadaists spurred each other on. These communal efforts produced highly original work.

 On the other hand, in some cultures tradition exerts so great an influence that originality is severely limited. An Egyptian statue, a Shaker chair, or certain African masks are capable of exciting admiration but were made according to well-established rules. Originality then, is a relative and imprecise term. At best it is useful as a measure of merit for works of art judged to be otherwise of high quality.

5. *Skill.* Sometimes skill gets in the way of quality. Certain paintings and sculptures strike us as being overly refined and therefore lifeless. At times a rougher or looser handling of the materials can be more effective, as in the paintings of Tintoretto, Manet, Van Gogh, or Picasso, or in the sculpture of Rodin. We recognize of course that these artists handled their materials adroitly. But their contemporaries deplored their techniques, which ought to suggest to us that skill is not always self-evident and therefore is not a reliable criterion of quality.

 Finally, while skill of execution can elevate an object into the category of art, it does not by itself guarantee great art. Objects of no great artistic value may be skillfully made.

Because each of these criteria is dispensable, its reliability as a basis for judgment is cast into doubt. As we have seen, art doesn't always aim at a traditional concept of beauty. Some art aims at truth. Are truth and beauty always the same? Some art aims at expressiveness, like this medieval woodcarving from Germany in Figure 12-2. Is expressiveness always beautiful? Art may be picturesque, or charming, rather than beautiful; it may be humorous, as are comic strips or animated cartoons. In art that aims to explore ideas, or to convey messages, in art that aims at supernatural efficacy or touches the faith of the viewer, like the *Pietà,* beauty may be irrelevant.

The other criteria are similarly dispensable. Most of the world's art, while attuned to things seen, has not insisted on exact representation. Much of the art and crafts that we admire, and certainly all of the architecture, is not representational at all. Many objects that we admire for their beauty may not transmit messages to us or improve us in an ethical sense. Does a vase, an abstract sculpture, or a building, have a moral? Should buildings or films be automatically considered inferior to paintings because they were made by a group of people rather than by one? Are only "polished" paintings and sculptures worthwhile?

Another thought: If we don't need all of these criteria to insure quality in a work of art, how many do we need? In what combination?

Whose Criteria Would You Use?

The identification of objective standards is made more complex by the inexhaustible diversity of art. As we saw in chapter 2, art serves many functions. Which art is best? Whose criteria shall we use to determine this?

12-2
Röttgen Pietà, early fourteenth century. Wood, 10½" high. Rheinisches Landes-museum, Bonn.

- Renaissance Europe developed representational painting to a high degree of excellence, and saw the human figure as the chief subject. But the Islamic world produced a complex art of abstract forms, condemning figurative images as idolatrous.
- Creativity and originality are highly valued today in judgements of artistic quality. In ancient Rome, however, exact copies of statues were thought of as no less valuable than the original model.
- In eighteenth-century Europe, the fine arts were distinguished from the lesser, or decorative, arts by virtue of their having no utilitarian purpose. That distinction was inconceivable in the Islamic world, where the best efforts of artists were devoted to the enrichment and embellishment of useful objects such as books, lamps (see Fig. 15-2), pitchers, plates, beakers, rugs, tiles, and the like.
- In the Tiv society of central Nigeria, most of the arts and crafts are produced communally. Designs initiated by one person are completed by others without any prearranged plan. In Chinese art, on the other hand, individuality was cultivated to such an extent that the very brushstrokes characteristic of an artist would be subject to discussion.
- The greatest art of the Middle Ages aimed to draw people closer to God. Since the Renaissance much of the art has been secular in orientation.
- In eighteenth-century Europe great importance was placed on the subject matter of a work of art. Modern art has tended to stress form.
- In nineteenth-century academic art, technique and skill of execution were highly valued. In our culture, art may be produced by a camera or even by a duplicating machine.

These examples undermine the reliability of artistic standards as absolutes. But they demonstrate that artistic standards are a reflection of specific cultural preferences and traditions. Every culture ascribes values to art in accordance with its own particular needs and interests. Thus, critical judgements reflect the outlook of their time, just as the art does. This helps us to understand why changes in criteria for art must occur as inevitably as the changes in art itself. These criteria can give us insights into the culture, as well as provide a basis for understanding and appreciating the art.

The Changing Forms of Art

In chapter 10 we saw that art in Western civilization gradually expanded to include wider possibilities for content. As this occurred, the forms of art also changed. Since form is the means through which content is conveyed, a change in one necessarily meant a change in the other. New ideas about what art could contain meant new ideas about how art should look, and new criteria for artistic quality.

Once again, we are going to take a brief journey through Western art. This time we shall look at some of the visual answers provided at different times to the

questions, What constitutes artistic quality? What should artists aim for? What looks right? Of necessity, we shall survey the art that is most characteristic of its time.

The ancient Greeks focused on the human form. They simplified it, but at the same time created images that were amazingly lifelike. They placed a great value on beauty, and to this end sought not only to imitate but—as in the statue of Poseidon or Zeus in Figure 12-3—to idealize the human form. This idealizing was realized in terms of harmonious proportions of the parts, as well as overall gracefulness. Architectural beauty was conceived in similar terms; proportion, balance, simplicity, and order were all greatly admired (see Fig. 3-5).

Greek sculpture of the early and classical periods aimed at ideal types. Later, a taste for particularity was developed, and the first statues that purported to be individual types appeared. The idea of art as evoking images of reality brought to perfection was revived sporadically in the Roman period and again in the Renaissance.

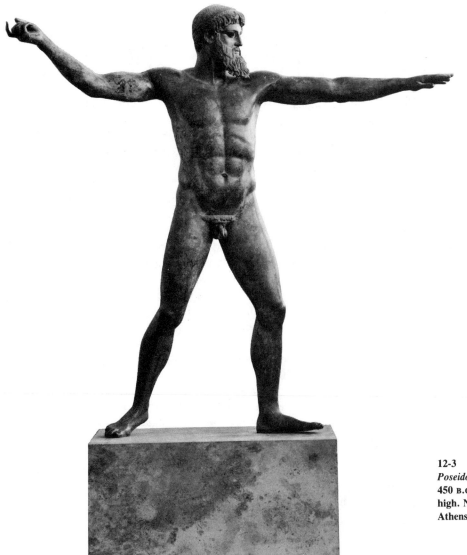

12-3
Poseidon (or *Zeus*), c. 450 B.C. Bronze, 6'10" high. National Museum, Athens.

The Romans based their art largely on that of the Greeks. But while they appreciated an art of ideal forms, their taste was for something more down to earth. They liked portraiture and believed that facial expressions should communicate principles of conduct such as dignity, piety, and honor. Their art told stories and described events. Like their architecture and their engineering, it was valued for its usefulness as well as for its beauty. On the Column of Trajan, for example, (Fig. 12-4), the campaigns in Dacia (now modern Rumania) were depicted in careful detail for the folks at home.

In late Roman art, classical principles of imitation and beauty gradually lost out to a more abstract art capable of making succinct statements. Solid, sculptural volumes in a three-dimensional space yielded to a preference for flat shapes and ambiguous space; harmony and proportion gave way to a crowding of figures or to monotonous repetition.

The Medieval Christian world, oriented to the afterlife, regarded an art that represented the beautiful things of this world as improper and out of place. Thus it fostered an art of abstract images with symbolic meanings (Fig. 12-5).

Throughout the Middle Ages—roughly a period of a thousand years—we find a great diversity of styles. Early Christian art was based on classical principles of balance and uniformity, and it perpetuated the classical interest in the human figure. The so-called barbarians (a term used by the Romans to designate the Germanic tribes not under their influence) developed an art characterized by vigorous, abstract linear designs. The fusion of these two traditions—classical and Germanic—was complete by the Romanesque period (roughly the eleventh and twelfth centuries). Artists of this period were expected to follow prescribed formulas in the depiction of sacred subjects, but for nonreligious subjects, they were freer to draw upon the earlier, Germanic artistic traditions, as well as upon their own imagination (Fig. 12-6).

Statements from the Middle Ages about quality in art tended to focus on the workmanship and on the costly materials used. Rich colors, and substances that transmit or reflect light, such as gold, precious stones, or, in the Gothic period, stained glass, were especially admired (see Color Plate 1).

Medieval painters and sculptors tended to copy earlier models, though the more creative artists introduced their own variations. Medieval art was heavily symbolic, and involved with communicating the concept or idea of the story. While this remained true to the end of the Middle Ages and even into the Renaissance, we find in the Gothic period a growing interest in recording the actual appearances of things.

In the thirteenth century, Gothic architecture—light, airy, and spatially unified—grew out of the darker, heavier, more compartmentalized Romanesque. The Gothic cathedral became a symbol of the Heavenly City of Jerusalem. Its integration of innumerable, variegated forms (see Figs. 3-1 and 3-3) accords with a concept of the universe as an immeasurable, multiform pattern.

Renaissance taste rejected the Gothic tendency toward elaboration, and set simplicity, measure, and proportion as a value. Renaissance architecture was inspired by the forms of Roman architecture and its detail. Roman statuary provided types which Renaissance painters and sculptors sought to emulate. The return to art as imitation that began in the late Middle Ages was assiduously

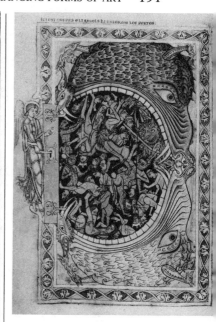

12-4 (upper left)
Column of Trajan, detail of the three lowest bands, A.D. 113. Marble, bands approx. 36″ high. Rome.

12-5 (right)
Angel Locking the Damned in Hell, Psalter of Henry of Blois. Mid-twelfth century. British Library, London.

12-6 (lower left)
St. Pierre, Romanesque capital from cloister. Moissac, twelfth century.

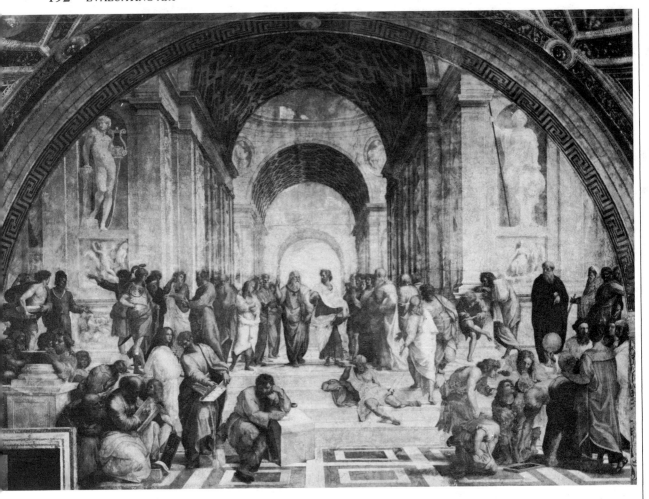

12-7
Raphael Sanzio, *The School of Athens,* **1509-11. Fresco in lunette, 25′ 3¼″ at base. Stanza della Segnatura, Vatican Palace, Rome.**

pursued in the Renaissance. The classical principles of balance, harmony, and order, having found their way back to painting, now gave images of an ideal world, perhaps nowhere more clearly stated than in Raphael's mural, the *School of Athens* (Fig. 12-7).

The balanced and unified world of Renaissance art was countered by conflicting principles in the sixteenth century. An independent style—Mannerism—altered the calm, harmonious relationships of Renaissance art and architecture in order to create drama, diversity, and surprise (Fig. 12-8). In painting and sculpture, conception and imagination seemed preferable to the Renaissance ideals of imitation and the perfection of things observed.

The Baroque style of the seventeenth century continued the Renaissance celebration of the material world, though in far more sensuous terms. Human figures attained heroic proportions, and were placed on a stage even more grand than that of the Renaissance (Fig. 12-9). Baroque architecture created splendid, theatrical settings for public events. Complexity, both visual and psychological, was val-

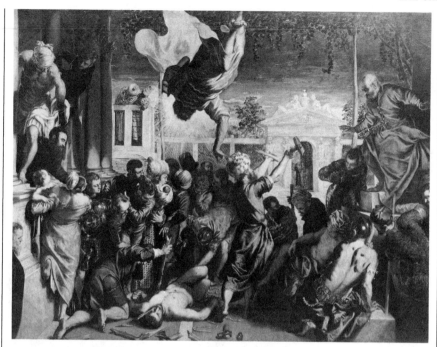

12-8
Tintoretto, *Miracle of the Slave,* **1548. Oil on canvas, approx. 14′ × 18′. Galleria dell'Accademia, Venice.**

ued, and contributed to a preference in art and architecture for movement, vivacity, and exuberance.

Some seventeenth-century artists and critics condemned the untidiness of this particular Baroque aesthetic, and rallied around classical values of restraint and decorum. Deploring sensuous color and voluptuous shapes in painting, artists like Poussin promoted a more austere style of precise edges, grayed color, and stable forms in a clear atmosphere (Fig. 12-10). In architecture, ornate Baroque decoration was discarded in favor of spare, measured, classical forms.

In the eighteenth century, resistance to the sober classical aesthetic was vigorously maintained, and sensuousness found expression in the style called Rococo. Emanating from the court of Louis XV, it quickly became fashionable throughout aristocratic Europe. Essentially a more delicate and decorative version of Baroque, Rococo sought to please the eye rather than appeal to the mind. The value of a painting was measured by the pleasure and delight it would give. With its pastel colors, graceful, curvilinear lines, and innocuous scenes, the Rococo style is associated with elegance to this day Fig. 12-11).

But the classicizing tendency persisted throughout the eighteenth century. During this period it was reinvigorated by the discoveries of the buried Roman cities of Pompeii and Herculaneum. By the time of the French Revolution, Rococo painting had given way to an art of hard, clear, stable forms deriving from classical antiquity, and recalling the paintings of Poussin. This style, called Neoclassicism, consciously aimed to evoke the dignity and moral seriousness it found in Greece and Rome, and thus to infuse a high moral tone into art (Fig. 12-12). Because it seemed an appropriate expression of the ideals of the Revolution, Neoclassicism became the official style of the French Academy.

12-9
Pietro da Cortona, *Age of Silver,* 1637. Fresco. Palazzo Pitti, Florence.

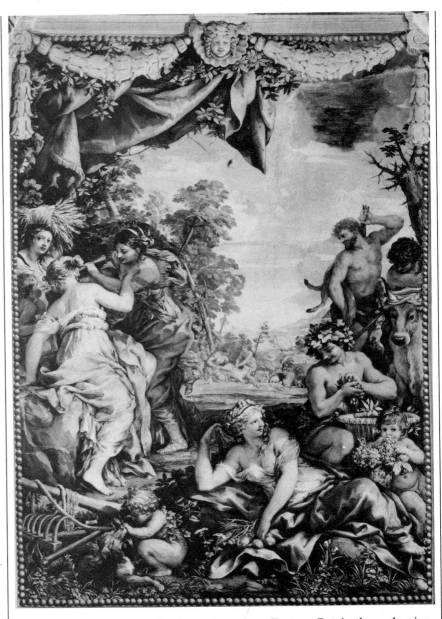

Neoclassicism became dominant throughout Europe. But in the early nineteenth century, it was opposed by the Romantic painters, who valued an art that would be more subjective, and whose forms would convey the feelings of the artist through bright colors, wild shapes, and rough and tumble brushstrokes. The Romantics saw their art as less artificial and more natural; in their desire to escape the increasingly dry themes of the Academy they tended to shun classical antiquity, turning instead to the more exotic Middle East, to the Middle Ages, and to the natural landscape (Fig. 12-13).

Some artists of the mid-nineteenth century regarded both Neoclassical and Romantic art as escapist. Instead, they sought to record life as it is. Committed to

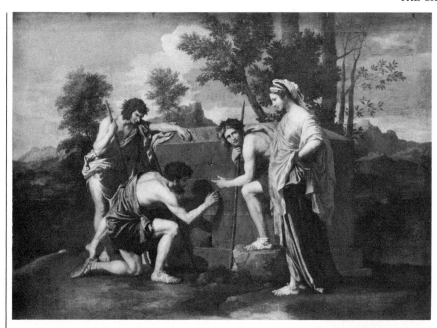

12-10
Nicholas Poussin, *Et in Arcadia Ego*, c. 1655 (?). Oil on canvas, 32½″ × 47⅝″. Louvre, Paris.

12-11
Antoine Watteau, *Embarkation from the Isle of Cythera*, 1717-19. Oil on canvas, 50″ × 76″. Louvre, Paris.

painting the truth, the Realists, and related artists, showed ordinary landscapes, unidealized and unromanticized, and treated plain, working-class people and peasants with similar objectivity (Fig. 12-14). Their use of direct, unrefined brushstrokes brought a sense of immediacy to the subject, and emphasized their belief that the message contained in the art is more important than the beauty of the image.

Impressionists in the latter part of the nineteenth century questioned the idea that a painting has to talk about something important. Aiming above all to show the landscape as we truly see it in the sparkle of atmosphere, they dabbed on bright paint in tiny, opaque strokes that coalesce to produce luminous color when viewed at a distance. Viewed up close, their paintings were a mass of flat colors, surging in loosely defined shapes (Color Plates 26 and 29).

Almost as soon as Impressionism asserted itself a number of artists associated with the movement began to reject its principles. These artists were subsequently known as Post Impressionists. Some, like Cézanne (see Fig. 7-8) and Renoir, wanted to restore to painting the solidity and compositional integrity of traditional painting. Others, like Van Gogh and Gauguin (see Color Plates 5 and 7 and Figs. 15-4, and 7-7), wanted to make their art a more personal statement that would transmit feelings and thoughts about the subject. These artists all based their work

12-12
Jacques-Louis David, *Death of Socrates*, 1787. Oil on canvas, 51″ × 77¼″. The Metropolitan Museum of Art, New York. (Wolfe Fund, 1931 Catharine Lorillard Wolfe Collection, 31.45.)

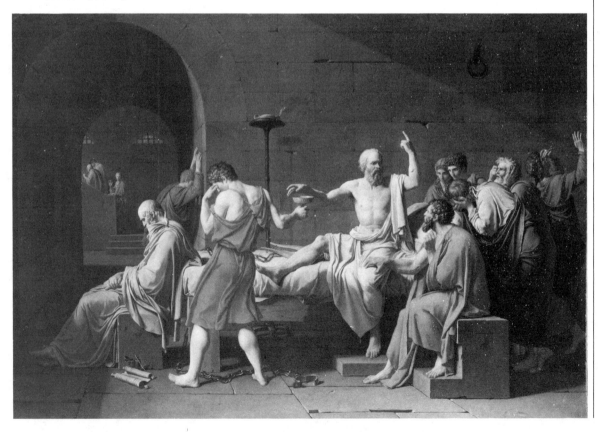

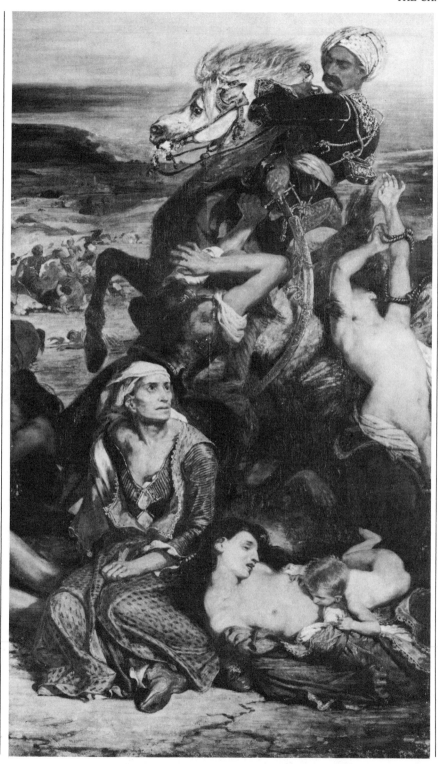

12-13
Eugène Delacroix, *Massacre at Chios*, 1822-24. Detail. (See Fig. 11-4)

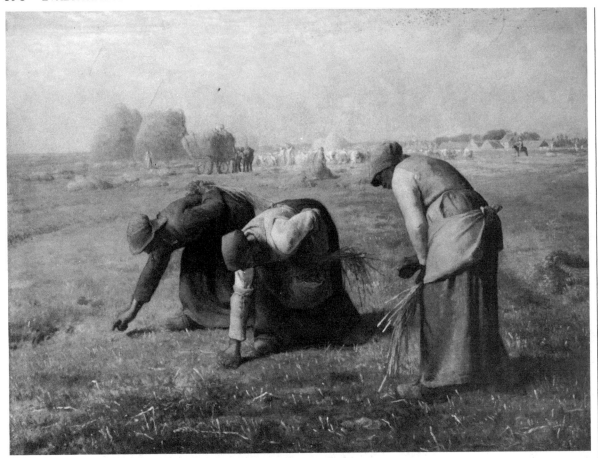

12-14
Jean Francois Millet,
The Gleaners, **1857. Oil**
on canvas, approx. 33″
× 44″. Louvre, Paris.

on the idea that the subject is not there simply to be copied but is a springboard to the imagination.

Abstract art of the twentieth century subordinates the subject or rejects it altogether, placing value on form. In Dada and in post-modernism, however, the aesthetic aspect of the piece may be of little or no interest; the art is evaluated by the impact of its ideas. In contrast with the Renaissance ideal of an art set apart from, and improving upon life, post-modern art may be merged with, and at times even indistinguishable from, non-art interests and activities.

Our survey reveals considerable variation in aesthetic theory. Indeed, were we to inspect any of these theories at closer range we would find further variation and diversity. We also see the recurrence of tastes, styles, and aesthetic ideas, especially those developed in the classical period. Well thought out artistic theories provide useful criteria for evaluating some kinds of art, but they do not provide tools by which to comprehend other kinds. The various theories by which art has been evaluated help us to look more carefully at the art of a particular period. They help us to better understand it, and to gain insight into the culture. But, however appealing, no one of these theories provides principles that apply to *all* art work.

The Value of Criticism

Criteria for the evaluation of art, like the art itself, have changed over the years, and have differed from place to place. Thus it appears that—unless we have overlooked something—the search for absolute and universal standards is futile. Yet in the absence of absolute standards we continue to enjoy *and* evaluate the art we experience. The existence of conflicting ideas of quality may be frustrating to those who require certainty above all, but the appreciation of art is not conditional on our being certain.

Despite the efforts of critics and theoreticians, the intrinsic quality of a work of art remains elusive. Artistic quality just can't be proven as we might a geometrical theorem. One's affection for a work of art is never a matter of logic; one's reasons for finding a piece appealing are always partially subjective.

There are any number of reasons to like a work of art, not all of them necessarily "good" reasons. You might like something that you realize isn't very good. And conversely there may be any number of things you judge to be good but just can't warm up to.

In evaluating art we ordinarily move between objectivity and personal preference. If I liked something I would naturally want you to enjoy it as well, and so I would try to show you why it pleases me. My first appeal would be to objective standards. If you didn't agree with me, we'd probably conclude that my affection for the piece is "a matter of taste."

It's problematic whether I could persuade you to change your mind about what you like or dislike. But talking about our disagreements can be useful. We must be able to justify our arguments in terms we can both accept. That makes us look more carefully at the object of our discussion, and reinspect our own attitudes toward it. Whatever our conclusions as to the merits of the object, we will have learned a lot more about it, and about art in general.

Ultimately, the question of artistic quality is one you will have to answer for yourself. Your own values and experiences will inevitably influence your conclusions. There is room for intuition. But you will never be certain that your hunches aren't wide of the mark without some understanding of the context in which the art was produced. And—if you are interested in formulating a respectable idea about the quality of the art—this is a good place to start. What aims and purposes were intended for the piece you are looking at? What were the values and the beliefs of the society? How was artistic quality identified? What did the *other* art look like? And what made this piece different? Only by trying to understand what the artist was aiming for can you begin to judge how close he came to achieving his goal.

Disagreement over issues of quality is inevitable in a culture as complex and changing as ours. It reflects our diversity of interests and values. Within the art world, debate over works of art is tempered by the understandable desire to be careful. As we saw in the last chapter, people made faulty judgements about art. Few of us today would care to draw the lines of our theories so rigorously as to make similar errors.

With this as a caution, I'll offer some of my own ideas about what artistic quality consists of. In making up a list it seemed to me that I should mention only

what I had actually experienced in the art I had looked at. So while my list implies that ''this is the way it has to be,'' it is really just a way of saying, certainly with greater justification, ''this is what I have recognized.''

If the art is of high quality it will have at least some of the following characteristics. Lack of some of these can be made up for by the strength of others.

- It will say something. You ought to be able to sense the presence of an idea behind it.
- The idea will have some significance. At least the piece should be able to convince you of its importance.
- The concept of the piece will be unique, original. It will strike you as imaginative and fresh, and not a restatement.
- The parts, details, formal elements, and materials of the piece will be expressive of the idea.
- There will be a substantial formal unity of those elements so that they contribute to, rather than detract from, the whole. That unity will give a feeling of rightness, a sense of the inevitable, to the piece as a whole.
- The piece will be executed with skill. Even if accident or chance play a part in it, we should feel that the artist knows what he is doing.

As a caution I would add that not all of this may be apparent all at once. Great art grows on you, and offers you more than you can catch in one sitting.

Great art may break rules, as we have seen, and as it does, it sets new standards. What you or I look for in a work of art is bound to change as well. So not only might my criteria be different from yours, they might be different from my own in the future. The criteria I draw up tell me more about what's in my mind than about the art. Using the criteria to decide whether I like or should like a piece is, of course, pointless; but I can use my criteria to better understand the piece and why I like it.

Art is an activity, like athletics, in which individuals test their limits. The chanciness of the performance gives it an exciting edge. Like athletes, artists are not always successful, and may fall short of their goals. But even if the Yankees are behind in the seventh, is that any reason to leave the game?

At the same time, we ought to try to be discriminating, so as to allow ourselves the best opportunity to experience the best that art has to offer us. Our greatest and worthiest challenge is to apprehend quality to the fullest extent of which we are capable. To this end, the task of criticism is not simply to decide between good and bad, but to help us gain greater understanding.

13 | *Images and Illusions*

Paintings can create convincing illusions of reality. Yet we find wide differences in the looks and styles we call "realistic." The reality of Jan van Eyck (see Color Plate 28 and Fig. 13-8), in which each separate object is distinguished by a clear outline and seen in meticulous detail, is not the reality of Rubens (Color Plates 11 and 30), where soft edges merge objects into a whole that is saturated with color and light. The world of Caravaggio (see Color Plate 24 and Fig. 13-9), a world of hard, solid forms drenched in shadow and pierced by light, is not the world of Monet (Color Plates 26 and 29), where forms dissolve in an atmospheric light that pulsates even in the shadows. All of these paintings satisfy our pleasure in looking at paintings that are, in a way of speaking, true to life. But each is a world apart from the other.

This should not, of course, surprise us, for no painting is simply a reflection of the real world. Artists of all times attempted to fuse something of their own vision with whatever they painted. In doing so, they developed painting techniques at times as individual as handwriting. By means of these techniques, artists were able to conjure up visions of reality on the canvas that were persuasive, even spellbinding. A good artist could make you see what he wanted you to see—and to believe that it was there in front of you, regardless of how removed from natural appearances it actually was, and despite your knowledge that you were looking at a flat surface.

In this chapter we shall look at some of the painting techniques that artists have used to create images of solid objects existing in space and light. We shall also investigate some of the tricks, schemes, and devices artists have used to heighten the illusion. Images give us pleasure. Understanding some of the ways in which images are produced may increase our pleasure.

Oil Painting Techniques

The development of distinctive individual painting styles owes much to the rich possibilities inherent in the oil medium, which has been used in Western painting since the fifteenth century. Functioning essentially to bind the pigment, or color, to the canvas, oil is extremely versatile, permitting the artist a wide variety of painting techniques. Oil paint can be applied in thick strokes or thin, and accordingly can be made opaque or transparent. A transparent film of paint will tint whatever color lies beneath it. A paint film that is darker than the color below it is called a "glaze." A glaze will create an effect of luminosity, as light from the underlying color literally shines through the darker film. Alternatively, a thick layer of paint will cover the underlying color completely, but the painter can let some of the underlying color show through by dragging the brush lightly over the surface and allowing the strokes to break in places. Because oil takes a while to dry, colors can be blended easily right on the canvas, thus making it possible to achieve infinite gradations of color and shading. Paintings take on character from the techniques of brush and paint. Some painters prefer one approach exclusively, though many paintings are built up of combinations of paint application: thick, thin, opaque, transparent, direct, and blended.

Along with the paint, the brush itself has an effect on the image. Jan van Eyck used fine round brushes that were extremely soft in order to blend his colors smoothly. Like many painters, he took pains that the strokes not interfere with the illusion. El Greco, on the other hand, used broad, stiff brushes, whose bristles left visible marks (Fig. 13-1). El Greco's dashing, nervous strokes help energize his paintings by bringing into every detail the movement of the whole.

13-1
El Greco, *Purification of the Temple*, c. 1600-05. Detail. Reproduced by courtesy of the Trustees, The National Gallery, London.

The range of techniques inherent in the oil medium is still being explored. The paintings of Willem de Kooning (see Fig. 11-9) have carried the medium beyond anything seen before, and have revealed some of its beautiful effects. De Kooning's handling of paint is spontaneous and intuitive, and in part at least, reflects an interest in exploring the properties of the medium.

Until the nineteenth century, however, all paintings were developed by a fairly standard procedure, one calculated to best produce the illusionistic effects of representational painting. First the raw canvas was covered with a coating of glue to protect it from rotting. Then the drawing was applied. Drawings, when used, were transferred to the canvas by blocking out a grid of squares or rectangles on the drawing and again on the canvas. By drawing the corresponding lines in each space, the drawing was easily and accurately enlarged on the canvas. Next a thin layer of paint, the "ground," was applied, sometimes rubbed into the canvas with a cloth. Often, the ground was tinted a warm color, such as gray, brown, or clay-red. Care was taken that the drawing show through the toned ground. The artist would then block out the basic volumes in monochrome, using the colored ground as a middle tone. The lightest areas would be picked out with a pure white. Over this monochrome underpainting the artist would apply his colors. Opaque strokes were reserved for highlights and details, while glazes were applied where soft, luminous effects were desired. A final protective coat of varnish gave a uniform glossiness to the painting.

This procedure, while standard, was modified in various ways by painters interested in particular effects. Some, like Jan van Eyck (see Color Plate 28 and Fig. 13-8), Raphael (see Color Plate 8 and Fig. 5-6), and Leonardo da Vinci (Fig. 13-2) painted on white or very light grounds that lent themselves to bright, clear effects. Much later, in the seventeenth century, Rubens, in contrast to the general practice of his time, used a light ground in order to heighten the luster of his colors. Like Van Eyck, Raphael, and Leonardo, he applied his paints in extremely thin layers, like transparent veils. His *Crowning of St. Catherine* (Color Plate 11) is filled with light, because the white ground shines through those transparent colors.

All of these painters used glazes to produce glowing surfaces that were particularly effective for the depiction of soft, interior light, and for warm, glowing flesh. Frequently, many delicate layers of glazes were used. Because the painter had to be sure the paint on the surface was dry before applying the glaze, the glazing process could take weeks and even months. The soft, translucent shadows that give so much life to the face of the *Mona Lisa* could only have been achieved by many glazes (Fig. 13-2).

In the sixteenth century, Venetian painters like Titian and Tintoretto (see Fig. 12-8) used loose, visible strokes of paint, which tended to energize their images while softening the edges of forms. In the seventeenth century Rubens, Rembrandt, Hals, and Velázquez furthered the development of loose, vigorous brush techniques. Like other painters of his day, Rembrandt began on a ground toned with a warm, medium brown. Then he blocked out his underpainting using shades of gray, working without a drawing. Rembrandt frequently brushed on his paint in thick, opaque layers, called "impastos." At times, broad strokes simplified the form by rendering it in simple, solid planes, as in the hand of *Hen-*

13-2 (left)
Leonardo da Vinci,
Mona Lisa, detail, c.
1503-05. Oil on canvas,
approx. 30″ × 21″.
Louvre, Paris.

13-3 (right)
Frans Hals, *The Gypsy
Girl*, c. 1628. Oil on
canvas, 23″ × 20½″.
Louvre, Paris.

drickje Bathing in a Stream (see Fig. 11-3). Towards the end of the painting
process, Rembrandt used glazes to create the marvelous effects of light that
played around his figures, and that seemed, at times, almost to glow out of their
faces. For the illusion of lace or jewelry, he built up mounds of pure white paint,
and then glazed over them with a warm tone so they would seem to glow. Occa-
sionally, Rembrandt also scraped into the thick paint with the handle of his brush
to convey the texture of jewelry.

A "toned ground" supplies the middle value to the underpainting, enabling
the painter to achieve a solid effect quickly and easily. In addition, it helps unify
the painting and gives warmth to the color. Frans Hals (Fig. 13-3) and Diego
Velázquez (Figs. 13-11 and 13-12) used toned grounds, and, instead of glazing,
built up their paintings using impastos. Like Rembrandt, they explored the effect
of letting the separate strokes and colors of paint coalesce in the eye of the viewer
to produce the illusion of the object. This technique departs from the more literal
representations of earlier artists like Van Eyck, Raphael, and Leonardo (see Col-
or Plates 28 and 8) and prefigures Impressionism (see Color Plate 26). Up close,

Hals's and Velázquez's loose, dashing brushstrokes create lively surfaces. Velázquez gives us a masterful display of illusionism, as brushstrokes, sometimes applied in almost abstract touches and rhythms, merge to create the object when viewed from a distance. Hals's direct and vivacious strokes give you the feeling that the figure has been caught in an instant of time. Compare the sense of movement of Hals's *Gypsy Girl* with the more poised, stable figures of Van Eyck or Raphael.

Fragonard's *Blind Man's Buff* (see Fig. 9-3) was built up of thin layers on a brown ground. Toward the end, Fragonard applied heavier paint in deft, self-contained touches to objects in the foreground. These strokes enrich the surface, and invite the eye to linger on such details as flowers, folds of cloth, the old, worn, wooden gate, and the copper pot (Color Plate 31). At the same time, the thick dabs help to bring the foreground objects closer by distinguishing them from the more thinly painted background. The heavy paint makes these objects seem more touchable, and thus increases the illusion of their solidity. The blue ribbon around the woman's neck, for example, is thickly painted, and stands out slightly.

Thick, white paint dabbled along the nearer rim of the copper pot pulls it forward in space and gives the illusion of light reflecting off the surface. Seventeenth-century Dutch still life painters were similarly fond of using touches of opaque white to show light reflecting off shiny objects such as glass, jewelry, and metal. Vermeer refined this technique for his interiors by applying opaque white in minute dots to give an iridescence to objects that catch the light (Fig. 13-4).

In the nineteenth century, artists revived the use of the white ground. One of the first was the English painter J.M.W. Turner (Fig. 13-5). Turner was trained in the watercolor technique, where the transparent strokes automatically depend on the white paper for luminosity. His landscapes are amazingly bright, due to the

13-4
Jan Vermeer, *A Painter in His Studio,* **c. 1666. Detail. Kunsthistorisches Museum, Vienna.**

13-5
Joseph Mallord William Turner, *The Campo Santo, Venice,* **1842. Oil on canvas, 24½″ × 36½″. The Toledo Museum of Art. (Gift of Edward Drummond Libbey.)**

white ground which comes through the thin, overlying layers of paint to create the illusion of natural light radiating out of the canvas. Instead of monochrome underpainting, Turner used colors from the start, which also contributed to the richness of his paintings.

Monet was particularly interested in depicting the changing sensations of light and atmosphere (Color Plate 26). Nevertheless, he built up his canvases by underpainting. He used a pale, tinted ground over which he applied thin washes of color in broad areas. Then he proceeded to apply small dabs of opaque paint, keeping the strokes distinct, so that when viewed from a distance the colors would mix together in the eye to create a sparkling effect. At times the color of the first washes would show through between the thicker strokes and help tie the area together—a technique used later by Matisse. Like other painters, Monet painted directly into wet paint, but he also exploited the effect of dragging fairly stiff paint over a rough, dry surface and letting the color break (see Color Plate 29). In this way, too, he was able to produce a sparkling effect. Monet worked out of doors with the subject before him, setting the canvas aside for another time when the light effects had changed. In this way he was able to achieve what he called ''instantaneity''—a fleeting moment captured on the canvas.

While Monet devoted himself to painting reality as he saw it, his paintings moved, paradoxically, toward abstraction. As solid forms dissolved in the light, details disappeared and space flattened; colors brightened and, perhaps most dramatic of all, the brushstrokes called attention to themselves and seemed almost to take over the image. This new independence of paint from the subject inspired later painters who, carrying these formal interests even further, developed the abstract art that has dominated the present century.

Of course, realist painting never disappeared; in fact it is currently thriving. Realist painters today are highly conscious of the formal investigations of abstract

13-6
Richard Estes, *Helene's Florist,* 1971. Oil on canvas, 48″ × 72″. The Toledo Museum of Art.

artists. But the Realists are interested in pursuing formal investigation in terms of the image. Fascinated by the phenomenon of illusion itself, many build their paintings in a way that makes the viewer keenly aware of the magic of illusion. Many work on a large scale, and thereby ensure that the viewer will confront the image both up close and from afar. The image, when seen from a few feet away, may dissolve into abstract shapes and colors.

Richard Estes uses photographs as a basis for his paintings but rearranges the parts to suit the composition. He underpaints in monochrome tones, which give a dusky quality to his colors when seen up close. Careful adjustments of the values of the colors—how light or dark they are—create the effect of a clear outdoor light in the painting when viewed from a distance.

In Estes's paintings, the discrepancy between near and distant views is striking. Approaching *Helene's Florist* (Fig. 13-6) you can see the photographic image breaking down into a mosaic of flat patches of opaque color. Up close, you see less blending of colors than you would expect; details have a crisp, abstract quality, and you discover in them a surprisingly wide range of color (Color Plate 32).

Neil Welliver works on a small scale with the subject before him, and then uses those paintings as a basis for large scale paintings done in his studio. He makes a large drawing on paper, transfers it to the white canvas, and paints the painting in sections from the top down. The scale of the paintings and the amazing details have the effect of drawing you into the scene. You can't miss the brushstrokes in Welliver's landscapes: they are thick and juicy, multilayered, springing with energy, and seem to be as full of life as the trees, rocks, waters, and skies of Maine that they depict. Welliver makes us aware not only of the life that is out there, but of the life that is in the paint as well (Fig. 13-7).

13-7
Neil Welliver, *Late Light*, 1978. Oil on canvas, 96″ × 96″. Detail. Extended loan to the Rose Art Museum, Brandeis University, Waltham, Massachussetts. (The Herbert W. Plimpton Foundation.)

13-8 (left)
Jan van Eyck, *Angel of the Annunciation*, c. 1416-20. Oil on panel, 15⅜″ × 9⅜″. Thyssen-Bornemisza Collection, Lugano, Switzerland.

13-9 (right)
Caravaggio, *Supper at Emmaus*, c. 1600. Oil on canvas, 55″ × 77″. Reproduced by courtesy of the Trustees, the National Gallery, London.

Visual Devices and Effects

These are some of the painting techniques used to create the illusions we see in oil paintings. Along with these techniques, painters developed a number of visual devices to heighten the illusion of reality. Fifteenth-century Flemish painters, for whom extremely fine detail was a tradition, occasionally reached for *trompe l'oeil* ("fool the eye") effects. In Jan van Eyck's *Angel of the Annunciation* (Fig. 13-8), the wings of an imagined statue appear to overlap the painted frame and to cast a shadow on it. The background, painted to look like dark marble, appears to reflect the back of the statue. Thus the statue seems to exist in real space. In a painting by Hans Memling, a man sits with a book before him. His elbow and the clasp of the book, painted onto the real frame, appear to extend out of the confines of the painting and into our world. Petrus Christus completed his portrait of a Carthusian monk by adding a painted wooden frame with a life-size fly walking on it. These and similar effects were repeated by other artists. Though never exploiting optical tricks for their own sake, they experimented with them now and then in order to heighten the sense of reality.

Foreshortening is another optical effect intended to overcome the flatness of the picture surface. When an arm reaches toward the viewer from the canvas (as in Caravaggio's *Supper at Emmaus,* Fig. 13-9), it is more exciting than it would be if the arm went sideways, or parallel to the plane of the canvas. This is because the foreshortened arm seems to penetrate space more explicitly. It makes you really *feel* the space. In a similar way three-dimensional movies of the 1950s would occasionally have some object (such as a spider) zoom right out at you from the screen. These were, needless to say, the moments that everybody waited for.

13-10
Jean Simeon Chardin,
Still Life, c. 1732. Oil
on canvas, 6⅝″ × 8¼″.
Courtesy of Detroit In-
stitute of Arts. (Bequest
of Robert H. Tannahill.)

A favorite device of still life painters is to have an elongated object project toward the viewer from its place on the tabletop. Sometimes, like the scallion in Chardin's tiny *Still Life* (Fig. 13-10), it extends forward from the nearest edge of the table. With the other objects arranged more or less parallel to the picture plane, it functions to make the scene more exciting by increasing the depth and making us aware of it. At the same time it connects the objects to the viewer by moving toward the barrier between the painted world and our own. Similarly, in Rembrandt's *Night Watch* (see Fig. 2-1), the extended left hand of the central figure connects the painted world to our own. Standing in front of the life-size figure, you feel as if you could shake hands with him.

In another visual effect the barrier is emphasized rather than minimized. A large object, called a *repoussoir,* is placed in the foreground, usually to one side, and the viewer looks past it into the scene. The *repoussoir* acts as a frame within the picture. This effect gives a more vivid feeling for the recession of space. In Church's *Parthenon* (see Color Plate 4), the column on the right acts as a *repoussoir*. In Vermeer's *A Painter in His Studio* (Color Plate 17), the *repoussoir* is the curtain.

When the *repoussoir* is placed nearer the center of a painting, the effect can be dramatic. In the *Surrender of Breda* (Figs. 13-11 and 13-12), Velázquez has you look at a large part of the landscape through screens of pikes and lances. Even more striking is the very center of the painting, where the extended arm, the hand, and the keys frame a view of soldiers in the distance. A similar situation appears in Delacroix's *Massacre at Chios* (see Figs. 11-4 and 12-13) where the horse's leg and the rifle barrel frame a view of the landscape. These areas take on

**13-11 (left)
Diego Velázquez,** *The Surrender of Breda,* **detail.**

**13-12 (right)
Diego Velázquez,** *The Surrender of Breda,* **1634-35. Oil on canvas, 10′1″ × 12′. Prado, Madrid.**

a dreamlike, irrational quality, as space both shrinks and expands, bringing together near and far, large and small, distinct and hazy.

Look again at the *Night Watch* (Fig. 2-1). Rembrandt uses the silhouettes of a gun stock and a leg to heighten the drama while making us experience the recession of space. Can you find other places where Rembrandt places dark shapes over light? Can you find the reverse?

Placing darks over lights and also lights over darks in the same picture was a favorite device of Dutch artists in the seventeenth century. It helped them achieve rich visual effects while also producing a strong illusion of receding space. Rembrandt used it frequently (see, for example, his etching *St. Jerome in an Italian Landscape,* Fig. 10-3).

A fascination with space and the determination to represent it convincingly is a persistent feature of Western art. The foreshortening of the figure in painting began in ancient Greece. Roman painters evolved systems of perspective so that space would appear in a believable way. In the Renaissance, the formulation of linear perspective gave artists a tool to create spaces that were overwhelmingly convincing and even measurable. You could practically walk into their paintings.

Renaissance artists competed with each other through paintings and sculptural reliefs designed to demonstrate mastery of perspective. An excellent example is Piero della Francesca's *Flagellation* (see Fig. 6-1). It is a daring painting. The sudden contrast in the sizes of the figures catches us by surprise, and at first glance seems wrong. But the pattern of tiles on the floor, as well as the coffers of

13-13
Andrea Mantegna,
ceiling of the *Camera
degli sposi*, 1474. Fresco.
Ducal Palace, Mantua.

the ceiling, show us that the painter knew what he was doing. Piero's painting exploits the potential of linear perspective to create a realistic illusion of space. Because the scene is conceived in terms of this orderly system, the sudden changes in size command our attention.

A number of Renaissance painters, fascinated by the way that accurate depictions of deep space seemed to dissolve the solid wall, painted murals that aimed at deliberately tricking the eye into seeing spaces that were not there (Fig. 13-13). By adjusting their paintings to existing architectural features, and sometimes even incorporating these features into their painting, they created a painted architecture that magically extended the room itself. This painted architectural space was used to create a more realistic ''stage'' for the figures in the painting, as well

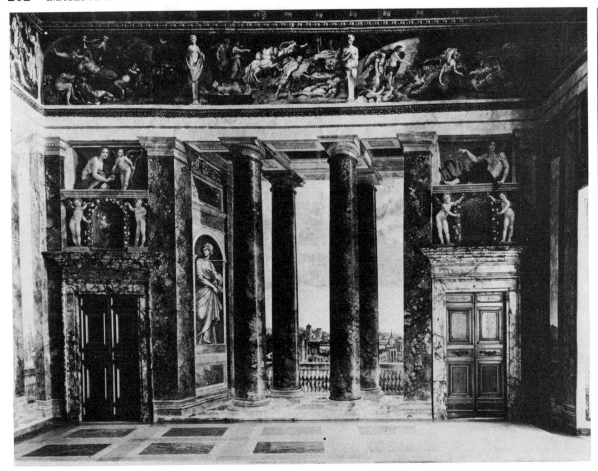

13-14
Baldassare Peruzzi,
Sala della Prospettive,
c. 1515. Wall fresco,
Villa Farnese, Rome.

as to impress and to amuse the viewers. The figures depicted in these illusionistic spaces became part of the viewer's own world.

This room in the Villa Farnesina, Rome (Fig. 13-14), was decorated by Baldassare Peruzzi. Here the mural surrounds the viewer. Painted columns and terraces create an illusion from floor to ceiling that opens onto a painted landscape that corresponds to the actual landscape outside. Included in the painted landscape is a distant view of Rome.

In seventeenth-century Europe a number of large churches were populated by companies of heavenly figures that appear to burst through the ceiling and descend into the space of the church itself (Fig. 13-15). Painting, sculpture, architecture, and architectural decoration combined to create the illusion of this inspirational vision. Painted angels and sculptured angels, and illusionistic as well as real architecture are integrated so carefully that it is impossible to tell where the one stops and the other begins. The usual clues delimiting works of art are absent: no frames, no pedestals. The boundaries between object and viewer have evaporated. In these Baroque spaces, we experience the power of illusionism at its most grandiose.

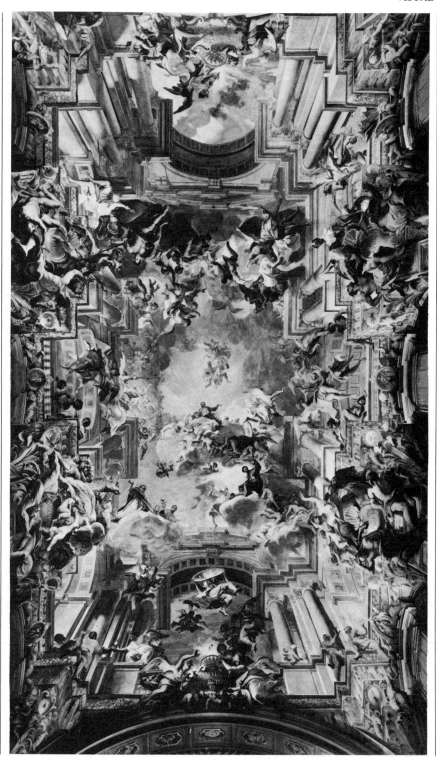

13-15
Fra Andrea Pozzo, *The Glorification of St. Ignatius*, 1691-94. Ceiling fresco in the nave of Sant'Ignazio, Rome.

13-16
John Peto, *Office
Board*, 1885. Oil on
canvas, 24⅜″ × 19⅞″.
The Metropolitan
Museum of Art.
(George A. Hearn Fund,
1955.)

13-16
John Peto, *Office Board*, 1885. Oil on canvas, 24⅜″ × 19⅞″. The Metropolitan Museum of Art. (George A. Hearn Fund, 1955.)

Trompe l'oeil paintings were popular in seventeenth-century Holland and in the United States in the late nineteenth century. They were painted for the pleasure of illusion. *Trompe l'oeil* paintings were basically still lifes, painted in life-size in painstaking detail. Using small brushes, the painter would eliminate any trace of the brushstrokes. In a popular format, bits and pieces of paper and other odds and ends were painted as though tacked to a board or placed just in front of it (Fig. 13-16). Because of the flatness of the objects, you have to stand close to the painting to see that they are painted and not real.

Closer to today, the lithographs of M. C. Escher create illusions of impossible spaces (Fig. 13-17). Escher's scrupulously realistic style fools the mind into believing those spaces could exist in reality. In showing us that things are not always as they seem, Escher's prints make us aware of our tendency to confuse illusion with reality. Thus in their own delightful way they remind us gently of our human fallibility. It is just this fallibility, of course, that allows us to get

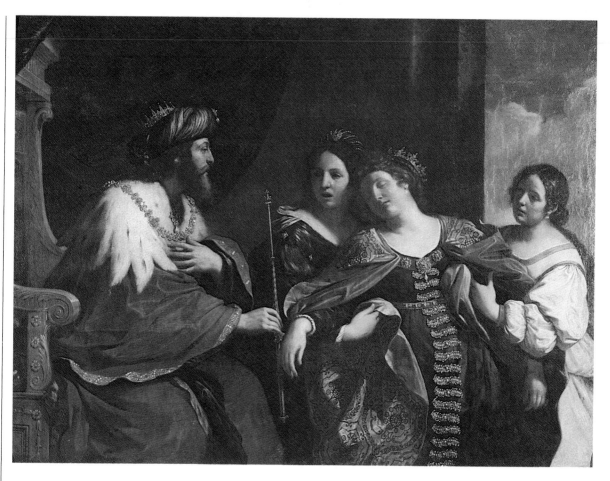

Plate 25
Guercino (Giovanni Francesco Barbieri),
Esther Before Ahasuerus, **1639.**
Oil on canvas,
62½″ × 84¾″.
The University of Michigan Museum of Art.

Plate 26
Claude Monet, *Poplars on the Bank of the Epte River*, 1891. Oil on canvas, 39½″ × 25¾″. Philadelphia Museum of Art. (Bequest of Anne Thomson as a memorial to her father, Frank Thomson and her mother, Mary Elizabeth Clarke Thomson.)

Plate 27
James Abbott McNeill
Whistler, *Nocturne in*
Black and Gold: The
Falling Rocket, **c. 1874.**
Oil on oak panel,
23¾″ × 18⅜″.
The Detroit Institute
of Arts. (Gift of
Dexter M. Ferry, Jr.)

Plate 29
Claude Monet, detail of
Poplars on the Bank of
the Epte River, **1891.**
Philadelphia Museum
of Art.

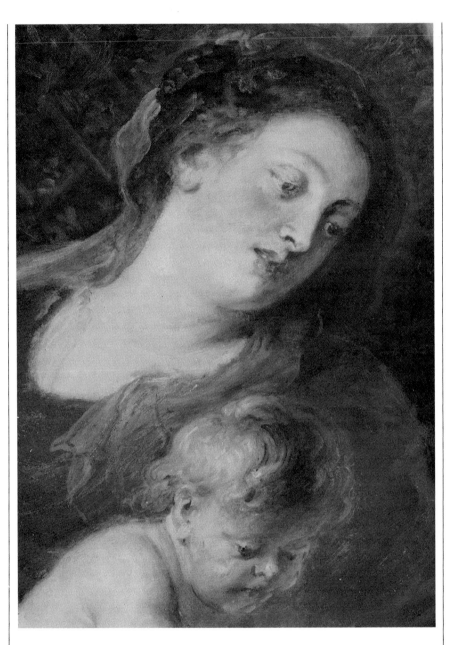

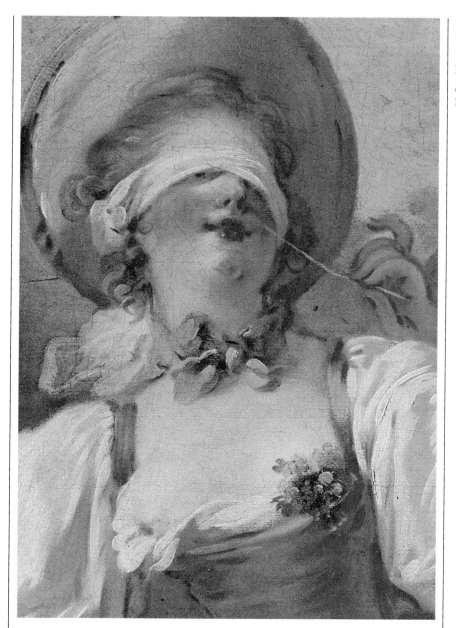

Plate 31
Jean-Honoré Fragonard,
detail of ***Blind Man's***
Buff, **c. 1750-52. The**
Toledo Museum of Art.
(Gift of Edward
Drummond Libbey.)

Plate 32
Richard Estes, detail of
Helene's Florist, **1971.**
The Toledo Museum of
Art. (Gift of Edward
Drummond Libbey.)

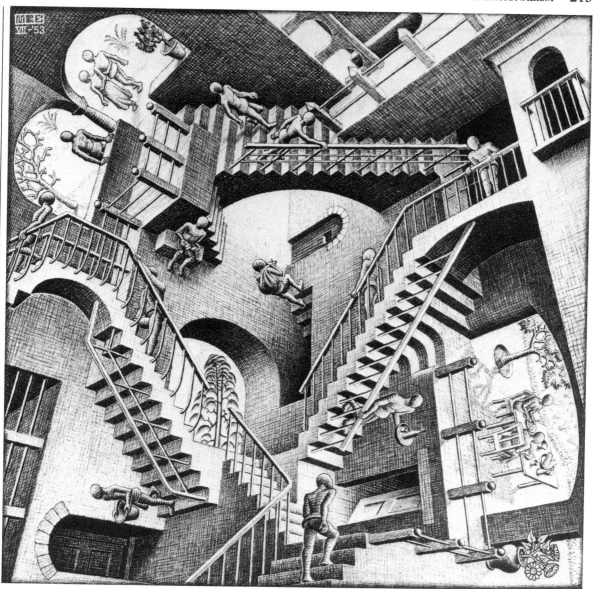

involved in what we see. But it is our willingness to laugh at ourselves that allows us to enjoy it.

Sensationalism

A number of artists exploited their subject matter to beckon the viewer through the magic window of realistic painting. They realized that a good story with interesting characters could help get you involved, and keep you there. Before the existence of movies and television, billboard-size paintings, loaded with detail

13-17
M. C. Escher, *Relativity*, 1953. Lithograph, 10¾″ × 11½″. National Gallery of Art, Washington, D.C.

and often with casts of thousands, provided wide screen entertainment to the public. The entertainment value of paintings was often enhanced by subject matter that was violent or erotic. Religious paintings were often pretexts for gory scenes depicted in meticulous detail, while paintings set in ancient Greece or Rome showed gorgeous women in various degrees of undress, with more than historical appeal for the viewer (see, for example, Fig. 11-17). Many artists played up the sensational aspects of their art, just as many movies do today, to make them more appealing. Thrills, danger, sex, and suspense weren't invented in Hollywood.

Years ago, huge paintings were hauled across the United States and exhibited at fairs to crowds eager to absorb their complex dramas and scenes of foreign lands. Films today provide similar public entertainment. Filmmakers quickly learned to exploit the heightened realism of moving pictures. In 1896, the Lumiere brothers in France placed their camera on the platform alongside a railroad track and filmed a train approaching. When their film was projected for the first time, on a tablecloth strung up in a cafe, people reportedly ducked under their tables or rushed to the exit at the sight of the oncoming train. Years later, three-dimensional films had a similar effect on audiences. Like many of those traveling paintings, many films we see are not, by themselves, the stuff of great art. They carry no serious messages. But however trivial they may be when compared to films with serious content, they serve a useful purpose. They give us a means of escape, and relieve the tedious inevitability of things as they are.

Image and Material

Images are shaped and affected by the material that gives them life. At the same time, the material is brought to life and given significance by the images. In a painting, the images come out of paint, and are thus subject to whatever paint itself can say and do. Likewise, a figure carved in wood will always carry in it something that speaks of wood. Old-time Hollywood glamour was bound up with sparkling images on the silver screen.

We may distinguish image from material for convenience in discussion, and for the sake of formal analysis or historical research. But our awareness that material and image in works of art are, indeed, inseparable keeps us open to the appreciation of what we see. The techniques and devices that we have discussed in this chapter demonstrate the unique reciprocity of material and image that is at the heart of every work of art, and the source of the spell it casts upon us.

14 | *Visiting Museums*

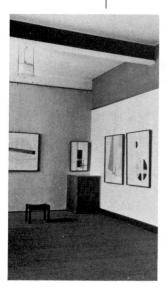

ow many times have you been to an art museum? Do you visit them regularly or do you put it off? It's not unusual for people to think of going to a museum as a chore. After all, museums can seem intimidating or stuffy. But museum visits can be enjoyable. Sometimes it's just a matter of handling them in the right way—in a way that works for you.

If you go to museums infrequently the visit can be exhausting. Chances are you feel bound to do the whole thing at one time. That's probably not a good idea. Unless the collection is small, don't try to look at everything at once. If you do, you're more likely to be aware of "museum fatigue" and your aching feet than the art you've seen.

You needn't spend too much time in a museum. Beyond a certain point, you're just not going to be fresh enough to get anything out of what you see. Use the museum directory to help you choose where to go. Consider a time limit for your visit. If there's something in particular that you want

to see, go there directly and look at it first, before you get tired. Spend as much time with it as you like, and consider saving the rest for another visit.

Not everything you see in a museum will interest you—nor should you expect it to. Chances are you'll feel more strongly for some things than for others. Some people who go to museums regularly look forward to seeing particular things they like. They think of them as old friends. But if you go infrequently or are visiting a new museum, you have the opportunity to make new discoveries, and you may be surprised by what you discover. You may find something altogether new, or see new things in an old friend. It's exciting to be surprised by a piece of art that comes alive for you. And that, of course, is what really counts. What you'll remember above all is the connection you make with a piece or two, or perhaps a small group of things. That's probably a lot more valuable than trying to see everything in the building.

Rather than a chore, a visit to a

museum can be a refreshing break in routine. Just follow your nose, with no specific goal or intention. Let yourself be surprised by something unexpected. It will release you from the usual pattern of programmed time that most people maintain. In addition, you will be doing something for yourself. There are few more pleasant ways to add to your knowledge and understanding of human experience than at a museum, whose objects are there precisely because they're special in some way.

Now that you have, I hope, agreed that a museum visit can be an *enjoyable* experience, I'd like to convince you that a museum visit is an *important* experience.

Why Visit a Museum?

In the first place, what you see in a museum contrasts strikingly with what's around you every day. Museum objects are, typically, unique. Each one is done or finished by hand. Very little that is one-of-a-kind is left to us today. We are surrounded by mass-produced things that have little or no intrinsic value apart from their function. They have little character. Perhaps they only accommodate a fashion or taste. They are impersonal. They are not often made with pride, or made to last.

Objects and aritifacts now turned out by machines were once made by hand. The craftsmanship that went into them demanded considerable skills. The high level of the carving, knot tying, weaving, metal work, and pottery produced in so-called primitive societies is often astonishing. Many hand-made objects are, even by modern standards, technically sophisticated, and can't be duplicated by machines or machine processes. Many such objects are justifiably envied by contemporary craftsmen, both for their technical qualitites and for the rightness of their design. Frequently the design integrates so perfectly with the object (as in the Peruvian weavings in Figure 10-1 and Color Plate 23) that it is impossible to consider one apart from the other. Museum goers may be awakened to the triviality of many contemporary commercial designs when compared to examples from societies that have not experienced technological progress.

A fine hand-worked art object is precious. It can't be replaced. In addition to its excellent craftsmanship it will have a personal quality, a character not found in machine-made things. This quality will enable the object to ''live'' long after its usefulness as an artifact is over.

The objects gathered in a museum generally represent the best that someone could do. They are nearly always the products of years of training and development. We see in them the skill and vision of exceptionally talented individuals. They may contain qualities of genius or inspiration. So rarely do we see *anything* that we can call superb, or anything of lasting value, that we may find ourselves wondering whether such things exist. They do—in works of art.

Among the great achievements of the human race are the works of art that men and women have produced. Perhaps it is *because* they are superbly done that we regard them as works of art. Current events can discourage us. That makes it especially important to experience works of art, for they come down on the side of life, testifying to the wisdom, energy, and aspiration to achievement of all peoples in all times.

A second reason to go to a museum is to see the real thing. Many people never see art—they see reproductions of it. Students viewing slides in art appreciation or art history classes will not see art unless they go to a museum or gallery. Art is reproduced in books and magazines, in posters, in calendars, and even occasionally on television, but rarely do we experience a work of art as it really is. The problem with reproductions can be simply put: they distort whatever they show you. Color and light, which are the very substance of painting, are altered. Brushwork and texture are replaced by a smoothed-out flatness. The size of every painting, sculpture, or building is reduced to a common standard. Details disappear. Subtleties are lost. The impact of scale is gone. These distortions in a reproduction alter the character of a work of art.

Experiencing space, which is basic to the enjoyment of architecture, cannot be achieved through reproduction. A photograph collapses the solid reality of a sculpture into two dimensions. Our need to move through a building or around a sculpture is thwarted. And, of course, the point of view from which a sculpture or a building is photographed is out of our hands. Whatever we see reflects the photographer's interests, not necessarily our own.

Clearly, unless you experience the real thing you're just not going to get as much out of it. A work of art is a delicate interplay of relationships, *all* of which count. A reproduction reduces it to bits of information, and not much more. In this condition it can hardly be appreciated.

People who go to a museum for the first time are surprised by the unexpected vigor of original works of art. For the first time they become aware of the life that is in them. They may, for the first time, really *enjoy* looking at a work of art.

A third reason for going to a museum is that a museum gives you the opportunity to be with a work of art for as long as you like. Art that is reproduced in magazines, on television, or on a screen in a lecture hall is often hurriedly seen. Looking at a good painting or a good piece of sculpture is like reading a good book—it takes time, and you may not absorb it all at once.

To some readers this may sound unusual. Many people, perhaps accustomed to television, expect art to communicate immediately. But art is more than just a story or a message. It can mean something on many levels, and these meanings may disclose themselves to us gradually. Over time there will be more and more to see in a solid work of art. Most television stories become less exciting with each viewing. How can we get the most out of a work of art? To begin with, trust that it's worth the time just to sit for a while in front of it. Relax, open your eyes, and look. Then think about it later.

Museums are designed to show off art in the best possible way. Museums give great attention to placement, to the space around each piece (whether on the wall or free-standing), to the creation of an environment, and to the lighting. All of these influence your perception of the art. Paintings require good light and ample space around them. The color and texture of the walls should not be intrusive. Sculpture too needs space and carefully planned lighting, and must be displayed at the right height.

We tend to take the exhibition for granted—after all, we are there to look at the art, not the walls behind it. But the environment in which we see a work of art affects the way we respond to it. It is helpful to remember that many objects now placed in museums were intended for very different situations. African masks

were meant to be worn, and to be seen in motion. Mosaics, now flattened in the blank glare of the museum light, once shimmered on the walls of churches. Panel paintings of saints once glowed softly in the light of candles. Sculpture placed out of doors, such as totem poles, fountain or garden statuary, and components of architecture, loses impact when dismantled and brought inside (often for the sake of preservation). To compensate, museums sometimes provide photographs showing the object in its original context. In addition, an environment suggesting that context may be created to help you get a better feel for the object.

Few people are aware that museum interiors have altered considerably over the years. Until the twentieth century, gallery walls were ornate and richly colored. Paintings were crowded side by side and one above the other up to the ceiling. It is hard to imagine anyone looking carefully at the paintings. Some were hung so high they could hardly be seen (Fig. 14-1).

In the late-nineteenth century, the Impressionists made a radical departure by hanging all of the paintings in their exhibitions side by side. In the 1920s another change in the exhibition of paintings took place. Stark, white walls provided the background for a limited number of paintings that were widely spaced. These exhibitions emphasized the idea that a painting is not something you take in at a glance, but is an object to be contemplated (Fig. 14-2).

Today a larger museum may create a different environment in each room or gallery. Some rooms may have white walls, others may have richly textured cloth of a soft color, while some may suggest or even recreate environments from other periods. Many larger museums have "period rooms" reconstituted from actual buildings, occasionally with the interior furnishings exactly as they were (Fig. 14-3).

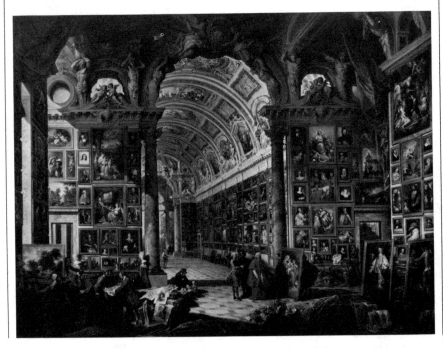

14-1
Giovanni Paolo Pannini, *A Gallery of Cardinal Valenti-Gonzaga,* **1749. Oil on canvas, 4′ × 8′9½″. Courtesy Wadsworth Atheneum, Hartford. (The Ella Gallup Sumner and Mary Catlin Sumner Collection.)**

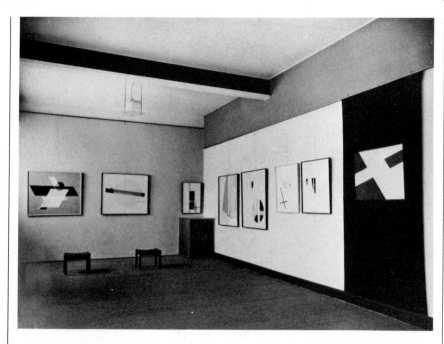

14-2
Laszlo Moholy-Nagy,
exhibition at the Neue
Kunst Fides Gallery,
Dresden, 1926.

Another reason to visit a museum is that a museum can help you get more out of what you look at. Not only is the physical environment important but also the arrangement of the paintings in the rooms. Typically, rooms are devoted to a particular historical period, or geographical area within that period. This helps you to recognize the style and the concerns of that period. It also helps you to distinguish what is unique to an artist or piece. In addition you may begin to recognize differences in the quality of work that you see, as when a series of portraits or still lifes or landscapes from the same period invite comparison. Thus a good display can help to inform you and sharpen your eyes.

Frequently a handbook or guide to the collection is available at the museum desk or store. Some museums provide background information to their exhibits in the form of papers or brochures placed in the appropriate galleries. A minute's reading can help place the art in context, and bring significance to an otherwise negligible piece. Slides and films may introduce special exhibitions. Prerecorded tours, available on tape, can be rented for use while viewing the exhibition.

In an effort to reach out to the public, many museums schedule free public tours. Trained docents—lecturers—provide useful information on both the permanent collection and on special exhibitions. In addition to the regularly scheduled tours, special tours may be arranged for a group by calling the museum ahead of time. These tours may be designed to accommodate the particular interests of the group.

Special exhibitions, planned around specific themes, are intended to provide a greater awareness of an individual artist, an historical period, a movement, or an idea. These exhibitions may be made up of art collected from a number of museums, private galleries, and private collections. It can take years of planning to assemble a show of this kind.

14-3
Room from the Chateau de Chenailles. Loire Valley, France, c. 1640. Carved, painted, and gilded woodwork with 18 oil paintings on panel and 5 oil paintings on canvas, approx. 12′6″ high; floor: 16′ × 13′. The Toledo Museum of Art. (Gift of Mr. and Mrs. Marvin S. Kobacker.)

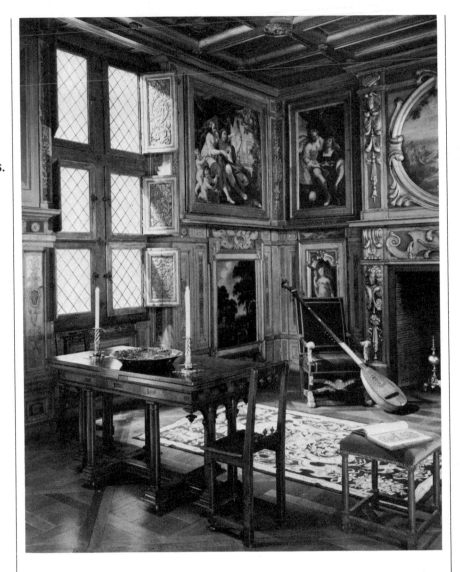

These exhibitions are extremely valuable in that they gather in one place pieces that may be seen together for the first time. Similarities and differences show up that promote a better understanding of the work. Special exhibitions can help you to recognize the influence of one artist on another, as well as to clarify what is original in an artist's work. Retrospectives, which exhibit the work of one artist over a period of years, allow the best possible view of his development.

A special exhibition can help us get a feel for a period of history remote from our own. Surrounded by the art or the artifacts of that time, we can imagine what life was like then. And of course what we see is not a Hollywood recreation of Pompeii, or the court of Louis XIV, for instance, but the real thing. We are immersed, in effect, in a kind of living history that we absorb through our senses.

While some exhibitions enable us to escape the confines of our own time and place, others may focus on what is current. They may be devoted to local artists, to recent work, or to work in progress. They may include plans, notes, sketches, and other bits of information made available by the artists.

Special exhibitions have also drawn attention to contemporary material that is not ordinarily considered to be fine art. In 1934, in a major exhibition entitled ''Machine Art,'' the Museum of Modern Art in New York presented ships' propellers, ball bearings, copper tubing, and cooking utensils, among other examples of industrial design. In 1975, the Detroit Institute of Arts held an exhibition of T-shirt designs. In 1974-1975 a traveling exhibition of postcards was held at five museums, and a year later, the Museum of Modern Art presented prototypes of taxicabs built to the museum's specifications. Ocean liners, their interior decoration and appurtenances (menus, napkins, ashtrays, matchbook covers, and so on), were the subject of an exhibition at the Cooper-Hewitt Museum in New York in 1980. Displays like these attune us to the aesthetic possibilities in everyday objects not intended as serious art. In addition they remind us that *all* objects created to suit our needs shed light on who and what we are.

Museums advertise their special exhibitions. You can get this information in your local newspapers, through your public library, through public and private schools in your area, local radio and television stations, magazines, at other museums, or by calling the museum itself.

Another reason for visiting a museum is that a museum functions as a repository for objects that are significant to society. Where else can you go to see things from the past, or from remote places, as well as contemporary objects thought to be worth saving?

You can think of the museum as a place where important things are gathered. Museums store, repair, and preserve them for the future. Museum collections are not restricted to painting and sculpture, but may include prints, photographs, folk arts, crafts, popular and commercial art, and well-designed everyday objects, both historical and contemporary. Because these objects are considered to be important, they are displayed—shared, as it were—for the benefit of the public.

Why does a museum acquire a particular work of art? There is no single reason. Some works of art are acquired because they stand on their own in terms of their beauty. Others because they are representative of a culture or a time period. Museums may buy the early work of a well-known artist because it sheds light on the artist's development. They may exhibit a piece because it is rare or unique. Or they may purchase pieces that fill gaps in their collection. In addition, there may be some intangible reason for acquiring the piece. Perhaps there is just something about it, some indefinable quality that sticks in the mind. Art has a way of escaping categorizing and defying attempts to pin it down. That indefinable quality may be the best reason for acquiring a work of art and sharing it with the public.

Museum personnel give careful consideration to what they buy and what they exhibit. Tastes and opinions differ and of course change over time. Not everything will be of equal quality. Not everything will be great art. But whatever you see in a museum, you may be sure that, within the limitations of availability, it is considered to be the best or most important work of its kind.

14-4
Stemcup, Ch'ing
dynasty, Ch'ien Lung
reign, 1736-95. Porcelain,
3⅞″ high. Yale University
Art Gallery New
Haven. (Gift of Dr.
Yale Kuesland, Jr.)

Above all, museums devote themselves to collecting what is beautiful, which brings us to the final reason for visiting them: we go to a museum to see beautiful things.

By their very existence, museums exemplify the idea that it is important to contemplate beauty, not just to read about it. The reaction to beauty is universal, and finds expression in the art of every culture we know of. Beauty in art, like beauty in music or beauty in nature, refreshes us and inspires us. Whatever our material circumstances, our lives would be blighted without the experience and the memory of beauty.

The beauty of man-made forms has its own special character. Whether inspired by nature or purely imaginative, works of art concentrate and preserve beauty for our contemplation and pleasure. Through the handiwork of artists and craftsmen of all times and places, a lovely color, or volume, or shape, a texture or a pattern is refined into an image or object that is whole, distinct, and—unlike nature—intentionally expressive (Fig. 14-4).

We shouldn't ever think of museums as the exclusive domain of what is beautiful or significant. Some of the things that you and I take for granted today will someday be in a museum. But for now they are around us, waiting to be discovered.

15 | *Outside the Museum*

Ways of Seeing

One beautiful, sunny day a friend of mine visited a Japanese temple. When he thanked the monk who showed him through, and complimented the beauty of the temple, the monk replied: "Yes, it is beautiful today, but you must come back and see it in the rain to really appreciate it."

People may enjoy a sunset, a flower, or a mountain, and still overlook many of the less obvious elements that make up our visual world. This is not surprising. What we see depends on what we expect to see. Custom and habit predispose us to look for beauty in sunshine and not in rain. For the monk, of course, it was different.

Generally we notice things in terms of their relevance to our interests. Two people look at a motor. One studies it to see how it works. The other imagines it framed in a photograph or illustration. These different ways of seeing reflect the interests of the observer.

Different ways of seeing are in fact different ways of thinking. For the most part, we operate in a practical mode. We use our eyes to gather in useful information. But while our minds operate in this matter-of-fact way, our aesthetic awareness is crowded out. For example, our reaction to rain, fog, or snow is likely to be restricted to their effect on our plans. As long as we think of them in terms of raincoats, slow driving, and shoveling, we will not be *seeing* rain, fog, or snow. If we choose, however, we can let go of these and other habitual associations and instead focus aesthetically on what we see. We can concentrate on tints of color and shades of light that had escaped us, as well as motion, rhythms, sounds, and smells of which we might otherwise have been unaware.

When we name things, as we do unconsciously when we look at them, we place them in a pre-established category—plant, button, pebble, dog, car, and so on. But we can release the things we see from the constraints of our preconceptions. Just take the time to investigate *visually* the object before you, and you will become aware of its

unique properties. Listen to these observations written by Kuo Hsi, a Chinese artist of the eleventh century:

> A mountain viewed at a close range has one appearance; a mountain viewed at a distance of several miles has another. When viewed from the distance of scores of miles, it has still another. The change of appearance caused by the varying degree of distance from the object is figuratively known as 'the change of shape with every step one takes.' The front view of a mountain has one aspect; the side view another; the back view still another. The ever changing view of the mountain from whatever side one looks is described as 'different shapes of a mountain as seen from every side.' Thus a single mountain combines in itself several thousand appearances. Should we not realize this fact?
>
> Water is a living thing: hence its aspect may be deep and serene, gentle and smooth; it may be vast and ocean-like, winding and circling. It may be oily and shining, may spout like a fountain, shooting and splashing; it may come from a place rich in springs and may flow afar. It may form waterfalls rising up against the sky or dashing down to the deep earth; it may delight the fishermen, making the trees and grass joyful; it may be charming in the company of mist and clouds or gleam radiantly, reflecting the sunlight in the valley. Such are the living aspects of water.[1]

Fine-Tuning Our Senses

Great works of art often reflect that fine-tuned kind of observation that Kuo Hsi makes. It is a quality of seeing into things that we admire in Rodin's *Burghers of Calais* (see Fig. 3-8), El Greco's *View of Toledo* (Color Plate 6), Hokusai's *Great Wave* (see Fig. 7-23), Van Eyck's *Portrait of Giovanni Arnolfini and His Bride* (Color Plate 28), or Rembrandt's *Hendrickje Bathing in a Stream* (see Fig. 11-3). When I look at a landscape by Monet I see it through his eyes. A sky painted by El Greco is not like any other. A portrait by Rembrandt evokes some aspect of humanity that I find in the work of no other painter. These images have come back to me again and again. I have seen sun-filled meadows that are Monet's, stormy skies with heavy, torn clouds that are El Greco's, and certain faces and expressions that are Rembrandt's. Had I not seen their paintings I may not have been aware of these things. I may have been thinking of something else, and not have noticed.

Art is a way of sharing what is seen and what is felt. Art, and artists, give us new eyes to see with. Oscar Wilde reflected on this idea in *The Decay of Lying* (1889) when he wrote:

> Where, if not from the Impressionists, do we get those wonderful brown fogs that come creeping down our streets, blurring the gas-lamps and changing the houses into monstrous shadows? To whom if not to them and their master, do we owe the lovely silver mists that brood over our river, and turn to faint forms of fading grace curved bridge and swaying barge? The extraordinary change that has taken place in the climate of London during the last ten years is entirely due to this particular school of Art. . . . Things are because we see them, and what we see, and how we see it, depends on the Arts that have influenced us. To look at a thing is very different from seeing a thing. One does not see anything until one sees its beauty.

Then, and then only, does it come into existence. At present, people see fogs, not because there are fogs, but because poets and painters have taught them the mysterious loveliness of such effects. There may have been fogs for centuries in London. I dare say there were. But no one saw them, and so we do not know anything about them. They did not exist till Art invented them.

Monet taught his audiences to see fogs. All good works of art teach us to see. Artists constantly renew our vision by presenting what we had not seen before. Raphael showed us ideal beauty; Rembrandt revealed the beauty of the old and the poor. Van Dyck evoked aristocratic elegance, while Chardin made an art out of humble pots and pans. To artists whose eyes are trained to observe carefully what they see, the world is eternally fresh and full of amazing things. The visual world can be wonderful for us too if we take the time to slow down and look at it.

In some cultures, pausing to observe things in nature is institutionalized, even ritualized. The Jewish sabbath begins when the setting sun touches the tree tops, and ends when three stars can be seen in the sky. The new moon is greeted with the recitation of psalms, out of doors if possible. Religious Jews are expected to recite a blessing when seeing a rainbow, lightning, a shooting star, lofty mountains, the ocean, a desert, or a beautiful tree; and upon first seeing trees blossom in the spring.

The important thing is first of all to have a real love for the visible world. . . . For the visible world in combination with our inner selves provides the realm where we may seek infinitely for the individuality of our own souls. In the best art this search has always existed.

—Max Beckmann, 1948

In Japan the tea ceremony evolved out of Zen practice into a secular ritual. It is a simple ceremony in which tea is prepared by a host and shared with a guest or guests, if possible in a tea house built for that purpose (Fig. 15-1). The tea house is a small building made of natural materials such as wood, cane, or straw, that are left to weather unpainted so their true character will emerge over time. Within the tea house, spare, asymmetrical rooms with bare walls heighten your awareness of the color and texture of the materials used. The floors are straw mats, and there is no furniture. While the guests await the serving of tea, they observe the *tokonoma*—an alcove, or niche built into one wall, where the host will have placed a painting, an arrangement of flowers, or perhaps a single blossom in a simple bowl. The *tokonoma*, with its object, is the focal point of the room. As tea is prepared and served, the guests are expected to contemplate the beauty of the utensils, which according to tradition, must be simple and unpretentious. The movements of the host in the preparation and serving of the tea are to be graceful. Conversation is subdued. Guests are encouraged to discuss the beauty of the

15-1
Shokintei tearoom,
Katsura Palace, Kyoto,
Japan.

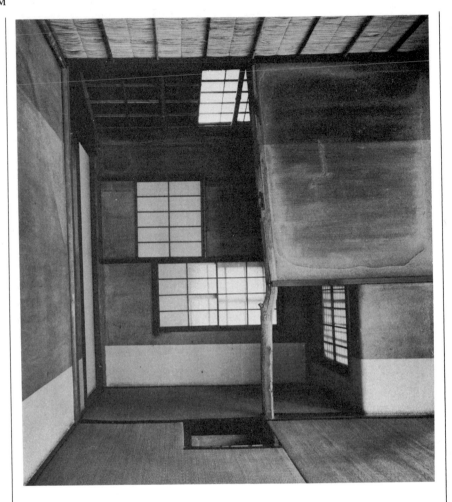

painting or flower selected by the host, or they may comment on the tea or the utensils. Beyond the tea house is a small garden, whose walls separate the tea house from the bustle of the outside world.

The tea ceremony is designed to create an atmosphere of serenity in which all the senses may be awakened. The sight of a few beautiful objects in an uncluttered setting, the sound of the whisk making the tea, the sound of the tea being poured, the fragrance of the tea and its taste, and the feel of the tea bowl in your hand are all a part of the tea experience. The tea ceremony slows down the pace and allows one, for a time, to be at peace with one's surroundings.

Everyday Aesthetics

Modern, urban environments make it difficult for us to feel connected to our surroundings. Still, wonderful things are all around us. Consider the elegant perfection of a ferris wheel, the massive grandeur of a grain elevator, fireworks,

pinwheels, juke boxes, neon signs, theater marquees, billboards or hand lettered signs. We may not think of these things as art. What matters, however, is not that we identify something as art, but that we open our eyes to notice and enjoy what is around us.

Objects in their own environment, doing their tasks, have a flavor that they lose in the museum. Someday a museum may exhibit a twentieth-century pinball machine. Standing silently, perhaps unlit, could it convey the excitement that it gives off when it is in action? It would look desolate. It would have lost its personality. And so would a float when it's not in a parade, or marionettes when they're not performing, or masks when they're not being worn (some of which we may see in a museum). How would a sandcastle look in a museum? A scarecrow? Or a hot air balloon?

Art can be anything people make. If a useful object is imaginatively conceived or beautiful, so much the better for those of us who use it or look at it. The Greek vase shown in Figure 6-12 was made to hold wine or oil. The porcelain bowl from China illustrated in Figure 14-4 was a dining utensil that held food. Peruvian fabrics like that shown in Figure 10-1 and Color Plate 23 were worn as clothes. The lamp shown in Figure 15-2 shed light in a mosque or a home. The Dan mask (Fig. 7-11) was a ritual object. The statue of Mycerinus, (see Fig. 6-2), was created to preserve his soul in the afterlife. The Brooklyn Bridge (see Fig. 2-2) connects the boroughs of Manhattan and Brooklyn. Are these objects any less art because they do not fall within the strict definition of fine arts?

15-2
Mosque lamp with Nashki inscription around neck, after 1331, Cairo. Enamelled glass, approx. 10¾″ high, greatest diameter 9″. The Toledo Museum of Art. (Gift of Edward Drummond Libbey.)

15-3
Allen Samuels,
drinking glasses
made for Libbey
Glass Co., 1979.

Consider, too, Veneziano's *Madonna and Child with Saints* (see Fig. 5-18) and Rubens's *The Crowning of St. Catherine* (see Color Plate 11). They were painted as altarpieces. Accordingly, their primary function was to nurture faith and direct the mind of the worshiper to prayer and religious contemplation. The reliefs from the Column of Trajan (see Fig. 12-4), the mosaic of Justinian and his court in the church of San Vitale (see Fig. 5-16), and Rigaud's commissioned portrait of Louis XIV (see Fig. 5-10) were likewise designed to perform functions that were specific and public. They were not intended for museums—indeed no art was made for museums until the twentieth century.

Many commonplace objects are superbly designed. Even though they lack the content we find in a painting or a sculpture, we may still draw pleasure from their forms. The paper clip, patented in 1900, is a useful tool whose form is perfectly matched to its function. Its shapes and lines are fluid and well-proportioned, its shiny finish is appealing, and its material is ideally suited to what it does. There are no leftovers in a paper clip; its design is as carefully considered as any piece of sculpture. Balloons, umbrellas, airplanes, springs, and pencils are also examples of clean, efficient, attractive, design.

Allen Samuels's drinking glasses were mass-produced by the Libbey Glass Co. in the 1970s (Fig. 15-3). The bubblelike swelling at the center catches light and makes you aware of the lovely, fluid properties of glass. At the same time it keeps the glass from slipping out of your hand and enables the glasses to stack easily. Sensitively integrating form and function, these glasses are wonderful both to look at and to use. They are as pleasing as sculpture I have seen; no less so for my being able to drink out of them.

Harmony of form and function explains the appeal of many man-made objects—but it is not the whole story. Some objects appeal to us because, with a certain crass perverseness, they have no visual or functional logic. A child may be delighted by a ceramic mug made with a small, green frog sitting on the bottom. Beauty is not the issue here. Mickey Mouse watches and radios, beaded coin purses that look like watermelon slices, and baseball hats with wings have a whimsey that's hardly based on aesthetic considerations. These, too, are the works of man—not destined for greatness perhaps, but appealing, and like all the products of our hands and minds, answering to our needs while reflecting our attitudes and values. How many of them will wind up in a museum some day? What will they tell about us?

Only indifference limits us in what we can see. Perhaps, too, we mistrust our own capacity to use our eyes. Children's drawings are alive with fantasy and individuality. In a few years' time they grow alike, private visions having been replaced by convention. I don't believe children see any better for having learned to draw birds with V's, or flowers whose petals are all the same. When Van Gogh painted the sky in *Starry Night* (Color Plate 5) he was agog with discovery, as if he had seen it for the first time. He also painted his boots, and gave them such character that they could almost walk out of the painting (Fig. 15-4). Boots were not, of course, a subject for painters, but Van Gogh saw a raw, awkward kind of beauty when he looked at his. He was not content to see the world through other people's eyes; very likely that's why he never tired of looking at it.

I think a painter is happy because he is in harmony with nature as soon as he can express a little of what he sees. And that's a great thing; one knows what one has to do, there are subjects in abundance. If that work strives to bring peace, like that of Millet, then it is doubly stimulating—one is then also less alone, because one thinks: It's true I'm sitting here lonely, but whilst I am sitting here and keeping silent, my work perhaps speaks to my friend, and whoever sees it will not suspect me of being heartless.

—Vincent Van Gogh, in a letter to his brother, Theo, 1882

15-4
Vincent van Gogh, *Boots*, 1886. Oil on canvas, 15″ × 18″. Collection: Rijksmuseum Vincent Van Gogh, Amsterdam.

The visual world is inexhaustible. No one can possibly take it all in. Even within the same context, everyone will see something different. Every artist will depict the same subject in a different way because every artist finds different material relevant. Each looks for different things, and sees them differently.

Those of us who don't paint, but want to appreciate what we see, can begin by observing what is around us, wherever we are. We can pick a scene and look at it until we find something in it we haven't seen before. We can choose a single object, observe its color or colors, its shape, and the light that is contained or reflected. We can look at the volume and notice the texture of its surface. We can imagine it floating in the air, or huge in size, or imagine multiples of it piled, stacked, or bunched together. To go further, we can imagine it as it would be interpreted by an artist. We can look at the corner of our room and ask how it would appear in a painting by Van Eyck, Vuillard, or Fairfield Porter. We can imagine a familiar landscape as if painted by Monet or Van Gogh.

Seeing what's around us through the eyes of an artist expands our vision. Ultimately, we can develop our own ways of seeing. Making a painting or a sculpture is a way of sharing those ways of seeing. But even as observers, we will find the world infinitely rich.

Endnotes

Chapter 5

[1]Heinrich Wolfflin, *Principles of Art History,* trans. M. D. Hottinger (New York: Dover, 1965; originally published 1915), p. 1.

Chapter 6

[1]Hsieh Ho, *Treatise on Ancient Painting,* 5th century A. D., cited in Osvald Siren's *The Chinese on the Art of Painting* (New York: Schocken, 1963), pp. 19–22.

[2]Michael Baxandall, *Painting and Experience in Fifteenth Century Italy* (New York: Oxford University Press, 1982), p. 61.

[3]Robert Enggass and Jonathan Brown, *Italy and Spain 1600–1750,* Sources and Documents in the History of Art Series (Englewood Cliffs, NJ: Prentice-Hall, 1970), p. 164.

[4]Elizabeth Gilmore Holt, *The Triumph of Art for the Public* (Garden City, NY: Anchor Press/Doubleday), p. 45.

Chapter 7

[1]Josef Albers, ''Prophet and Presiding Genius of American Op Art,'' *Vogue,* October 15, 1970, p. 127.

Chapter 8

[1]*Christo: 10 Works in Progress,* Michael Blackwood Films, New York, NY, 1978.

[2]Allan Kaprow, *Assemblages, Environments, and Happenings* (New York: Abrams, 1966), p. 183.

[3]Calvin Tomkins, *The Bride and the Bachelors/Five Masters of Avant-Garde* (New York: Viking Press, 1968), p. 199.

[4]Sibyl Moholy-Nagy, *Laszlo Moholy-Nagy/Experiment in Totality,* 2nd ed. (Cambridge, MA: MIT Press, 1969), p. 72.

Chapter 10

[1]Holt, *The Triumph of Art,* pp. 283–284.

[2]Holt, *The Triumph of Art,* p. 296.

[3]Lucy R. Lippard, *Eva Hesse* (New York: University Press, 1976), pp. 29, 33.

[4]Cindy Nemser, *Art Talk* (New York: Charles Scribner's Sons, 1975), p. 203.

[5]Nemser, *Art Talk,* p. 222.

[6]Nemser, *Art Talk,* p. 207.

Chapter 11

[1]Wayne Craven, *Sculpture in America* (New York: Thomas Y. Crowell, 1968), p. 118.

[2]Craven, *Sculpture in America,* p. 118.

[3]Craven, *Sculpture in America,* p. 117.

[4]John W. McCoubrey, *American Art 1700–1960,* Sources and Documents in the History of Art Series (Englewood Cliffs, NJ: Prentice-Hall, 1965), p. 181.

[5]McCoubrey, *American Art 1700–1960,* p. 191.

[6]W. Eugene Kleinbauer, *Modern Perspectives in Western Art History* (New York: Holt, Rinehart, and Winston, 1971), pp. 194–201. (Originally published in *Burlington Magazine,* LXIV 1934, pp. 117–127.)

Chapter 15

[1]Kuo Hsi, *An Essay on Chinese Landscape Painting,* Shio Sakanashi, trans. (London: John Murray, 1959), pp. 40, 47–48.

Glossary

abstract art Any art that is not subject to the limits imposed by representation. In modern abstract art, the emphasis is on form rather than on subject matter; in fact, in some abstract art there is no recognizable subject matter at all.

Abstract Expressionism Also known as Action Painting. A style of abstract painting originating in New York in the 1940s and 1950s. An Abstract Expressionist painting is developed spontaneously and intuitively rather than according to studies and drawings; hence it provides a direct record of the gestures of the painter.

academic art Art associated with the French Academy of the nineteenth century, the official art school of France. The academy endorsed art that tended toward illustrative, frequently classical subject matter, exacting detail, and refined technique. Academic art also refers to any art that accords with institutionalized doctrines or theories.

aesthetic(s) The beauty or attractiveness of an object. Aesthetics may refer to the quality of beauty in general.

allegory A story that functions on two levels, one of them symbolic. Typically, the characters in an allegory represent ideas, such as Truth, Liberty, or Time.

Assemblage A work of art consisting of everyday objects removed from their usual context and stacked, heaped, or otherwise arranged.

avante-garde Artists or individuals who seem to be ahead of their time. From the French military term meaning ''the vanguard.''

axis An imaginary line around which things are placed roughly equally. Vertical axes appeared frequently in Renaissance painting, when balanced, dignified compositions were in favor.

Baroque A seventeenth and early eighteenth-century style of art and architecture, characterized by an intense physical presence, and in painting and sculpture, by dramatic light effects and a wide range of emotional states. In painting, three distinct tendencies can be seen: one ornate and dynamic, one more classical and restrained, and one more realistic.

The Bauhaus An influential German art school, open from 1919 until 1933. The Bauhaus stressed the unity of fine art, architecture, crafts, and industrial design, and sought to apply principles of good design to all of these areas.

Byzantine The art and architecture of the Eastern Roman Empire, beginning in the sixth century A.D. Byzantine art developed out of classical forms into a highly conventionalized, abstract, frontal style, reflecting the influence of near Eastern traditions. Byzantine architecture, based on Roman types, favored a centralized plan topped by a large dome. Although the Byzantine Empire ended in the fifteenth century, the Byzantine style persists in the art and architecture of Eastern Orthodox religions to this day.

canon A system of proportions used when drawing a figure or designing a building. Canons vary depending on the culture and the time; they were used in ancient Egyptian painting and sculpture, in ancient Greek sculpture and architecture, in Byzantine painting, in Renaissance architecture, in certain Buddhist traditions, and elsewhere.

classical The ancient civilizations of Greece and Rome. The ''classical period'' of Greek art refers specifically to Greek art of the fifth century B.C., a period in which the art was subsequently believed to have reached its highest development.

classicizing The use of artistic forms and principles based on those developed in ancient Greece and Rome.

collage A work of art that is made wholly or partly by gluing down flat materials such as paper or cloth.

composition The organization of a work of art.

compositional line In a painting, an actual or implied line that divides sections of the work. Compositional lines are often used to direct the eye through the painting.

conceptual art A kind of post-modern art that emphasizes the concept, or idea of a work of art, rather than its form. Conceptual art is based on the proposition that a work of art is essentially an imaginative entity, and that form is merely the vehicle. Hence conceptual pieces are intended to stimulate thinking rather than to be admired as aesthetic objects.

content The meaning or meanings of a work of art; the ideas that it contains.

contrapposto In a sculpture or painting, a pose in which the weight of the figure is shifted, allowing the torso to twist.

convention A traditional form, procedure, or approach.

crafts Hand made objects traditionally distinguished from fine arts because they were utilitarian, and hence less purely imaginative. Today crafts are commonly made as aesthetic objects, and the line between art and craft is not always clear. In many non-Western cultures, no distinction is made between art and craft.

criticism An evaluation of a work of art. Because it may investigate what the artist is attempting to do or to say, criticism can help to interpret, as well as to evaluate, a work of art.

Cubism An abstract style of painting developed between 1910 and 1912 by Pablo Picasso and Georges Braque. In a Cubist painting, both the objects and the space around them are fragmented and reassembled in ambiguous relationships.

culture The sum total of a peoples shared ways of doing things and understanding things; their way of life.

Dada A nonsense word coined by a group of artists and writers during World War I. Reflecting the outrage and cynicism engendered by the war, the Dada group staged events intended to shock the public. Dadaists claimed to be anti-art; they purged their work of aesthetics, and promoted irrationality, absurdity, and aggressive humor.

Environment A work of art in which objects are arranged, often casually, in a space large enough to walk through.

fine art Art whose primary function is aesthetic rather than utilitarian. The classification of the fine arts was first made in eighteenth-century Europe; the distinction between fine art and other art does not necessarily appear in pre-Renaissance art or in non-Western cultures.

focal point The place where your eye comes to rest in a painting.

folk art Typically, art produced by non-professionals, based on traditional patterns and techniques. Folk art is produced in the same societies that produce fine art, but remains separate from it.

foreshortening The illusion created in a picture when an object of some length is depicted as extending toward the viewer. The foreshortened object appears correct, though noticeably compacted.

form The appearance of a work of art; how it looks. Form may be determined by necessity, tradition, or by the artist. Form also refers to what we can see of an object or representation of an object.

formal analysis An investigation of the form of a work of art. A formal analysis is usually conducted by isolating the formal elements that can be identified in the piece, and assessing their function and impact on the whole.

formal elements In a painting, these include color, light, texture, volume, shape, line, space, and composition. In a sculpture, these include mass, space, material, texture and

color. In architecture, these include space, light, the wall and its decoration, material, color, rhythm, and the site.

freestanding A sculpture that is free of the wall or of the block from which it was carved; one that the viewer can walk around.

fresco A mural in which the colors are mixed into the wet plaster and painted directly on the wall.

frontal Describes a painted or sculpted figure that faces the viewer directly.

glaze An extremely thin, transparent film on a painting, usually applied as a finishing touch.

Gothic The last expression of Medieval art. The Gothic style flourished mainly from the twelfth to the fifteenth centuries. In contrast to the earlier Romanesque style, Gothic architecture is lighter and airier, and space is more unified. Gothic painting and sculpture moved toward realism.

ground A coat of paint covering a surface, such as canvas or board, on which a painting is to be executed. A ground may be white or toned.

Happening An art form consisting of an event in which the participants perform pre-planned or agreed upon activities for their own sake.

icon A holy image. Specifically, images used in Byzantine, Greek, or Russian Orthodox churches. In loose usage, an icon may be any image of a revered subject.

iconography The depiction of figures and objects according to certain conventions or traditions so as to make them recognizable, and hence, to communicate specific meanings.

idealism The presentation of a subject in its most beautiful, refined, or exalted form. Idealism in art was encouraged by Plato's belief in the existence of Forms or Ideas that are perfect and eternal. The perfected figure or object in art was believed to reflect ultimate reality, as opposed to the world of appearances.

image A recognizable representation of something; specifically the representation of a person. Image also refers to the way something appears in a work of art or in the imagination.

impasto A thick, pasty, hence opaque layer of paint applied to a canvas.

Impressionism In the later nineteenth century, a style of painting that aimed at capturing light and atmosphere as perceived in a precise moment of time. Toward that end, Impressionist painters applied bright colors in tiny dabs of opaque paint, which from a distance combine to produce a sparkling effect.

interpretation A statement or a work of art intended to clarify or reveal something. To interpret a work of art is to explain its meaning or meanings.

linear perspective A mathematically-based perspective system in which lines moving into the distance appear to join at a point on the horizon. The fifteenth-century architect Brunelleschi is believed to have formulated the rules of linear perspective.

Mannerism A sixteenth-century style of art and architecture that consciously violated Renaissance principles by its excessively complex compositions, distortion of space, elongation of figures, and harsh combinations of colors. This style is sometimes characterized by extreme elegance.

mass The three-dimensional, solid aspect of a sculpture.

medieval art The art of the Middle Ages, extending roughly from the dissolution of the Roman Empire in the fifth century to the Renaissance in Italy in the fifteenth century. Medieval art developed out of late Roman art and was influenced by the native traditions of Northern Europe. Generally, the style is abstract, frequently figurative. Religious art represented the Church and communicated its teachings; secular art was largely utili-

tarian, and in both, art was frequently used as a decorative embellishment.

Minimal Art (also **Minimalism**) A development of abstract art in the 1960s that reduced to a minimum the lines, shapes, or colors in a work of art.

modern art A general term referring to art from the latter part of the nineteenth century through the twentieth century that is characterized by an interest in form and a determined rejection of past art.

mosaic An image or pattern made up of small pieces of colored stone, glass, or tile embedded in concrete.

mural A painting applied directly to a wall or ceiling.

Neoclassicism An eighteenth- and nineteenth-century style of art and architecture. In part a reaction against the ornateness and sensuality of Rococo, this style found inspiration in the art of ancient Greece and Rome. Neoclassicism attempted to express the moral seriousness it found in Greek and Roman civilization using classical forms and subject matter.

nonobjective art Abstract art that contains no images of recognizable objects.

pentimenti From the Italian, meaning ''I repent.'' In a painting or drawing, marks showing a place where the artist changed his mind and altered the original image.

perspective The depiction of receding space on a flat surface.

photogram An art form invented and named by Laszlo Moholy-Nagy. A photogram is made by placing an object on photosensitive paper and shining a light on it, so that a silhouette of the object appears on the paper when it is developed.

plane A flat surface.

Pop Art A movement appearing in the early 1960s that focused on everyday, commercial objects, and that frequently used the techniques and the imagery of commercial art.

Post-Impressionism A term used for a number of late nineteenth-century painters who retained the bright color and light of Impressionism, but who reacted against its amorphous compositions and its emphasis on optical effects. The Post-Impressionist painters were involved with the exploration of form; some emphasized its structural aspects while others explored its expressive possibilities.

post-modern art A general term for the work and interests of a number of artists who, beginning in the 1960s, reacted against the formal and aesthetic concerns associated with modern art. Post-modern artists share the aim of moving art closer to life, and hence to a broader range of experience. To this end, they explore new forms of art, some of them nearly indistinguishable from non-art.

primitive art See *tribal art*.

ready-made Invented and named by Marcel Duchamp, who bought ordinary manufactured objects and placed them in an art gallery. Duchamp insisted that these objects—''ready-mades''—were works of art because he chose them to be.

realism Art that corresponds closely to visual perception. Also refers to that aspect of a painting or sculpture that has to do with its exacting and scrupulous depiction of the external world.

Realism A mid-nineteenth century movement affirming that artists should depict life as it is. Generally, Realist painting depicts the more mundane aspects of life.

Regionalism A movement in American art in the 1920s and 1930s that aimed to celebrate the spirit of America mainly through scenes of rural or small town life.

relief A sculpture that is nearly flat. Relief sculpture is usually set into, or placed before, a wall.

Renaissance A period in Western culture following the Middle Ages. The Renaissance

was characterized by a revival of interest in classical antiquity, and by more rational, objective attitudes toward man and the universe. These interests and attitudes are reflected in Renaissance art in the realistic though idealized images of human beings in an orderly world.

repoussoir In a painting, a large object placed in the foreground that acts to frame the action, and to emphasize the recession of space.

representational art Art that aims to create convincing illusions of recognizable objects.

Rococo A delicate, decorative style that evolved in the eighteenth century out of the Baroque style. Rococo is characterized by pastel colors, graceful, curvilinear lines, and light-hearted subject matter.

Romanesque art Medieval art of the eleventh and twelfth centuries. Romanesque art represents the fusion of classical and Northern European traditions. Romanesque architecture is solid and massive. The art is abstract and mainly figurative; sculpture is frequently integrated with architecture in an overall decorative scheme.

Romanticism An early nineteenth-century movement, in part a reaction to the intellectualizing tendency of neoclassicism. Romantic artists regarded works of art as an expression of their feelings; in painting, the Romantic style is characterized by bright colors, movement, and exciting, exotic, or mysterious subject matter.

site piece An art form in which a natural environment is intentionally altered in some way.

Social Realism A movement among artists in the 1930s that focused on themes of social concern, such as unemployment, poverty, and hunger. Social Realists believed that artists should devote their work to raising social consciousness.

space In a painting, the illusion of depth. In a sculpture or a building, the voids or cavities between or around the solids.

style The characteristic appearance of art in a particular time or place. Style is determined both by cultural conventions and the initiative of individual artists.

subject matter The story, theme, characters, or objects represented in a work of art.

Surrealism A movement in art flourishing between the 1920s and 1940s that sought to evoke dreams and the unconscious. Surrealist painters worked in both abstract and representational styles.

symbol An image or object that stands for something else. The meaning of a symbol is usually quite specific: a cross symbolizes Christianity, a heart symbolizes love, a yellow ribbon symbolizes faithfulness.

symmetrical Describes a composition in which one half is more or less the mirror image of the other.

tribal art Art produced in traditional communities; tribal, or otherwise closely knit. Generally, the art has a practical function, but is usually characterized by an intense concern for design and technique.

trompe l'oeil ("fool the eye") A painting intended to trick the viewer into thinking the objects or scenes depicted are real.

Western art The art of Western civilization. It originated in ancient Greece, evolved in Europe, and later spread to the Western Hemisphere. Today its influence is seen throughout the world.

Picture Credits

2-2 Port of New York Authority **2-3** *Secrets* by Douglas Huebler was published by and is distributed by Printed Matter, Inc., New York.

3-1 Photo by Jean Roubier; **3-2** Photo by Greek National Tourist Office; **3-3** Photo by Jean Roubier; **3-4** Alinari/Art Resource, New York; **3-5** Freelance Photographers Guild; **3-6, 3-7** Alinari/Art Resource, New York; **3-10** Giraudon/Art Resource, New York.

4-2 SCALA/Art Resource, New York; **4-3** Colorphoto Hans Hinz, Allschwil-Basel; **4-4** Courtesy of The Oriental Institute, University of Chicago; **4-6** Courtesy of the Frick Art Reference Library; **4-7** © 1980 George Hausman; inset photo by Dan Kozan.

5-1 New York State Office of Parks, Recreation and Historic Preservation, Bureau of Historic Sites, Olana State Historic Site, Taconic Region; **5-4** Pinacoteca di Brera, Milan; **5-5** Bruckmann/Art Resource, New York; **5-6** Cliché des Musées Nationaux, Paris; **5-8** Alinari/Art Resource, New York; **5-9** Cliché des Musées Nationaux, Paris; **5-10** Giraudon/Art Resource, New York; **5-14, 5-16, 5-17** Alinari/Art Resource, New York; **5-20** Giraudon/Art Resource, New York.

6-3 Colorphoto Hans Hinz, Allschwil-Basel; **6-4, 6-8** Alinari/Art Resource, New York; **6-13** Caisse nationale des monuments historiques, Paris; **6-15** Courtesy of Washington Convention and Visitors Bureau.

7-1 Alinari/Art Resource, New York; **7-2** A.C.L.-Bruxelles; **7-7** Cliché des Musées Nationaux, Paris; **7-28** Photo Margaret Bourke-White, LIFE Magazine © 1954, Time Inc.

8-1 Photo by Rudolph Burckhardt; **8-2** Photo courtesy of Leo Castelli Gallery, New York; **8-3** From *Assemblages, Environments, and Happenings* by Alan Kaprow published by Harry N. Abrams, Inc., photograph courtesy of Ken Heyman; **8-4** Photo by Robert R. McElroy; **8-5** Photo courtesy of Metro Pictures, New York; **8-7** Photo by Susie Zeig; **8-8** Photo by Gianfranco Gorgoni; **8-10** Photo by Hans Haacke; **8-11** Courtesy of M. Knoedler and Company; **8-13** Photo courtesy of The Philadelphia Museum of Art, Mrs. Marcel Duchamp.

9-2 Cliché des Musées Nationaux, Paris; **9-6** Hans M. Wingler, *The Bauhaus,* © 1969 by The Massachusetts Institute of Technology; **9-9** Iowa State Historical Department, State Historical Society; **9-11** Eric Pollitzer; **9-12** From *Subway Art,* Holt, Rinehart and Winston, New York, 1984, and Thames and Hudson, London, 1984; **9-13** © Public Art Workshop, Chicago; **9-14** Courtesy of MPM Partnership Group, Ann Arbor, Michigan; **9-15** © Norman McGrath; **9-16** Photo by Michael Alexander.

10-2 Giraudon/Art Resource, New York; **10-5** Arizona State Museum, University of Arizona. E. B. Sayles, photographer; **10-6** Timothy Hursley/The Arkansas Office; **10-8** The Museum of Modern Art/Film Stills Archive.

11-2 SCALA/Art Resource, New York; **11-4, 11-5** Cliché des Musées Nationaux, Paris; **11-6** Photograph courtesy of The Museum of Modern Art, New York; **11-15** Cliché des Musées Nationaux, Paris.

12-1 Courtesy of Robert Brumbaugh; **12-4** Fototeca Unione, at the American Academy in Rome; **12-6** Caisse nationale des monuments historiques, Paris; **12-7, 12-8, 12-9,**

Index